WHO SHOT ROCK & ROLL

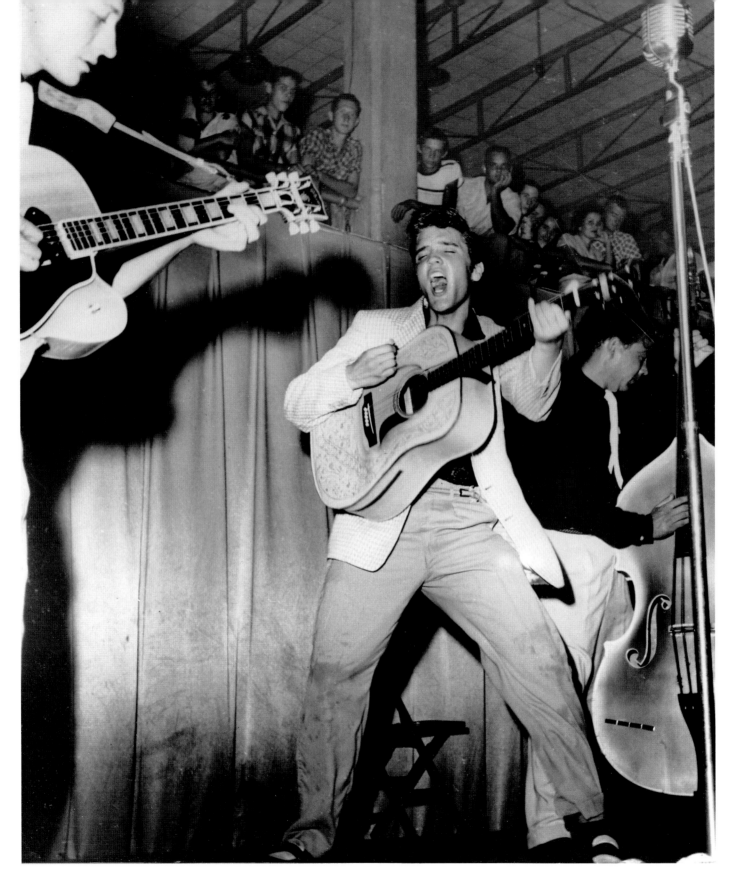

Elvis Presley performing at Fort Homer Hesterly Armory, Tampa, Florida, July 31, 1955

Photograph by William V. (Red) Robertson

WHO SHOT ROCK & ROLL

A PHOTOGRAPHIC HISTORY

1955 TO THE PRESENT

GAIL BUCKLAND

ALFRED A. KNOPF · NEW YORK · 2009

**THIS IS A BORZOI BOOK
PUBLISHED BY ALFRED A. KNOPF**

Copyright © 2009 by Gail Buckland
All rights reserved. Published in the United States by
Alfred A. Knopf, a division of Random House, Inc., New York,
and in Canada by Random House of Canada Limited, Toronto.
www.aaknopf.com
Knopf, Borzoi Books, and the colophon are registered trademarks
of Random House, Inc.

Grateful acknowledgment is made to the following for permission to
reprint previously published material:
Laura Levine: Excerpt from text by Laura Levine from *Backstage Pass:
Rock & Roll Photography* by Thomas Denenberg (New Haven, Conn.:
Yale University Press, in association with the Portland Museum of
Art, Maine, 2009). Reprinted by permission of Laura Levine.
Mick Rock: Excerpt from text by Mick Rock from *Rock X-Posed: Five
Decades of Attitude in Pictures*, by Kodak, edited by Max Brown
(Toronto: Rock Shutter Productions, Inc., 2002). Reprinted by
permission of Mick Rock.
Eddie Vedder: Excerpt from Introduction by Eddie Vedder from *Touch Me
I'm Sick* by Charles Peterson (Brooklyn, N.Y.: powerHouse Books, 2003).
Reprinted by permission of Eddie Vedder.

Library of Congress Cataloging-in-Publication Data
Buckland, Gail.
Who shot rock & roll : a photographic history, 1955 to the present /
Gail Buckland.—1st ed.
p. cm.
Includes bibliographical references and index.
ISBN 978-0-307-27016-0 (alk. paper)
1. Rock music—Pictorial works. 2. Rock musicians—Portraits.
I. Title.
ML3534.B83 2009
779'.978166—dc22 2009019122

Manufactured in Singapore

FIRST EDITION

**ALFRED A. KNOPF WOULD LIKE TO THANK
UNIVERSAL MUSIC GROUP FOR ITS PARTICIPATION
IN THE MAKING OF THIS BOOK.**

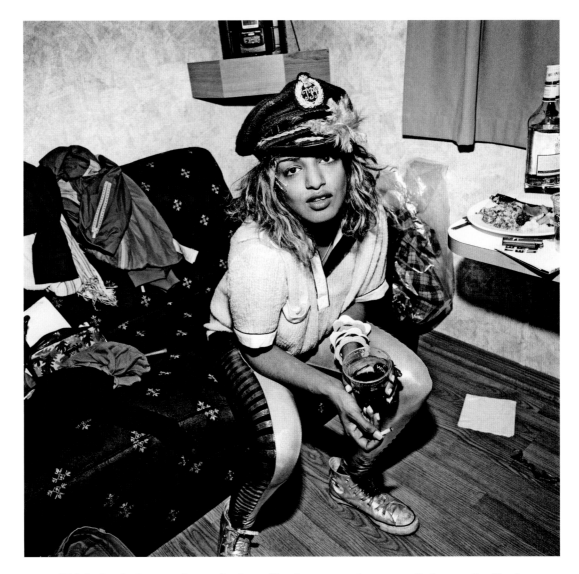

**M.I.A. backstage, a few minutes after her second encore, Osheaga Festival,
Montreal, Canada, September 9, 2007**
Photograph by Valérie Jodoin Keaton

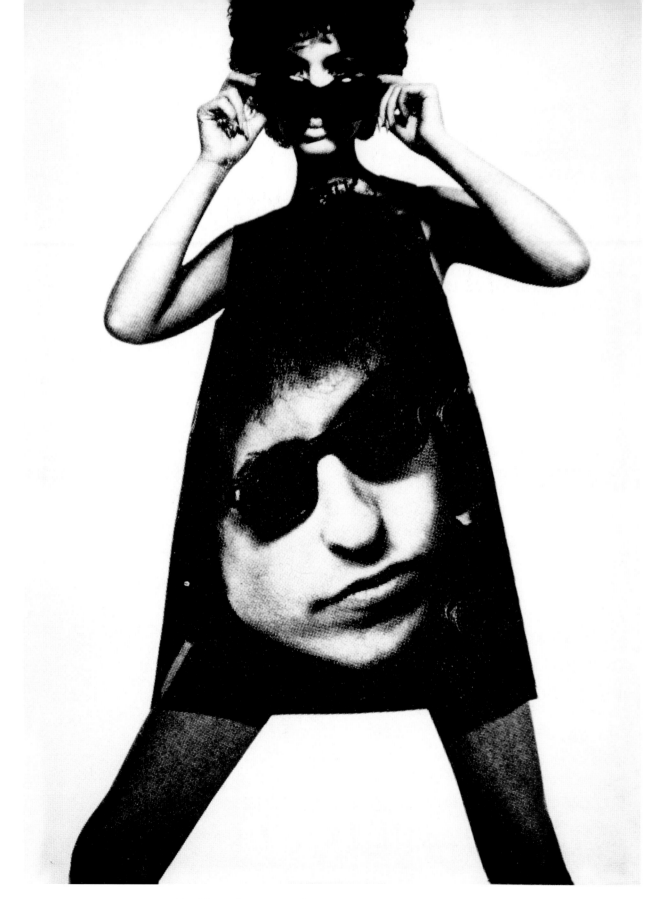

Fashion photograph from British *Vogue*, July 1967
by David Bailey

CONTENTS

PREFACE ix

INTRODUCTION 3

WHO SHOT ROCK & ROLL 28

AN ALBUM COVER CHRONOLOGY 297

ACKNOWLEDGMENTS 303

BIBLIOGRAPHY 305

INDEX 311

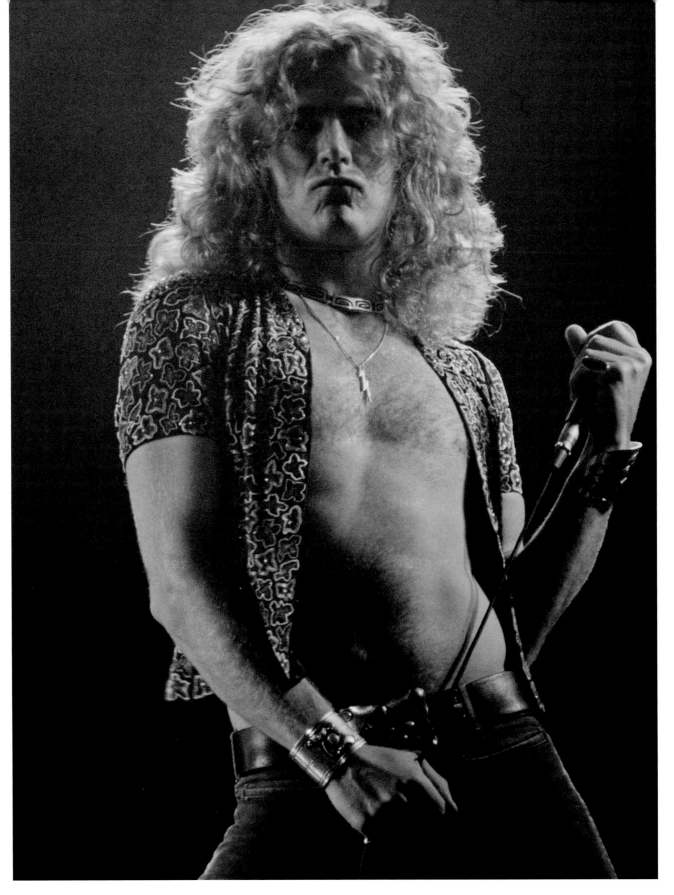

Robert Plant of Led Zeppelin, performing at the Forum, Los Angeles, California, 1975
Photograph by Henry Diltz

PREFACE

The idea for a book came first. Then the Brooklyn Museum, learning of the project, invited me to work with them to develop and curate the most exciting museum show of rock-and-roll photography ever produced. The Worcester Art Museum, Massachusetts; Memphis Brooks Museum of Art, Tennessee; Akron Art Museum, Ohio; and the Columbia Museum of Art, South Carolina, decided they wanted to share in the excitement that is rock-and-roll photography. The book serves as the catalogue to this landmark exhibition.

My rock-and-roll life covers the same time span as the photographs in this book. In 1956, as a little kid, I went to an Elvis Presley concert in Jacksonville, Florida. I don't remember much other than my older sister screaming and a girl fainting in front of me. I loved, loved, loved the Beatles in the sixties. In the summer of 1967—the Summer of Love—I passed through Haight Ashbury with my best friend strumming her guitar. During the craziness and sadness of 1968, I was sad and a little crazy and passionate about photography. That summer, I lived and photographed in Crete and hung out with the hippies in the caves at Matala (so did Joni Mitchell). On my way to study in Manchester, England, I stumbled upon and somehow got a ticket for the opening night of *Hair* in London. At Manchester University, the Rolling Stones blared from the speakers in the cafeteria. I worked in London in the early seventies, which did swing as much as in the sixties. I lived in New York City in the late 1970s and early eighties but unfortunately did not hang out at CBGB, Max's Kansas City, or any of the places

that would have provided excellent material for *Who Shot Rock & Roll*. I was busy writing photography books, teaching the history of photography, and then having babies. I listened to the music my kids listened to in the 1990s. My iPod, a gift from my daughter and son-in-law in 2008, came loaded with their eclectic music—which, interestingly, contained a lot of *my* music.

Music has always been the background; front and center was photography—it gave meaning and clarity to my life. As passionate as any rock musician with his or her guitar and record collection, so was I with my Pentax, my Nikon, my enlarger, my prints, and my photo books. Hearing the sound tracks of my youth connects me with my eighteen-, twenty-two-, twenty-eight-year-old self, and I know that rebellious girl with the camera still exists. My rebellion manifested itself in the act of seeing. My goal in writing this book and presenting this extraordinary selection of photographs is to share my passion for photography while holding on to that rock-and-roll spirit.

My twenty-five-year-old son, Kevin, has been thinking about the relationship between music and photography almost as long and hard as I have. He has been my "consultant" for the past four years. After going to a concert in Olympia, Washington, and experiencing "the music in every moment of the music," he wrote to me that "in the photographs in your book, we see the singers silenced, yet we hear the song—the pictures bring the roll to a slow and steady stop."

Warwick, New York
May 2009

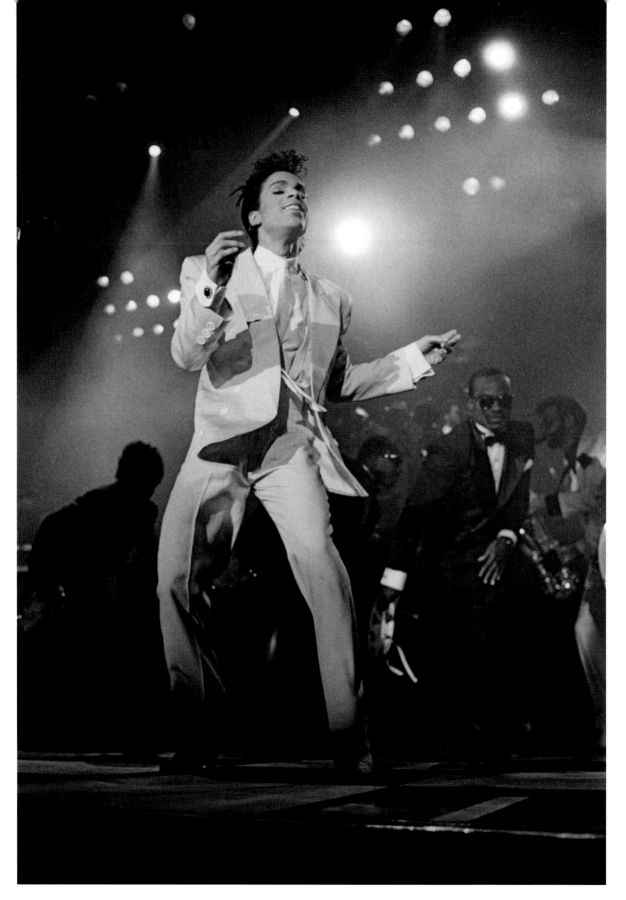

Prince, Wembley Stadium, London, 1986
Photograph by Michael Putland

WHO SHOT ROCK & ROLL

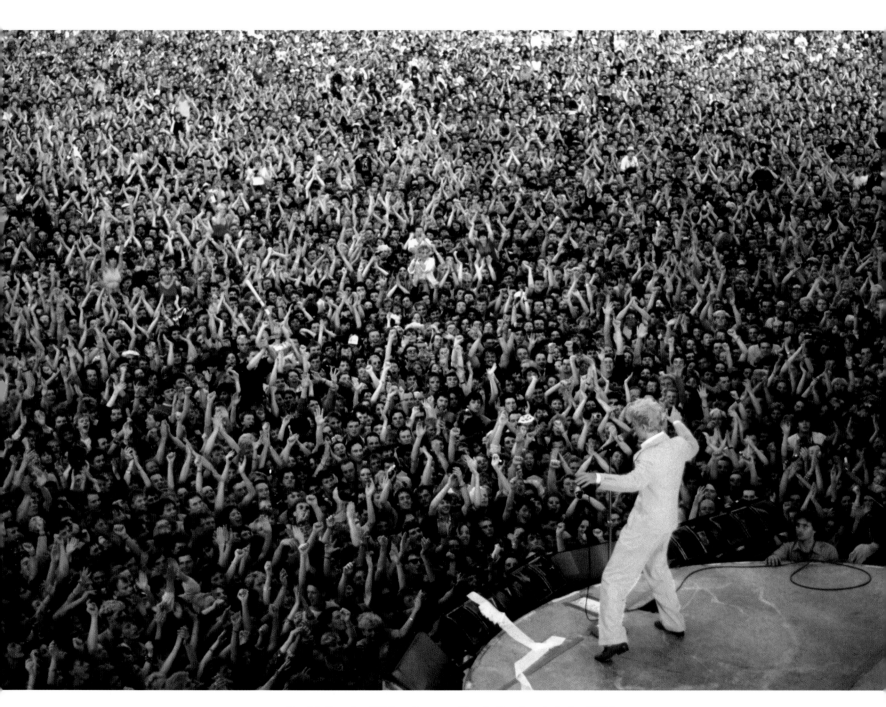

David Bowie, Milton Keynes Bowl, England, July 1983
Photograph by Denis O'Regan

INTRODUCTION

Too much bullshit is written about photographs and music. Let the music move you, whether to a frenzy or a peaceful place. . . . Let the photograph be one you remember—not for its technique but for its soul. Let it become a part of your life—a part of your past to help shape your future. But most of all, let the music and the photograph be something you love and will always enjoy.

—Jim Marshall, *Not Fade Away: The Rock & Roll Photography of Jim Marshall*

"Elvis Presley," said the composer and orchestra conductor Leonard Bernstein in the late 1960s, "is the greatest cultural force in the twentieth century." "What about Picasso?" replied Dick Clurman, Bernstein's friend and an editor at *Time*. "No," Bernstein insisted, "it's Elvis. He introduced the beat to everything and he changed everything—music, language, clothes, it's a whole new social revolution—the Sixties come from it. Because of him a man like me barely knows his musical grammar anymore."

—"Elvis and the Fifties" by David Halberstam in *Rock 'n' Roll 39–59,* published by Fondation *Cartier* pour l'art contemporain, edited by Dominique Perrin

lvis Presley wasn't the first rock & roll artist," writes the critic Michael Ansaldo, "but his debut album cover presented the world with the music's first tangible image."

Rock and roll has a handmaiden, and her name is photography. The music alone cannot convey the rebellion, liberation, ecstasy, and group dynamic that is rock. The music needs images to communicate its message of freedom and personal reinvention. After the music stops, the still image remains, a conduit for the electricity that is rock and roll.

The photograph for Elvis's first album (see page ii) was taken in 1955 by a middle-aged, commercial, Tampa, Florida, photographer, William V. (Red) Robertson. He was hired by Presley's manager, Colonel Tom Parker, to take pictures of "his boy." Robertson's full-frame photograph shows the young Elvis's legs spread apart, pelvis thrusting, mouth open, guitar pressing against his chest. The picture was cropped to fit the 12 × 12-inch square album format, leaving most of Elvis's lower half on the cutting-room floor. (This was 1950s America, and trouble lurked below the waistline.) But Elvis's ecstasy was not excised. His closed eyes, sensuous mouth, and convulsive body movement was enough to make the kids go wild and parents fear for their children—and their way of life. In 1956, the Florida preacher Robert Gray held a concert poster with the infamous image of Elvis by Robertson in one hand and the Bible in the other and declared from the pulpit for one of the first times (but certainly not the last) that a singer had "achieved a new low in spiritual

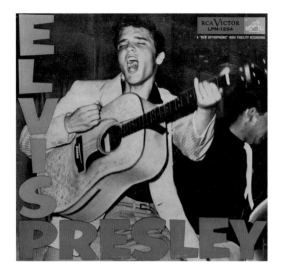

Elvis Presley's debut album, 1956
Photograph by William V. (Red) Robertson

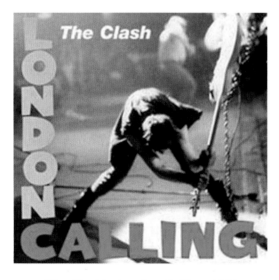

The Clash's *London Calling,* 1979
Photograph by Pennie Smith

degeneracy." The photograph was the proof of the degeneracy; he wasn't playing the music. (The author, as an elementary-school girl, attended this advertised blasphemous concert in Jacksonville.)

The Elvis photograph captures the Dionysian intoxication and the fervor that is rock and roll—music that liberates the soul and stimulates the hormones. This early

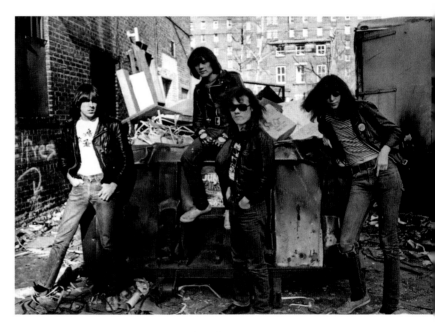

The Ramones in alley behind CBGB, New York City, December 1976
Photograph by Danny Fields

image of Elvis on his first album was as erotic and dangerous as record stores could safely display. The bipartite revolution—musical and visual—had begun.

Twenty-four years later, in a world of the Pill, pot, and rampant teenage angst and anger, the Clash's *London Calling* album paid homage to the graphics and energy of Presley's debut LP. Pennie Smith, trained at art college

(like many of the musicians), made the cover photograph of Paul Simonon smashing his Fender bass guitar. In 2002 the British rock magazine *Q* voted it the "Greatest Rock 'n' Roll Photograph of All Time." Smith says she doesn't photograph "musicians"; she makes graphically strong pictures of people with real emotion. Simonon smashing his bass is the ultimate rock-and-roll image—a musician totally in the moment and totally out of control. Everyone who sees this picture understands the truth of it—life can be hard and full of frustration. The picture shows the feeling when even the music is not enough to quell the chaos within. As Simonon wields his bass, though, another image arises: rockers are warriors against hypocrisy and the status quo, and their weapons are their instruments and their music their war cry. Smith captures a haunting, luminous, energized shape that extols the meaning of rock and roll. Rock and roll is not a musical genre; it is a communal spirit.

Bob Gruen, whose portrait of John Lennon in a sleeveless New York City T-shirt (see the full contact sheet for the shoot on page 201) is among the world's most pilfered pictures, says rock photography is "about capturing passion and emotion. . . . [The bands are] so big because they express common ideas." He knows that "the success of the Ramones was helped by photography—because it communicated their style and attitude. Rock and roll is haircut and attitude." Rock photos are study guides for hair, clothes, and body language. They are the cheat sheets for modern culture. Music transports the soul but photographs convey style. To embrace the music is to live the music, wear the music.

•

Picture this: in a remote Mexican village a teenager walks behind a plow pulled by two oxen. He wears a baseball cap backward, an oversize T-shirt, and jeans so big they

Madonna, Danceteria, New York City, 1982
Photograph by Josh Cheuse

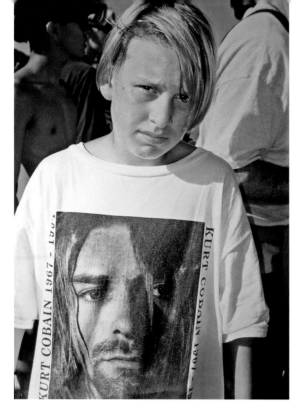

A young Nirvana fan at the Lollapalooza music festival in
Washington State, 1994, a few months after Kurt Cobain
died and Nirvana canceled their performance
Photograph by Alice Wheeler

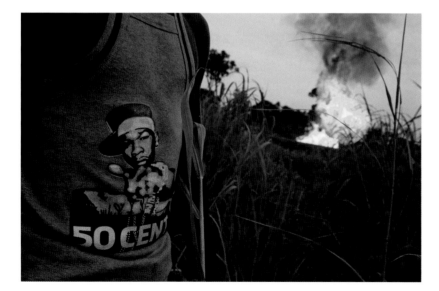

An unemployed local youth in a 50 Cent T-shirt hangs out
in the polluted environment near Shell Petroleum's flow station
in the Niger Delta, Nigeria, 2006
Photograph by Ed Kashi

show his underwear and his ass. He dresses like he is from
Queens. He is humming words he doesn't understand.
The oxen pull in one direction; he is off in another.

Learning "Stairway to Heaven" on the guitar is not
easy, but adopting a hairstyle that makes one's parents
cringe can be done in twenty minutes with an electric
razor. Every teenager can put up pictures on his or her
bedroom walls of rock icons and dream about escape as
well as sex. The medium is the message, and photography
is the medium that most accurately describes and reports
on the revolution that is rock. The photography of rock
is broad and rich and transformative, and reflective of the
times as well as the music.

•

This book is not a history of rock and roll, but of the men
and women who photograph it with integrity and give
the music its visual identity.

•

Photographic history can be parochial and hierarchical.
In its short history, at different times, one genre, previ-
ously considered "unworthy," is recognized as having pro-
found aesthetic and social significance. Some of the
preconceptions are based on art history, some on preju-
dice, some on semantics. Gradually, over time, one more
genre is brought into the pantheon and written into the
history books. This has happened with fashion, advertis-
ing, industrial, Hollywood portraiture, sports, dance, and
vernacular photography—and wonderful books have
been compiled on these subjects. Fashion photography,
for example, once a stepchild, is now recognized as chart-
ing new visual territory and is practiced by some of the
world's most accomplished and imaginative photogra-
phers. It has always been about fantasy; now it is also
considered a subcategory of performance art. Fashion
photography is shown in art museums throughout the
world and sold at auction houses. In an article in *The*

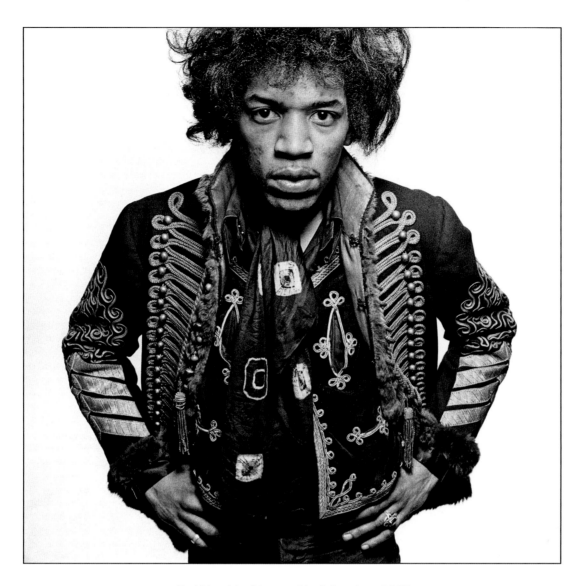

Jimi Hendrix, Masons Yard, London, 1967
Photograph by Gered Mankowitz

New Yorker, fashion critic Judith Thurman provocatively wrote, "The history of modern fashion as we think we know it is actually the history of fashion photography."[1]

Many images that have most shaped consciousness and desire—Bob Dylan walking with his girlfriend Suze Rotolo down a snowy Greenwich Village street in a photograph by Don Hunstein (*The Freewheelin' Bob Dylan*, see page 263); the poster of a seductive yet vulnerable Jimi Hendrix by Gered Mankowitz that hangs in millions of teenage bedrooms and college dorms; the image of a baby underwater, arms outstretched, swimming toward the almighty dollar (*Nevermind*, Nirvana, see page 301) by Kirk Weddle—are made by photographers whose names are unfamiliar but whose pictures have been seen by millions. The Hunstein/Dylan/Rotolo is so memorable that when Mrs. Obama clutched the arm of her husband, the newly elected president, as they walked down Pennsylvania Avenue on a cold January 20, 2009, the photograph taken of that tender touch and warm smile was matched over the Internet with Hunstein's shot. The time has come for these music photographers, who have been part of creating seminal twentieth- and twenty-first-

century iconography, to be brought into cultural history and the history of photography, and to have their work and contribution acknowledged. Like the musicians they photographed, they, too, changed the world and how we see and experience it.

•

Roy DeCarava's book of jazz photographs, *The Sound I Saw,* marks a watershed in photography. DeCarava's photographs of jazz musicians performing in the 1950s and 1960s proved two things: light waves and sound waves could be in a symbiotic relationship, and people making music can be the subject of great art.

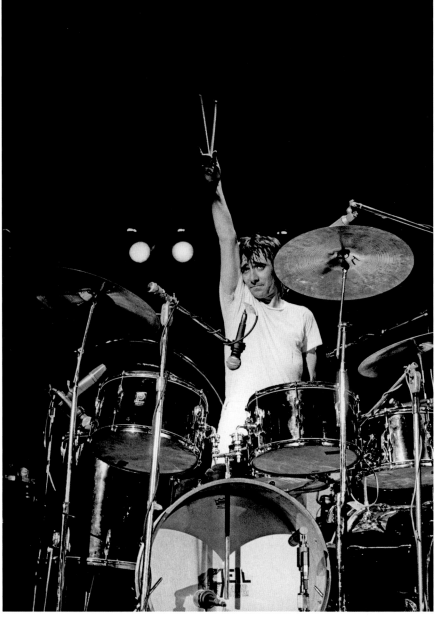

Keith Moon at the San Francisco Civic Auditorium, 1972
Photograph by Jim Marshall

of nights. Pete Seeger. Johnny Cash at Folsom Prison. Good God. Was I lucky.[2]

Others, too, might be transported on those evenings, but often only one person in the room had the tools—mechanical, artistic, and spiritual—to capture the moment and to share it for all time.

Marshall uses only Leicas and prints his 35mm negatives full-frame without retouching. Marshall has made more than five hundred album and CD covers and doesn't need stylists or makeup people "fussing around." He gets "95%" involved in the moment; the other "5%" is reserved for the camera.

"I do see the music," wrote the music photographer Jim Marshall:

> You know, when I had unlimited access, when the lighting was good and the music was right, there was no greater high. . . . There are no words to describe that feeling. The music washes away all the crap. There were nights . . . Coltrane took me to other planets. The Allman Brothers, Mahavishnu and Santana. Hendrix. Joan Baez a couple

> When you see my pictures, it's about the person in the photograph, not me—not the guy behind the lens. I want someone to see those people, not my picture of them. When I'm able to capture the essence of my subject and show something of what they do or reveal who this person is, then I've achieved what I want to do.[3]

•

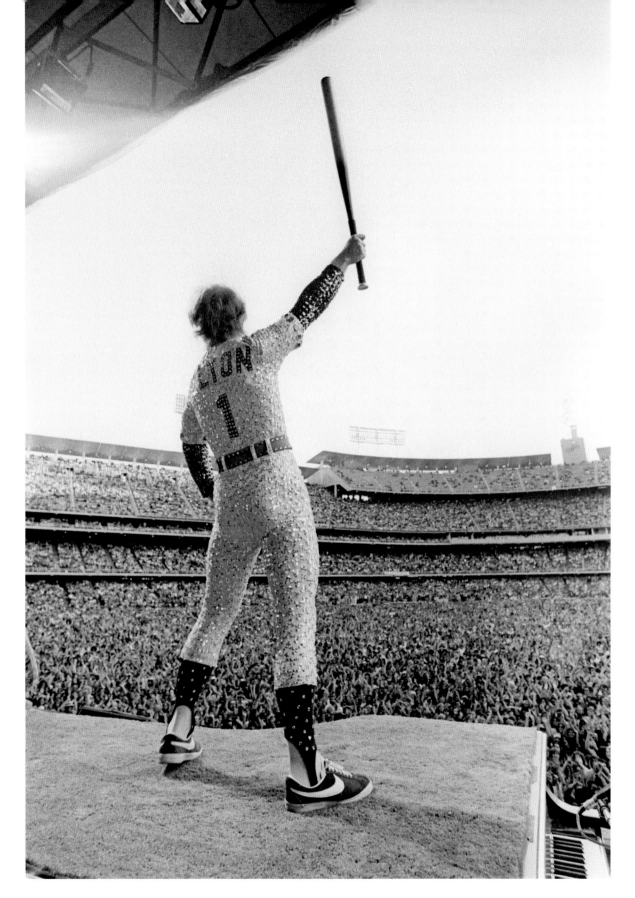

Elton John, Dodger Stadium, Los Angeles, California, 1975
Photograph by Terry O'Neill

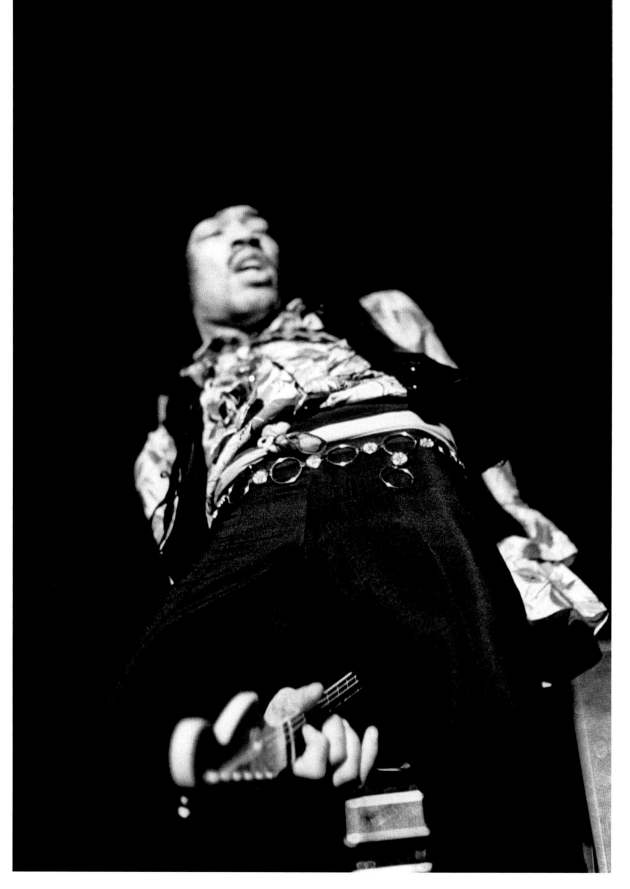

Jimi Hendrix at Fillmore Auditorium, San Francisco, California, February 1968
Photograph by Baron Wolman

"Untitled" (Morrissey concert), 2004
Photograph by Ryan McGinley

Baron Wolman, the first chief photographer for *Rolling Stone* magazine, speaks about the communion he felt photographing Jimi Hendrix at the original Fillmore Auditorium in 1968: "My body began literally to resonate to the sound, my brain seemed to anticipate the moves of Jimi's body. . . . In my mind Hendrix was playing the guitar and I was accompanying him with my camera." Only a year before, at the Mills College conference on rock and roll where he met Jann Wenner, founding publisher of *Rolling Stone,* did he realize "rock and roll was here to stay, that it now had political and social significance and was about to grow far beyond the music itself." Wolman loved making passionate pictures of the flower children and their music until, as he says, "the business of music became bigger than the music" and he moved on.

Who Shot Rock & Roll is a silent window into the world of sound. It has exhilarating and heady photographs of live performances that convey the charisma, magic, energy, and eroticism of the performers onstage. There are photographs of crowds and fans reminiscent of the great historical paintings of battle scenes where bodies blend and bend and faces radiate with what can only be described as transcendence. Snapshots reveal the passion, ambition, and insecurity of aspiring young musicians. There are portraits of godheads, objects of mass adoration; the best could hang next to paintings of Renaissance princes, so similar are these royals with their finery, wealth, and power.

•

Music photography has a tender place in people's hearts. In the days of the long-playing record, album covers were substantial objects, big enough in format to display on a shelf or a wall. Even just lying around, they had visual impact. Album covers were held while listening to the LPs, valued as portals to the performers and the music. (Just think about how many album covers have been kissed by adoring lips.) The album photograph could be as straightforward as a group portrait or as ambiguous and strange as a Hipgnosis (Storm Thorgerson, Aubrey Powell, and Peter Christopherson) fantasy. Or it could just be a feeling. Many albums are known by their images— think *Blind Faith* (see page 103).

The importance of the visuals diminished when first tapes and then compact discs miniaturized and then often trivialized the images. There are CDs, of course, with provocative pictures on the covers and that, once opened, have a page that unfolds or a booklet that contains carefully crafted arrangements of images. But as anyone over fifty will tell you, they don't have the presence of the 12 × 12-inch vinyl album cover.

MTV is the "anti" still photograph; seduction comes from the moves, not the frozen frame—or even the music ("Video Killed the Radio Star"). Downloading songs leaves one holding only one's iPod. Still images externalize the music, give listeners something to think about outside themselves and the sound. The iPod generation, earphones embedded, are lost in their own private worlds, even while walking down a busy street or sitting on the New York City subway at rush hour. A photograph is locked in time and space; sound is fleeting. The still image on the album or CD cover gives more than visual identity to the music, it gives people a shared totem.

A great Annie Leibovitz, Mark Seliger, Anton Corbijn, Norman Seeff, Max Vadukul, Albert Watson, or Timothy White photograph offers a visual and visceral punch in a music or general-interest magazine but normally has a life expectancy only as long as the next recycling period—or until a monograph is published of their work or *Rolling Stone* brings out another compilation of "the best of rock-and-roll photography."

There was a golden age of the album cover when musicians and photographers collaborated closely. Bob Seidemann, who made the haunting image of a prepubescent girl for Blind Faith, wrote about being asked to do the cover in 1969: "This was big time. It seems as though the western world had for lack of a more substantial icon, set-

Led Zeppelin's *Presence,* 1976
Design and photography by Hipgnosis and George Hardie

The Eagles camping with Henry Diltz in
Joshua Tree National Park, California, 1972
Photograph by Henry Diltz

refers to is the industry's "packaging" of performers. When photographers were allowed to be creative and spontaneous, when they worked closely with the musicians, the photographs could soar. When the photographers were controlled, just as with the musicians, sincerity and much else was lost. Even after more than forty years in the business, Mick Jagger could say in a *Rolling Stone* interview in 2008, "The thing about rock and roll is people expect it to be real, sincere and heartfelt, or something—it's not supposed to be manufactured."[4] The same is true for the photography of rock.

•

tled on the rock-and-roll star as the golden calf of the moment. The record cover had become the place to be seen as an artist."

Some photographers spent time "hanging out" with the band before making a cover shot; others conceptualized the image before crafting it in the studio or at a predetermined location. Most photographers listened to the music over and over again, even going to the recording sessions.

•

Jim McCrary, who worked for A&M Records and made the photograph of Carole King for her best-selling album *Tapestry*, puts it quite succinctly: "Whoever had the best idea [for the album cover], they were in control of that image—and then, it changed." The "change" McCrary

Photograph taken for Carole King's *Tapestry*, 1971,
by Jim McCrary

Corinne Bailey Rae, Oxford Street, London, December 2006
Photograph by Andy Earl

Andy Earl, who represented the United Kingdom at the 1979 Venice Biennale and has made more than 70 album and single covers for Madonna, the Rolling Stones, Prince, Eurythmics, and others, often uses a unique approach:

> Sometimes it is better not to listen to the music. Usually more important to meet the person. I ask the group to bring in something they like, like a painting. I am interested in what they are THINKING about. I ask up-and-coming musicians what INSPIRES them and then try to translate their inspiration visually. (Answers range from nothing; Marlon Brando meets Pee-wee Herman; everyday life; open road; escape; walking around at night; old record shops.)[5]

Earl did an "Inspiration Series," the best of which shows Corinne Bailey Rae surrounded by the glow of "everyday light" and Tom Vek walking at night, looking like he is catching inspiration on a moonbeam.

•

And then there are the posters. Jean-Marie Périer, a French photographer, tells the story of driving through Paris and looking up into the windows along the boulevards and seeing, in apartment after apartment, posters of famous musicians, many by him. A sly smile comes over his face when he comments that his posters were very popular, but almost no one knew who the photographer was. How many people know who made their favorite album photographs or posters, many of which are among the most recognizable and popular images in the world? The only music photographers whose names are well known are those who themselves have become celebrities.

It is a cliché now to speak about music being the "sound track of our lives." The pictures on adored albums, the posters on bedroom walls, band books purchased—cherished images—are rarely mentioned as having an impact on our lives. Yet music is one of the predominant ways in which people divide themselves and classify themselves into subcultures. Millions model their "look" on the photographs of their musical idols. And just as the music becomes part of one's being, something profound also transpires when looking at pictures. The "optical unconscious," a term coined by Walter Benjamin, vigorously holds on to images. They are as much part of us as the music. They touch the heart, open up the imagination, feel like old friends. Comrades-in-arms are recruited simply by identifying with a common image. The pictures, as much as the music, are markers along life's journey.

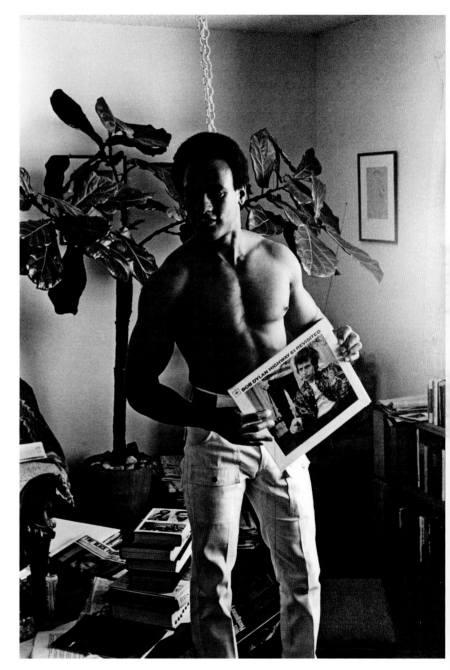

Huey P. Newton at his home in Berkeley, California, in 1970, holding Bob Dylan's *Highway 61 Revisited* with its enigmatic photograph by Daniel Kramer
Photograph by Stephen Shames

Chuck Berry in Atlanta, Georgia, October 1964
Photograph by Jean-Marie Périer

Fans at Marilyn Manson concert, Mazda Palace,
Milan, Italy, 2005
Photograph by James Mollison

Fans at P. Diddy concert, Crobar,
Miami, Florida, 2006
Photograph by James Mollison

Fans at Rod Stewart concerts, M.E.N Arena,
Manchester, England, July 4, 2005, and
Earls Court, London, December 20, 2005
Photograph by James Mollison

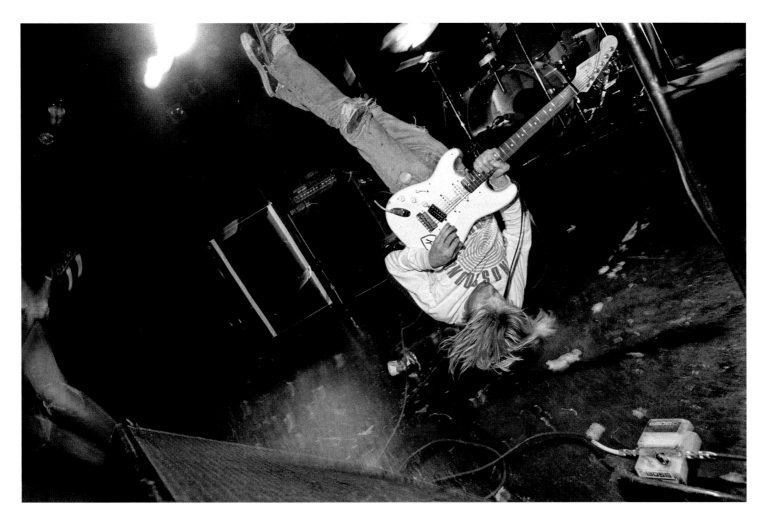

Kurt Cobain at the Commodore Ballroom, Vancouver, British Columbia, April 1991
Photograph by Charles Peterson

Unfortunately, many of the pictures today are manufactured or taken by paparazzi, turning performers into generic "celebrities" or art-directed rebels. The photographs that are genuine, even if they are carefully constructed, still stir the emotions and tap into something real in both the subject and the viewer. The rest just read more like smut. Because so many pictures are without heart or good humor, identifying outstanding achievements in rock-and-roll photography becomes much more important.

The camera is as much a tool for self-expression as a musical instrument or the human voice. The photographers in this book and the musicians are, for the most part, fellow artists. There is mutual respect and understanding and, in many instances, real comradeship. Charles Peterson, a fearsome and phenomenal photojournalist whose subjects include Seattle grunge bands and break-dancers, was friends with the musicians of Soundgarden, Pearl Jam, Mudhoney, and Nirvana. He speaks about going to the "front lines" and not returning until he has the most honest visual report of the extraordinary things he has witnessed. Revolutions—military or musical—need to be photographed to be believed.

Understanding and trust have always been key components in achieving great photographs. Eddie Vedder, lead singer of Pearl Jam, writes:

I hate getting my picture taken. . . .

What started as an extension of adolescent sheepishness in front of cameras soon became deep-rooted suspicion. Where will these photos end up? Who will recklessly profit? It can be a violating experience to be co-opted and put on the cover of, let's say *TIME* magazine (and for anyone who hasn't had the pleasure, they don't ask or need your permission). The humiliation is trifold when it's a shit picture. . . . And then there were the exclusive grunge supplements complete with color pin-ups of your favorite grunge stars. I can't remember what was worse . . . the feeling that editors and photographers were greedily selling us out, or being bothered that I wasn't photogenic! . . .

But while others were speed-dialing their return calls to *Rolling Stone*, Charles [Peterson] would venture nary a reply. . . .

After 1992, when we were all swimming in a sea of other people's agendas, a trustworthy face whose actions backed up his words was an invaluable commodity. And for the amount of opportunities at various levels of exploitation which he refused, I imagine our enduring friendship has been quite costly.

[He waited for] a proper outlet. One where he could control the quality and let the photographs maintain their dignity.[6]

•

Laura Levine, who photographed the New York punk, New Wave, No Wave, hip-hop, indie, and "college radio" scene from 1980 to 1994, explains succinctly why she had to give up the profession she dearly loved:

It was 1994. I spent a lovely day taking portraits of Nick Cave, put down my camera, and walked away. Up to that moment I assumed I would be working with musicians forever. But the fact is much had changed in the music industry over the years I'd been a photographer. Too many people were con-

trolling access to the artists, insisting on approval of images, and focusing more on the clothing the musicians were wearing than on the artists themselves. What started out as a fun, spontaneous, intimate, and creative collaboration between two artists ended up becoming more akin to a marketing session. So I left.[7]

The types of pictures Peterson, Levine, and others make are important because many young people feel like outcasts and need a group identity and real musicians to look up to. As Jocko Weyland explains in his essay "Damned to Be Free: The Photographs of Edward Colver":

Photographs can affect people in a much more personal way, and also later come to define social movements that have become known but at the height of their existence defined esoterica. . . . Now they are important documents of something extraordinary that no longer exists. The pictures prove that it did and at the time were life affirming, a powerful salve against isolation and boredom.[8]

The kids believe in the truth of the pictures when they appear honest, taken by people who were living the life and loving the music.

Henry Diltz hung out with David Crosby, Stephen Stills, Graham Nash, Neil Young, the Eagles, Joni Mitchell, the Mamas and the Papas, the Lovin' Spoonful, and others. They would spend the days "bopping around from place to place," and Diltz would always have his camera with him. It was his compulsion to take pictures of everything that was going on with all his friends. Originally, Diltz says, his friends didn't even see him as a photographer but rather as a musician (he was a member of the Modern Folk Quartet) with a camera.

Glenn O'Brien, editorial director of *Interview* and *Art*

in America and the host of the public access television show *TV Party* from 1978 to 1982 (among many, many other things), said the photographers he knew back in the seventies and early eighties "were co-conspirators with their subject. They hung out together, drank together, fell down together, slept together, OD'd and got sober together, went to the top together, went down the drain together. They would do what it took to get the shot. Because most of these here camera users rocked as hard as these here guitar users."[9]

•

Many of the photographers in this book, as with many people all over the world, say they fell in love with rock and roll when they first heard the Beatles. The Beatles established close relationships with a multitude of photographers as they went through a myriad of musical, emotional, intellectual, cultural, and fashion conversions.

Before the Beatles there were the Silver Beatles (John Lennon, Paul McCartney, George Harrison, Stu Sutcliffe, and Pete Best) who performed, most significantly in the history of rock-and-roll photography, in Hamburg in 1960, where they met the young German photographers Astrid Kirchherr, Klaus Voormann, and Jürgen Vollmer. The Germans, like Lennon and Sutcliffe, were art students. The only rock-and-roll photographs Kirchherr had ever seen were a few pictures of Bill Haley and Elvis Presley on the covers of magazines. She had never heard rock and roll before going with her friends to a Silver Beatles gig. But as a young artist, she felt an immediate connection to these musicians playing remarkable music and asked if she could photograph them. The results are the most tender and haunting studies of these young men (Harrison was seventeen, McCartney was eighteen, and Lennon was twenty) on the threshold of their world rev-

olution. "They were just discovering who they were," said Kirchherr, and I think that the photos helped them make that discovery." She wrote in her book *When We Was Fab*, "What amazed me was that, behind all the outfits and rock and roll behaviour, they were very sensible, sensitive young men looking for something new in life, which was exactly what I was doing then in the Sixties. We were so confused straight after the war and we were searching for ways to exist and to accept everything that had happened. I hope that is what you can see when you look at my pictures."

The British photographer Dezo Hoffmann went to Liverpool in 1962 on behest of a reader of his publication, *Record Mirror*, who had written in that there was a "Fab" group up north that the press was ignoring. Hoffmann, a veteran of Mussolini's invasion of Abyssinia, the Spanish Civil War (he was a photojournalist with the International Brigade press corps working alongside Ernest Hemingway and Robert Capa), and World War II as a member of the Czech army, became one of the photographers most closely associated with the early days of the Beatles.

According to author Gordon Burn, the Beatles' manager Brian Epstein took them out of "their grimy T-shirts and steamy leathers and put them into the shiny mohair Mercurochrome suits, part-band-balladeer, part-bank-clerk" and then had Hoffmann create the happy-go-lucky yet "cool" image of the Beatles. "I became a sort of father figure to them, and would advise them on how to behave," Hoffmann wrote. The soon-to-be Fabulous Four looked up to this man who had so much worldly experience and who, not inconsequently, had recently been photographing all the leading performers of the 1950s and early 1960s, including being on "speaking terms" with some of the Beatles' favorite stars. Hoffmann said, "I was struck by their sincerity and simplicity" and helped

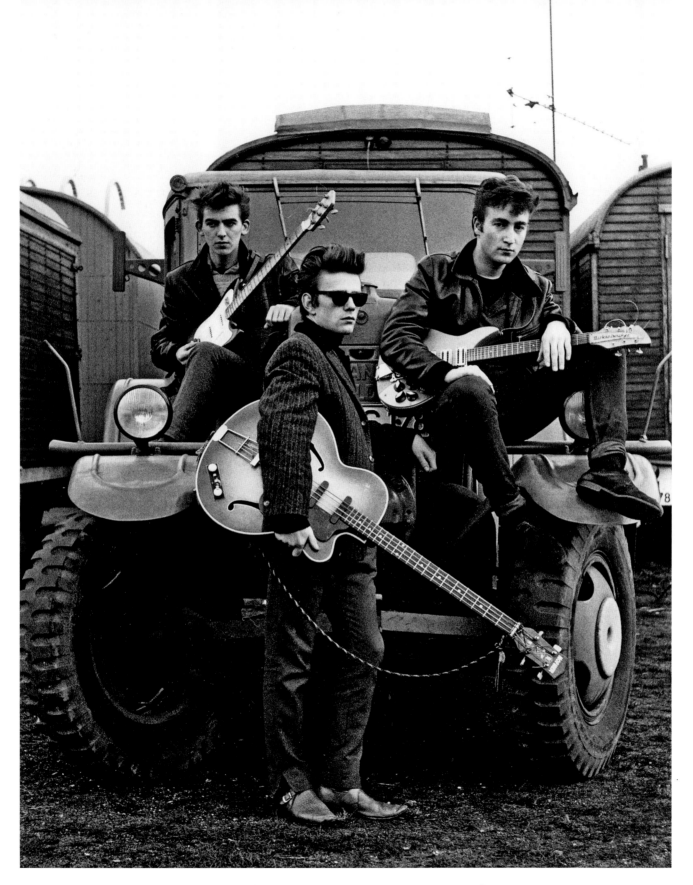

George Harrison, Stu Sutcliffe, and John Lennon in Hamburg, Germany, 1960
Photograph by Astrid Kirchherr

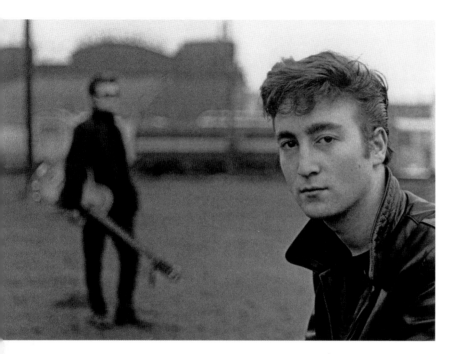

John Lennon, with Stu Sutcliffe in the background,
Hamburg, Germany, 1960
Photograph by Astrid Kirchherr

preserve their boyish playfulness. He made the iconic image of the four Beatles jumping in the air for the album *Twist and Shout* (see page 298), which started the craze of groups acting "carefree." Hoffmann covered every major event in the career of the Beatles—their audition at Abbey Road with George Martin, their first tours of Europe and America, the making of their first albums, their appearances on radio shows and in films.

Glasgow native Harry Benson, working for British newspapers, not the Beatles, nevertheless had good access in 1964. Paul, John, George, and Ringo liked him. Benson, younger than Hoffmann, realized the advantage of staying up after the older photographer went to bed. At three a.m. in a French hotel room, Benson instigated

the famous "pillow fight" photographs. The timing, Benson remembers, was perfect: Brian Epstein had just told them "I Want to Hold Your Hand" had become number one in America and they were invited to perform live on *The Ed Sullivan Show*. The pillow fight for the camera begins! Then Hoffmann and Benson accompanied the Beatles on their first trip to the United States, and their lighthearted, playful pictures added enormously to the group's popularity.

Another important and very different photographer in Beatles history is Robert Freeman, a Cambridge University graduate who specialized in jazz photography. He met Robert Frank and several Beat writers in New York in 1959. He was influenced by Frank's black-and-white, grainy, "honest" photography. Freeman was a member of the Independent Group, a group of artists, architects, and writers in London who were using popular culture to permeate "high culture." In August 1963, Freeman made the flat, bold, black, and mysterious group portrait of the Beatles for their second album *Meet the Beatles!* (see page 298) that declared to their adoring fans, "You don't know us." The studio wanted to scrap the picture because the Beatles weren't smiling, until they realized real rock and rollers don't smile for pictures. Paul McCartney admitted, "We work much harder with someone like Robert Freeman or [fashion photographer Norman] Parkinson than with the [press] nationals, who only want a cheesy grin."[10] Freeman also made the photographs for other Beatles albums: *A Hard Day's Night, Help!,* and *Rubber Soul.*

In a National Public Radio interview in 2008, Kirchherr said that the group trusted her as "an intelligent individual and a fellow artist." They allowed themselves to open up, and in doing so, she was able to capture their yearning, their tentativeness, and their struggle. Kirch-

From the book *Rock 'n' Roll Times: The Style and Spirit of the Early Beatles and Their First Fans*, photograph taken in the early 1960s in Europe by Jürgen Vollmer

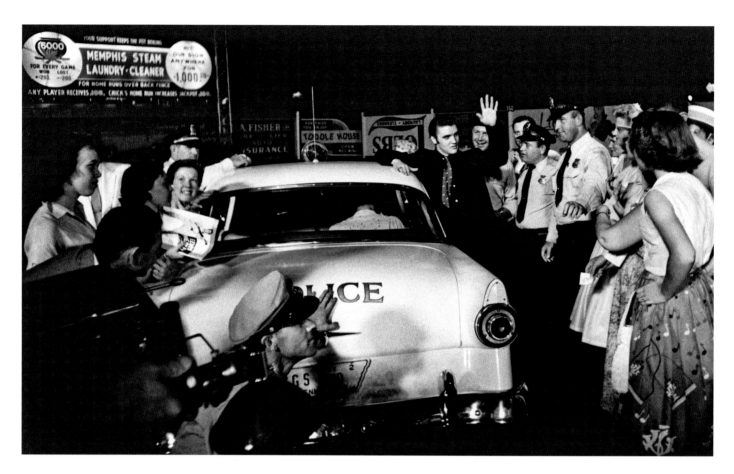

"Memphis Steam Laundry," Elvis Presley arriving for his concert at Russwood Stadium, Memphis, Tennessee, July 4, 1956
Photograph by Alfred Wertheimer

herr saw the Silver Beatles as existential rebels, more akin to punk musicians such as the Clash and the Ramones than the soon-to-be popular image of the Beatles as the wholesome lads girls could bring home to meet their dads.

Lennon, McCartney, Harrison, Best, and Sutcliffe, from the port city of Liverpool, the Luftwaffe's principal target in the United Kingdom after London (Lennon was born in 1940 during a German bombing raid), and Kirchherr, Vollmer, and Voormann, from the port city of Hamburg, the city that experienced unparalleled horror and civilian deaths and destruction from Royal Air Force and

United States Air Force bombers during the war, became more than friends, they became part—leaders of—a youth culture that knew no national boundaries, that made love not war. Rock and roll, in addition to drugs and sex, was about healing and remaking the world—making it better and brighter than previous generations had done, and creating a space and a place for young people.

•

The complicated story of translating rock and roll into image begins with Elvis Presley, whose Hollywood idols—James Dean and Marlon Brando—were his rebellious guides. Alfred Wertheimer made the finest photo-

graphic record of the King, although Wertheimer's pictures were not well known until after Presley's death. He said in conversation with the author at his home in New York in 2008:

> Nineteen fifty-six was [Elvis's] first year in professional music. Had I come along three years later, these pictures would not have been taken. I would have been different. I would have started directing, I would have had the fanciest cameras, I would have had an assistant, [Elvis] would have probably said, "What do I need you for?" Then, he was a struggling young performer. The first pictures I took of him were pre–first gold record. . . . It is just through dumb luck that I crossed his path or he crossed my path.

The photographs of Elvis were teenage girls' ultimate fantasies. They clutched them to their breasts, slept with them by their bedsides, imagined a kiss or more from this bad boy, mama's boy, boy next door, boy oh boy of my dreams.

Bob Dylan, as always, said it best: "Nothing's real, man." In 1964, the year of the Beatles' "pillow fight," Dylan was twenty-one years old (the same age as Elvis when Wertheimer photographed him in 1956) and he was responding to the photographer Douglas Gilbert's request for him to engage in a conversation that looked real. In 1964 Gilbert was a staff photographer for *Look* magazine, and a story on Dylan was his first assignment. It never ran, according to Gilbert, "because Dylan looked too 'scruffy' and *Look* was a family magazine."

The title of the album Dylan released that year is *The Times They Are A-Changin'*. He got it right. *Look* was on its way to being history; Dylan was on his way to sainthood. Dylan's friend Barry Feinstein took the cover photograph. It shows a contemplative, workmanlike Dylan, not trying to seduce or cajole anyone. He isn't smiling (except in Elliott Landy's photograph for *Nashville Skyline*, Dylan never did smile on an album cover) and doesn't look like he cares if people like him or not, or find him attractive or not. The off-center composition and from-below angle give the photograph its impact but not its uniqueness. What makes it special is that it is a portrait of someone thinking, not jumping up and down pretending to have fun or self-consciously looking straight at the camera in a contrived pose. It is a picture of the inside, where you know some strange and unique poetry is brewing. Describing the photo session, Feinstein writes:

> I was kneeling down and I said to Bob, "Look around." . . . I went click, click, click. I didn't have to shoot a lot of pictures because I knew immediately it was a very unusual shot and an angle, and a moment with Bob. We looked at the proof sheet and he chose that shot. In those days the record company normally chose the picture for the cover, especially Columbia, but they let him do it this time. . . . It wasn't premeditated or anything; it was one of the quickest and easiest photo sessions I've ever done.[11]

Dylan was always in control of his image as well as his music. As Glenn O'Brien writes, the "pose is as much part of the act as the sound. It's sound and vision." A photograph ain't real, man, but it does have an uncanny relationship to both external and internal realities.

In the introduction to Mick Rock and David Bowie's book *Moonage Daydream*, about Bowie's Ziggy Stardust period, Rock quotes Oscar Wilde: "Man is least himself when he talks in his own person. Give him a mask and he will tell you the truth." All performers have multiple personas. It is one of the things that makes them so fascinating.

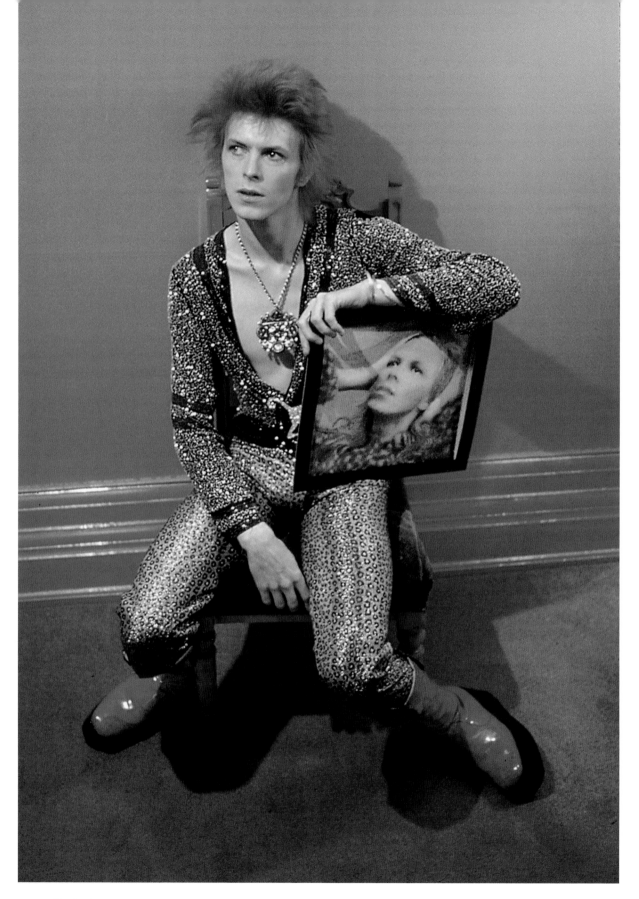

David Bowie holding the original cover art for *Hunky Dory,* Beckenham, England, March 1972
Photograph by Mick Rock

Brian Eno writes in the introduction to Anton Corbijn's book *Star Trak:*

> Anton did, in an interview, say something to the effect of "I always thought that my job was to tell the truth." This is confusing, because in fact, there are few better and more interesting liars than he. The camera inevitably lies, so choosing the kind of lie you want to tell is actually the creative act of photography. And Anton invites his "subject" to take in that game—to create something new with him, to let go of the idea that the picture is going to show the real you, and say "So what would I like to be?" . . . And that is one of the central games of pop culture. It's the game that says "So what else could I be?"[12]

Elsewhere Eno adds that play-acting is a relief, since it means "participating in the carnival of life."

•

Rock-and-roll photography is varied and elastic. It must be. Sometimes rock and roll is just someone playing a sequence of G, C, and D chords; sometimes it is a multimillion-dollar stadium spectacular. The selection of photographs in this book mirrors the depth, breadth, and passion of the music, the musicians, and the fans. There is no one sound track that is rock; there is no one photographic vision. The unity comes, as Mick Jagger notes, in trying to keep it "real, sincere and heartfelt, or something."

NOTES

1. Judith Thurman, "The Absolutist," *The New Yorker,* July 3, 2006, p. 60.
2. Jim Marshall, "Still Crazy After All These Years," *Not Fade Away: The Rock & Roll Photography of Jim Marshall,* p. 130.
3. Jim Marshall, introduction, *Not Fade Away: The Rock & Roll Photography of Jim Marshall,* pp. xi–xii.
4. Brian Hiatt, "Mick Jagger," *Rolling Stone,* April 17, 2008, p. 46.
5. Andy Earl, interview with author, London, September 2007.
6. Eddie Vedder, introduction, Charles Peterson, *Touch Me I'm Sick,* not paginated.
7. Laura Levine, *Backstage Pass: Rock & Roll Photography,* catalogue essay, p. 48.
8. Jocko Weyland, "Damned to Be Free: The Photographs of Edward Colver," Edward Colver, *Blight at the End of the Funnel,* pp. 5–11.
9. Glenn O'Brien, "Images of Punk," Roberta Bayley et al., *Blank Generation Revisited: The Early Days of Punk Rock.*
10. Gordon Burn, "Introduction," Liz Jobey, ed., *The End of Innocence: Photographs from the Decades That Defined Pop,* p. 18.
11. Barry Feinstein, *Real Moments: Bob Dylan by Barry Feinstein,* p. 8.
12. Brian Eno, introduction, Anton Corbijn, *Star Trak,* not paginated.

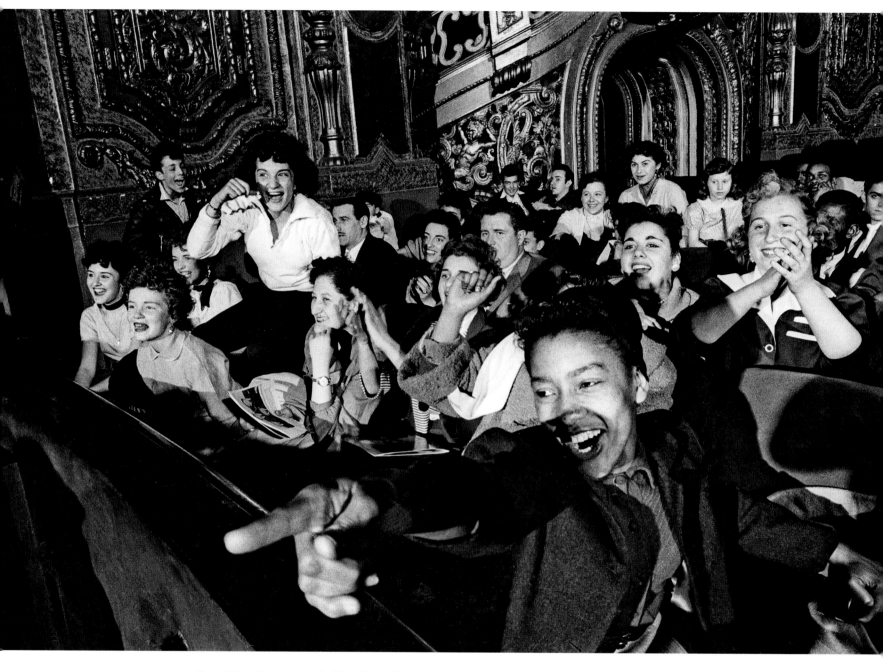

Brooklyn Paramount, Alan Freed's Easter Rock 'n' Roll Show, New York, 1955
Photograph by Walter Sanders

WILLIAM "POPSIE" RANDOLPH

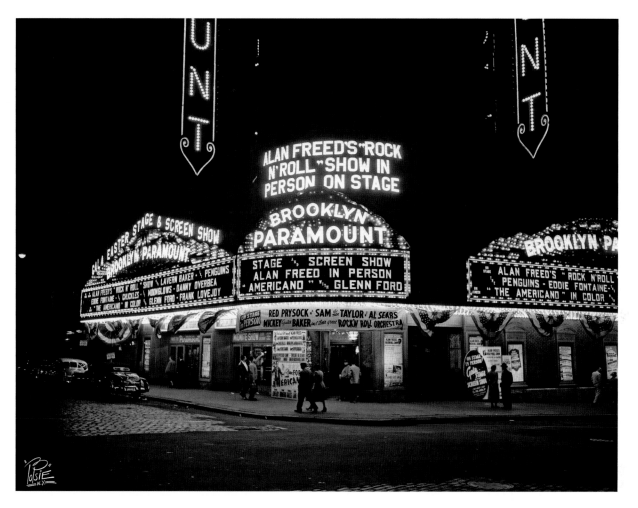

Brooklyn Paramount, Alan Freed's Rock 'n' Roll Show, New York
April 11, 1955

The Brooklyn Paramount, on Flatbush Avenue at the corner of DeKalb, was the largest venue for seeing rock and roll in New York City. The theater, built in 1928 for "talking" pictures, started hosting Alan Freed and his Rock 'n' Roll Show in 1955. More than four thousand screaming teenagers could have a seat on which to jump up and down as they saw their radio heroes for the first time in the flesh.

William "PoPsie" Randolph photographed the chang-ing music scene and everyone from Billie Holiday in 1940 to Lou Reed in 1969. He was at rehearsals of *The Perry Como Show* every week (he photographed Como, a barber before he was a crooner, cutting rocker Frankie Avalon's hair) and on the set of *Hullabaloo* on NBC. He shot the guests on Dick Clark's *American Bandstand* and *The Ed Sullivan Show.* As he hardly slept for three decades, he just dashed around New York making his living photographing friends and friends of friends, all of whom were musicians.

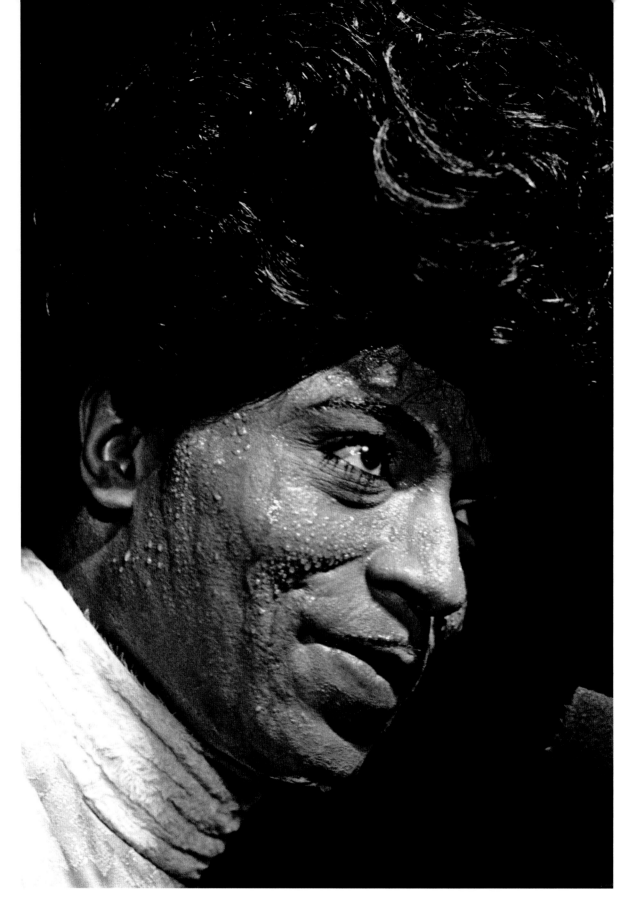

Little Richard, Fillmore West, San Francisco, California
October 19, 1969

BARON WOLMAN

It was a time of new fashion and new ideas, of enlightened innocence. Beyond that, it was a time when music, rock and roll in particular, emerged to become both the messenger and the message, grew to become the enormously photogenic entertainment of the People. How things looked and sounded suddenly became metaphors for shifting attitudes. . . . I stretched for the ultimate visual harmony: that single picture which might bring the essence of a concert to the printed page. I heard the sound, but I reached to see the music.

—FROM THE INTRODUCTION "I SAW THE MUSIC" IN *CLASSIC ROCK & OTHER ROLLERS: A PHOTO PORTFOLIO,* BY BARON WOLMAN

STEVE GULLICK

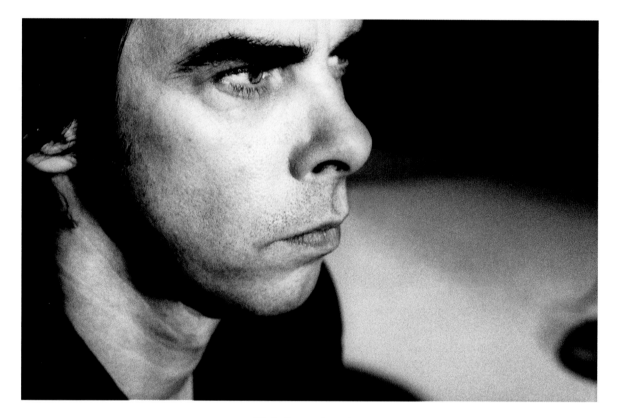

Nick Cave, London
2004

Steve Gullick is an English photographer and musician (he has a Bender, and he is the lead singer in Tenebrous Liar). He is one of the only photographers with whom the Prodigy happily work. He not only understands the artists, he understands the music. Intense and somewhat dark himself, he sees the seriousness of the life's commitment on the part of the musicians he photographs. Gullick is like a Pre-Raphaelite painter trying to capture true spirit and commune with something greater than ego. In his performance shots, Gullick catches light waves as if they are sound waves and blends the two—the viewer simultaneously feels the energy of the performance and the music. It is a startling accomplishment. His portraits are probing psychological studies of the creative mind.

Gullick's photography is in demand. Bands fly him all over the world. He has a wife and three kids. He is a busy man. But he still goes into the darkroom and prints black and white and color. Like every artist, he takes responsibility for the way the final print looks and feels. Being in the darkroom is part of the process, and it helps him understand the substance and meaning of his work.

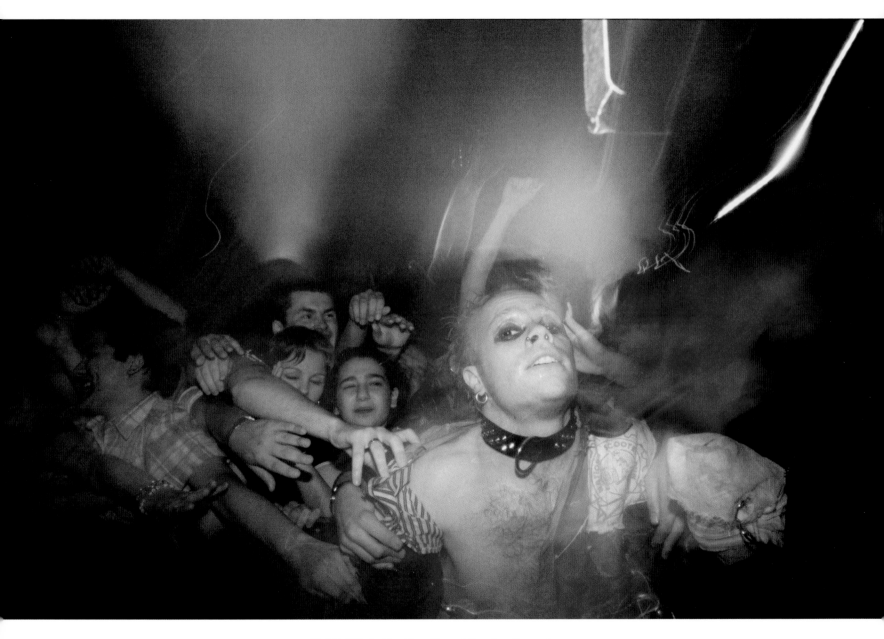

Keith Flint, the Prodigy, Atlanta, Georgia
June 1997

BARRIE WENTZELL

n the pit during a performance, the photographers would jostle for the best position. Wentzell stayed in a nearby pub until he thought the other photographers would be running out of film. He came in, felt the music, and then relied on his "little finger" to know when the light was the most sensual, the bodies onstage the most rhythmic, and the moment the most true to the feeling of the music.

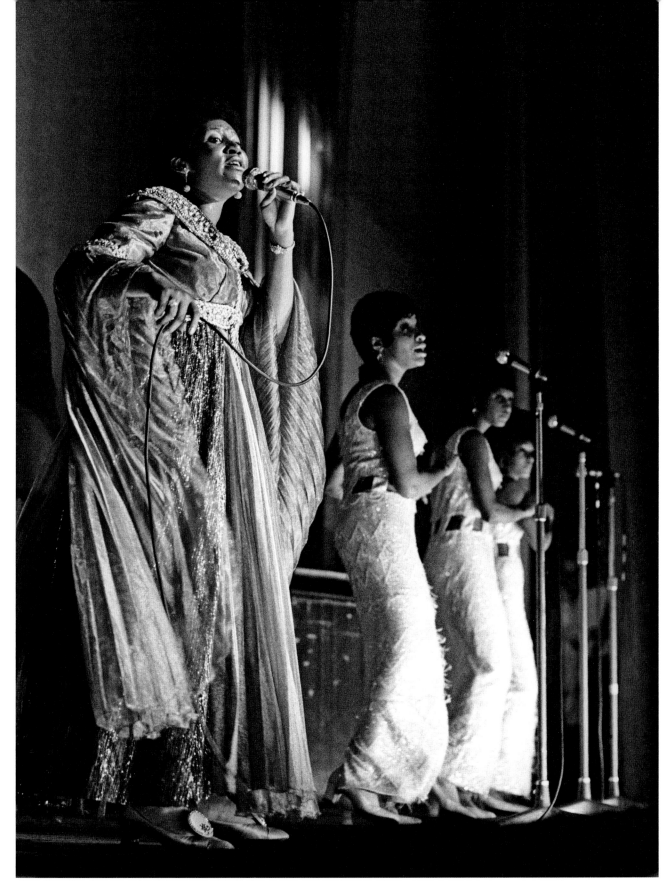

Aretha Franklin, possibly Hammersmith Odeon, London
August 1970

PETER BESTE

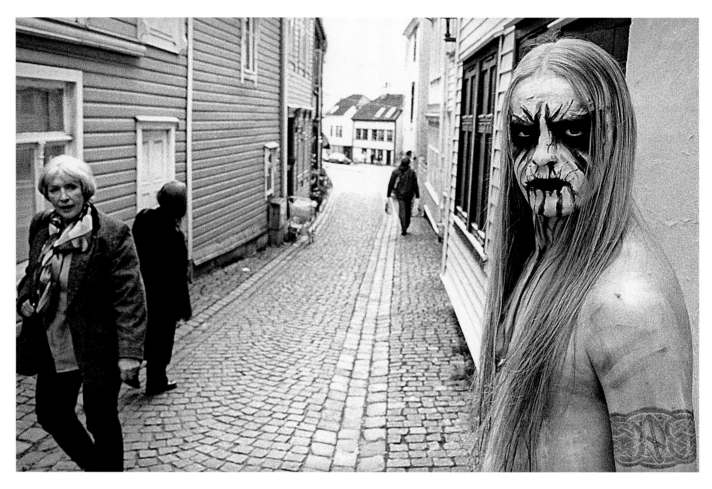

Kvitrafn of Wardruna, Bergen, Norway
2002

Peter Beste wants to experience lives he has no business living. He is a nice guy from Houston, Texas, blond, with an earnest expression and a wholesome demeanor. He spent seven years hanging out with and photographing Norwegian black-metal musicians, men so extreme they have been accused of burning churches and committing murder. Perhaps it is the contrast between the "average" Norwegian in this prosperous, stunningly beautiful country, where even the unemployed get a state pension of $35,000 a year, and the black-metal people with their dead animals, crucifixes, instruments of torture, makeup, tattoos, and ghastly outfits that initially attracted Beste to this subject. Why, one wonders, the anger and the rage in this most idyllic of countries? Some say Norwegians are too puritanical and self-satisfied. Others are just dumbfounded.

The musicians are visually exciting and, as Beste says, their concerts cannot be described in words—one reason he decided to photograph them. Beste has always liked the music. He feels it comes from richer sources than most heavy metal. In his photographs he shows Norwegian black metal's deep connection with the forces of nature, Satanic ritual, Norse mythology, and pagan religion.

DAVID LACHAPELLE

He was about to blow up," explained David LaChapelle, when discussing Eminem's first *Rolling Stone* cover story, in 1999. At this time, David knew him as Slim Shady. When he was told his name is Eminem, *Rolling Stone* reported that LaChapelle inquired if it was spelled "like M&M, the candy?" The companion photograph to "About to Blow" shows Eminem covered in ash.

LaChapelle Land is the title of LaChapelle's first book. Perfect title. Entering a LaChapelle photograph is like falling down the rabbit hole. One enters a world that is a lot more fun, a lot more humorous, than where we came from. Saturated color is part of it, but so, too, is crisp detail. Nothing in real life is perfect, so we know immediately upon viewing LaChapelle's perfect pictures that we are in fantasy—no, LaChapelle—land.

LaChapelle has made wild and winsome pictures of Macy Gray, Moby, Marilyn Manson, No Doubt, Whitney Houston, Lil' Kim, Courtney Love, Elton John, Madonna, and many others. He is one of the most sought-after and best-known photographers in the world, moving from fashion to advertising to celebrity to personal work. He has directed music videos for Jennifer Lopez, Britney Spears, Avril Lavigne, Whitney Houston, Moby, Macy Gray, Elton John, and Christina Aguilera. To add even more icing to the confection of his life's work, he conceived and designed Elton John's "The Red Piano" show at Caesars Palace in Las Vegas.

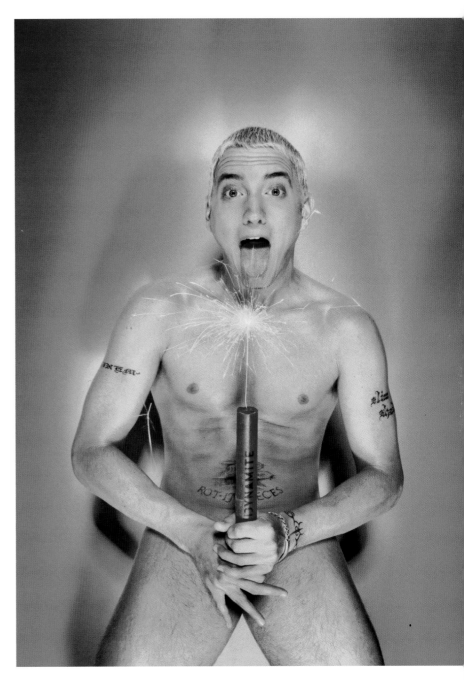

"About to Blow," Eminem, LaChapelle Studio, New York City
1999

DAVID GAHR

You can feel their hearts fluttering; you can feel Bruce Springsteen's joy in being able to create music that makes young girls' hearts flutter. Rock and roll is life-affirming. However old you are, when you hear the music of your youth, you are not only taken back to the time and place you originally heard it, you tap into your youthful self. Somewhere in that aging body is the teenager who had all those dreams and passions, the kid who wanted a better world and who saw rock-and-roll heroes speaking a truth that connected him or her with others of his or her generation. Rock and roll is huge because it makes people feel alive. David Gahr said this photograph is "the essence of rock and roll. Virile young man surrounded by lovely sixteen-year-old girls crazy about him."

Gahr spent a lifetime capturing the essence of rock and roll—as well as folk, blues, and jazz. He was one of Bob Dylan's favorite photographers because, as is well documented, Dylan can't stand phonies. (Dylan asked the seventy-nine-year-old photographer to shoot his thirty-first studio album, *"Love And Theft,"* when most musicians look to engage the hottest young photographer. Gahr's photographs of Dylan go back to the 1963 Newport Folk Festival.) André Kertész was Gahr's favorite photographer. Gahr used the same darkroom assistant as Walker Evans. There are music photographers who are hacks, but the best, like Gahr, stand proudly in a long line of distinguished photojournalists and art photographers.

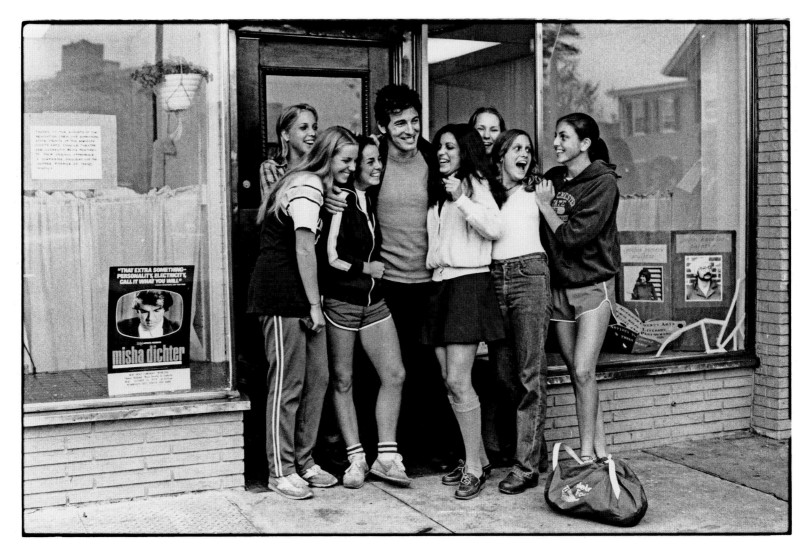

Bruce Springsteen with fans, Red Bank, New Jersey
1973

ALFRED WERTHEIMER

Alfred Wertheimer has taken the best photographs of Elvis Presley. Period.

Wertheimer spent only ten days with the King, but what he captured of Elvis during that short time has given millions not the myth, but the man—the beautiful, exceptional, tender, sexy, and talented young man.

Nineteen fifty-six was Wertheimer's first year as a professional photographer. It was Elvis's first year as a star; he didn't even have his first gold record yet. Wertheimer realizes how lucky he was. "Three years later," he reflects, he would have felt obligated to "direct" the pictures. Elvis's handlers, Wertheimer is convinced, would not have allowed an unknown freelance photographer total access to their "kid." Elvis was twenty-one years old, Alfred twenty-six.

The publicist for RCA's pop record division telephoned Wertheimer in March 1956 because she needed some photographs for her files of a singer they had just signed named Elvis Presley. Wertheimer remembers responding, "Elvis who?"

Wertheimer is a photojournalist in the *Life* magazine tradition of making pictures that tell a story. In this charismatic, polite, handsome, small-town Southern youth who was starting to make girls scream everywhere he went, Wertheimer felt there was a great story. If he followed his instincts and photographed the things he found interesting—Elvis flirting with a waitress, kissing a girl, sitting at a lunch counter, listening to a test recording of "Hound Dog," appearing on *The Steve Allen Show*, playing a concert—others would be interested, too.

Wertheimer photographed Elvis when he could "still walk alone," even documenting him getting off a train and strolling home by himself. Wertheimer photographed Elvis reading *Archie* comic books on long train journeys,

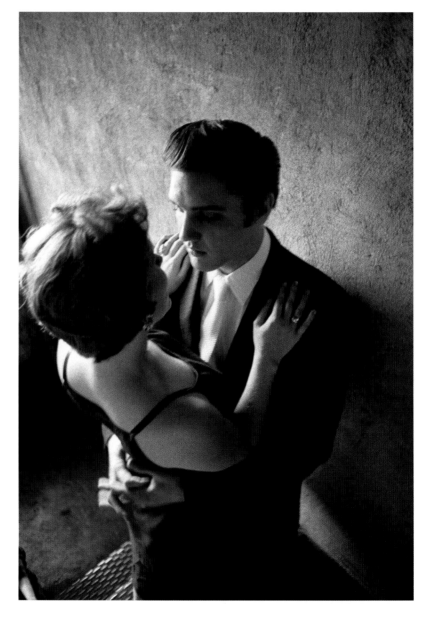

In the stairwell of the Mosque Theater, Richmond, Virginia
June 30, 1956

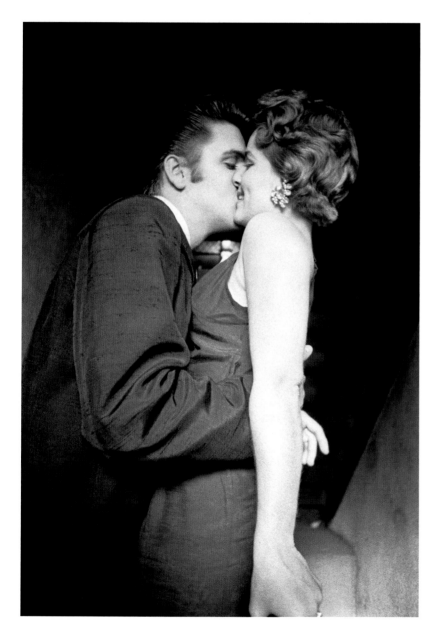

carefully combing his hair, brushing his teeth, and eating breakfast. He wanted to be a "fly on the wall," and made sure to always get at least eight to ten good photographs to tell a particular story. Wertheimer's heroes are the giants of photojournalism: W. Eugene Smith, Dorothea Lange, David Douglas Duncan, and especially Dr. Erich Salomon.

Wertheimer enjoyed photographing Presley for two reasons: he permitted closeness, and he made the girls cry. He also was convinced that "this guy" had something unique. Other photographers have shown Elvis performing; none have so acutely observed and captured his relationship with people. Elvis knew how to—wanted to—touch people, physically and musically. The way he looked at the plain-Jane waitress (see page 133) taking his breakfast order made her feel beautiful and sexy. He did it onstage; he did it in life.

Wertheimer knew that "posed pictures never showed Elvis" and that he needed to be a keen observer; he never told Elvis what to do. By watching carefully, by "hanging around," Wertheimer discovered the source of Elvis's musical genius.

Wertheimer, a German refugee, was a 1951 graduate of the Cooper Union in New York City, one of the country's best art schools. He came out of college knowing how to compose a picture, work with perspective/play with space, organize the background so as not to interfere with the main subject, and vary his camera angles so that neither he nor the viewer got bored. He kept the technical part simple: almost all the 1,500 photographs of Elvis Presley taken in 1956 were made with two 35mm cameras, one with a 35mm lens and one with a 105mm lens, Tri-X film at 400 ASA, and natural light. He would load his own film in hundred-foot rolls, figuring each exposure cost him a penny or a penny and a half. He felt an enormous

freedom shooting, because the film was cheap, he developed it himself, and made 8 × 10s only of the ones he could sell to magazines.

"For nineteen years, no one called for even a single picture. The day Elvis died [August 16, 1977], the phone started ringing and it hasn't stopped" says Wertheimer. "Still photographers," he goes on to say, "have their contact sheets as part of their memory. I am discovering pictures now that I didn't even realize I have. Out of 1,500, about 600 or 700 have been blown up to at least 8 × 10 size, some larger, maybe 350 have been used in printed material. . . . And so what happens, you go over the same material over and over again and so it wasn't just the ten days I was with Elvis but the hundreds of days over the last fifty years."

I was worried about how Elvis was going to react to the invasion of his privacy. He couldn't have cared less; his focus was entirely on giving this girl a kiss. I took my shots from the left [of the stairwell], but I felt I needed another angle. With my maintenance man voice, I grumbled, "Excuse me, please— coming through." Squeezing past them, I positioned myself on the other side. . . . At last, I had a much better view.

"I'll bet you can't kiss me, Elvis," she said and stuck out her tongue mocking him.

"I'll bet ya I can," he said and stuck out his tongue. On his first try, he overshot the mark and bent her nose.

Always remaining cool, Elvis backed up slightly and the tips of their tongues just touched.

Five minutes later, Elvis came out from the back, combed his hair one more time, grabbed his guitar, and jumped on stage in front of 3,000 screaming fans.

—ALFRED WERTHEIMER,
ELVIS AT 21: NEW YORK TO MEMPHIS

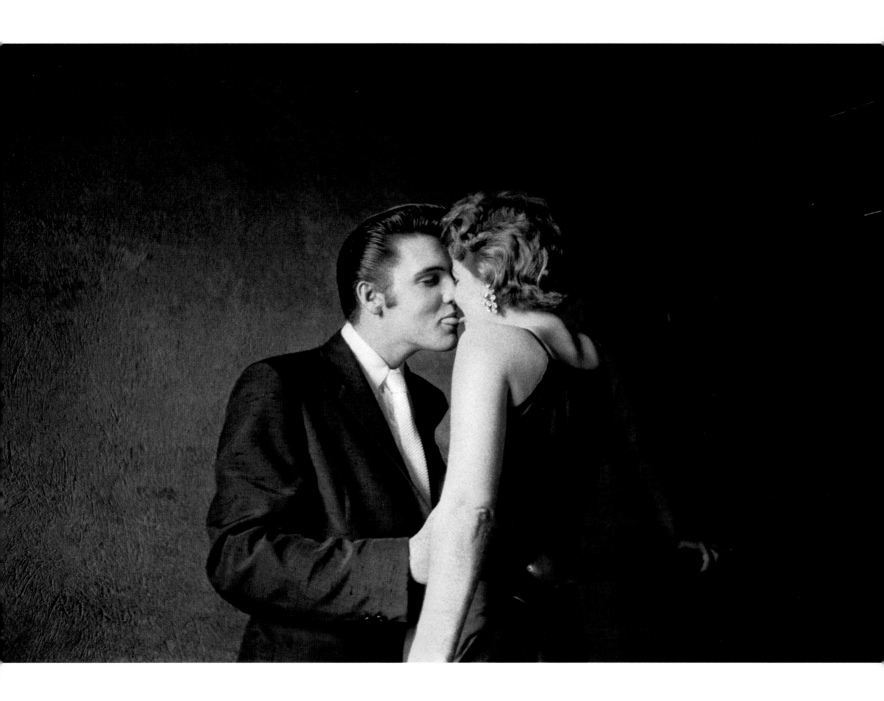

PENNIE SMITH

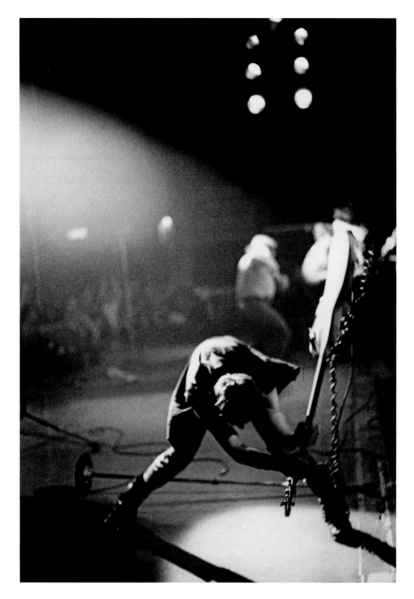

Paul Simonon, the Clash, Palladium, New York City
September 21, 1979

The Clash's *London Calling* LP design was an homage to Elvis Presley's first album cover. They both have the same distinctive pink and green typography and photographs that show the raw energy and vibrancy of the musicians. The Elvis photograph was taken by William V. (Red) Robertson. The photograph of the Clash's Paul Simonon was shot by Pennie Smith.

Smith was on the Clash's 1979 U.S. tour. She loved being with the group and the vast expanses of the American West, living out of a single bag, being left alone to do her thing. Smith knew how the Clash moved onstage and

continued on page 283

RICHARD CREAMER

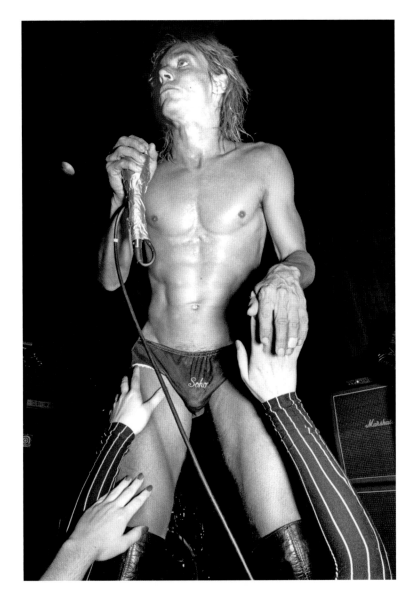

Iggy Pop at the Whisky a Go Go, Los Angeles, California
October 30, 1973

Art historians have long discussed the image of the eroticized Christ on the cross, a semi-naked male posed in ecstasy or extreme suffering. It is a figure to be gazed at and adored and, if permitted, touched. Iggy isn't a god, but tell that to his followers.

Richard Creamer was friends with Iggy Pop. He was also close to Robert Plant of Led Zeppelin. Creamer, an eccentric L.A. magazine photographer, earned his living documenting celebrities and working for the big-time publicists. He covered many musical events with his friend journalist Darcy Diamond. In a letter to the

continued on page 283

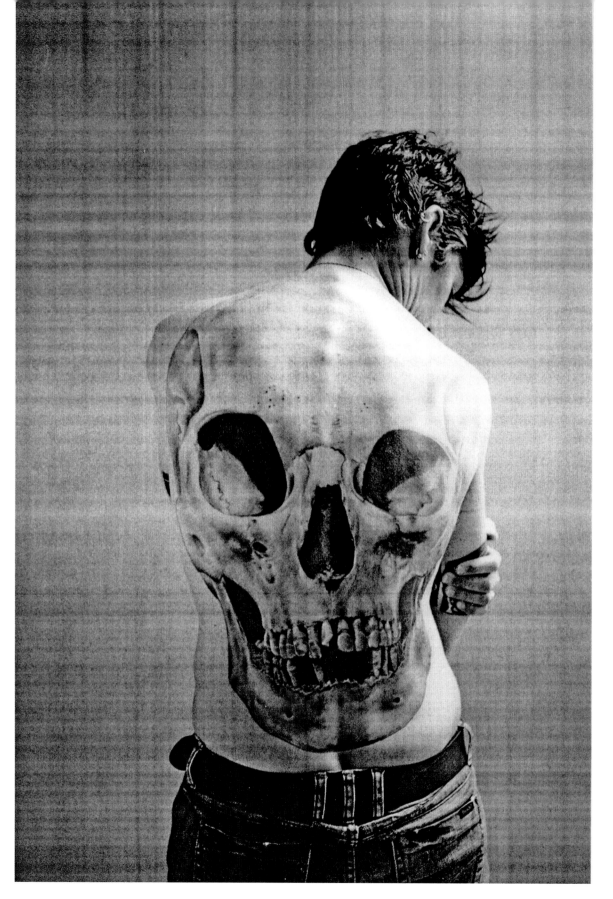

Alice Temple, New York City
2008

ARI MARCOPOULOS

Maybe it is because Ari Marcopoulos printed thousands of Andy Warhol's negatives over a two-year period that he developed a sixth sense of knowing who and what is culturally important. Alone in the darkroom with the 8 × 10 black-and-white prints floating in the wash, he had time to learn what compositions work as entities in themselves and which are studies for larger projects.

Marcopoulos's pictures always appear instinctive and as an extension of his life. They do not abide by any rules of composition but possess an edginess that feels right.

Marcopoulos came to the United States in the early 1980s because he was bored at home in Holland. More specifically, he says, he came because of "basketball, baseball. No, I just had to leave The Netherlands, it was too small of a place for me. None of the inspiration I found in the streets here in New York City."

Working for Warhol, Marcopoulos met and photographed Keith Haring, Peter Halley, and Jean-Michel Basquiat. He stumbled onto hip-hop and got hooked. In 1988 he did a book titled *Portraits from the Studio and the Street*. His photographs conflate distance; they try to connect the viewer intimately with the subject.

Marcopoulos took this photograph of the English singer Alice Temple during one of her visits to New York City. He had heard about the tattoo on her back and knew he wanted to photograph it. He figured skulls have a long history in art, and having one palpating on a woman's back was an irresistible subject. Photographing a young woman from the back has a long history in photography, too, dating back to the Scottish photographers Hill and Adamson in the 1840s (shoulders and necks, seen from behind, turned Victorians on). Marcopoulos's carbon-pigment ink-jet print has the soft focus found in nineteenth-century photographs, but it is applied to a very contemporary woman.

ELAINE MAYES

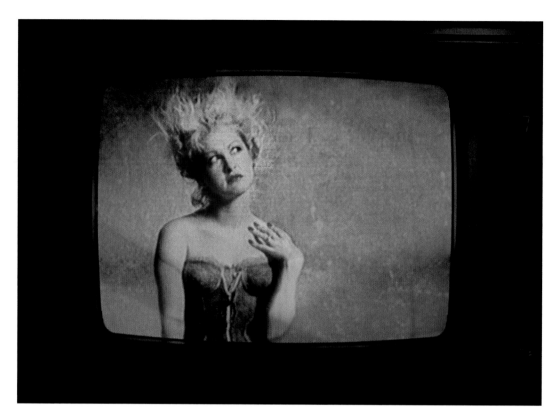

"Cyndi Lauper on Television"
1987

Elaine Mayes writes about her series titled "Portraits of Musicians on Television":

In 1987 I was home in the evening with a headache. When my head felt better I turned on the TV set and discovered Deborah Harry singing. I had been photographing musicians in clubs but realized that my club days and seeing live performances were numbered, and that all of us were going to have MTV instead of the real thing very soon. . . . Like most all media junkies, I held many musicians and popular stars in awe. . . . The abstractions we live by and with in our lives are incredible and complex. For me, these portraits are strange and provocative. I like the way the phosphor dots of the TV screen show an effect not normally visible to the naked eye. . . . I like how these images seem to illuminate the reasons people seem to feel they know their favorite media stars without having met them in person. I also like the way the images cannot really be seen on television . . . one image passes so quickly that our perception sees the movement but not the separate images.

—LETTER TO THE AUTHOR, FEBRUARY 20, 2008

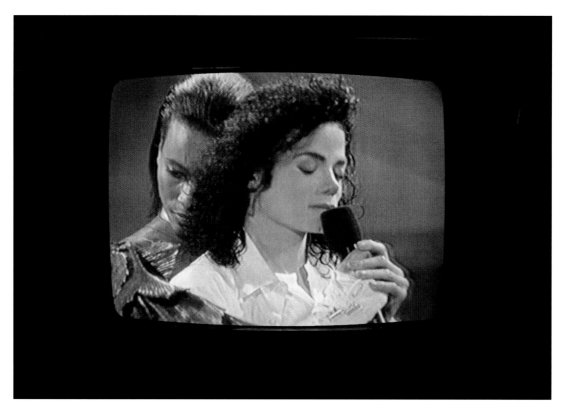

"Michael Jackson on Television"
1987

The first time I saw James Brown was on television. I was six years old. I was mesmerized. I'd never seen a performer before like him, and right then and there, I knew that that was exactly what I wanted to do for the rest of my life.

—MICHAEL JACKSON, QUOTED IN *ROCK AND ROLL,* BY LYNN GOLDSMITH

PETER VERNON

Carlsberg couldn't pay for such a promotion. The Sex Pistols exploding out the door at EMI, splattering lager everywhere—creating their own snowstorm in the parking lot. Here come the Sex Pistols, boys just wanting to have fun—and anarchy.

Peter Vernon's picture is an invitation to join the circus. Punk is participatory. The musicians and audience have a symbiotic relationship. This photograph appeared in the British press the day after the Sex Pistols infamously appeared on the English *Today* television show with Bill Grundy and only a few days after their single "Anarchy in the UK" was released. Philip Hoare, author of books on Noël Coward, Oscar Wilde, and Stephen Tennant (could the Sex Pistols be any further removed from these English gentlemen?), writes: "This extraordinary collection of Dickensian sci-fi misfits were encouraged by Grundy to 'say something outrageous'—and duly obliged. The next day this photograph appeared on the front of the *Daily Mirror* under the headline, 'The Filth and the Fury,' along with reports that one angered viewer had actually kicked in the screen of his £380 colour TV" (*Icons of Pop*, p. 46).

It was kids kicking their bedroom doors to get the hell out of the house and out of the claustrophobic class system that was the real story. The Sex Pistols were "misfits"—punks—but not "Dickensian." They were something new. In his book *Lipstick Traces: A Secret History of the Twentieth Century*, Greil Marcus quotes Elvis Costello: "It was 2 December 1976 [Elvis Costello was still Declan MacManus, working as a computer operator and commuting daily to Central London]. . . . On the way to work, I was on the platform . . . and all the commuters were reading the papers when the Pistols made headlines—and said FUCK on TV. It was a great morning—just to hear people's blood pressure going up and down over it" (p. 3). Costello said the Sex Pistols' record changed the world but should not be confused with "a major event in history."

Marcus argues it *was* a major event in history. The Vernon photo is the flag-raising over Iwo Jima in the history of rock-and-roll photography.

England in the seventies was a bleak place for a kid who left school at fifteen. The revolutions of the sixties did not translate into jobs and opportunities for millions of British youth, and the Sex Pistols, their image even more than their music, became a model of rebellion. The photographs of the Sex Pistols are often disgusting—think Sid Vicious's slashed and bleeding chest or his mouth covered in mustard, hot dog, and bun, the button on his leather jacket reading I'M A MESS (see page 283), or the group with straws up their noses, as captured by Bob Gruen. These are not paparazzi pics, these are the images the band wanted seen. They needed the pictures to convey the mayhem. Anyone could form a band—the fanzine *Sniffin' Glue* printed a diagram of three guitar chords with the challenge, "Now form a band." The kids had to study the photographs a lot harder and longer than they needed to practice the guitar if they really wanted to understand what the Sex Pistols were all about.

continued on page 283

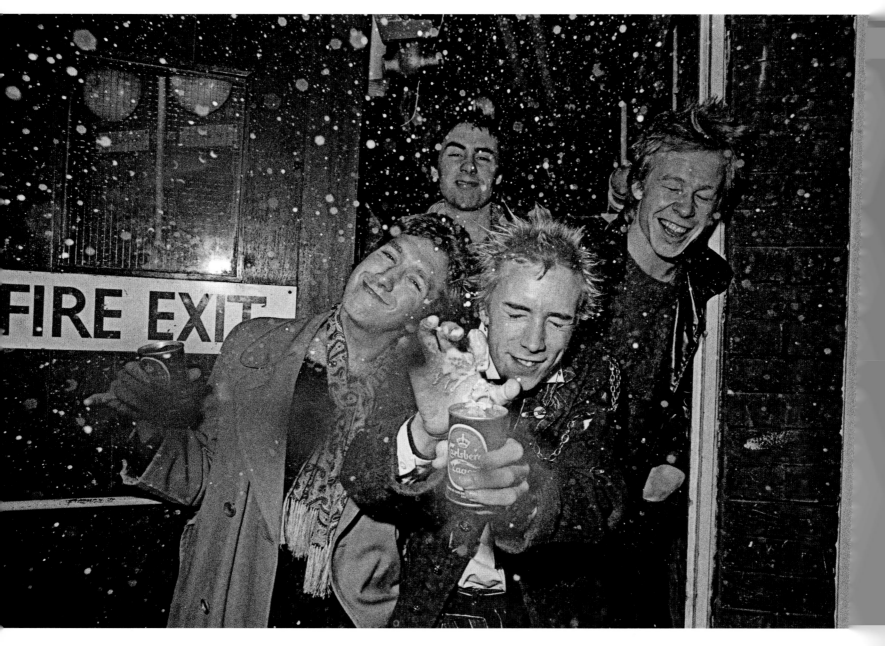

The Sex Pistols, EMI headquarters, Manchester Square, London
1976

IAN TILTON

The English photographer Ian Tilton had photographed Nirvana in 1988 under difficult circumstances. Coming out of CBGB, he was hit by a bus. His injuries were not life-threatening, but he couldn't tour with the American bands as he had planned. Nirvana came to his East Village digs for their photograph. While Tilton maneuvered on an office chair with wheels, the musicians commiserated and posed. They invited him to come to Seattle when he was better, and later in the year, he stayed with Krist Anthony Novoselic II, Nirvana's bassist. He got to know the band members as friends.

The photograph of Kurt Cobain in tears has been extensively published. Tilton, one of the most empathetic of men and now a trained counselor/psychotherapist, watched Cobain smash his guitar through an amplifier and walk offstage. He followed him backstage. The pent-up emotion "just had to go somewhere," says Tilton, and Cobain burst into tears. "What I really love about it is that it is a very real moment and he allowed it. Other artists would have said, 'Not now, Ian, please.' It is very unusual," adds Tilton, "for anyone from a band to show such vulnerability." Through photography, Cobain's tears, which lasted only a minute, are also the tears of his fans who miss him.

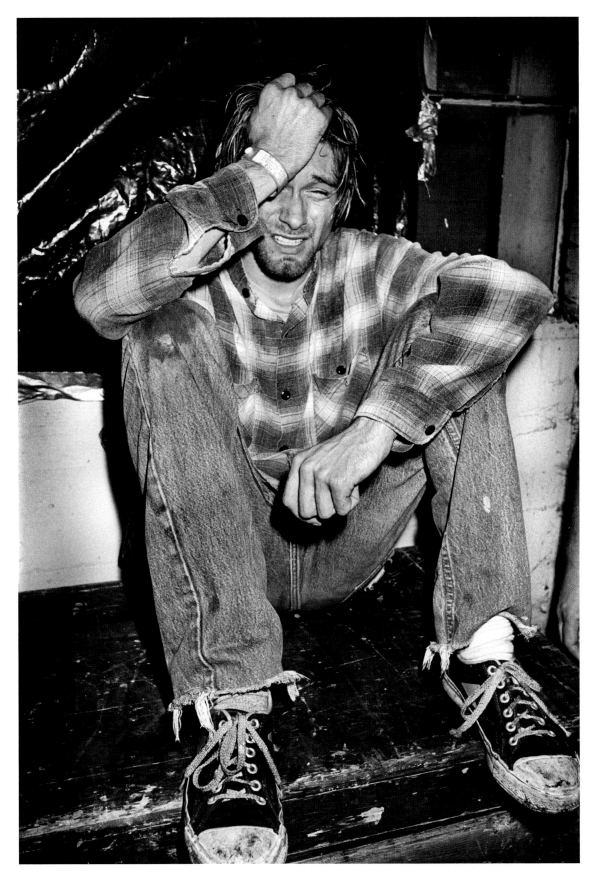

Kurt Cobain, Motor Sports International Garage, Seattle, Washington
September 22, 1990

JERRY SCHATZBERG

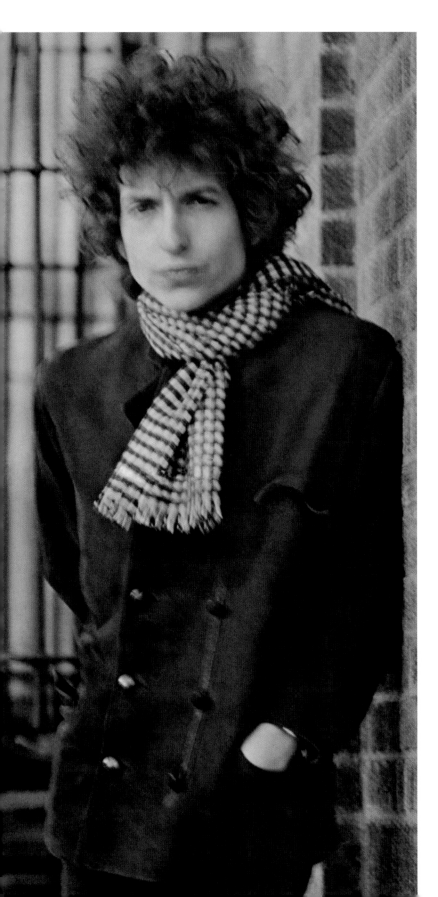

n 1864, British photographer Julia Margaret Cameron wrote to her dear friend the astronomer and early photographic experimenter Sir John Herschel in frustration. Her portraiture was "condemned" as out of focus. She demanded to know "What is focus and who has a right to say what focus is the legitimate focus?" Photography was only twenty-nine years old.

Jerry Schatzberg's photograph of Bob Dylan—hair wild, features fuzzy—has much in common with Cameron's portrait of Herschel. In both the Cameron and the Schatzberg, it is as if the subjects' brains are too active to "freeze."

For *Blonde on Blonde*, Schatzberg first shot two or three rolls of 2¼ square film in the studio. He then took Dylan to the Meatpacking District of New York City: "It was very cold but we did one roll of 35mm outside, two, maybe three, frames were fuzzy (the rest were sharp) because we were so cold and kept on moving around a bit. Dylan to his credit chose one of the fuzzy ones."

In *The Greatest Album Covers of All Time*, by Barry Miles, Grant Scott, and Johnny Morgan, the authors explain the significance of this image: "The famous blurred photograph by Jerry Schatzberg sums up both the album and the image problem Dylan was having at the time. The record was actually made in Columbia's Nashville studios, but despite the presence of many well-known Country and Western players on the record, *Blonde on Blonde* contains some of Dylan's most urban, drug-influenced songs ["Sad-Eyed Lady of the Lowlands" took one side of the double LP with "Rainy Day Women #12 & 35" proclaiming "Everybody must get stoned"]. As well as the out-of-focus photograph, it had no title and no clue as to whose album it was, just a curious figure with long hair and an intense stare; and the image was turned ninety degrees and opened out to become a full-length portrait. The sleeve perfectly reflects Dylan's increasingly hazy blurring of musical boundaries and the burgeoning hippie movement's psychedelic influences" (p. 64).

Bob Dylan, *Blonde on Blonde*, New York City
1966

NITIN VADUKUL

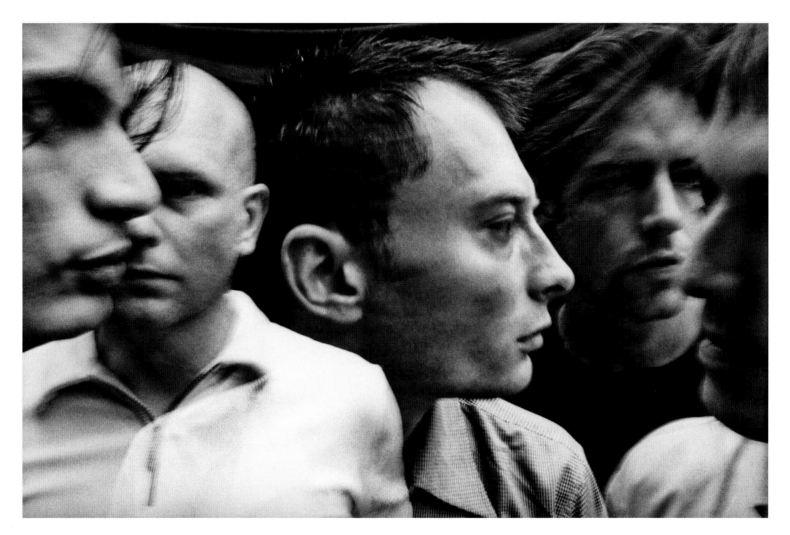

Radiohead, St. Louis, Missouri
1993

Nitin Vadukul's group portrait of Radiohead (left to right: Jonny Greenwood, Phil Selway, Thom Yorke, Ed O'Brien, and Colin Greenwood) is the most perfect evocation of the dissonant, cerebral, complex music coming from these five individuals. Vadukul double-exposed one Tri-X 35mm negative to give an image simultaneously real and unreal. This image is inherently photographic in its ability to challenge perception and raise questions about illusion and actuality. Scale plays havoc with the viewer's brain. The picture is fluid but the disportionate size of Yorke's ear anchors the image—"hear us," it seems to say.

MICK ROCK

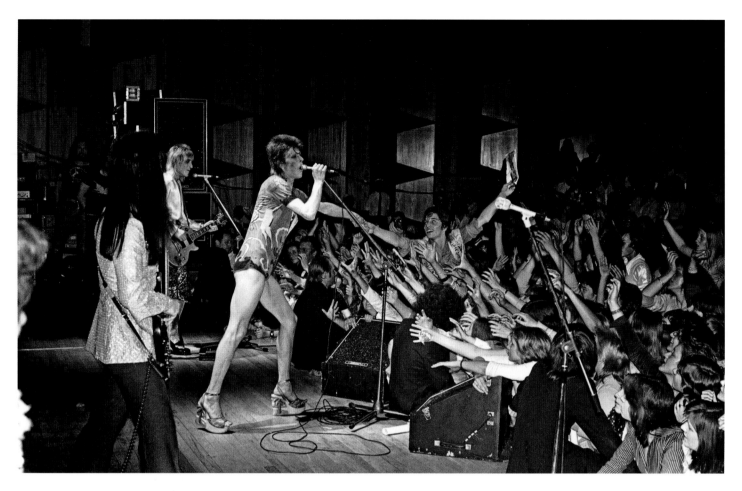

**David Bowie during the United Kingdom Ziggy Stardust summer tour
(left to right: Trevor Bolder, Mick Ronson, and David Bowie)**
1973

What do they want of me? That's the joke of it. But then again people need figures like me, the clowns. And this is the most enjoyable way I know of making a living. What else would I do? Upholstery?

—DAVID BOWIE, QUOTED IN *GLAM! AN EYEWITNESS ACCOUNT*, BY MICK ROCK

This was taken in the summer of the last Ziggy tour in 1973 [all his fans "wanted a piece of him"]. At this point David wanted to be physically close to the audience. In 1972 the audience was more passive, mesmerized. But by the final tour in 1973

I have a lot of images of him touching, being touched, kids running on stage, grabbing him. There's something about this particular shot that people love—the long arch and the reach and the guy being lifted out of the crowd—Ziggy Stardust and the whole persona was really a work in progress, and by this point it's reached its final manifestation, with the high makeup, all the Japanese gear. He's really perfected Ziggy.

—MICK ROCK, QUOTED IN *ROCK X-POSED: FIVE DECADES OF ATTITUDE IN PICTURES*, ED. BY MAX BROWN

continued on page 283

MASAYOSHI SUKITA

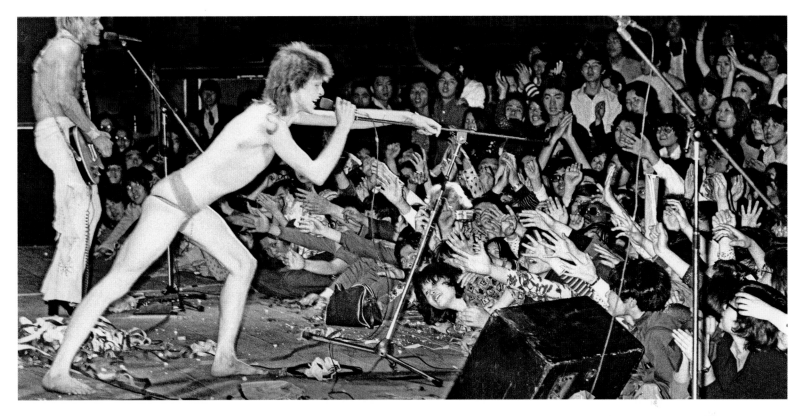

David Bowie and Mick Ronson (left), the Ziggy Stardust Japan tour, Shibuya Kokaido Hall, Tokyo
April 1973

Masayoshi Sukita, like Mick Rock, is one of Bowie's favorite photographers. They first met in London in August 1972 when Sukita took his first Ziggy Stardust pictures. The chronicling of Ziggy continued in New York in February 1973 and on the Japanese tour in April that year. There is no discernible difference in affection for the pop star among teenagers on three continents. Sukita can't explain the phenomenon, but his insight is worth noting: "Spiritual force defies explanation. . . . Spiritual force touches us and flows from us, like the ripples on a still pond. Spiritual force is concentration and an inner energy. . . . Spiritual force is the fundamental secret shared by artists and is the reason art so vitally inspires. Spirit force, or ki, is everything. And without ki, there is nothing" (from the foreword to *Ki: Spiritual Force,* by Masayoshi Sukita, 1992).

PENNIE SMITH

ennie Smith's first commission for *New Musical Express* was to photograph Led Zeppelin on tour. From the get-go she was, as she says, "in at the deep end." She later became chief photographer for *NME* and was there from the early 1970s through the 1980s—without, as she emphasizes, editorial override.

Prior to her joining *NME*, Smith was part of the creative team of the short-lived but influential British magazine *Friends of Rolling Stone* (later *Friends*, and then *Frendz*), started in December 1969 by Alan Marcuson with contributions by Barney Bubbles, Charles Radcliffe, Nick Kent, and other constituents of the London underground scene. Everyone was "dangerous" in those days, Smith reflects.

Smith has always been an artist, carefully building her pictures with strong lines and patterns. As meticulously as a musician constructs a chord, so, too, does Smith make a composition. Even though she knows she could sell almost any picture of a famous musician, she will print only the negatives that meet her standards of excellence. Her pictures have to say something real about the people in them; otherwise, they become part of hundreds of rock photographs that record but don't reveal. The camera angle, the stage lights, the lump in the tight pants, the bodies in ecstatic expression—we see what can only be described as the pure force of rock and roll.

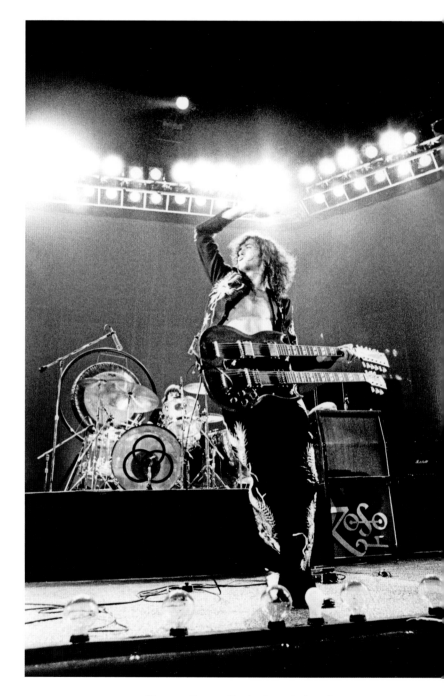

Jimmy Page, Earls Court, London
May 1975

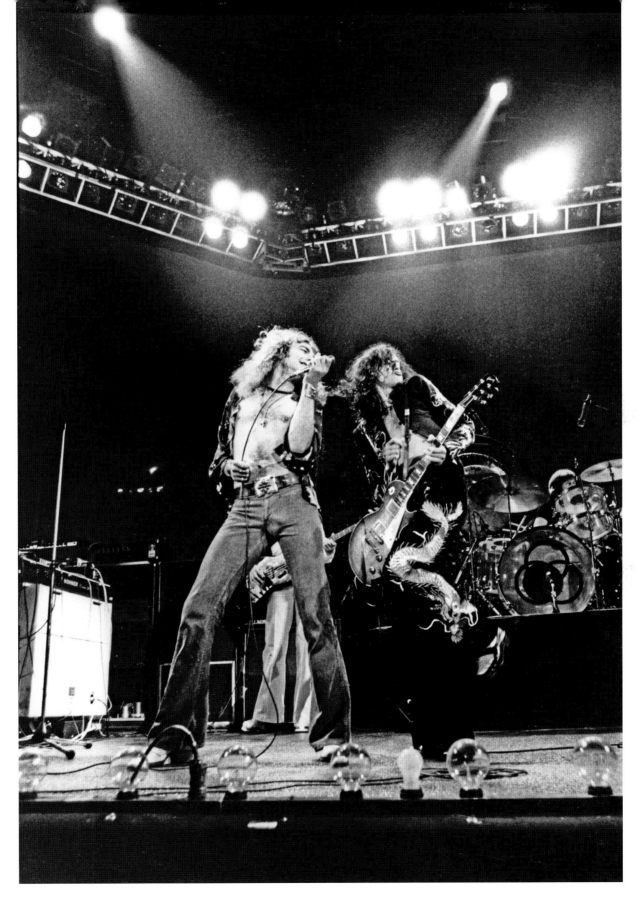

Led Zeppelin (left to right: Robert Plant and Jimmy Page), Earls Court, London
May 1975

JERRY SCHATZBERG

A wonderful straight portrait of a goofy, great rock-and-roll Dadaist. What perfect colors for the man whose final album would be called *The Yellow Shark*. What perfect colors considering Tom Wolfe's *The Kandy-Kolored Tangerine-Flake Streamline Baby* (1965) was set, in part, in Jerry Schatzberg's studio at 333 Park Avenue South. The parties there, with the Rolling Stones and everyone else who was anyone, were famous.

Schatzberg studied with Alexey Brodovitch in the historic ten-week course Brodovitch taught in the 1950s in John Rawlings's studio. Bob Cato, the famed art director, "discovered" Schatzberg and mentored him (as he did Norman Seeff). In the 1960s Schatzberg had an important career as a fashion photographer, and in the seventies and eighties he made films, including *Puzzle of a Downfall Child* (starring Faye Dunaway); *Scarecrow,* which shared the Palme d'Or at the Cannes Film Festival in 1973; and *The Panic in Needle Park* (starring Al Pacino and Kitty Winn, who won the Best Actress award at the Cannes Film Festival, 1971).

Frank Zappa named his four children Moon Unit, Dweezil, Ahmet Emuukha Rodan, and Diva Thin Muffin Pigeen, and somehow Schatzberg's portrait makes it fit. The portrait doesn't look into the soul of Zappa, it looks at what makes him unfathomable.

Frank Zappa, "Himself," New York City
1967

ED CARAEFF

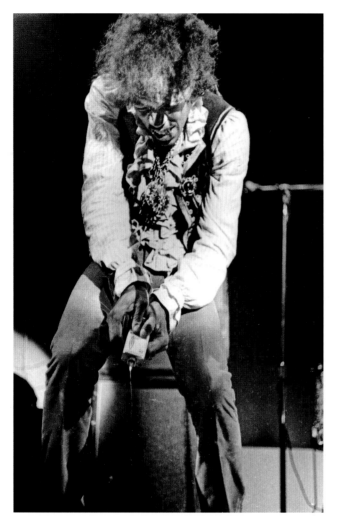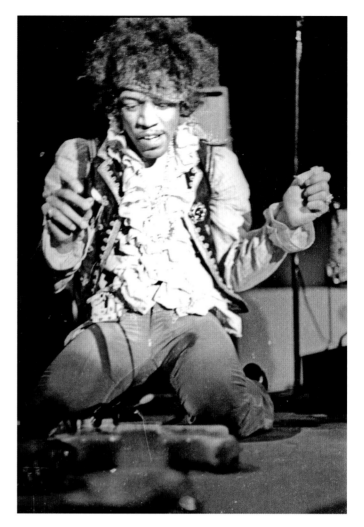

Jimi Hendrix, Monterey Pop Festival, Monterey, California
1967

He had the longest fingers I'd ever seen," said Ed Caraeff about Jimi Hendrix. When he took this famous sequence in black and white, Caraeff was seventeen. He had never even seen a photograph of Hendrix or heard his music.

Jim Marshall, the maestro of music photography, was on the stage at the Monterey Pop Festival with cameras with black-and-white and color film. Forty years later, Caraeff said that Marshall just "didn't have the angle."

The kid, however, had somehow gotten a chair right up to the edge of the stage, and by standing on it had a clear shot of Hendrix. Thanks to an older German photographer who advised the teenager to "save some film for this Jimi Hendrix chap," Caraeff had a few exposures left in his camera, but just—the guitar burning is number 36A on a roll of 36-exposure 35mm film—call it beginner's luck.

Caraeff was close enough to the burning guitar to feel the heat. He used his camera to shield his face.

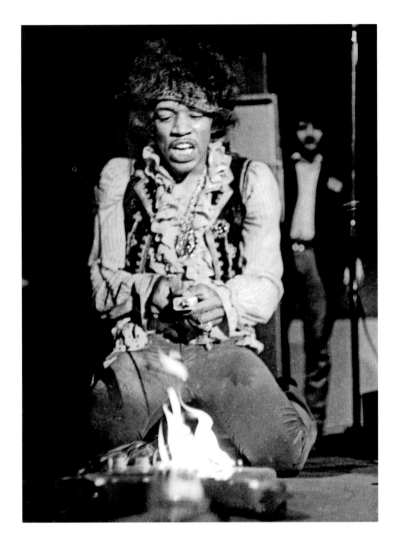

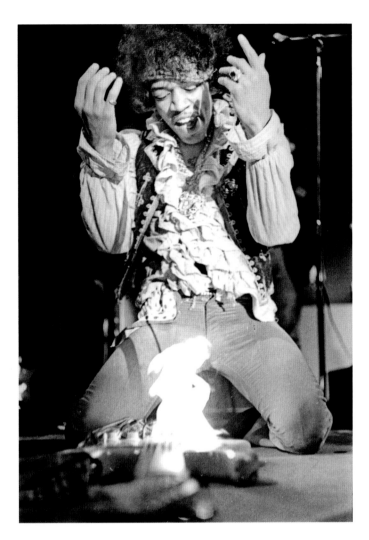

The sequence has not been published before, but the final frame, Hendrix kneeling in front of his burning guitar, hands raised, is one of the most famous images in rock. *Rolling Stone* matched the colors in Marshall's picture to hand-color Caraeff's classic for a cover.

Caraeff took photographs for many album covers. One of his most famous, Captain Beefheart's *Trout Mask Replica* (see page 298), was taken while Caraeff still lived at home with his parents. He shot it in a borrowed studio with hot tungsten lights (he couldn't afford strobes). Beefheart had a real fish over his face, and the hotter it got, the smellier the fish became. In a 2009 e-mail to the author, Caraeff humorously wrote, "It was a quick session as the Captain was a very testy guy." Later, when professional art directors started "screwing up" the album covers, Caraeff moved to art directing as well as photographing album covers.

KEVIN CUMMINS

Morrissey, Jones Beach, Long Island, New York
July 10, 1991

Kevin Cummins was born in Manchester, England, in 1953. After studying industrial art and design at Salford College in the mid-1970s, he embarked on a career photographing performance—first for major theaters such as Manchester's Royal Exchange, London's Royal Opera House, and Liverpool's and Oxford's playhouses. He never lost the sense of the drama onstage, even after he became one of Manchester's premier music photographers. To begin with, he focused on the nascent and vigorous punk scene of the late seventies and early eighties. The photographs of the Smiths, with their lead singer, Morrissey, and Joy Division, con-stitute some of his most important and moving imagery.

Cummins is a serious art photographer who happens to specialize in music and football (specifically Manchester City). Walking into his home, one sees a wall of photographs by Diane Arbus, Bill Brandt, Henri Cartier-Bresson, Lee Miller, Jerome Liebling, Eugène Atget, Robert Doisneau, Bert Hardy, and other greats in the history of photography. Elsewhere are photographs by David Bailey, Humphrey Spender, Tony Ray-Jones, Weegee, Bert Stern, Ruth Orkin, Annie Leibovitz, and others. He says that Bill Brandt, Irving Penn, and Diane Arbus are his principal inspirations.

STEPHANIE CHERNIKOWSKI

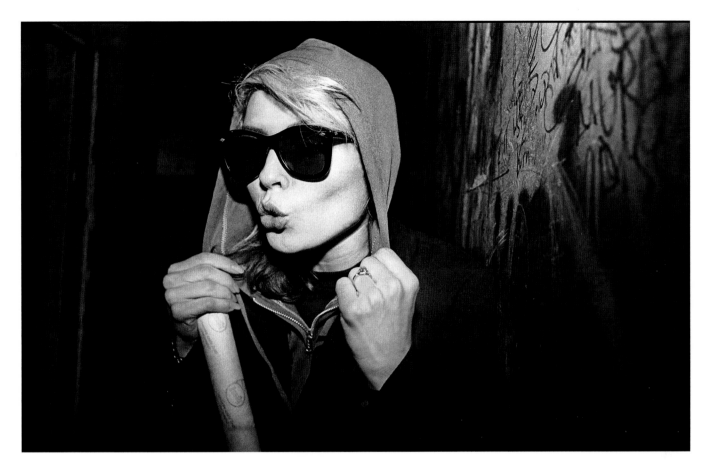

"Debbie Harry CBGB NYC"
1978

Stephanie Chernikowski was kissed by Elvis as a teenager and recalls teaching George W. Bush freshman English at the University of Texas. Who would have thought it possible in one lifetime? She was one of the main photographers of the Blank Generation, documenting a very wild time in the arts in New York in the late 1970s and early 1980s. Her forte was portraiture; the musical style was punk and No Wave.

This is the "face that launched a thousand photographs," says Chernikowski of Debbie Harry, lead singer of Blondie. It was taken during the Blitz Benefit, a marathon of performances at CBGB to raise money for the hospital bills of the Dead Boys' Johnny Blitz after he was stabbed.

PENNIE SMITH

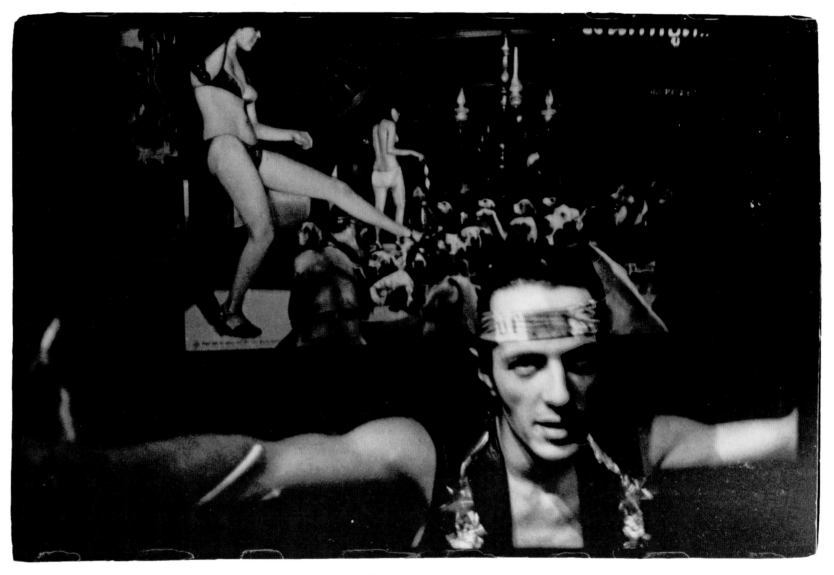

Joe Strummer, Thailand
February 25, 1982

The Clash: *Before & After* by Pennie Smith, with "Passing Comments" by Joe Strummer, Mick Jones, Paul Simonon, and Topper Headon, is the best book on the Clash, and one of the best books in the history of rock-and-roll photography. It is to rock-and-roll photography what Robert Frank's *The Americans* is to photojournalism: they both are radical departures from the norm.

Smith spent many days and nights with the Clash. "Being on the road with the Clash is like a commando raid performed by 'The Bash Street Kids' [an English comic strip]," she comments. Her photographs and resul-

continued on page 284

NORMAN SEEFF

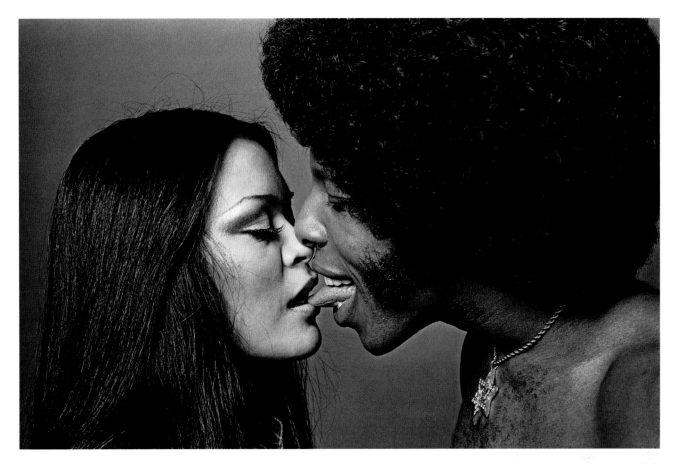

Sly Stone and Kathy Silva, Los Angeles, California
1974

Sly was just wild, in a positive sense—he had this incredible energy and enthusiasm, and there was a sort of dangerous creativity about him," says Norman Seeff.

Norman Seeff is all about finding that creativity—it has been his life's work. His camera is only a tool to tap the sparks of genius that fly in front of his lens. Joy, foolishness, freedom, reflection, expression, seduction, strumming, stamping, singing, kissing, the sound of one hand clapping—that is the stuff of a Seeff portrait. Because the life force and the creative process, as Seeff sees it, is too much to contain in a single frame,

Seeff has been working for decades with cameramen to record his photographic "sessions."

Seeff was born in South Africa, trained as a physician, and worked as an emergency medical doctor in Soweto; wishing to escape the oppressive apartheid system and to also explore his creative passions, he immigrated to the United States. Crashing at friends' homes, he somehow met one of the most powerful people in graphic design—Bob Cato. Cato, himself a photographer, liked the young doctor's street photography and gave him his first commission—photographing the Band for the inside notes of a new album. Seeff was not only petrified

continued on page 284

DAVID LaCHAPELLE

David LaChapelle's wildly colorful, totally over-the-top portraits are about the most fun one can have with a camera. "Funny is beautiful," LaChapelle says, and he quotes Truman Capote, "'Good taste is the death of art.'" LaChapelle pushes pretension out and puts play back into photography. "There is a tradition of celebrity portraiture that attempts to uncover the 'real person' behind the trappings of their celebrity," he observes. "I'm more interested in those trappings." There is nothing subtle in LaChapelle's wonderful, crazy world, and it is a perfect fit for photographing the musicians whose lives often have that superreality that LaChapelle's imagination concocts so well.

"A lot of people think it's all done on the computer, but it's not," explains LaChapelle in a video interview. "I'm a photographer, not a computer person. It's more fun to photograph something real than to do it on a computer." For LaChapelle, it is important that these scenarios existed in time and space. His art is a combination of imagination, physical engagement, and skill.

Lil Kim, New York City
March 2000

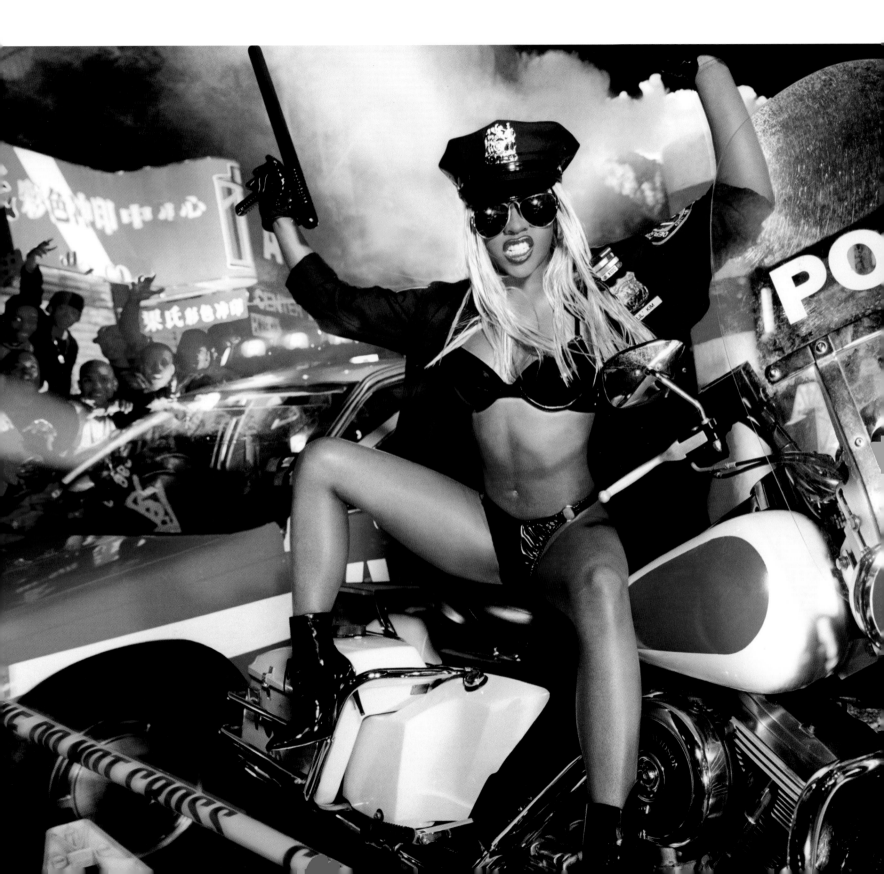

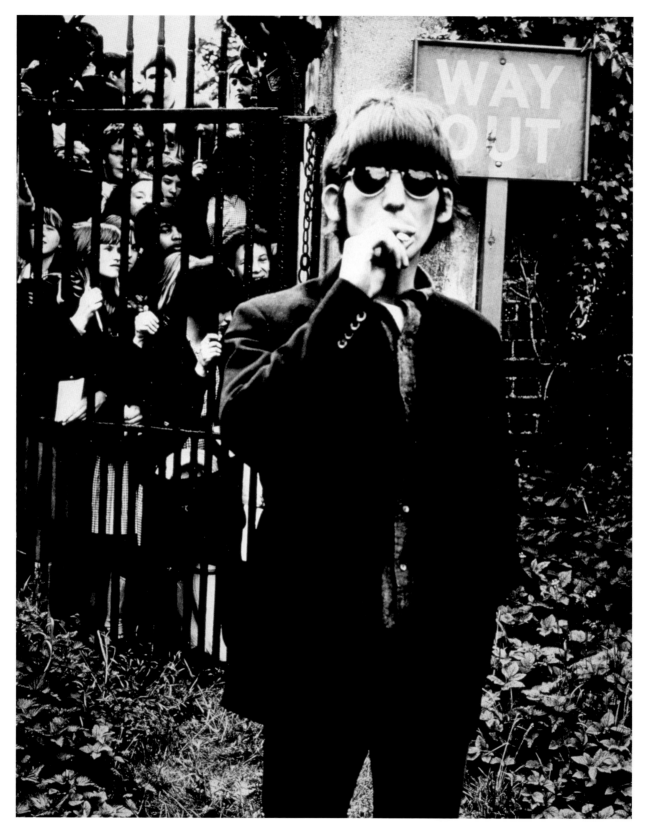

"Way Out," George Harrison, Chiswick Park, London
1965

ROBERT WHITAKER

The photograph of George Harrison was taken in the garden of Chiswick House outside of London. The Beatles were making a promotional film to accompany their release of "Rain." This, along with another Beatles film made at the same time to promote "Paperback Writer," sparked Harrison to say in the documentary *The Beatles Anthology*, "So I suppose, in a way, we invented MTV." The films show the Beatles walking and singing in the garden and greenhouse and on a soundstage.

The photograph of Harrison, smoking a cigarette, is a hilarious summation of where the Beatles were in 1965—forced to be separated from their wild admirers (who appear like animals in a cage) to preserve life and limb, but also having arrived at cool sophistication. Another irony is that the Beatles were now the new aristocracy in a very class-conscious Britain. They chose the home and gardens of the late Lord Burlington, to whom George Frideric Handel dedicated three operas, as the location for their rock and rolling. During the Chiswick Park shoot, Robert Whitaker made the portraits that Klaus Voormann collaged into the illustration for the landmark 1966 Beatles album *Revolver*.

Whitaker, an Australian artist influenced by Man Ray, Meret Oppenheim, and Salvador Dalí, photographed the Beatles when they toured Australia in 1964. Brian Epstein, the Beatles' manager, liked his photography and invited him to come to England and placed him on retainer. One of his first assignments was to accompany the Beatles during their triumphant second American tour, including the historic Shea Stadium concert in New York. He spent the next two years traveling with them, making especially fine photographs in Japan. He took many photographs behind the scenes, including family portraits, but because his vision tended toward surrealism rather than documentary, his pictures are often manipu-

lated, hand-painted, or made through a fish-eye lens, or the Beatles and their wives and girlfriends are posed in outrageous ways. He developed a close friendship with John Lennon, who valued a photographer who balked at the continual "squeaky-clean" image of the Beatles Epstein was still insisting upon.

The most controversial photograph of the Beatles is the notorious "butcher" picture, shot by Whitaker originally for *Yesterday and Today* (see page 284). It shows the Beatles, dressed in white butcher coats, draped in raw meat, false teeth, and dismembered doll parts. "It was inspired by our boredom and resentment at having to do another photo session and another Beatles thing," Lennon is quoted as saying. "We were sick to death of it. Bob was into Dalí and making surreal pictures." (Much of the history of album cover photography can be seen as musicians being "sick of the same old thing" and the industry desperately holding on to successful marketing strategies.)

Whitaker has said, "All over the world I'd watched people worshipping like idols, like gods, four Beatles. To me they were just stock standard normal people" and he wanted to show they were "made of flesh and blood." The album was released with Whitaker's picture and then barred by Capitol Records. It is now a collector's item. The president of the company issued a letter saying Whitaker's "pop satire" of the Beatles as "flesh and blood" (Whitaker's description) was "subject to misinterpretation" and to avoid any controversy or "undeserved harm to the Beatles' image or reputation" would be withdrawn. The acceptable replacement photograph made by Whitaker had the Beatles in a trunk in an office. Whitaker remarked, "That dumb-ass photo of the Beatles with the trunk in Brian Epstein's office when we were all in Argyll Street . . . It was far more stupid than anything else I could think of. The trunk was to hand in the office,

continued on page 284

RAY AVERY

The genre may be rock, but Ray Avery's years of listening to and loving jazz certainly taught him improvisation. The Ronettes had rhythm even before they started singing. Phil Spector, their producer, wanted a "bad girl" image for them, but even with the beehive hairdos, heavy eyeliner, and tight pants, their sweet smiles belied the PR. Amy Winehouse (see pages 210 and 310) appropriated the style but not the smile, and really understands what being a bad girl means.

Avery owned and ran many jazz record stores, specializing in hard-to-find recordings, and Spector was a regular customer. Avery had been taking photographs since World War II, when his father gave the young pilot an Argus C3 camera as he went off to the Pacific. In 1956 Avery started photographing jazz sessions at Gold Star Recording Studios. Jazz photographers, if one can generalize, are laid-back and don't impose their will. They feel the music through their eyes, and Avery, in his two pictures of the Ronettes, captures exactly what he feels.

TOP: **The Ronettes (left to right: Ronnie Spector, Nedra Talley, Estelle Bennett) and Sonny Bono (far left), Gold Star Studios, Hollywood, California**
1963

BOTTOM: **Phil Spector and the Ronettes (left to right: Nedra Talley, Phil Spector, Estelle Bennett, Ronnie Spector), Gold Star Studios, Hollywood, California**
1963

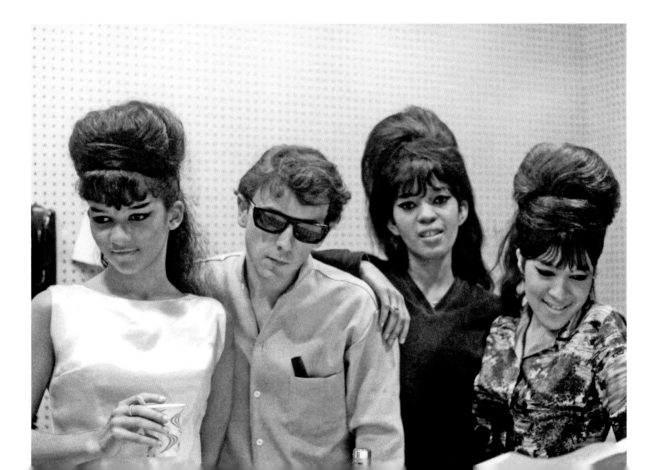

ELLIOTT LANDY

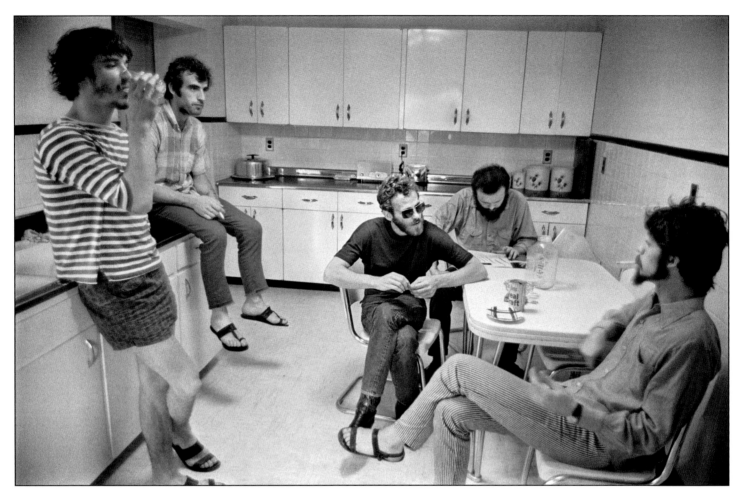

The Band in Rick and Levon's kitchen, Bearsville, New York
Spring 1968

Rick Danko, Richard Manuel, Levon Helm, Garth Hudson, and Robbie Robertson (from left to right) had not taken a name for their band because they didn't want to be "labeled." They wanted attention focused on their music, not themselves. Eventually, they became simply the Band. The photograph is as basic as the kitchen cabinets. It is a perfect visual statement about this group of musicians who are less worried about how

they are seen and more worried about making good music.

Elliott Landy is a fine photojournalist. Even though he is best known for the iconic image of Bob Dylan on the cover of *Nashville Skyline* and the photographs he has taken of the Band, Dylan, and at Fillmore East, he did important work covering civil rights and Vietnam War protests. His music photographs are often made with a photojournalist's eye.

BOB GRUEN

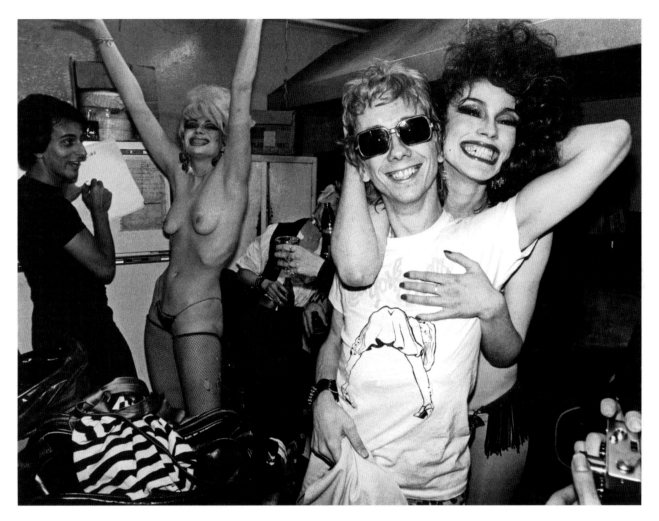

Stiv Bators and the Dead Boys, CBGB, New York City
1978

n the 1960s, living in Ohio, Bob Gruen read *Rock Scene* magazine. In 1969, he came to New York City to live the "rock-and-roll lifestyle." He ended up living with a rock band and becoming chief photographer for the magazine.

Rock Scene magazine stood out because it showed a whole story. We would have a whole page of the band on the bus, the band doing sound check, the band onstage, backstage getting ready, the band with manager—[kids] looked at those pictures to learn how to be in a band and to live a rock-and-

roll lifestyle—have fun in bars. A lot of people told me "I read *Rock Scene* magazine and I left Iowa and came to New York"—or wherever they were. . . . Hard to describe what rock-and-roll lifestyle is other than a hairstyle and an attitude—but it is an attitude of freedom—self-definition—people reinvent themselves. Something happens when a rock-and-roll band is playing and the audience is getting into this intense moment with the heavy driving beat and it's kind of like anarchy and people do whatever they want. For me, this is what rock and roll is all about—personal freedom. It is what the Statue of Liberty is about; it is about

continued on page 284

JUSTIN BORUCKI

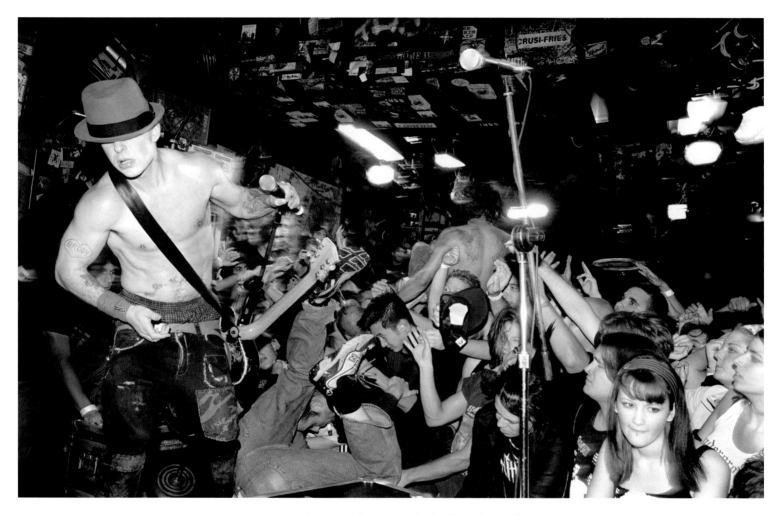

Tim Armstrong of Rancid, CBGB, New York City
2003

A band that gives itself a name meaning offensive or disagreeable must be punk, as "punk" is synonymous with just those endearing qualities.

Look at the beauty of the blurred faces behind Tim Armstrong's mic stand. The upside-down young man's legs form a perfect triangle framing an Adonis wedged into the top of the geometric shape. Look at Armstrong's strong right arm—a band member's face is framed by the sensuous curves of the lead singer's muscular torso. Follow the curved fingers—they lead to more wonderful faces in the scrum. This is photography of the highest order—composition, balance, content—just try doing this in a studio.

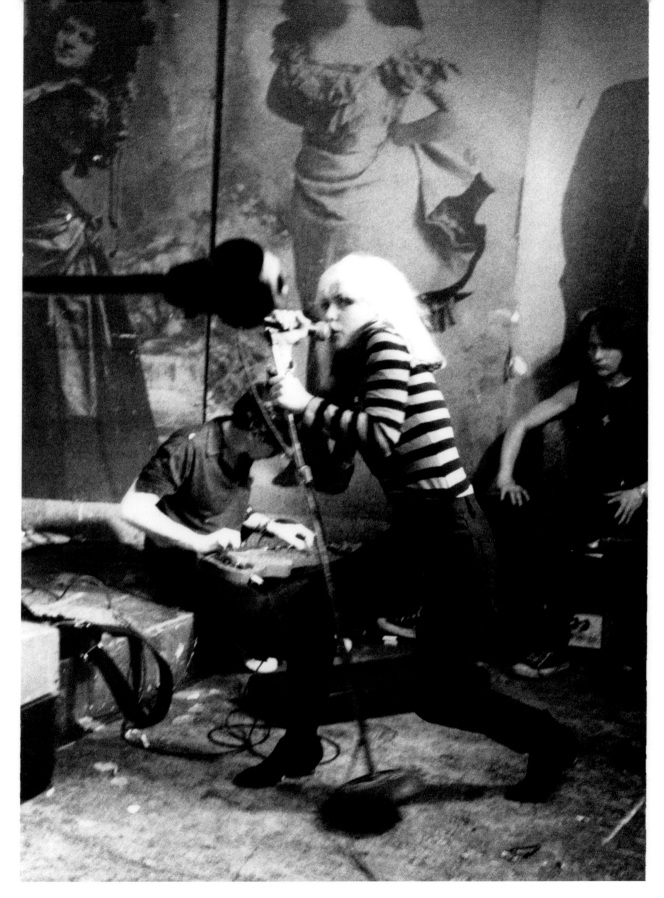

Blondie (left to right: Chris Stein and Debbie Harry with roadie Michael Sticca), CBGB, New York City
1977

GODLIS

The first day of classes at the progressive photography school Imageworks in East Cambridge, Massachusetts, Godlis made friends with classmates Nan Goldin and Stanley Greene. Henry Horenstein was their teacher. When Godlis came to New York in 1976, he took over Abbie Hoffman's old apartment on St. Marks Place and studied photography with Garry Winogrand.

Godlis was a young street photographer in New York. He was trained to do photo essays, to get to the heart of a subject while maintaining a personal style and expression. He got a day job and started hanging out at CBGB at night, an easy walk from his apartment. "After a few nights sitting at the bar, I had an epiphany," Godlis grins and recalls. "It occurred to me that this place is really cool and should be photographed. I had been looking at a lot of Brassaï pictures—[from his book] *Paris by Night*. . . . How to make pictures at night? What film, what paper, what exposure? I started to solve the various problems and had to piece a style together. No one knew the club—hardly anyone in New York—and certainly not in Boston. I showed my photographs to [my art-school] friends who were very cutting-edge. The snobbery of artists! They couldn't even comment on it. How did he go [they wondered] from Winogrand and [Lee] Friedlander street photography to just making pictures of 'musicians in a club.' And then they said, 'You are taking pictures of BAD musicians—the next level down.' It wasn't like taking a good musician like Miles Davis."

Fortunately, Godlis wasn't intimidated. His subject was going to be CBGB as a place and the people there. Gradually, it expanded to the larger downtown music scene. He didn't forget about Brassaï, Friedlander, or Wino-grand. He worked in a tradition of excellence, and his pictures are brilliant documents of the time, place, and people. Godlis's New York at night owes a huge debt to Brassaï's Paris at night.

If it wasn't for Godlis's photographs—and those of Janette Beckman, Stephanie Chernikowski, Anton Perich, Chris Stein, Danny Fields, George DuBose, Ebet Roberts, Bob Gruen, Roberta Bayley, Jenny Lens, Marcia Resnick, and a few others—punk would be remembered by the sensational press photos of spike-haired kids shot from below and in extreme attitudes and outfits. Godlis gave the period its humanity; the media made it into a circus. Godlis gave himself three years—1976 to 1979—to record an epoch. "While I was having a conversation with the musicians, I would take their pictures. . . . I was never a rock photographer. I photographed a scene," he said in 2007.

There were often four bands a night at CBGB, each playing two sets, and everyone would pour onto the street to get some air and cool down. Godlis was still a street photographer. He perfected his technique, his vision, and his printing. Pushing Tri-X with the Leica 3F he bought by selling his car, he shot at an aperture of 5.6 at a shutter speed of ¼ second, no flash. He developed his negatives in a stronger-than-normal solution of Acufine, and when he had enough negatives he liked, he printed them on Agfa paper in the darkroom he set up at his parents' Long Island home. "Once I hit it [film, exposure, developer, paper] I mined the subject," says Godlis.

Godlis's photographs are lyrical. He sculpts his subjects with light. His pictures are revelations. In every Godlis picture, the viewer sees—senses—something vital about the subject.

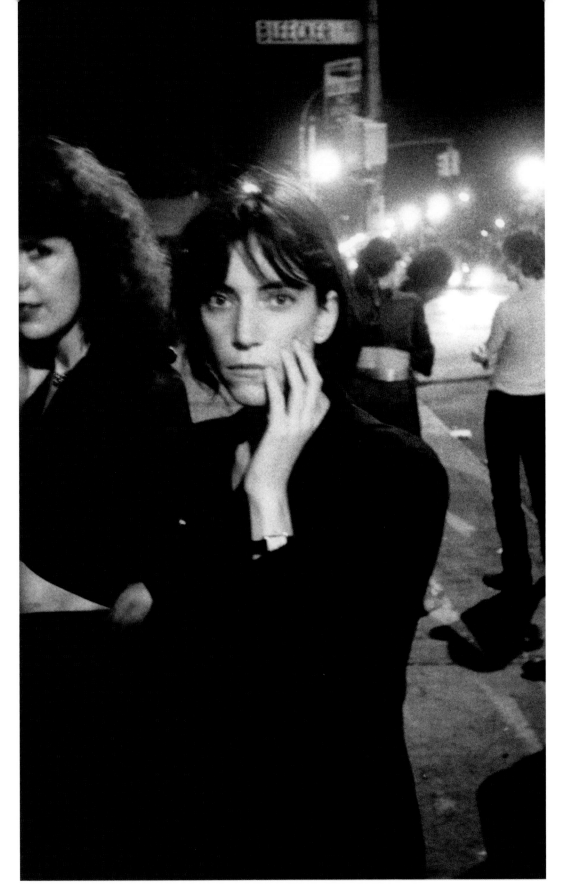

Patti Smith outside CBGB, Bowery and Bleecker Street, New York City
1976

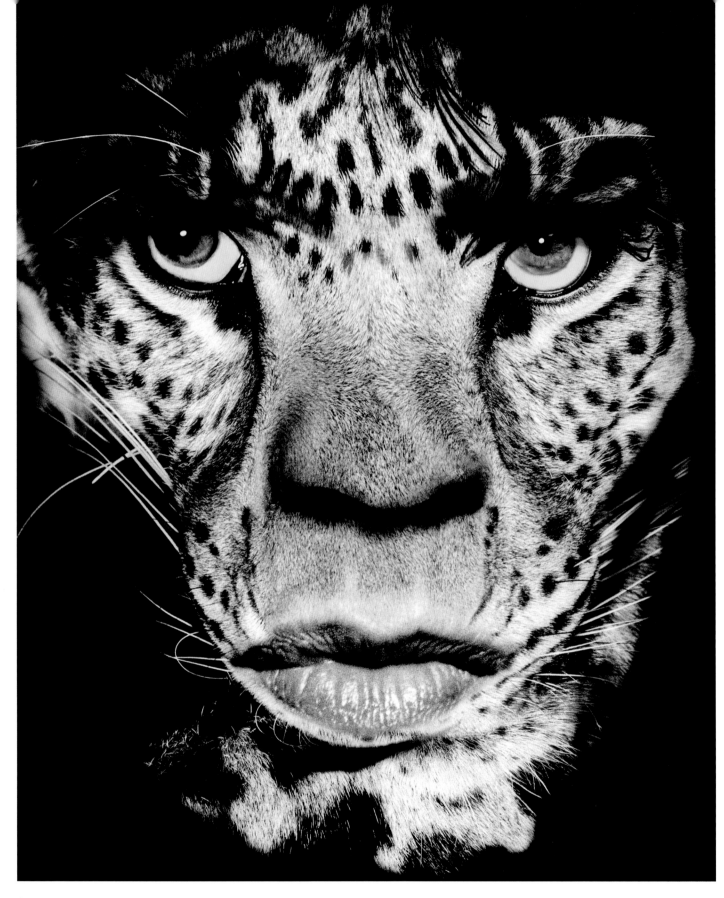

Mick Jagger, Los Angeles, California

1992

ALBERT WATSON

Very occasionally, in the history of photography, someone comes along whose technique and imagination are so unparalleled he or she creates a unique universe of imagery. Erwin Blumenfeld in the 1940s and 1950s was one such photographer who, with complexity and assertiveness, straddled the art and commercial worlds; Albert Watson is his photographic heir. Their work never appears as a mere commodity in the marketplace even though they both were/are fabulously commercially successful. Their photography is marked with experimentation, the ability to turn ideas into images that linger in the mind's eye, that unsettle, that amuse, that startle, that reach into the deep recesses of the subconscious.

In a copycat world that accepts shortcuts and 90 percent, each and every Watson picture achieves that 100 percent called *perfection*. But perfection itself is hollow; it needs to be filled with intelligence and vision. No Watson picture looks like anything that has been seen before, and no one trying to copy a Watson ever succeeds. No one has the mastery.

Blumenfeld told his colleague, the photographer Cecil Beaton, that Beaton's work was always and only ever half completed. This was because Beaton, like most commer-cial photographers, took the picture and had someone else make the print. Watson, like Blumenfeld before him, loves the darkroom and understands its black magic and its potential for transfiguration of the image. It is here that Blumenfeld and Watson breathe life into their negatives.

The Mick Jagger photograph was taken for the twenty-fifth-anniversary issue of *Rolling Stone* magazine. In an e-mail to the author, Watson relates how Jagger and the leopard became one: "The original idea for the shooting was to have Mick Jagger driving a Corvette, with the leopard in the passenger seat. The big cat, a wild animal, seemed to suit Jagger, who likes to jump around a lot onstage, of course. However, putting the leopard in the car with him ended up being so dangerous that we had to build a partition. So, while we were waiting, I thought, 'Let me try a quick double exposure with the leopard.' I shot the leopard first and drew its eyes and nose on the viewfinder of the camera. Then I rewound the film and photographed Jagger, fitting his eyes and nose over the eyes and nose of the leopard on the viewfinder so they matched. I didn't think it would work, and I almost threw out the film. But of the twelve shots, four of them matched, and this was the best of the four that worked." Masterly!

ART KANE

Art Kane, born Arthur Kanofsky, of Russian Jewish immigrants in the Bronx, was one of a handful of photographers who, from the late 1950s onward, made fashion and music photography fun. His imagination was the territory he found most intoxicating, and he rarely saw a musician straight on—except, of course, in his 1958 picture titled "A Great Day in Harlem" of fifty-seven famous jazz musicians gathered together on a stoop one summer morning. Normally, his musicians are strange creatures, not quite of this world, who magically produce a sound or a song that transports the listener to another realm. But they reach this visual paradise (or paradox) not by accident but by careful design. Pete Townshend remembers a Kane photo session: "He told us [the Who], go there, do this, do that, be asleep, put your head on his shoulder. . . . We like that kind of direction." And the former art director–turned-photographer was good at directing. Kane said of music photography, "Performance shots are a waste of time, they look like everyone else's. If you want to shoot a performer, then grab them, own them, you have to own people, then twist them into what you want to say about them." Kane was always more interested in making a unique image than in finding what was unique in his subject. Only Art Kane would arrange the tough-looking Mothers of Invention with sixteen naked peeing babies (shot for *LIFE* magazine, but they wouldn't publish it). Some of his photographs prefigured punk imagery—Keith Richards using a photograph of Queen Elizabeth II to clean his teeth and Brian Jones biting Her Majesty (photographed for *McCall's* magazine, but they wouldn't publish it either).

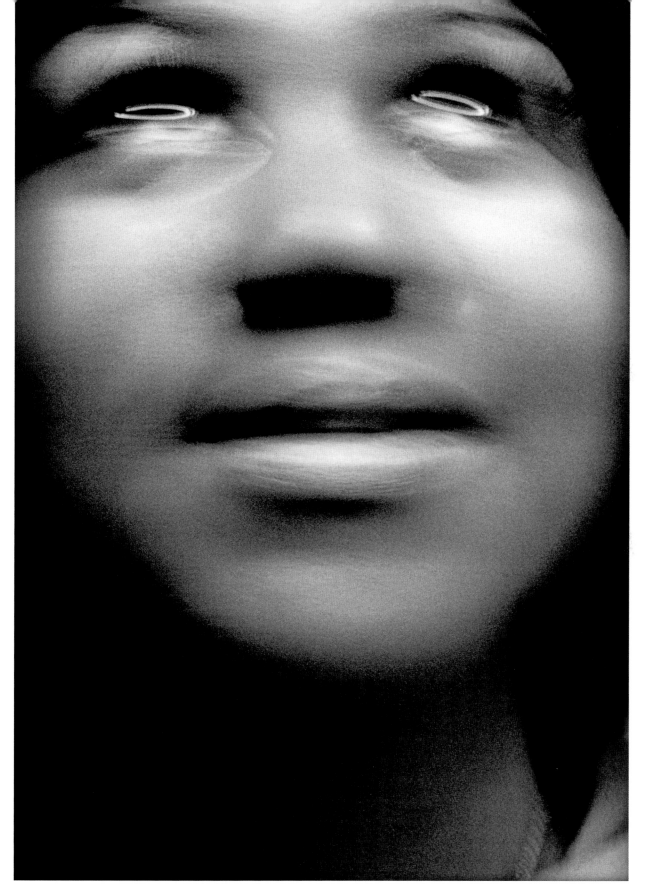

"Halos," Aretha Franklin, Carnegie Hall Studio, New York City
1967

The Who, Morningside Park, New York City
1968

"Brian Jones and the Queen," London
1966

CHRIS STEIN

Richard Hell and Debbie Harry, Seventeenth Street, New York City.
Photograph by Chris Stein, with graphics by John Holmstrom, "The Legend of Nick Detroit"
PUNK magazine, no. 6 (October 1976)

ustave Courbet in his "Realist Manifesto" declared his aim "to be in a position to translate the customs, the ideas, the appearance of my epoch, according to my own estimation. . . . When I am no longer controversial, I will no longer be important." If he had lived in the late 1970s instead of dying in the late 1870s, he probably would have played in a rock-and-roll band. It wouldn't have stopped him from painting.

Chris Stein, a founding member of Blondie, is a photographer as well as a musician. When he tours, he takes

pictures. But not snapshots. He is trying to make sense of what he visually and viscerally experiences—the colors, the shapes, the historical imperative of place. Lenin's tomb in grays and pinks; the Arizona desert with garbage and a sign reading DEAD END pointing to the endless horizon.

Stein hated high school but enjoyed art school, specifically the School of Visual Arts, where he had good photography teachers and freedom to explore. In New York in the 1970s, many musicians went to art schools and many artists went downtown to make music. It was a

Anya Phillips and Debbie Harry, Staten Island ferry, New York City.
Photograph by Chris Stein, with graphics by John Holmstrom, "The Legend of Nick Detroit"
PUNK magazine, no. 6 (October 1976)

time when Yoko Ono, Captain Beefheart, Brian Eno, and Philip Glass could mix it all up, challenge convention, and be "controversial" and "important."

In the 1970s, Jean-Michel Basquiat played in a group called Gray; Barbara Ess, Robert Longo, and Richard Prince were in the band Menthol Wars. The Talking Heads was founded by three Rhode Island School of Design students—David Byrne, Tina Weymouth, and Chris Frantz. The band Destroy All Monsters was Mike Kelley, Jim Shaw, Niagara, and Cary Loren. In 1976, Kelley joined Tony Oursler in founding the band the Poetics.

Kim Gordon started as an artist and critic for *Artforum*. She joined with fellow artist Lee Ranaldo and Thurston Moore in forming a group that later became Sonic Youth. Artists Mike Kelley, Richard Kern, Raymond Pettibon, Gerhard Richter, James Welling, and Marnie Weber have given Sonic Youth a strong aesthetic visual identity.

Chris Stein, one of the world's most notable musicians, made many photographs for the hysterically funny, totally irreverent *PUNK* magazine. Under the masthead "Punk's Punks" he was listed sometimes as a "contributor" and sometimes as "contributing photographer." Roberta

continued on page 285

JUSTIN BORUCKI

S.T.U.N. (Bobby Alt, seated; Christiane J.'s feet), CBGB, New York City
2003

Richard Hell, musician/poet/novelist, was in Television, the first band that drew attention to CBGB—"the dump," as he affectionately calls it. He knew the place well:

Naturally, the graffiti in CBGB also has a lot in common with the style of music that made the club famous. It's not about an intellectual argument, it's not about opinions, it's about a condition, about being young and hungry, about energy, anger, and sex; pure formless assertion. . . . It's horrible, but beautifully horrible. . . . It's about ennui and inertia and their perfect realization in violence and sex. It's so good-looking it hurts.

—RICHARD HELL, "CBGB AS A PHYSICAL SPACE," IN *SYMPATHY FOR THE DEVIL: ART AND ROCK AND ROLL SINCE 1967*, BY DOMINIC MOLON

Justin Borucki's stunning photograph of S.T.U.N., Bobby Alt seated, Christiane J. at his feet, was taken twenty-nine years after Hell's band Television first played at CBGB, which is no more. Some of the graffiti exists in John Varvatos's store on the Bowery and in the Rock and Roll Hall of Fame Annex in New York City.

GERED MANKOWITZ

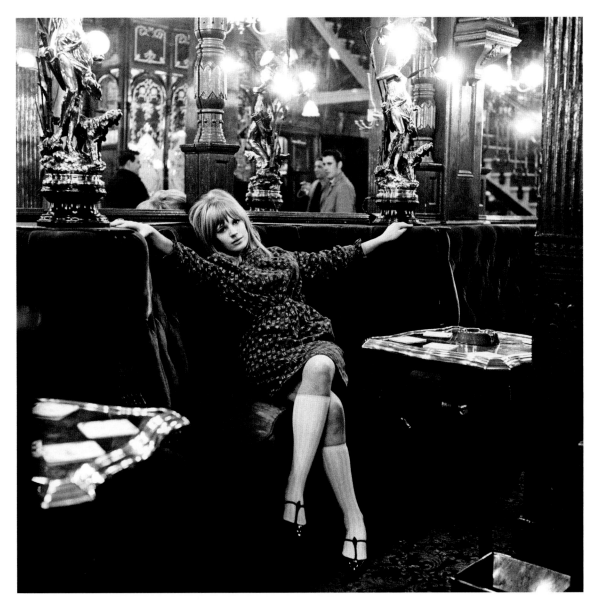

Marianne Faithfull, Salisbury Pub, St. Martin's Lane, London
1964

The eighteen-year-old photographer Gered Mankowitz was a friend of the eighteen-year-old singer Marianne Faithfull. She had already had a big hit with "As Tears Go By," which was written by her manager, Andrew Loog Oldham, and Mick Jagger and Keith Richards.

Mankowitz was asked to shoot a photograph for Faithfull's first Decca album cover. The photograph of Faithfull in the richly furnished London pub was too hot for Decca to handle—not because of the schoolgirl knee socks or the come-on look on her angelic face, but because two older men at the bar could possibly be perceived as

continued on page 285

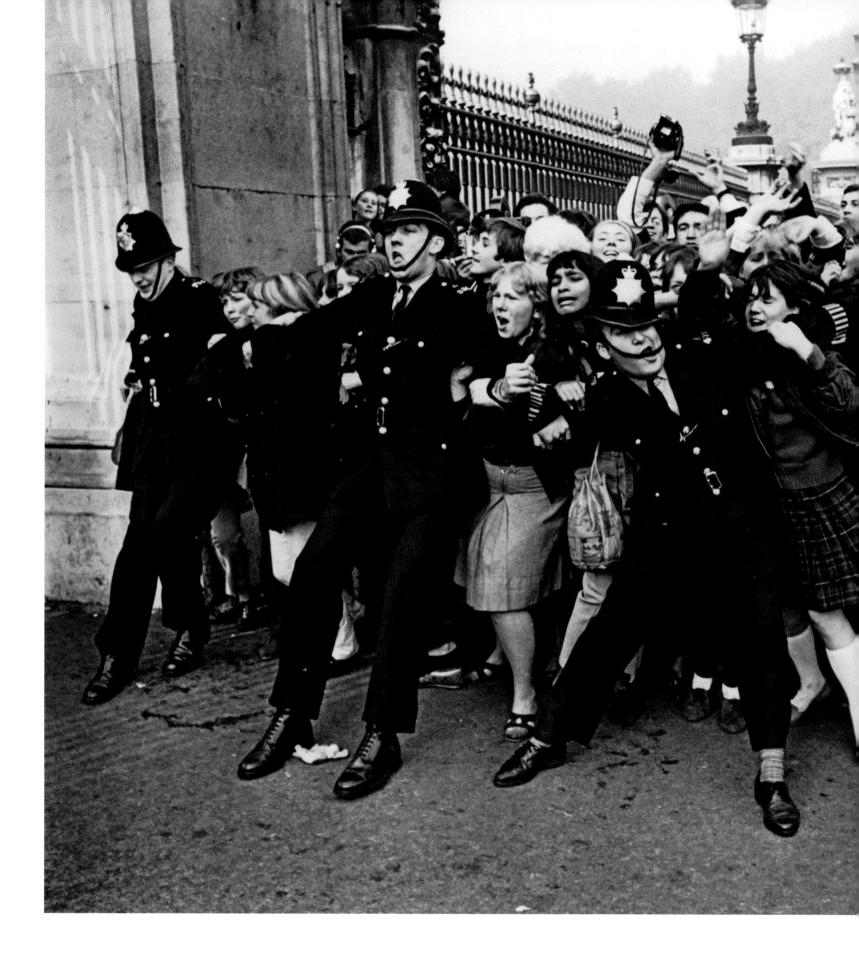

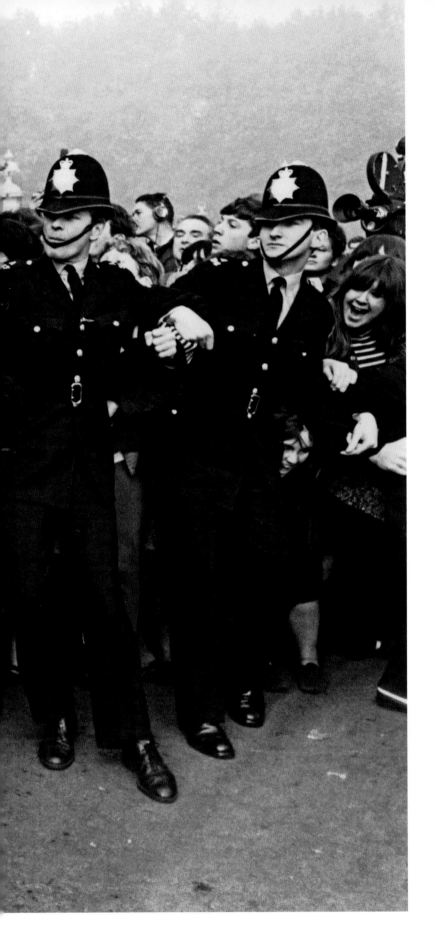

CENTRAL PRESS LTD.

The girls look like they are about fourteen years old but a formidable match for the London constabulary. The troublemaker on the far right is just about to break through the British bobbies' line of defense by sneaking under an officer's arm. Chaos! Pandemonium! The Beatles are at Buckingham Palace to become Members of the Most Excellent Order of the British Empire (MBEs) and, although it sounds more like a nursery rhyme, this event marks a huge cultural and societal shift. A new Great Britain. The sun will never set on the British Empire as long as people everywhere can listen to the Mersey beat.

This photograph epitomizes why parents were so frightened of rock and roll. The music made their kids uncontrollable. Young people were going to break down the barriers one way or another, and this photograph—humorous in its depiction of authority, gender, and age—is one of the great documentary photographs of the twentieth century.

Fans outside Buckingham Palace on the day the Beatles receive their MBEs from the queen, London (probably taken by Ted West or Roger Jackson working for Central Press)
October 26, 1965

LAURA LEVINE

Laura Levine met Björk the night before this picture was made. She had gone to Woodstock to be with her friends the Darling Buds, who were sharing a recording studio with the Sugarcubes, Björk's band. When Björk overheard Levine was going to shoot pool with her friends at a local bar, she asked if she could come along. Levine, a professional music photographer, relates what followed:

I took snapshots that night. Björk and I spoke for hours and hours, and at some point that night I told her "I would love to take your picture." She explained that she was leaving the next day, but would be happy to do it before she left. . . . I started to tell her my experience as a photographer so she would know I wasn't just a fan with a camera and she stopped me and told me she didn't need to know. She liked me, she trusted me, and that was enough.

The next morning I picked her up and we went to my friend Ben's house, who helped out as my assistant for the shoot. We did this in his backyard, which has a lovely forest glade. A lot of times I have taken pictures of people and they have ended up taking off their clothes. It was always their idea. I would never push anyone to do it. The setting really evoked Eve in the Garden of Eden and at some point she began to shed her clothes, and we picked out some oversized leaves. Just then it started to rain and she caught a raindrop with her tongue. It was one of those moments. It is so corny to say someone is like a sprite or a free spirit but she is. She is this totally open person. . . . She is just so special. And that is the best kind of photo shoot you can do, when there is a collaboration and you are both excited about creating something and they're giving, you're giving, it was great.

This is Levine's favorite photograph from a long career in music photography. Why? "No makeup artists, no stylists, no trendy fashions, no managers, no publicists, no record label politics, no artificial lighting, no gimmicks, no self-consciousness. Just natural light, some foliage, and Björk."

Björk, Woodstock, New York
1991

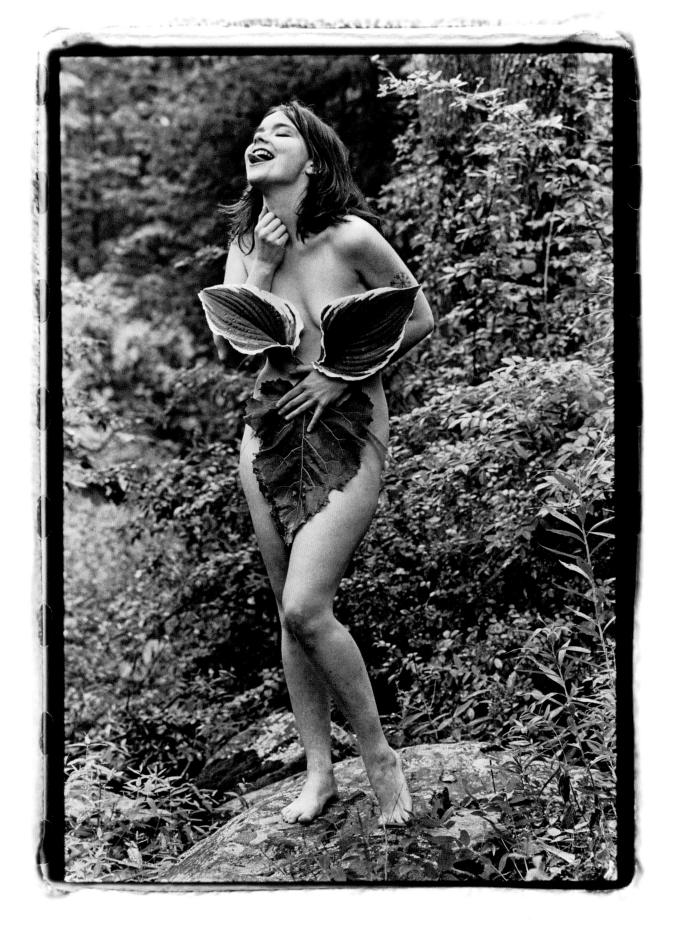

GUY WEBSTER

The photograph of the Mamas and the Papas— Cass Elliot, Denny Doherty, John Phillips, and Michelle Phillips—in the pool at the Phillipses Bel Air home, drinking from a hat, epitomized, for Guy Webster, a time when "we loved one another."

Webster made the photographs for the album covers of Barry McGuire's *Eve of Destruction*, the Rolling Stones' *Big Hits* (*High Tide and Green Grass*), Simon and Garfunkel's *Sounds of Silence*, the Hollies' *Stop! Stop! Stop!*, The Byrds' *Turn! Turn! Turn!*, and many more, for some of these groups as well as for the Doors, Captain Beefheart, the Incredible String Band, Carole King, the Beach Boys, Taj Mahal, Procol Harum, and Paul Revere & the Raiders, to give a partial list. "We were all friends," said Webster. "It was a small group."

Individually, the photographs vary from fabulous to prosaic, but together they are part of the collective conscious of an entire generation. The look of a Webster photograph is the look of the period; he took the photograph of the gorgeous, seemingly naked blonde in a pool of water with flowers surrounding her that was the centerpiece of the brochure for the Monterey Pop Festival of 1967. He identified and isolated a look and an attitude, and then millions copied it. His photographic record of the sixties is as descriptive, in its own way, as Kerouac's is of the fifties. The kids (musicians) in his photographs are generally doing some silly things—but there is a vital difference between the controlled, formulaic "silly things" asked of musicians by the studios. In a Webster photograph, the musicians and the photographer are on a high—literally and figuratively—as they work together.

The photograph taken for the Mamas and the Papas' album *If You Can Believe Your Eyes and Ears* (see page 285) was one of Webster's first album covers and probably his most "scandalous." As Webster says, "We didn't know we couldn't show a toilet." Sears, JCPenney, and other stores refused to sell it. Webster tells the story: "The Mamas and [the] Papas needed a photograph for a new album. Musicians and photographer were stoned out of our minds. We got as far as the bathroom when they [the Mamas and the Papas] decided they had gone far enough (under the conditions) and the group got into the bathtub for their photo. Did it make any sense? No. Did lots of things we did when we were young make any sense? No."

To solve the merchandising problem, "We pasted a little sticker on the shrink-wrap [over the toilet] that said INCLUDING CALIFORNIA DREAMING so it could be sold. When the kids took it home and took off the wrapper, there was the toilet, so we got away with a lot of stuff." Even today, the compact disc carries Webster's photograph, but the toilet is obscured by a sign that reads INCLUDES "CALIFORNIA DREAMING," "MONDAY, MONDAY," "I CALL YOUR NAME."

In an interview, Webster said:

> We were all innocent in the very beginning. I was one of the first in this business. No corporate master telling us what we could do or not do. I got disenchanted with it after the managers took over and dictated what was going to be on the cover and creative freedom was pretty much gone. You had so little say. In the first ten years of rock and roll I had complete control over the images and the covers. I loved that. I could design the covers and do everything myself.
>
> I got into it through a fluke with two friends of mine, Lou Adler and Terry Melcher, record producers. I was working with them. One of the records I shot with them for Columbia was the Byrds' *Turn! Turn! Turn!* Got a lot of work with Columbia over the years. I had no idea about the power of what we were creating until I did a poster of the Byrds. Kind

continued on page 285

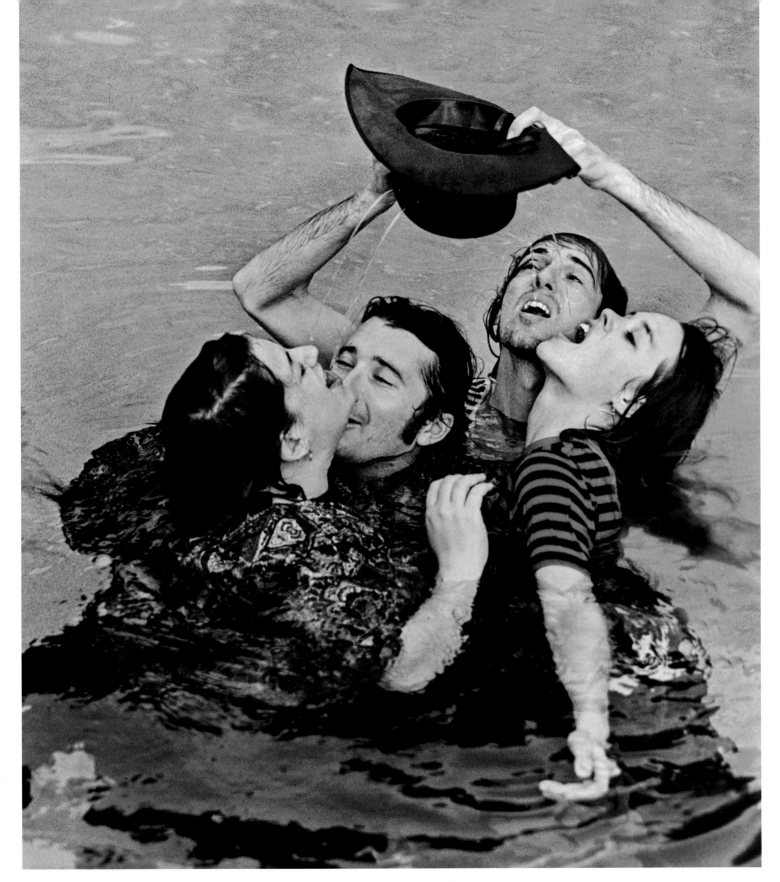

**"Deliver," The Mamas and the Papas at the home of John and Michelle Phillips
(left to right: Cass Elliot, Denny Doherty, John Phillips, and Michelle Phillips), Bel Air, California**
1966

ANDY EARL

Andy Earl has shot more than seventy album covers—including covers for Madonna, Prince, Elton John, Annie Lennox, Sting, Pink Floyd, the Rolling Stones, and Spandau Ballet. Stars come to him to help mold an image. He does a lot of work for Apple and Canon. But scratch the surface and you will discover the art-school kid determined to find his own vision. He studied with Paul Hill and Tom Cooper at Trent Poly-technic in Nottingham, England, and with Ralph Gibson in the United States. His hero then was William Eggle-ston. His hero now is Philip-Lorca diCorcia. He likes to find locations and then create entirely new realities. He wants to see in his pictures what can't be seen anywhere else. He is the consummate professional; he is the strug-gling artist asking all the hard questions.

At twenty-four years old, Earl represented Britain at the 1979 Venice Biennale. The previous year he had exhibited his inventive student color work at the Photog-raphers' Gallery, London, where the impresario Malcolm McLaren, who had birthed the Sex Pistols, saw his blurred and haunting color photographs. McLaren wanted something striking and shocking for a new album cover for his group Bow Wow Wow. He settled on a reen-visioning of Manet's *Déjeuner sur l'herbe*. Earl scouted locations and found a spot in Surrey without a "council estate." The male musicians, beautifully costumed by Vivienne Westwood, were delicately arranged, with the naked fourteen-year-old lead singer, Annabella Lwin, tastefully positioned. To McLaren's delight, the picture immediately became controversial. The underage rock star did not have her mother's permission to pose naked. A typical British scuffle ensued in the press, and there were lawsuits. Lwin was whisked away by her family to the windswept moors of Devon, yet, lo and behold, there was the clandestine release of some of the pictures to *The Face*. RCA's threatening to sue McLaren helped McLaren get more publicity than he could have paid for. Eventu-ally, the mother relented, the photograph was used by the record company after a hefty fee was paid to Earl (with which he bought his first cameras), and this beautiful pic-ture has gone down in music history. It is also worthy of a place in photographic history: the lighting is delicate, the composition refined, and the young woman signifies Thomas Fuller's seventeenth-century dictate: "Craft must have clothes, but truth loves to go naked."

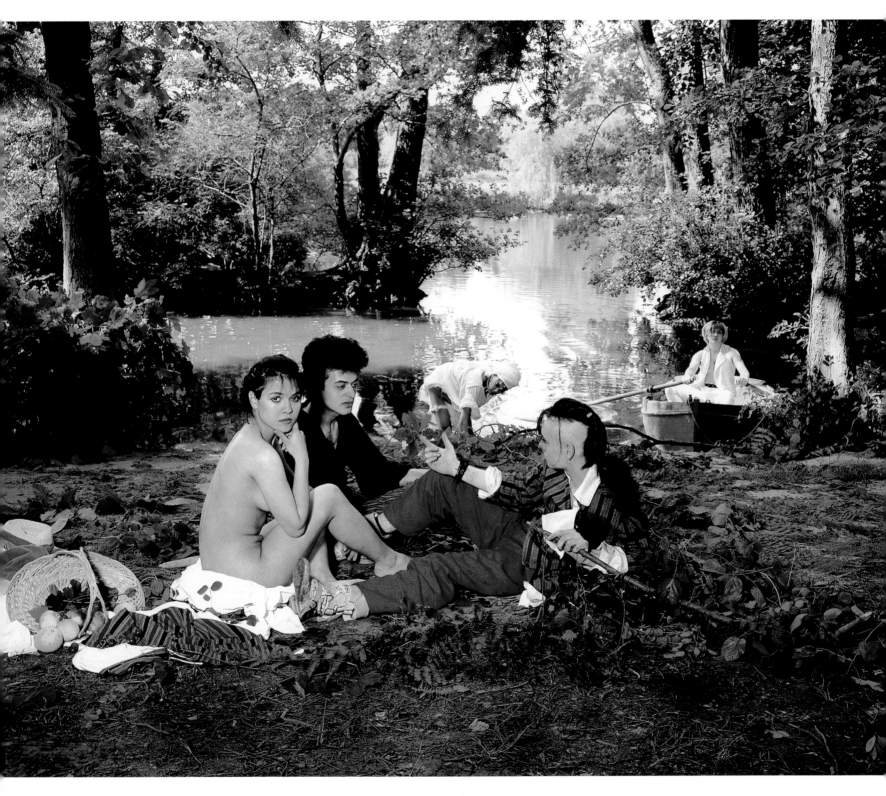

Bow Wow Wow

1981

MICHAEL PUTLAND

t breaks my heart," lamented Michael Putland when asked about music and celebrity photography. "A five-year-old can get a camera and shoot on the red carpet." And that five-year-old's picture, continued Putland, could be worth as much or more than a fine photograph taken by a longtime professional. "There is no premium for quality. I love photography, not the nonsense." And the nonsense—like paparazzi shots of Britney Spears—is demeaning to the musicians, the photographers, and the public.

Putland has been photographing seriously since the age of sixteen. Tenderly he speaks about the warm tones of the old Agfa paper and time spent happily in the darkroom. He loves going through transparencies with a loupe to find both the marketable and the memorable pictures, often turning a color image into black and white because it better conveys character and soul. Putland is one of the photographers frequently mentioned—and

admired—by his peers. He has been closely associated with the Rolling Stones, Queen, David Bowie, Duran Duran, George Michael, the Bee Gees, Billy Joel, and the first Live Aid concert. He has worked for CBS, Warner, Elektra, Atlantic, Polydor, RCA, and EMI. He founded the picture agency Retna.

Putland is a survivor, not only because he steered away from the rock-and-roll lifestyle, even on tour with the Rolling Stones, but because he is discreet. He never crossed the line between priority and impropriety, all the while taking the sexiest pictures of Jagger onstage ever (no one will ever be able to look at a microphone innocently again). Because he was the "official" photographer on the Rolling Stones' U.S. and European tours, he was not thrown out of the pit when the other photographers were removed. He captured the Stones sweaty, sexy, and sleepy, and his book *Pleased to Meet You* is a gem.

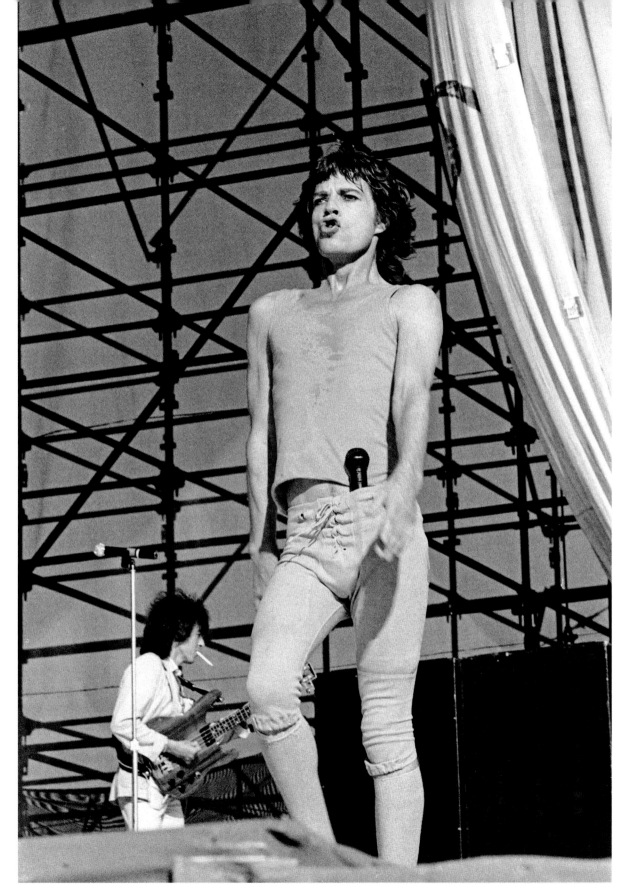

Mick Jagger, Philadelphia, Pennsylvania
1982

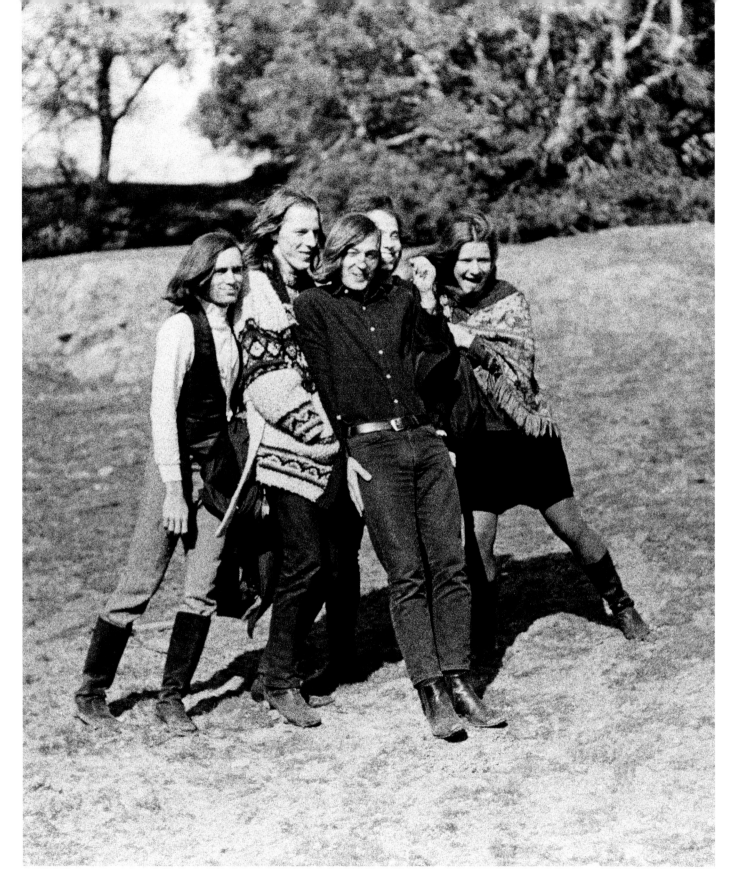

**Big Brother and the Holding Company (left to right: Peter Albin, James Gurley,
Sam Andrew, David Getz, and Janis Joplin), Woodacre, California**
1967

LISA LAW

isa Law knows everyone. In 1965–66 she rented rooms in her Los Angeles home, the Castle, which she co-owned with her husband, Tom, and her brother-in-law John Phillip Law, to the Velvet Underground, Bob Dylan, Tim Hardin, Barry McGuire, the Mamas and the Papas, Tiny Tim, Allen Ginsberg, Andy Warhol, David Crosby, and many others. It was the place to hang out. Then she and Tom moved to San Francisco during the Summer of Love and met most of the musicians living in and around Haight-Ashbury. Pregnant, she went with Wavy Gravy and the Hog Farmers, the "security force," to Woodstock in 1969, where she shopped for the food that would be prepared and served, including the hundreds of pounds of ingredients for her famous muesli. She was in charge of feeding 200,000 hippies "breakfast in bed." She epitomizes the spirit of the 1960s and still lives with a teepee and a psychedelic painted van in her backyard. A flower child that has never wilted, Law insists on keeping the best ideals of the sixties alive. She is founding a museum to *her* decade in Santa Fe.

Law photographed her friend Janis Joplin and Big Brother and the Holding Company in Woodacre, Marin County, California, early in 1967, before the Monterey Pop Festival turned them into a sensation. This photograph, so playful, happy, and young, was taken, as Law says, when they were just "screwing around"—in fields, on tractors, in a barn.

BOB SEIDEMANN

She is filled with awe and wonder and hope. She is innocent. Blind faith. A Pre-Raphaelite virgin, half undressed, she represents, for the photographer Bob Seidemann, the sixties' search for truth and beauty, and the need for new beginnings. The shiny spaceship "symbolizes human creativity and its expression through technology," according to Seidemann, who both conceptualized and photographed the album cover. It was 1969 and men were going to the moon. It was 1969 and many of the hopes and dreams of the sixties had gone up in flames and down in needless deaths.

Eric Clapton, Ginger Baker, Steve Winwood, and Ric Grech were collaborating on a new album. It has been said that the name came out of Eric Clapton's "blind faith" in the future of this group of artists working together. When their manager, Robert Stigwood, called Seidemann, a friend of Clapton's, to ask him to do the album cover, the group was still unnamed.

Seidemann knew he had a stab at immortality if he could create an image that perfectly evoked a rock-and-roll optimism after the wasted lives and lost promises of the sixties. Weeks went by as he floundered. He had an idea for "technology and innocence." He had a friend, Mick Milligan, a jeweler at the Royal College of Art, who could make the spaceship; finding "innocence" was harder. Seidemann wanted a girl, not too old because it would be "cheesecake," not too young because it would be "nothing." He said she had to be at "the transition from girl to woman . . . that temporal point, that singular flare of radiant innocence."

He found the girl—sort of—on the London Underground. As soon as he saw the young woman he told her quickly he was making a cover for a new Eric Clapton album. She inquired if she had to take her clothes off. "Yes" was his answer. Before she jumped off at her stop, he gave her his contact information.

Her parents, quite sophisticated and liberally minded, called him. Seidemann's pubescent model was not the girl on the Underground but her younger sister. He described her as "Botticelli's angel, the picture of innocence, a face which in a brief time could launch a thousand spaceships."

Seven hundred thousand albums were printed and quickly sold out. Eric Clapton had had to fight the industry bosses to allow Seidemann's composite photograph made from two transparencies to be used, threatening to stop the production if the picture didn't appear. The image would identify the group—no words necessary—on the front or the back (but the record company did insist on shrink-wrapping that gave the title). Asked in 2009 about using only the Dorset landscape on the back cover, Seidemann said it was some "existential twist" in his brain. On the back, the girl had disappeared, and only the land and sky remain. It is a powerful metaphor.

The album cover was controversial—the girl too naked, the spaceship too phallic. In the United Kingdom, it could be folded and placed in the racks so no breasts could be seen. The second print run was a capitulation to the nervous record company and record stores: Seidemann's innocuous group portrait shot at three a.m. in Clapton's flat and originally used for a handbill, replaced the image that "was created out of hope and a wish for a new beginning . . . innocence propelled by BLIND FAITH."

In a vault in L.A., Seidemann has the fifty 8 × 10 Ektachromes he shot of the eleven-year-old girl in the studio and of the gentle rolling hills of the Hardyesque

continued on page 285

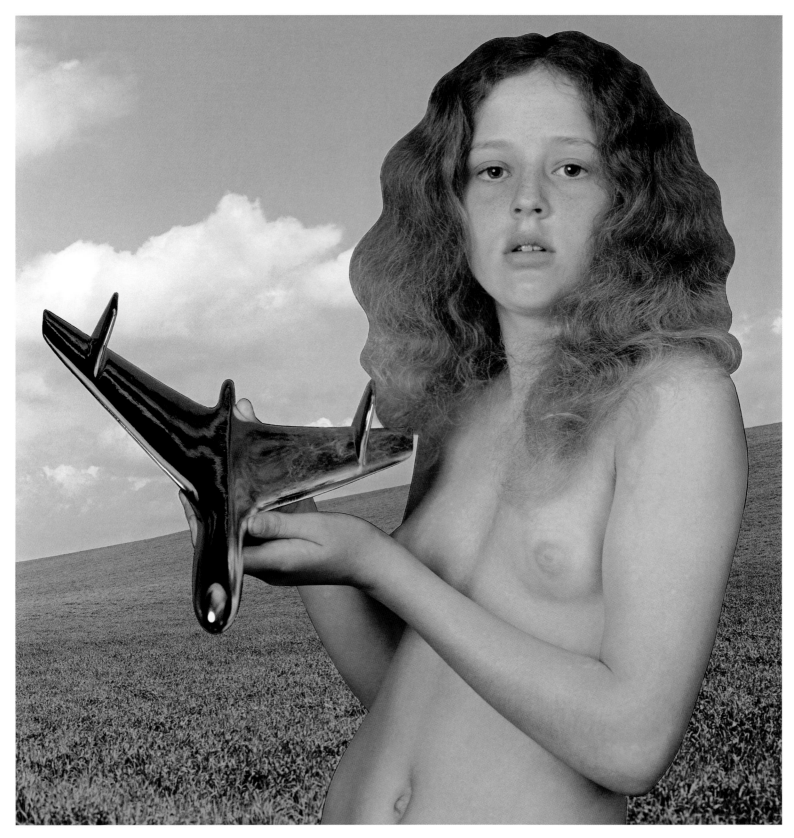

Blind Faith**, **London and Dorset, England
Spring 1969

MARK SELIGER

The beauty of the shot is that it feels like the real photo session was yet to start or had just finished. Not looking at the camera, not posing, not performing, makes the portrait of these hip-hop giants just sitting there next to each other texting, focused on their toys, especially tender. They look like they could *almost* be just two friends hanging out.

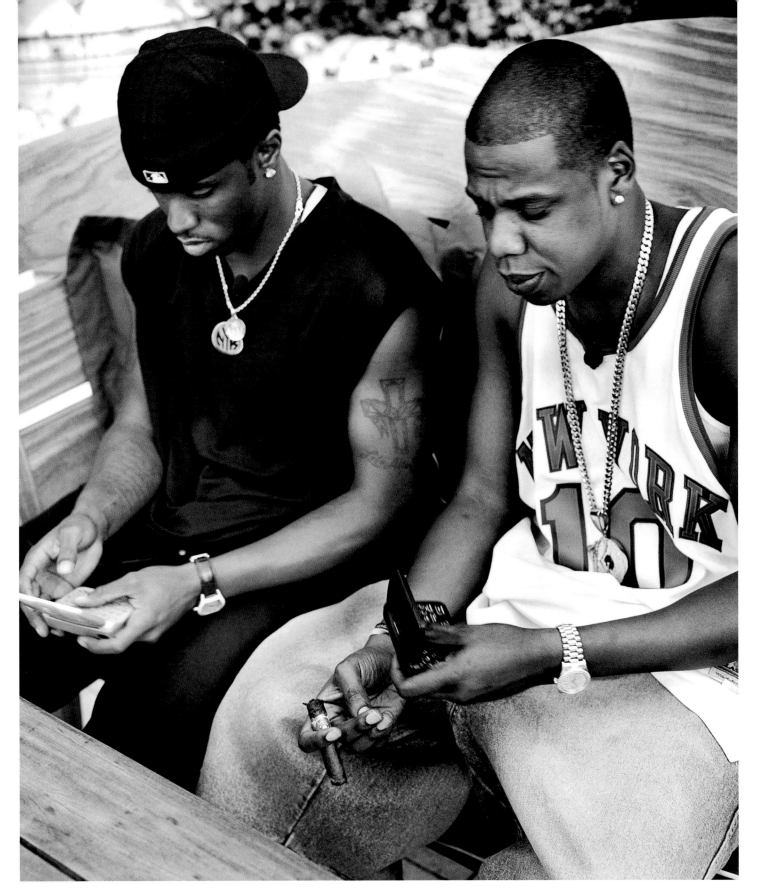

Puff Daddy and Jay-Z, New York City
February 9, 2001

TERRY O'NEILL

I think when you concentrate you can have a relationship with the camera. . . . I don't think good photographs are taken if you're not working. . . . I really feel you can't be passive. . . . If someone says "OK, in a week's time we're going to do a photo-session," then I'll prepare myself. I'm not quite sure how I do that but I do it mentally. . . . When the camera's there you say OK this is what you're going to focus on, not, "take me I'm all yours." I don't want the camera seeing everything. I'm only interested in the camera seeing what I want the camera to see.

There is something about the person behind the camera that gives you the confidence to work, a desire to work. If you don't like the photographer for some reason, it's a chemical response, then it's very hard to work for them, in fact I don't. Not these days.

—STING, QUOTED IN *THE MOMENT:*
25 YEARS OF ROCK PHOTOGRAPHY,
BY JILL FURMANOVSKY

Terry O'Neill is a famous British portrait photographer. He has made some of rock and roll's most enduring images: David Bowie with the Great Dane on his hind legs for *Diamond Dogs*; Elton John in his sequined Dodgers "uniform" in front of thousands of fans at Dodger Stadium, Los Angeles; Tom Jones, standing next to his Rolls-Royce, in Pontypridd, Wales, his birthplace; a young Marianne Faithfull in corset, garters, and black silk stockings taking directions from O'Neill to look "sexy" (she succeeds!).

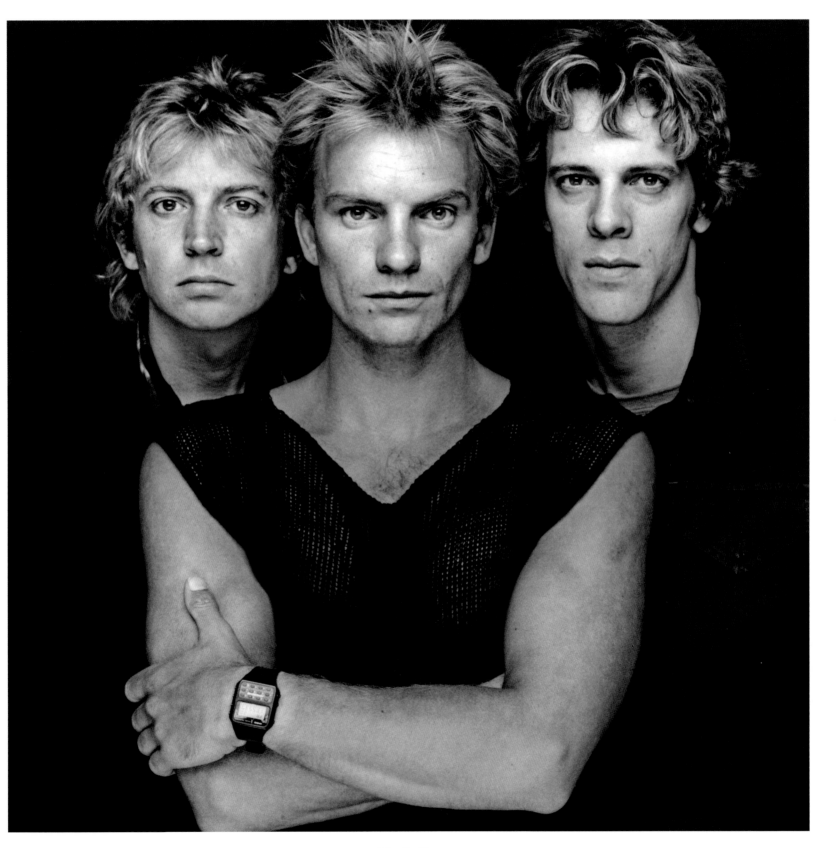

The Police
1982

GLORIA STAVERS

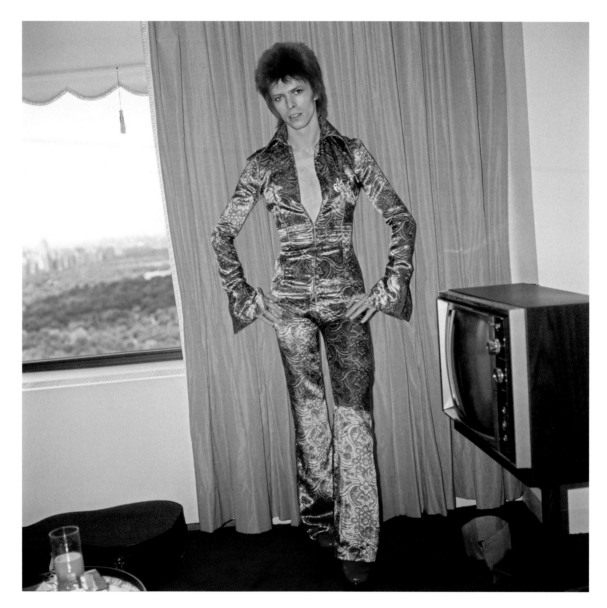

David Bowie
1973

Gloria Stavers, the editor, head writer, and chief photographer of the teen music magazine *16*, read three hundred heartrending letters a day from the girls who bought her magazine. She knew some cried themselves to sleep over their love for a particular Beatle or Monkee. She took adolescent girls' problems—and desires—seriously, giving them male music idols who, with their answers to her "40 Intimate Questions," became real enough to imagine (almost) as boyfriends.

Stavers, a former model, knew about fashion and fame and image, and a little about cameras. When taking

continued on page 286

RICHARD KERN

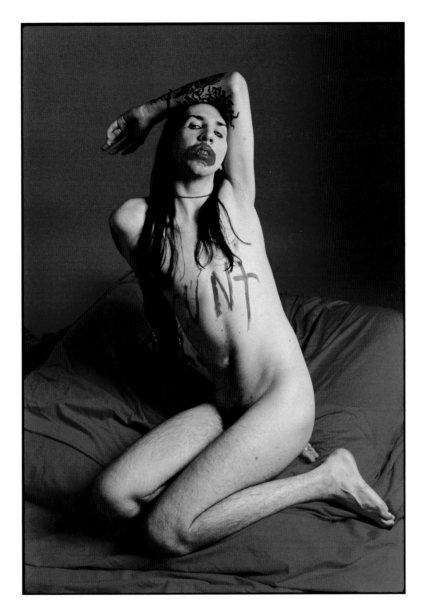

Marilyn Manson, "Lunchbox" shoot, New York City
1995

Richard Kern and Marilyn Manson do their take on the famous nude Marilyn Monroe calendar photograph. Kern said Manson, just starting to get attention, wanted some pictures to sell to a "sex magazine."

An alternate photograph was used for Manson's single "Lunchbox." It comes as no surprise that the record company wanted the word "cunt" excised. Kern also did the music video for the song and, as with all his video work, it is strange and amazing and extreme.

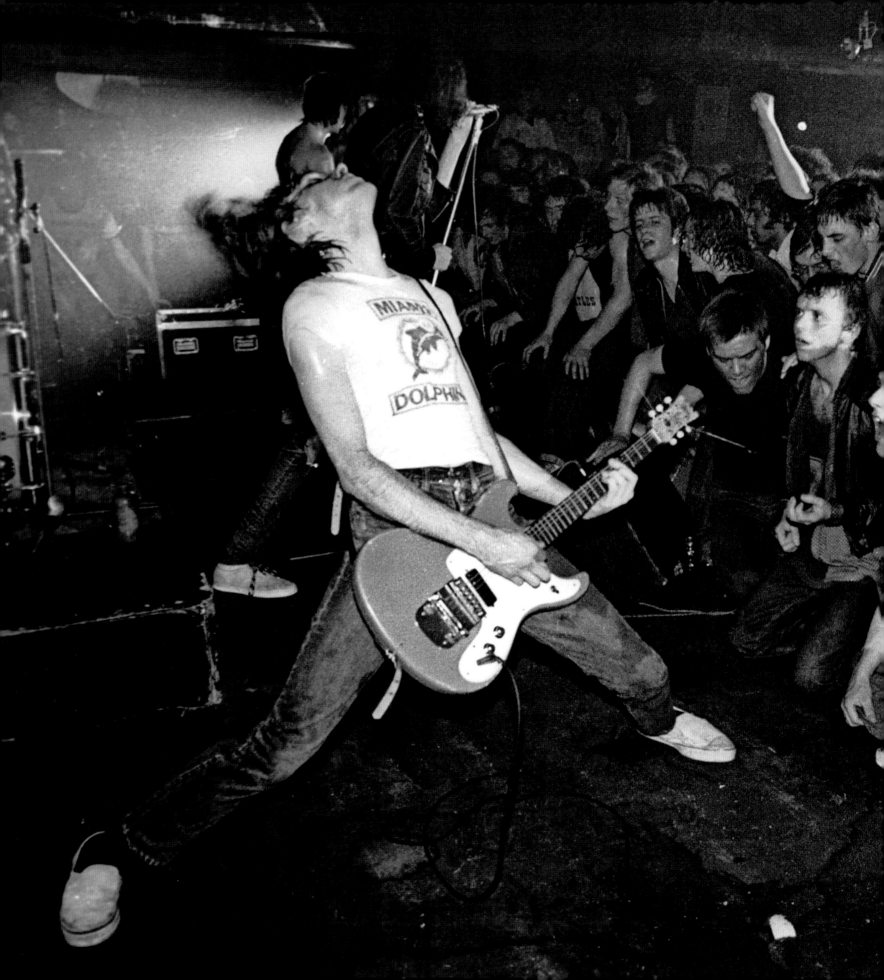

IAN DICKSON

Not far from the famed Cavern Club on Mathew Street in Liverpool, where the Beatles got their start, the Ramones, four boys from Forest Hills, Queens, give Liverpudlians what they want. Touchingly, Ramone, the surname adopted by all four nonrelatives, was in honor of the pseudonym Paul McCartney used in his Silver Beatles days—Paul Ramon. And no one at Eric's Club in 1977, least of all the four guys from Queens, would have believed that in 2002, *Spin* magazine would vote the Ramones the second-greatest rock-and-roll band after the Beatles.

Ian Dickson was positioned perfectly to fuse performers and audience. "I'd get caught up in the stampede down the front. There have been moments when I've been taking photographs with my feet six inches off the floor, honest. The worst thing was the gob. I couldn't wait to get home sometimes, to have a shower. I counted it a blessing if it happened to be raining after I'd left a gig!" remembers Dickson.

"Punk was never glamorous—quite the opposite, in fact," continues Dickson. "Old sweaty clubs and pubs—none of your Wembley bright lights and all that razzamatazz. So black-and-white photography was it." And when you look at Dickson's black-and-white pictures you know the medium is perfect for the grime, the spit, and all the rest of the crud being "dispensed."

The year before this picture of the Ramones was taken, *Sounds* magazine sent Dickson to photograph the Sex Pistols with specific instructions to photograph the audience as well as the performers. They understood, as did Dickson, that punk was visual as well as audible, and that a "concert" was the total package—musicians and audience working toward a frenzy.

The Ramones at Eric's Club, Liverpool, England
May 1977

asked Elton John what he does," remembers Barrie Wentzell. "He said, 'I am just a piano player.' "

Barrie Wentzell was the chief photographer for *Melody Maker,* a leading music magazine in the United Kingdom, from 1965 to 1975. He calls it "the longest cocktail party." His recollections follow.

My mum said, "You have to have a job [when you leave school], what do you want to do and I said "photography" and she phoned up all the photographers in the Yellow Pages. I got a job at a place in Belgravia with a couple of eccentric characters who taught me everything. Tried to be Cartier-Bresson or W. Eugene Smith—my idols. Maurice Newcombe needed someone to print his stuff. He gave me free passes. I got into *Top of the Pops*. Someone from *Melody Maker* was interviewing Diana Ross. I asked Miss Ross if I could take a few pictures. The reporter said, "If you have a few snaps, drop into the *Melody Maker,* we can always use a few snaps." I brought some pictures in the next week [early 1965]. The next week I saw one of the pictures on the front page with a credit.

The editor Bob Houston called and said, "Our photographer has been arrested for some misdemeanor. We will pay you ten pounds a week plus expenses. Come in to see me."

I was about twenty-two.

I would shoot Tri-X pushed to 1,000 ASA at a sixtieth of a second and develop with Acufine from Chicago. Made it possible to take pictures almost in the dark.

After the gig it was usually a late-night club like the Speakeasy, which shut about three in the morning. It was hard to define what was work and what was pleasure. A typical week, everything had to be in by Monday afternoon, at the latest, because then everything went off to the printers in Essex. The paper came out on Wednesday. . . . The weekend was busy, there were a lot of gigs, and then Saturday and Sunday printing. . . . Didn't have time for contact sheets, just looked at the stuff and picked one or two off a roll, and made prints.

No time for reflections or perusal. I tried to make the best [black-and-white] prints I could make on Kodak paper at 12 × 8 inches.

It was all about the music. . . . It was very free and easy and relaxed. . . . Nobody had a huge ego.

[I would] talk to Pete Townshend about his idea for a rock opera about a deaf, dumb, and blind kid and really engage him and then say, "Just hold it," and click. It is all in the eyes, focus on the eyes. Nobody had makeup, nobody had stylists, there was no posing. Trying to get a picture to look interesting. Tried not to intrude. I didn't want to direct stuff.

If an artist was static [boring], you take him to a setting.

With people like Keith Moon, you had no choice, he was going to do whatever. . . . Call it "Zen and the Art of Seeing," just let the finger on the shutter think for itself. Just let yourself open to chance.

A lot of freedom. No one ever said I couldn't take their pictures.

I did Pink Floyd's passport pictures.

There are millions of pictures I didn't take that would fill a book of paparazzi images. I didn't photograph if someone was not really looking their best, like Janis Joplin. You don't go there. There was a responsibility, integrity and a trust in the job; many of the artists were personal friends and I felt my job was to put the artist in their best light.

Once we were free to photograph with impunity and a freedom which is rare today. Artists, managers, and record companies want to control the image of the artist and have contracts and restrictions about what you can and mostly can't do as a photographer.

In 1973, Rolling Stones were playing, Mick comes onstage and says we are going to throw photographers out after three songs. Michael Putland was the only one allowed to take pictures, as he was working for the record company and Mick wanted control.

continued on page 286

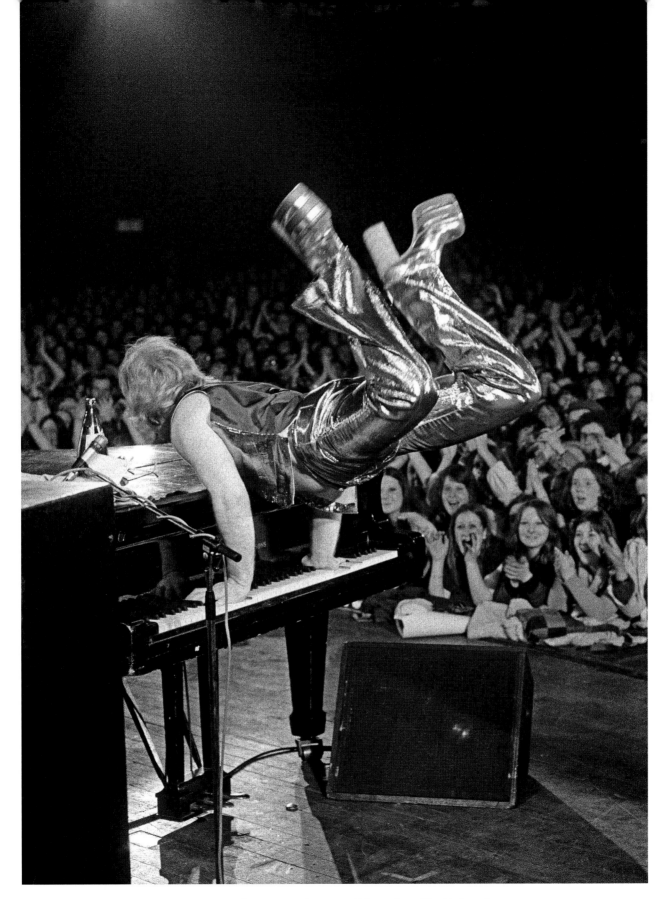

Elton John, Sundown Theatre, Edmonton, North London
1973

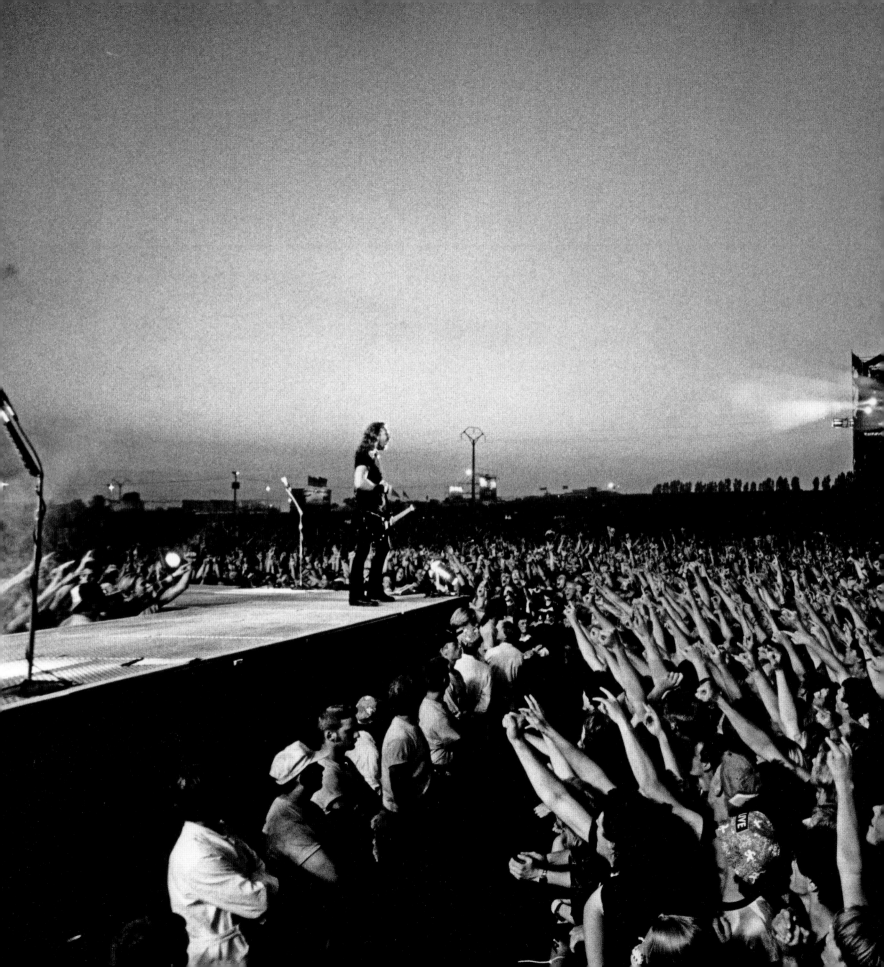

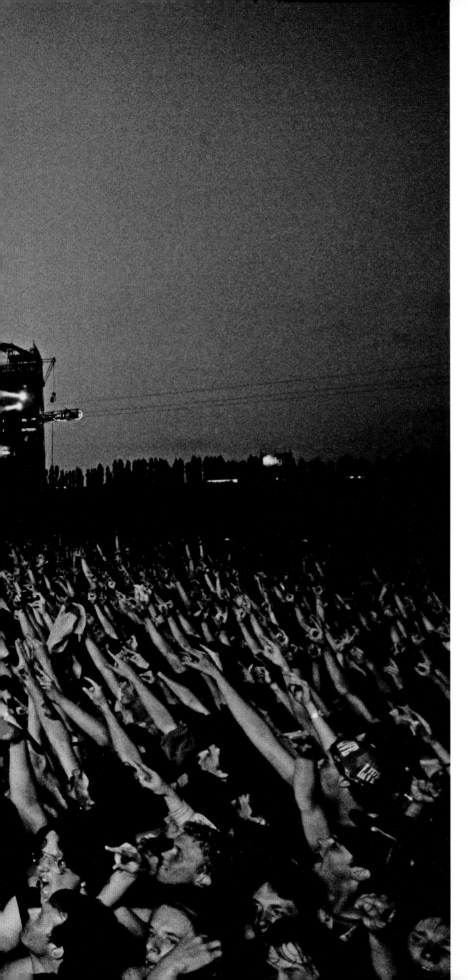

ROSS HALFIN

Working with Ross Halfin is as much fun as shaving your head with a cheese grater while chewing on a cactus. He's not only the biggest pain in the ass on this planet, he's their leader (he has assistants). On tour, whenever his name is mentioned along with the fact that he's gracing us with his presence, our eyes light up (with hatred or fear or boredom) and we can't wait to wake up early for another brilliant adventurous photo session (standing in front of another white wall). But the most annoying thing of all is that we must put up with all of this shit because he produces some of the most amazing shots ever!!

 Luv,
 James Hetfield
 Metallica

—FROM THE INTRODUCTION TO
FRAGILE: HUMAN ORGANS,
BY ROSS HALFIN

Metallica at the Werchter Festival in Belgium
July 4, 1993

DAVID CORIO

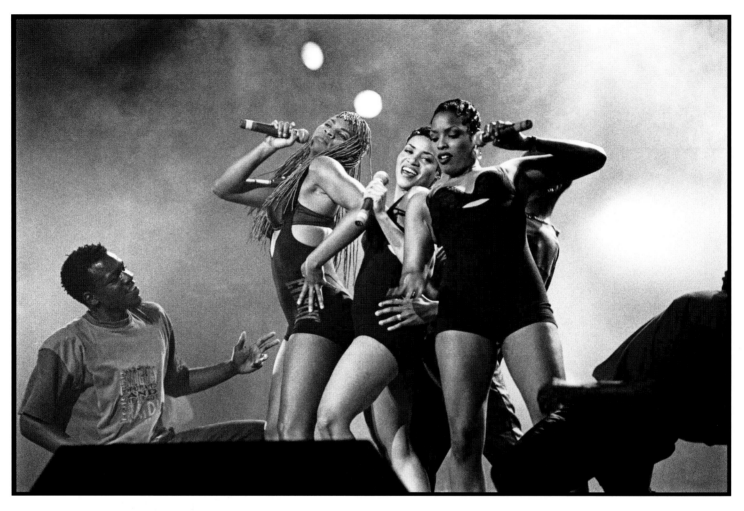

Salt-n-Pepa performing at Radio City Music Hall, New York City
May 27, 1994

One of the finest photographic surveys of black music at the end of the twentieth century is David Corio's book *The Black Chord: Visions of the Groove: Connections Between Afrobeats, Rhythm & Blues, Hip Hop and More,* with more than two hundred photographs of black musicians shot over twenty years, with text by Vivien Goldman and foreword by Isaac Hayes. Corio captured genius and talent in revealing, insightful, clear, and generous photographs.

Salt-n-Pepa are sexy ladies. "I'm glad that this group," said Salt (middle), aka Cheryl Wray, "showed we could be female rappers and still be female. There's nothing wrong with being sexy as long as you can show someone that you're intelligent, you have a brain, and demand your respect" (interview with Goldman on the MTV special *Ain't Nothin' But a She Thing,* Good Karma Productions, 1995, quoted in *The Black Chord*). Corio consistently gets the moves right.

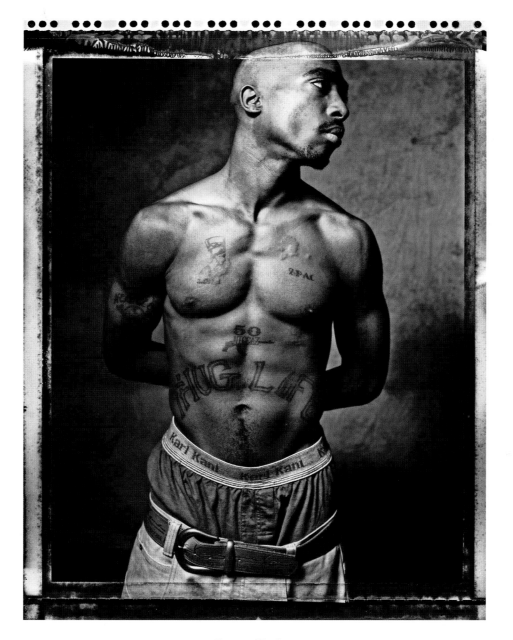

Tupac Shakur
August 1993

n America, with black skin, I'm just Tupac the cop-killer," asserted Tupac Shakur in a *Rolling Stone* interview. Here, in Danny Clinch's 1993 portrait, he proudly exposes that black skin. The photograph was made in the studio with a 4 × 5 inch Polaroid camera. The detail in the Polaroid negative is superb, and the viewer experiences the soft skin tones, the sheen of the belt buckle, the raised scar on Tupac's chest, the stubble on his chin, the light touching his lip, the indentation of his cheek, the shape of his muscular arm. Clinch and Tupac are insisting the viewer see more than just black skin.

Clinch gives musicians something they need—

continued on page 286

DAVID CORIO

t may look like a studio shot, but it is not. David Corio was twenty-one when he took this photograph, but he had been shooting live events since his teens. He photographed concerts while at art college even though his instructors advised him against shooting music (which was not considered an "artistic" subject). From 1979 to 1984 he freelanced for *New Musical Express* while working in an industrial darkroom near their offices. He would shoot at gigs and make the prints in his kitchen at night, dropping the photographs off in the morning at the *NME* office before anyone had arrived at work.

When he was twenty he went on tour with U2 in Ireland before they had a record deal. It was Corio's first trip abroad and he describes himself as "young and innocent," but so, too, he adds, were U2. He remembers imagining the girls, the sex, the drugs, everything he had heard about rock and roll, but to his disappointment, all of U2 lived up to their Catholic education and were in bed early.

Corio's instructors at Gloucester College of Art and Design made a fundamental mistake when they advised Corio against taking pictures of musicians. They were prejudiced. There is no hierarchy of subject matter. Capturing what touches our humanity is what is important, regardless of the subject. When Corio is asked, "What are you trying to achieve in your photography?" he answers, "Capture the moment . . . to create a good image that stands up as a good picture. Not just about who is in the picture. I always loved lots of types of photography." Grace Jones on those steps is as monumental as any mountain by Ansel Adams. Incidentally, when Corio isn't photographing musicians, he shoots Irish megaliths of profound power and beauty and tombstones in London graveyards.

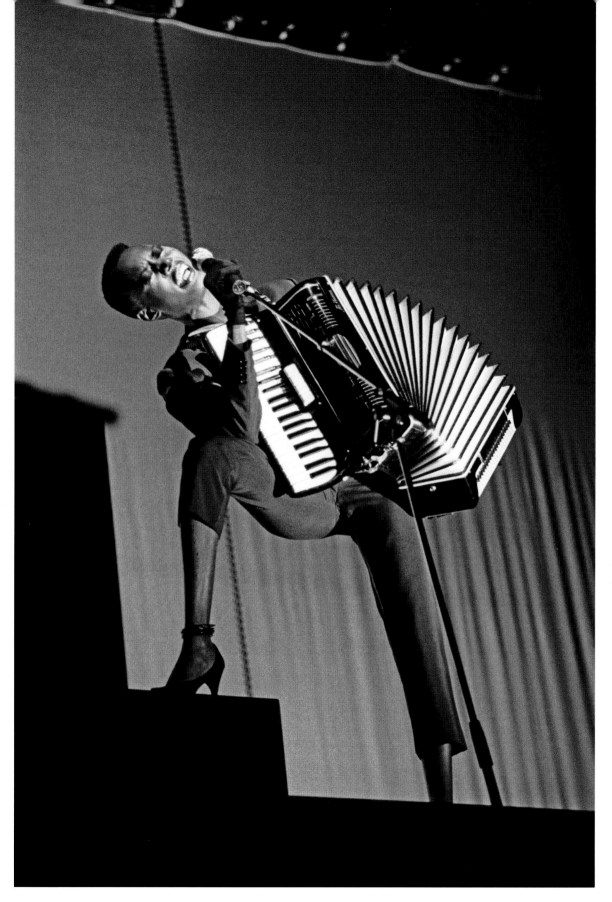

Grace Jones performing at Theatre Royal, Drury Lane, London
October 10, 1981

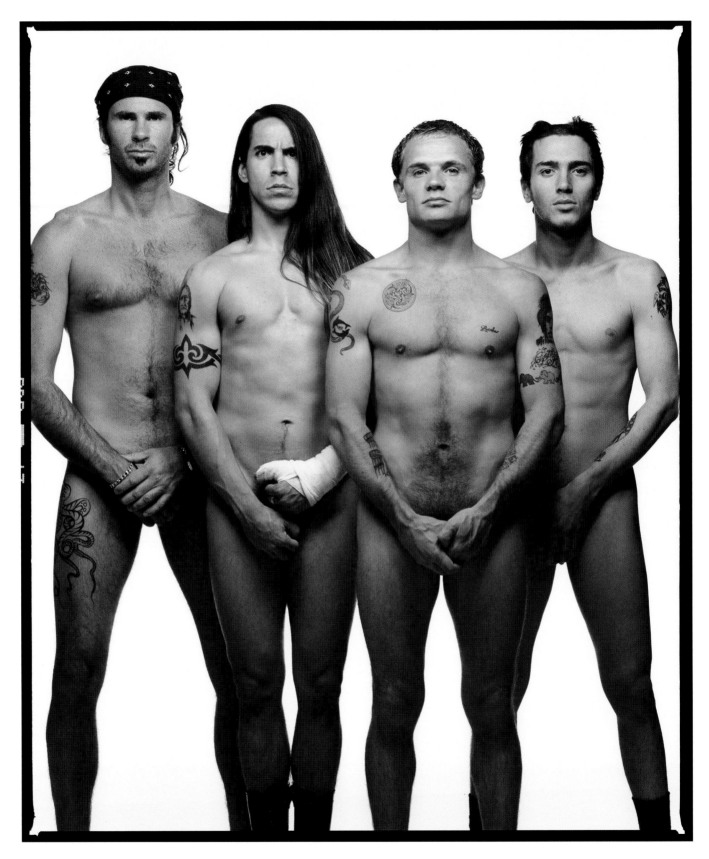

Red Hot Chili Peppers, Los Angeles, California
April 15, 1992

Mark Seliger nailed Chad Smith, Anthony Kiedis, Flea, and John Frusciante and created one of the most revealing (and fun) pictures in rock and roll. When the photograph was used on the cover of *Rolling Stone*, Frusciante was no longer in the band and, like someone who had fallen out of favor with the Soviet politburo, disappeared from the picture. No one would argue that three naked men are better than none, and who better to bare (almost) all than the Red Hot Chili Peppers, whose motto was "rock out with your cock out." Seliger has a sharp wit. He also has a serious, poetic side.

A student of George Hurrell lighting and Eikoh Hosoe burning and dodging in the darkroom, Seliger's finest portraits are timeless studies, in the great tradition of Alfred Stieglitz and Paul Strand. Many are in black and white, for it is with the elimination of color that he can most sensitively draw with light. They also have something in common with the great paintings done in the fifteenth century by Hans Memling and in the sixteenth century by Hans Holbein. Although centuries separate them, the subject—men who carry the weight of greatness upon them and struggle within—is the same. His close-up of Kurt Cobain, eyes questioning the world and himself, leaves an indelible mark on the viewer. So, too, his mature Neil Young, hand covering his mouth, eyes truly "the gateway to the soul."

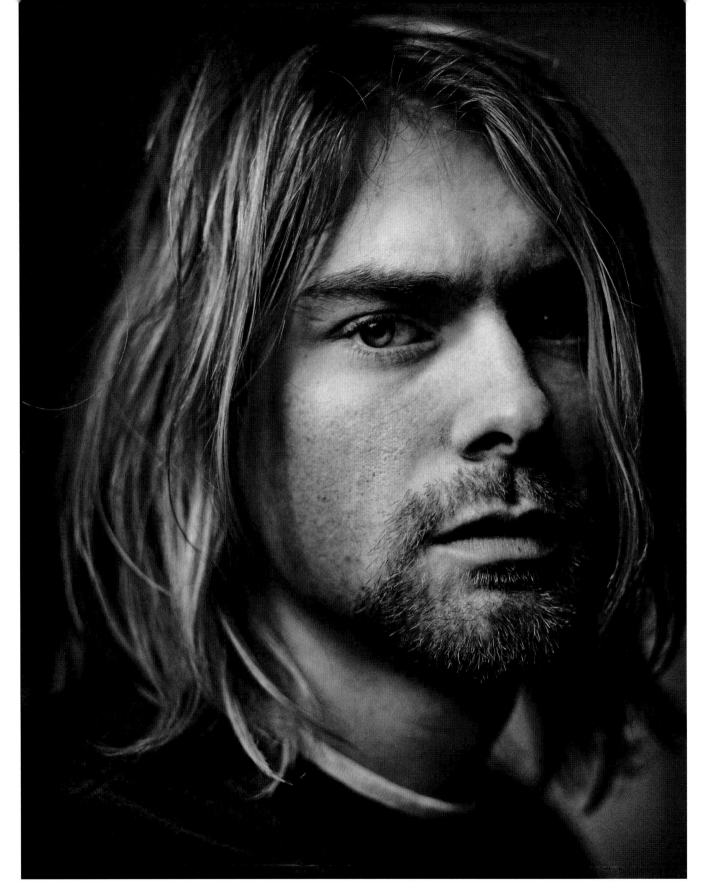

Kurt Cobain, Kalamazoo, Michigan
1993

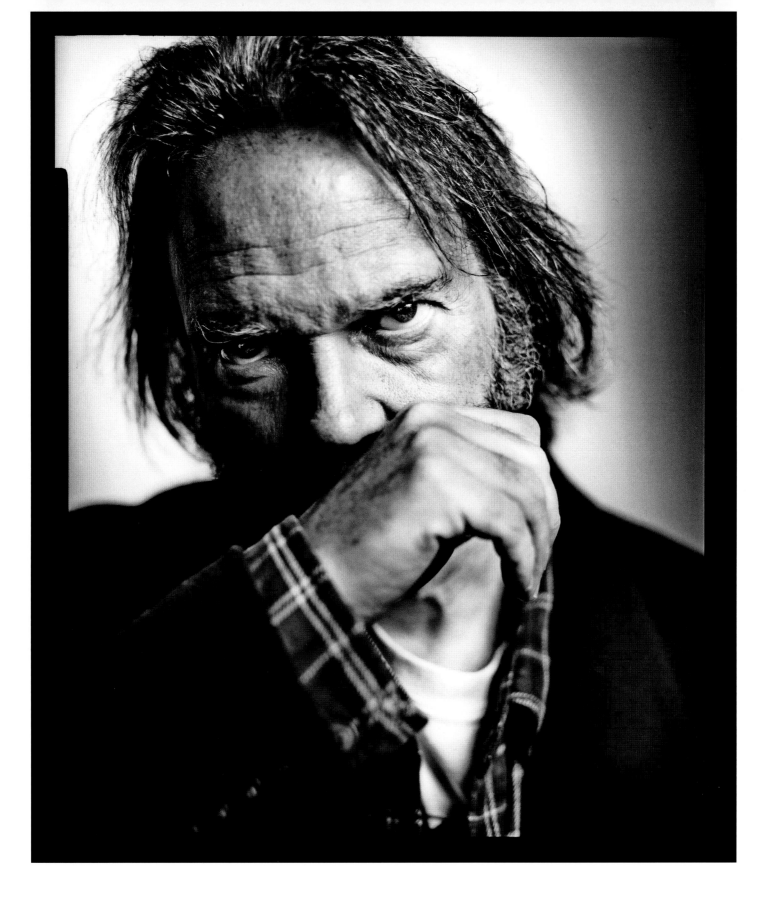

Neil Young, Chicago, Illinois
1992

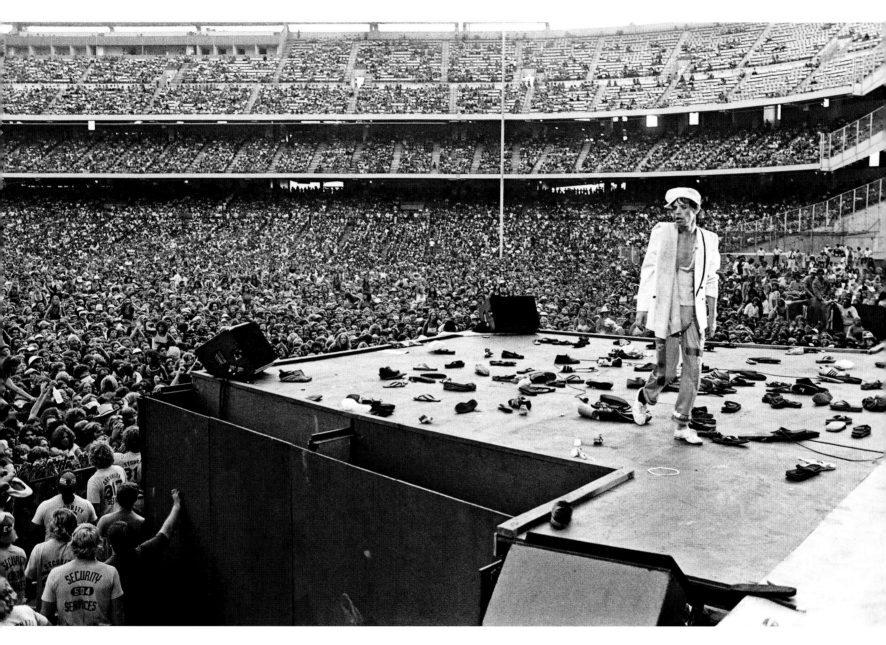

Mick Jagger, onstage with shoes, Anaheim, California
1978

LYNN GOLDSMITH

Man is like a candle.
He must radiate light by burning himself.

—Yogi Bhajan

There are thousands of energized people in Lynn Goldsmith's masterpiece and one worn soul surrounded surreally by lots of lost soles. The pathos captured in this picture is rare in rock-and-roll photography. Music photographers go for the pinnacle of the performance, not the nadir.

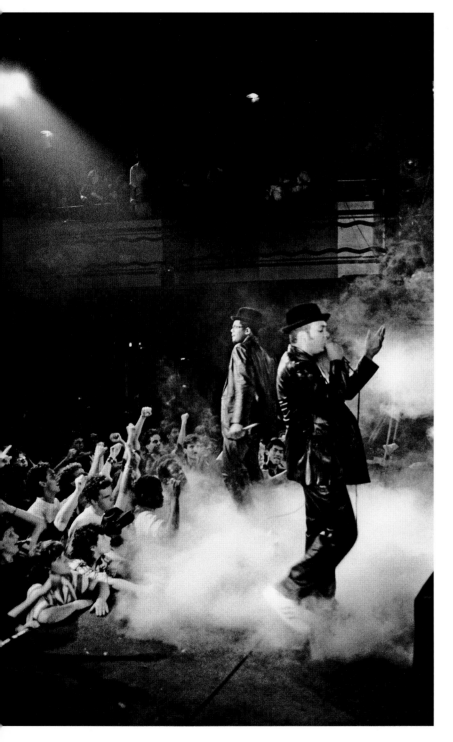

Run-DMC, live at the Ritz, New York City
May 15, 1984

osh Cheuse's book, *Rockers Galore*, opens with a disc jockey spinning records, moves to the Bronx street culture of big speakers and turntables, then shows break-dancers forming strange geometric shapes, a street scene in Belfast, a profile of his friend Joe Strummer under a single white light, and then, poignantly, a one-legged break-dancer about fourteen with his crutch and boom box–laden crew. As Jim Jarmusch, another one of Cheuse's friends, writes, "These are the worlds he inhabits by choice, by interest, by personal connection."

By the time the reader is into the heart of the book, which Cheuse designed, he or she cares more about Cheuse's vision than any celebrity who might pop up. Damien Hirst and Michael Joo, in a jointly written postscript to the book, say they were thrilled to be asked to write the afterword because "Josh's work is up there with art, it's not mere journalism." Cheuse's photographs are not "slick," and what they lose in sharpness, they make up in depth. He has photographed Madonna, Siouxsie and the Banshees, Adam and the Ants, the Young and the Useless, the Beastie Boys, LL Cool J, D Generation, Oasis, the Black Crowes, and the Clash, and he has also covered hip-hop, but it really doesn't matter. Something bigger than celebrity is going on—it is called community.

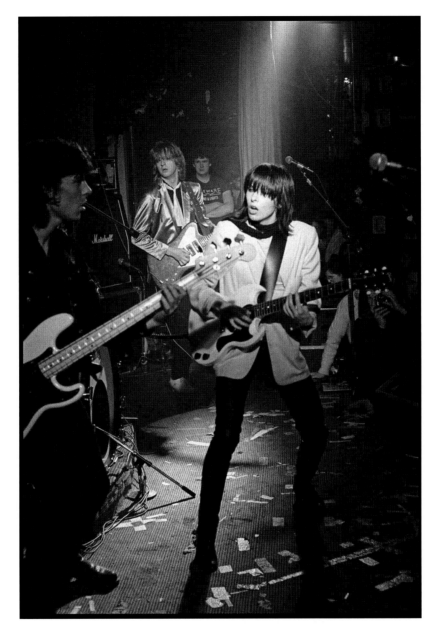

Chrissie Hynde of the Pretenders, Nashville Rooms, London
March 9, 1979

n an interview with Jill Furmanovsky, Chrissie Hynde said, "Presentation is half of it in rock and roll. It's not just the music—there's music and there's attitude and there's the image. It almost represents a way of looking at life" (*The Moment*, p. 116). And David Corio's way of looking at musicians onstage is to present them with dignity and grace while showing their vital energy.

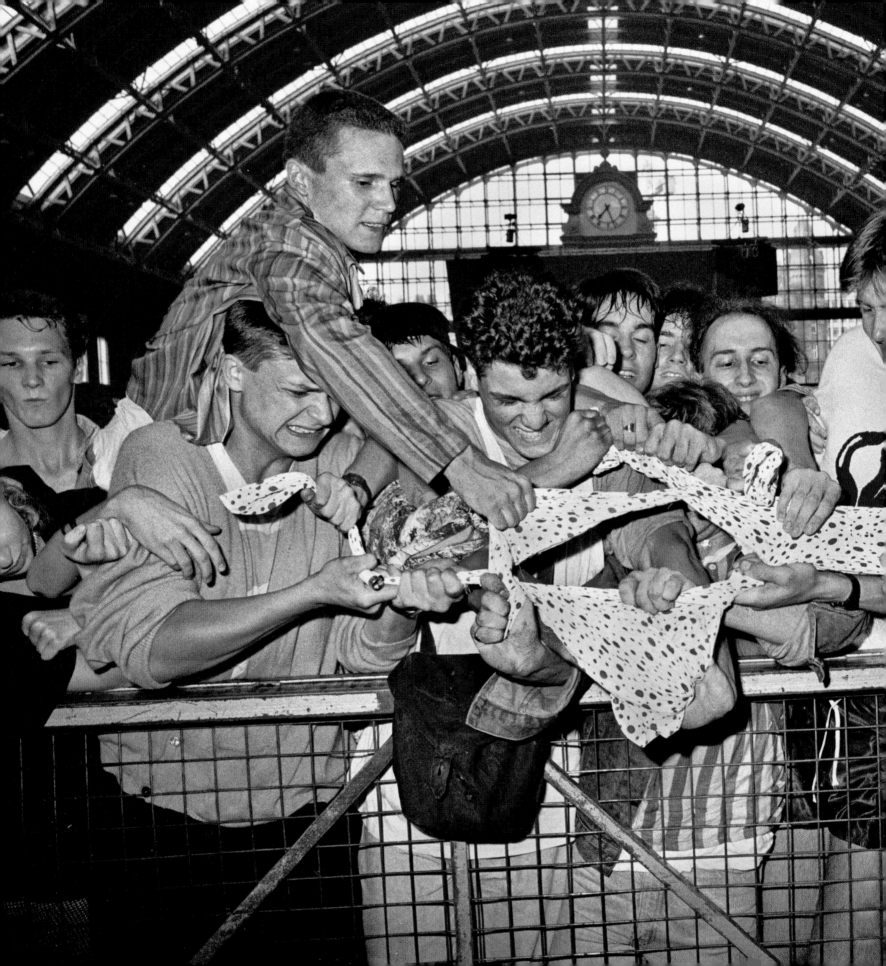

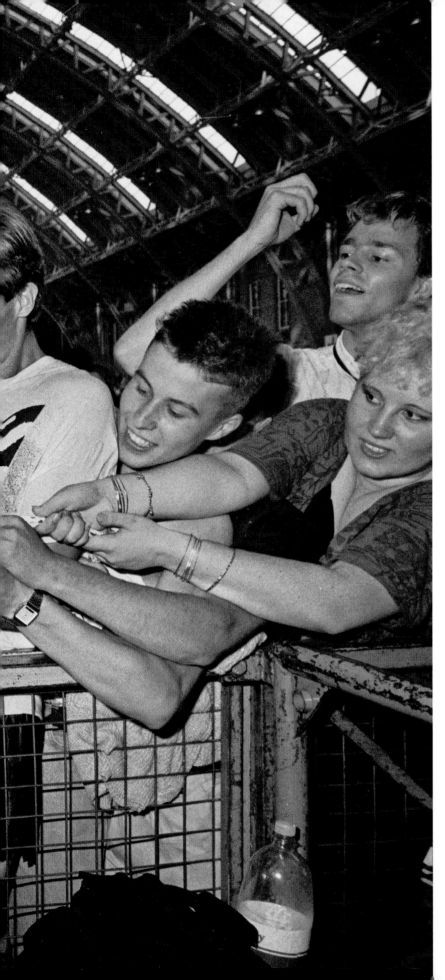

IAN TILTON

T his is Morrissey's shirt being torn to shreds after he tossed it into the audience. Morrissey chose to use this fabulous picture as the gatefold for the Smith's album *Rank*. It was taken at the Festival of the Tenth Summer, celebrating ten years of punk rock in the United Kingdom.

"Rank" has many definitions. The author (an American) asked Ian Tilton about its use in Britain. His reply follows.

Rank was the name of a well-known chain of cinemas in Britain that began in Britain's golden age of cinema in the 1940s. They were owned by the famous J. Arthur Rank. . . . As well as showing movies, they were popular venues for bands to perform in [see page 166].

A "J. Arthur" is also well-known cockney rhyming slang:

"Apples and pears"—stairs
"Carving knife"—wife
"Patsy Cline"—line (of cocaine)
"J. Arthur Rank"—wank (masturbate)

Interestingly it is also slang for "bank" but Morrissey would not have found that funny. Unless he was laughing all the way to the "J. Arthur Rank" on the sales of the album.

Another meaning of "rank" in the English dictionary is "foul tasting or foul smelling," and it can also be used as a slang term in a derogatory way.

Q. "Whaddya think of Ian Tilton's photograph?"
A. "I think it's rank."

So I think its multi meanings really appealed to cheeky young Morrissey.

And let's not forget another meaning: "a number of persons forming a separate class in a social hierarchy."

**Morrissey's shirt, taken as the Smiths played at GMEX
(Greater Manchester Exhibition Centre), Manchester, England**
July 19, 1986

The Doors perform on a local TV show.
(Left to right: Robby Krieger, Ray Manzarek, John Densmore, Jim Morrison),
Los Angeles, California
1966

Here is the proof. There was a time Jim Morrison sang and the girls looked elsewhere, as seen in Jasper Daily's 1966 photograph taken on the set of a local Los Angeles television station. Daily, the house photographer for the Palomino Club, a famous music venue in North Hollywood, also photographed on the sets of *The Glen Campbell Goodtime Hour* and *The Smothers Brothers Comedy Hour*.

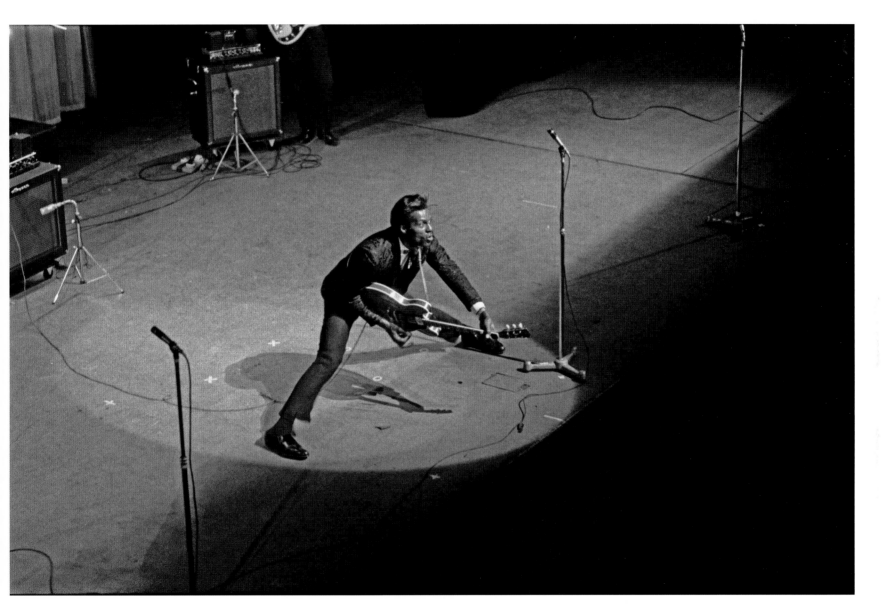

Chuck Berry at Théâtre de l'Olympia, Paris
1966

Jean-Pierre Leloir's first published photograph was in April 1951, the year he purchased his first Rolleiflex. Leloir not only witnessed and recorded musical shifts over sixty years, he experienced all the changing film and camera technology. And his stories about photo-graphing eleven thousand (!) musicians are priceless.

Leloir recalls being backstage with photographer Jean-Marie Périer: "Ella Fitzgerald opened her dressing-room door and she was in her underwear. Neither of us moved. We wouldn't have taken her picture. We were not paparazzi. We wanted to meet her again in a couple of

continued on page 286

LYNN GOLDSMITH

New Kids on the Block fans in a hotel, Paris
1990

Take the energy, liveliness, excitement in those eleven girls and put it all in one person and you begin to understand the dynamism of Lynn Goldsmith. She is a force of nature more than a whirlwind, like a tornado that sucks one into her energy field. Laurie Anderson speaks about the joy Goldsmith takes in her camera as "infectious." Iggy Pop described her as a "rockin' chick" from their days together as students at the University of Michigan, but she is also one astute, talented, smart woman.

She has managed to capture Marianne Faithfull in the shower, follow Roger Daltrey and the B-52s fully clothed into the sea, frame Keith Richards dancing slowly with his future wife Patti Hansen, hike the Gloucestershire hills with Steve Winwood, tiptoe with her camera to catch Debbie Harry and Chris Stein asleep in a rooftop hammock, and recognize the picturesque quality of Television's crummy van. And because she understands the nature of rock and roll so well, she has as much empathy for the fans as she does for the stars.

ALFRED WERTHEIMER

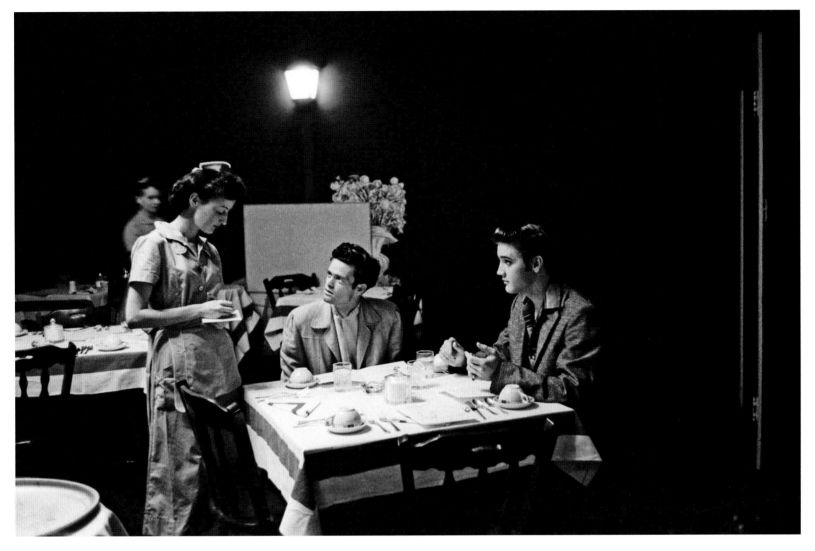

Breakfast at the Jefferson Hotel, Richmond, Virginia, with cousin Junior Smith
June 30, 1956

Within fifteen minutes of Elvis Presley's ordering bacon, eggs, home fries, and a glass of milk, followed by cantaloupe and ice cream for breakfast, Elvis had his arm around the waist of the waitress. Elvis, by his look, his voice, and his moves, made every woman feel sexy. He was one of America's greatest revolutionaries: he set people free.

HERB GREENE

**Jerry Garcia and Mountain Girl (Carolyn Elizabeth Adams),
Golden Gate Park, San Francisco**
Summer 1967

erb Greene says he saw Jerry Garcia of the Grateful Dead and Mountain Girl (Carolyn Adams), Garcia's future wife, "just sitting together." For him, they seemed so full of idealism that they "radiated." Greene observed their bodies touching, their faces in parallel, and made a very powerful portrait of an archetypical hippie couple.

In 1965 Greene photographed the Warlocks before the group morphed into the Grateful Dead. He was closely associated with the group, taking their first album cover and probably more pictures of them than any other photographer. Greene was a central figure in the San Francisco psychedelic cultural world, making many of the memorable portraits of Jefferson Airplane, Blue Cheer, the Charlatans, Jeff Beck, the Pointer Sisters, the Grateful Dead, Janis Joplin, Led Zeppelin, Carlos Santana, Sly Stone, Rod Stewart, and many others. In his catalogue for the exhibition *San Francisco Psychedelic* (Minneapolis Institute of Arts, 2007), curator Christian Peterson writes that Greene "helped create an astonishing family album for an entire generation."

KEN REGAN

Keith Richards, Patti Hansen, and their daughter Theodora Dupree Richards
1985

Ken Regan has been close to the Rolling Stones ever since he toured with them in 1975. That year, he also toured with Bob Dylan. He is the consummate professional and gracious gentleman. He is the most diversified of photographers, documenting poverty in Harlem and famine in Africa; providing in-depth coverage of sports giants Muhammad Ali, Mike Tyson, Wilt Chamberlain, and Mario Andretti; creating photo essays on politics and campaigns for the news magazines while establishing close ties with the Kennedys; working on numerous and famous Hollywood movies; and covering the Band's

continued on page 287

135

BARRY FEINSTEIN

Bob and I were friends long before we worked together. We hung out and understood each other. When there was something to say we would talk, when there wasn't we were silent. We were similar in that way, no bullshit.

That's the way it is in music. What often makes a piece of music great are the notes left out. And it's like that with photography; knowing when to take a shot and, more importantly, when not to. I wanted my pictures to say something. I don't really like stand-up portraits, there's nothing there, no life, no feeling. I was much more interested in capturing real moments.

—FROM THE INTRODUCTION TO *REAL MOMENTS: BOB DYLAN BY BARRY FEINSTEIN*

This area of Liverpool was great," writes Barry Feinstein in his book *Real Moments*. "It had space, dimension, old buildings, vacant lots . . . everything for great shots." Dylan related immediately to the Liverpudlian waifs in their dirty clothes with their scraped, knobby knees and hard-knocks attitude. Dylan contemplates the bricked-up buildings, the cobblestone street, the kids, and the horizon line. It is a beautiful composition. The geometry is reminiscent of an Atget photograph; the spacing of the figures a Cartier-Bresson decisive moment.

Bob Dylan with kids, Liverpool, England
1966

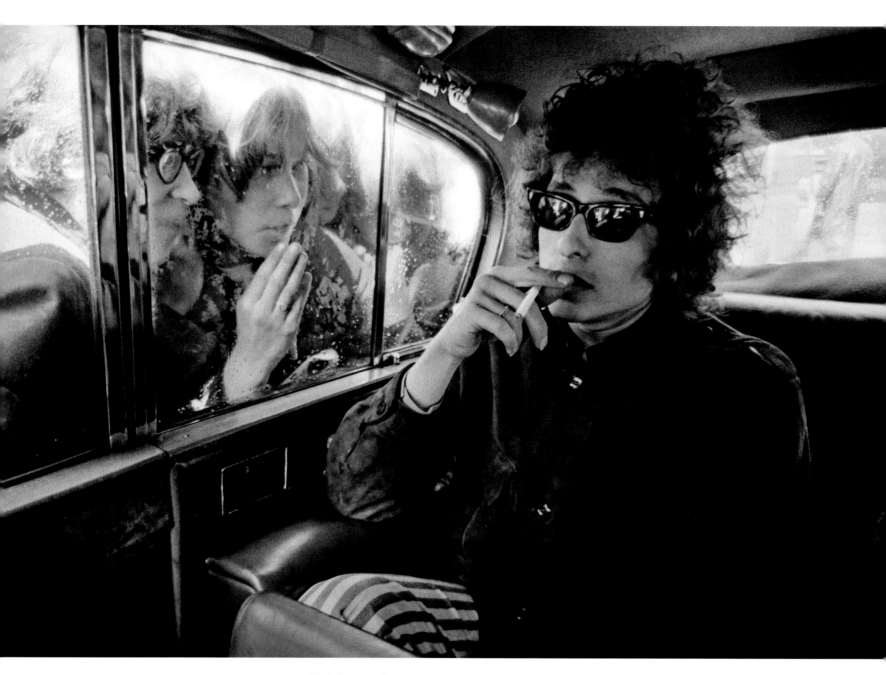

Bob Dylan, fans looking in limousine, London
1966

Dylan is on the way to his famous 1966 concert at the Royal Albert Hall, London. There are not many classic photographs made *inside* cars; miraculously, Feinstein gets the composition right. Dylan is the cool celebrity; the girls the worshipful fans. The subject of the picture is the tension between *inside* and *outside*. And in the case of Dylan, the *inside* always includes his own head as well as the physical space.

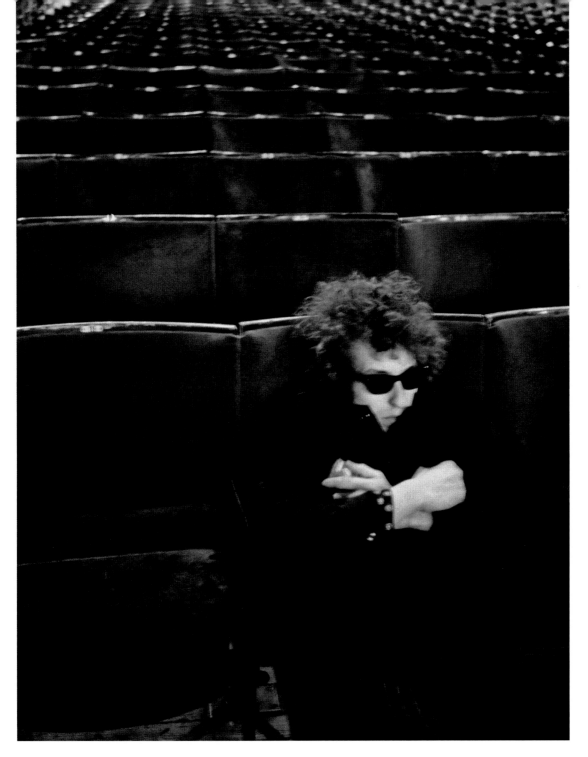

Bob Dylan, sound check, Royal Albert Hall, London
1966

Feinstein describes this photograph as capturing "the loneliness and isolation of being Bob Dylan." The band was doing the sound check before the concert. Feinstein's special relationship with Dylan permitted him to capture private moments leading up to the public performances. It is his skill as a photographer that allows him to enlarge on the meaning of those moments.

Feinstein is a gentle giant of music photography. There is lyricism and mystery in his pictures. His photographs are psychologically and compositionally complex, a perfect fit for Dylan. Feinstein captures Dylan as frozen-faced as the dummy, and turns a press conference into surrealist drama. Feinstein writes: "In the morning we went to the flea market and Bob bought this puppet. Every time one of the journalists asked him a question, he put his ear to the puppet's mouth and pretended to listen to the answer. Then he would tell the press. It drove them nuts. They didn't understand him." Feinstein does.

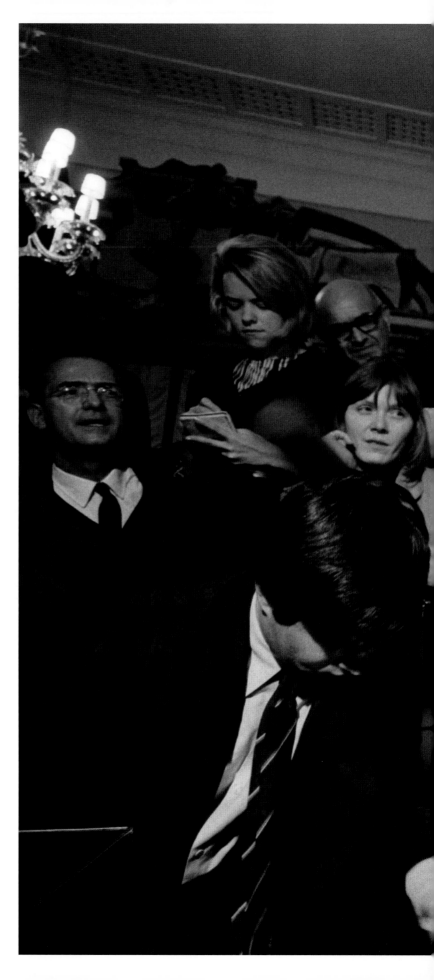

Bob Dylan, press conference, George V Hotel, Paris
1966

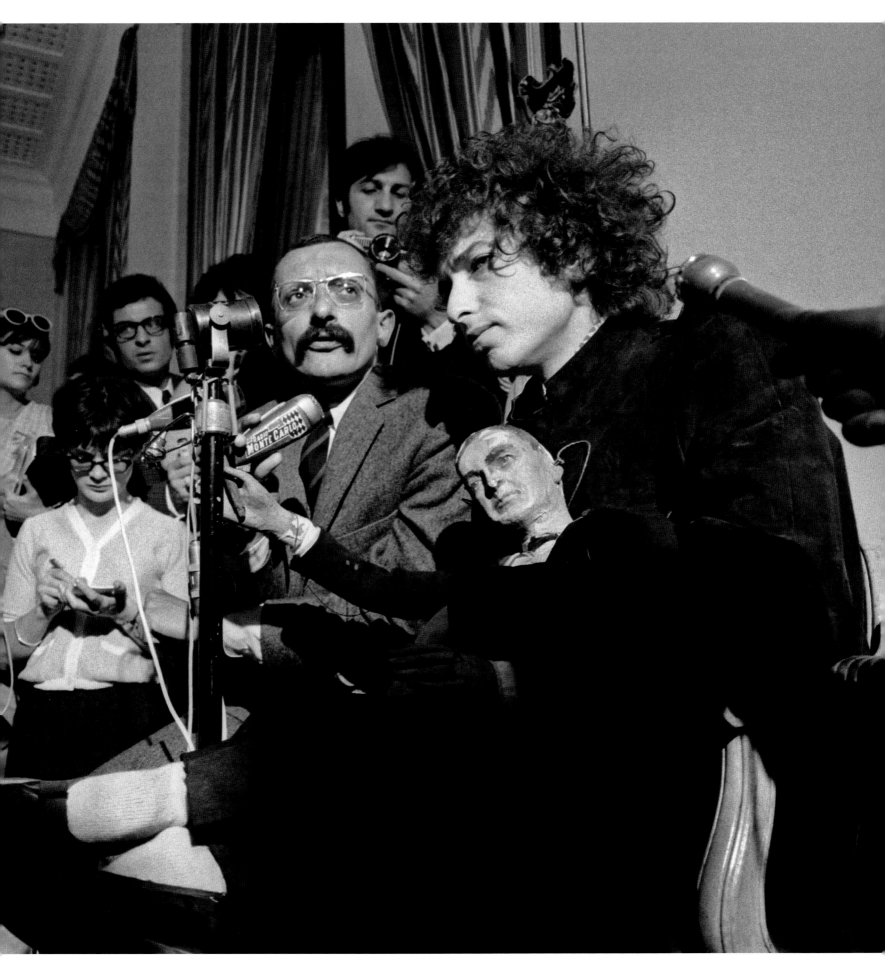

Annie Leibovitz is the superstar of music photography, although a long time ago she dropped the label "rock-and-roll photographer" in favor of the classier "portrait photographer." Even in her twenties, she enjoyed going to live performances but not shooting them. "I found concert work difficult. You never could take your eye from the camera and you were at the mercy of the lighting people, who were usually on drugs. Plus you had to be prepared to be crushed by the audience" (Leibovitz, *Annie Leibovitz at Work*, pp. 33–34). Berry and Diddley at the Cow Palace in San Francisco, surrounded by adoring girls, is not celebrity portraiture; it is pure rock and roll and great photojournalism.

An exception to Leibovitz's preference of photographing musicians anywhere but onstage—front porches, hotel rooms, living rooms, recording studios, bars, churches, country roads—was when she toured with the Rolling Stones in 1975. Her picture of a leaping Mick Jagger and a big-booted Keith Richards onstage is a classic, but her black-and-white pictures taken behind the scenes humanize the Stones in poignant and revelatory ways. People old enough to have read *Rolling Stone* in the seventies always speak tenderly of "Annie's early work." Although she has many books to her credit, *American Music* is her best.

In 1970, at age twenty-one, Leibovitz, a student at San Francisco Art Institute, showed her portfolio to Robert Kingsbury, art director of *Rolling Stone*. In it were pictures taken on a kibbutz in Israel and, more impressive, photographs of an antiwar rally that had taken place the day before. Kingsbury must have had his fill of folks coming into *Rolling Stone* with their rock-concert

continued on page 287

**Chuck Berry and Bo Diddley, Cow Palace,
San Francisco, California**
1972

LAURA LEVINE

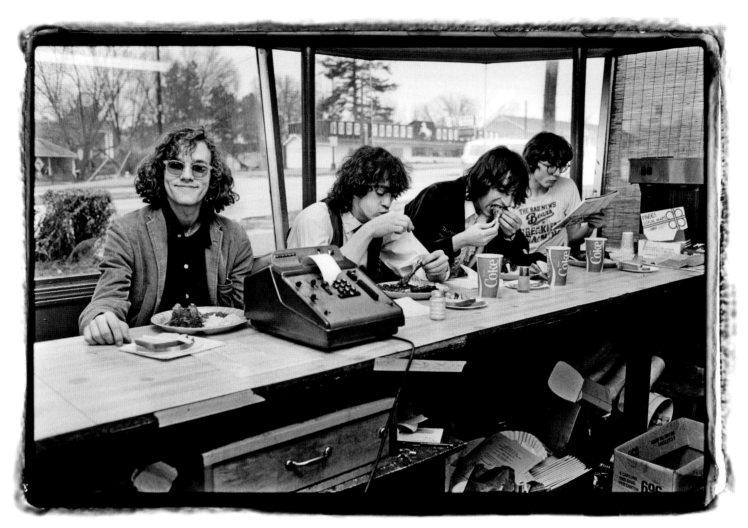

R.E.M., Walter's BBQ, Athens, Georgia
1984

The band lauded the barbeque beef at Walter's BBQ (made even more famous in R.E.M.'s ode to the place, "Walter's Theme") in their hometown, Athens, Georgia. From left to right, vegan Michael Stipe eats only the coleslaw while carnivores Bill Berry, Peter Buck, and Mike Mills dig in. They are just about to release their album *Reckoning*.

Laura Levine was friends with the band and toured with them. Her photos of R.E.M. range from Stipe bathing in an old four-legged bathtub to the band in motel rooms across the country to Stipe and the B-52s having fun in a great swimming hole near her home. R.E.M. was comfortable with Levine and her camera and knew she wouldn't take pictures to compromise them or do anything that would jeopardize the friendship.

LYNN GOLDSMITH

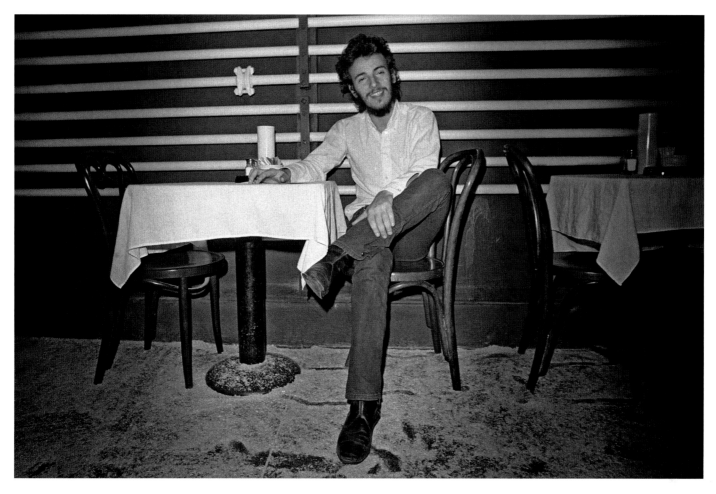

Bruce Springsteen, New York City
1972

I met Bruce in April of 1972. It was my first assignment for *Rolling Stone*. They told me he was the Bob Dylan of the '70s. The article was going to be called "It's Sign up a Genius Month." Because the shoot was set to take place in a bar on Bleecker Street, I knew I'd need a flash. I'd never used one before and thought this "genius" is going to know I'm stupid. [Five] years later Bruce told me what he was thinking the first time I took his picture. "I thought a *Rolling Stone* photographer, a girl who lives in New York City, she knows what she's doing. She's going to think I'm just this guy with a bar band from New Jersey. She's going to think I'm a dope."

—LYNN GOLDSMITH, *PHOTODIARY*, UNPAGINATED

The success of this picture is its tentativeness, sweetness, and tenderness. There is no artifice. Springsteen is presenting the same countenance for the pretty young *Rolling Stone* photographer as he would for any relative with a snapshot camera. A simple honest smile is rarely seen in rock-and-roll photography.

IAN DICKSON

Bob Marley and the band, Odeon Theatre, Birmingham, England
1975

t must have been a strange sight, seeing dreadlocks walking along a British city main street in 1975!" remarks photographer Ian Dickson in an interview with the author. *New Musical Express* sent Dickson to Birmingham to cover the Wailers' first British tour. He expected they would go to the concert hall by limo; the Wailers were not going to waste good money on transportation. Dickson met them at their hotel and walked with them to the gig, nearly a mile away.

There is something that can be called photographic truth. A great documentary picture has no agenda other than to show how something really is. Much of music photography is concerned with image, but that rarely is where truth lies. In Dickson's photograph, Bob Marley and the Wailers walk and connect to real things—like the alley, the bricks, the feeling of pavement beneath their feet. As well as the surprise of seeing musicians walking to their own concert and carrying their instruments, we realize how infrequently we see a band all together not posing or performing or fooling around for the camera.

Buddy Holly on the bus (left to right: Frank Maffei of Danny and the Juniors, Jerry Allison of the Crickets, Buddy Holly, and Judy Shepherd)
January 19, 1958

Minor White, the first editor of *Aperture*, America's most important photographic journal, was also one of the most influential photographers and photography teachers in America in the second half of the twentieth century. He believed in the power of photography to transcend subject and enter a metaphysical realm. He spoke of equivalency—upon "reading" a photograph, one could have a deeply emotional and spiritual experience. Looking at a photograph of a rock, a cloud, a face, or any subject *seen and photographed* with all

of the photographer's being and consciousness can result in a transcendental experience for the viewer.

Ralph Hattersley, writing for *Popular Photography* and teaching photography courses at Columbia University and elsewhere at the same time as White, examined photography's relationship to the subconscious. He gave innocuous assignments to his students and then asked them to *really* explore what emotional hang-ups and fears might lie behind the way they see the world. The camera, he argued, was a tool for self-discovery. Both Hattersley and White helped raise photography to an art form

continued on page 288

This photograph of the Everly Brothers is pure rock and roll in ties, jackets, and hair.

"A portrait is not a likeness," Richard Avedon said at the time of his exhibition *In the American West*. "The moment an emotion or fact is transformed into a photograph it is no longer a fact but an opinion. There is no such thing as inaccuracy in a photograph. All photographs are accurate. None of them is the truth."

And in an interview with art critic Jeffrey Brown on the *Online NewsHour*, October 24, 2002, Avedon elaborated on this contradictory aspect of photography: "They're representations of what's there. 'This jacket is cut this way;' that's very accurate. This really did happen in front of this camera at . . . a given moment. But it's no more truth . . . the given moment is part of what I'm feeling that day, what they're feeling that day, and what I want to accomplish as an artist."

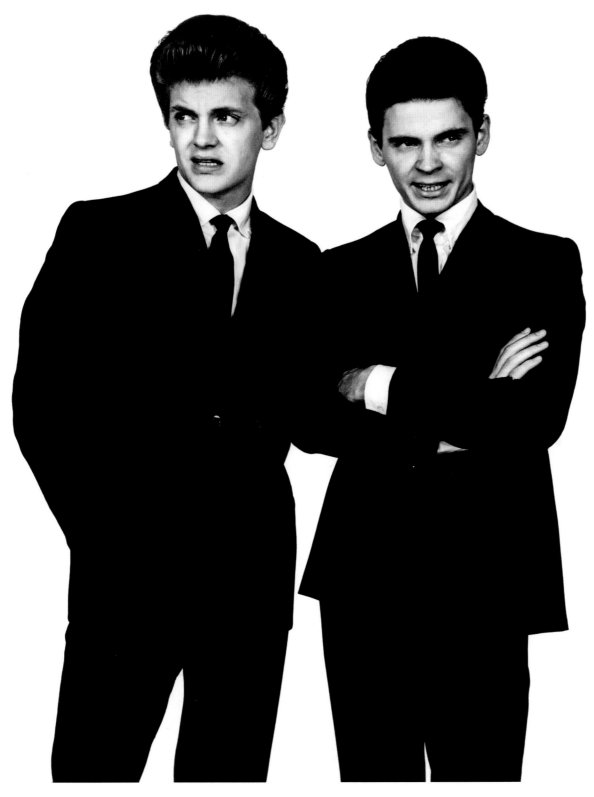

The Everly Brothers: Phil and Don Everly, Las Vegas, Nevada
January 17, 1961

MARVIN ISRAEL

Marvin Israel is one of the most important American graphic designers of the twentieth century. He is better known for commissioning photographs and laying them out than for taking them. But in 1956 when he was art director of *Seventeen*, he gave himself two plum assignments: James Dean on the set of *Giant* and Elvis Presley on tour.

Israel shot five hundred pictures of Presley during a brief period in 1956, the same year Alfred Wertheimer did his deeply revealing study of the young Presley. Although their subject was the same, Wertheimer's extended essay is clear-eyed, first-rate photojournalism; Israel's pictures are more impressionist and psychological. Israel, a painter at the beginning and end of his life, studied art with Josef Albers at Yale University and design and photography with Alexey Brodovitch. In 1945 Brodovitch's own photographs were published in a self-designed book titled *Ballet*. Elvis and the ballerinas in Brodovitch's book have little in common, but Israel's Elvis photographs are influenced by Brodovitch's grainy, soft-focus, backlit images. Brodovitch and Israel both see their subjects as fluid, inscrutable, existing in a twilight zone that moves into a dream sequence even as it purports to document a person or action.

Nineteen fifty-six was the last time photographers could have a degree of intimacy with Presley. He gave two performances at the University of Dayton on May 27, 1956. He slumps in one of the folding chairs set up in the field house for his concert. He sits where a student will sit in a few hours, looking at him. He holds himself and is very much alone. It is quiet in the room. He is thinking. He is twenty-one, the same age as many of the students. Guys like Presley didn't go to college, but here he is, about to turn on a whole auditorium of college kids. Around this time he was quoted as saying, "I'll bet I could burp and make them squeal."

Israel's résumé also included the title of art director for Atlantic Records and *Harper's Bazaar*. He was close to both Diane Arbus and Richard Avedon, professionally and personally, collaborating on books and exhibitions. Michael Hoffman, former publisher and executive director of *Aperture*, the journal and publishing house dedicated to fine photography, worked with Israel on the posthumous 1972 Diane Arbus monograph that accompanied her exhibition at the Museum of Modern Art. Hoffman believed Israel was unparalleled in sequencing and laying out photographs.

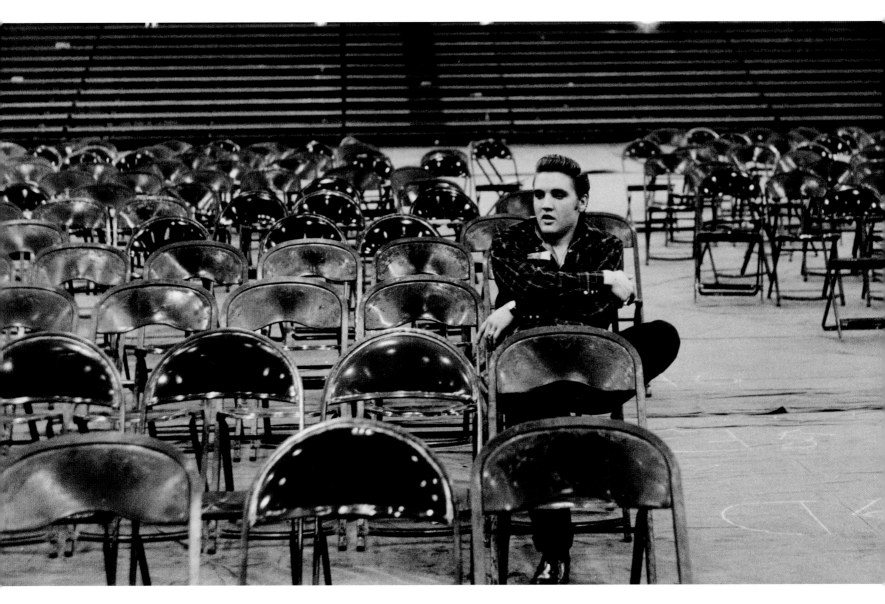

Elvis Presley, University of Dayton (Ohio) Fieldhouse
May 27, 1956

DANIEL KRAMER

Daniel Kramer photographed Bob Dylan from August 1964 to August 1965, documenting Dylan's "state of creative evolution" as he went from being a folk-music hero to a rock and roller. At the beginning of Kramer's extended photographic essay, Dylan did not want to pose formally. "I was aware, even on first acquaintance, that Dylan is a restless man. It is difficult to pin him down, difficult for him to remain still. It was also obvious that he didn't like to be photographed. He said that photography was a waste of his [precious] time," wrote Kramer in his book *Bob Dylan*. Kramer was allowed to follow him with his camera and photograph the things he did: thinking, composing, playing chess, working with the guitar, climbing a tree, walking down the street, touring with Joan Baez, recording, performing.

Gradually, a trust was established, and when Kramer had a rough idea for the "home" portrait needed for the album cover of *Bringing It All Back Home* (1965) (see page 298), Dylan not only posed but enthusiastically gathered treasured possessions to put in the composition—possessions still being deconstructed and analyzed by Dylanites.

Kramer, who learned photography by reading books and manuals at the Brooklyn Public Library and working with Allan and Diane Arbus and then Philippe Halsman, had two astute pairs of eyes other than his own looking over his Dylan contact sheets. One belonged to Dylan himself, who liked to see everything Kramer shot but chose only the serious pictures to release for PR. It was, Kramer recalls, the way Dylan wanted to be seen.

The other pair of eyes combing the contracts was W. Eugene Smith's, one of the twentieth century's most important photojournalists, who also, incidentally, photographed the young Dylan. One day Kramer spotted his idol Smith photographing, introduced himself, and said he was an admirer of his photography. When the older man asked Kramer what he was working on, Kramer told Smith he was immersed in a documentary project on a singer named Bob Dylan. A week later, Smith invited Kramer over to his loft—a loft famous in both jazz and photographic history.

From eight p.m. until daybreak the next morning, Smith discussed, frame by frame, Kramer's Dylan photographs. He marked the contact sheets (Kramer still cherishes these grease-penciled pages). Smith wanted to know why the young photographer wasn't using a wide-angle lens, and when Kramer told him he couldn't afford one, Smith loaned him his 28mm. Many of the wide-angle views taken of Dylan's first solo electric concert at the Forest Hills Stadium were made with Smith's camera and lens.

It was hard for the young photographer to print his negatives with sufficient subtlety and range to satisfy the legendary high standards of his friend and mentor W. Eugene Smith. The master printer often had Kramer redo prints until the full potential of the negative was realized. Smith wanted a selection of the Dylan pictures and some text for a new magazine he was editing and wouldn't accept any photographic print, even for reproduction, that lacked character and depth.

When a publisher approached Kramer about doing a Dylan book, Smith helped him organize the pictures by hanging them on a clothesline in Kramer's studio and moving them to and fro, so the book would have a particular rhythm, laid out like a musical score.

Dylan asked Kramer to photograph his next album cover, too, creating a dramatically different "image" of Dylan for *Highway 61 Revisited* from the elegance and opulence of *Bringing It All Back Home*. *Highway 61*

continued on page 288

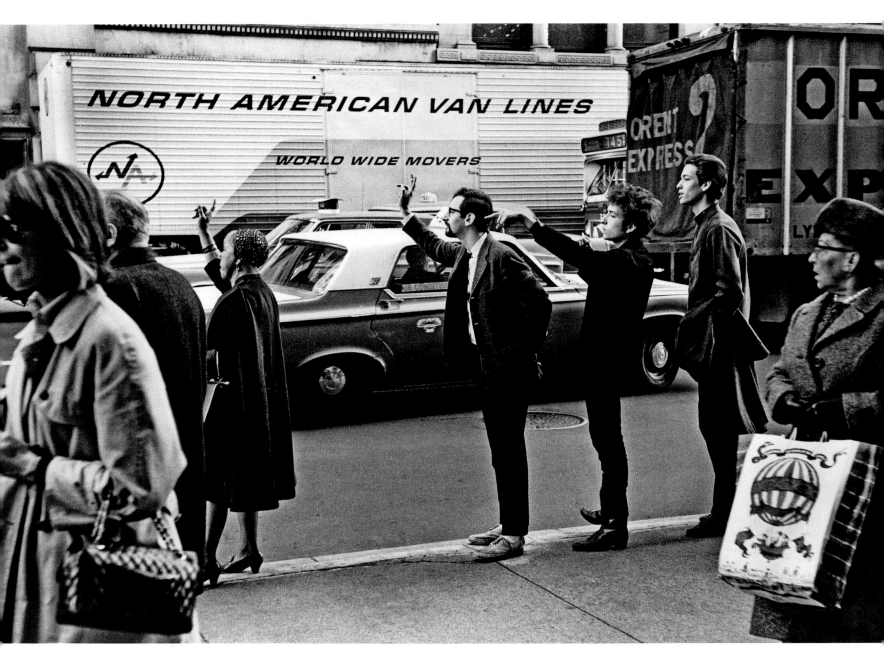

Bob Dylan with Peter Yarrow and John Hammond Jr. hailing a cab, New York City
1965

ROBERTA BAYLEY

The Heartbreakers
1975

CBGB's was my home away from home between 1974 and 1978. I worked the door, saw
the bands, took photographs, met strange and interesting people, had great conversations,
and made lifelong friends. Hilly [Kristal, owner of CBGB] was my guardian. CB's was a
welcoming place for all kinds of people who might not have fit in anywhere else. . . .

—ROBERTA BAYLEY, QUOTED IN *CBGB & OMFUG: THIRTY YEARS*
FROM THE HOME OF UNDERGROUND ROCK, TAMAR BRAZIS, ED.

Roberta Bayley photographed a baby-faced Johnny Cougar, aka John Mellencamp, in 1976 and Elvis Costello in 1978 and, famously, the Heartbreakers in 1975 in "bloodstained shirts" made from Hershey's chocolate syrup judiciously squirted over their hearts. Bayley's simple backgrounds highlight just how good she is in knowing exactly when to click the shutter to get the most deadpan moment out of each photo session. Her photographs of punk groups are like police lineups but totally compelling because the suspects are all so interest-

ing. No one ever smiles in a Bayley photo. There is this quality of "I look at you, you look at me, let's keep this real and get it over with—unless we want to fool around and have some fun. Otherwise, we are just going to stand here." Her pictures should be boring, but they never are—in fact, they are refreshing because they lack pretension. They are the perfect evocation of punk—the bodies slump, the smiles are nil, the clothes have holes, the eyes are shot, and everyone is young.

This photograph of the Ramones was used on their first album cover. It was originally shot for *PUNK*, the

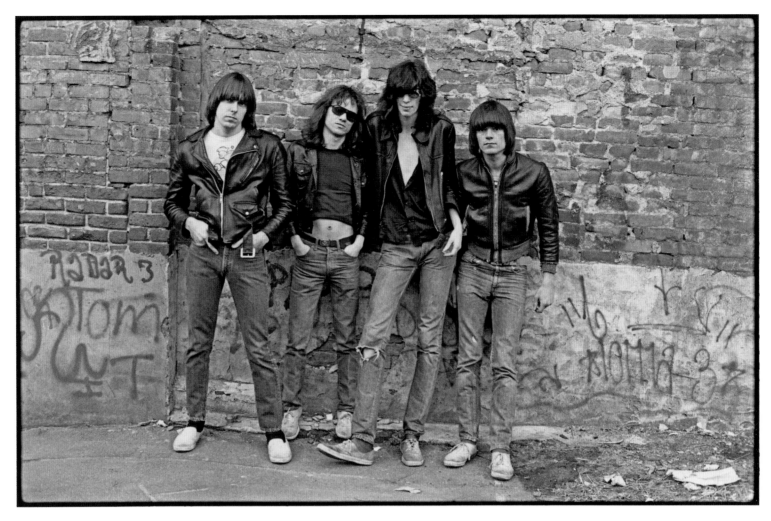

The Ramones (left to right: Johnny Ramone, Tommy Ramone, Joey Ramone, and Dee Dee Ramone), New York City
1976

outrageous magazine edited by Legs McNeil and John Holmstrom, with photographs by Bayley in each issue. Such classic photo cartoons as "The Legend of Nick Detroit" (October 1976) and the "Mutant Monster Beach Party" (1978) were photographic and conceptual tours de force. As Bayley says of her stint at *PUNK,* "I learned the true meaning of creative insanity."

This photo wasn't supposed to be the cover for the Ramones' first album. Their record company, Sire, had hired a professional photographer, but the group didn't like the result. They had blown their photo budget and could pay Bayley only $125 for what has become the classic Ramones image. The Ramones' tight, torn jeans, sneakers with holes, and leather jackets launched millions of kids in torn jeans, holey shoes, and short leather jackets. (As everyone who knew them reports, the holes were there because they couldn't afford new clothes.) Their style, haircuts, and attitude, as communicated through photographs, were every bit as important to their fame as any song they ever played.

JIM MARSHALL

Jim Marshall cares about musicians. His photographs are never skin-deep. He doesn't, to paraphrase the way Marshall speaks, give a fuck about making a buck if it means exploiting people he respects. "I feel that in my photographs there is a trust given by the artists. When I point the camera at somebody, there's a covenant, and I will not violate that trust," he says. He is a difficult man who sets his own rules. He also sets his own standards, which are much, much higher than most people's in the business.

My style is that I don't have a style. I never do anything the same [way] twice. When you see my pictures, it's about the person in the photograph, not me—not the guy behind the lens. I want someone to see those people, not my picture of them. When I'm able to capture the essence of my subject and show something of what they do or reveal who this person is, then I've achieved what I want to do.

—FROM THE INTRODUCTION TO
NOT FADE AWAY, BY JIM MARSHALL

There is no "bullshit" in Marshall's photographs. He makes honest pictures: Mama Cass and Michelle Phillips joking on a tour bus; Otis Redding singing his heart out at Monterey Pop; Bob Dylan kicking a tire on a Sunday morning in New York, with garbage on the street left from the night before; Michael Bloomfield slouched in a chair listening to a playback at Columbia Studios; Johnny Cash with a friend in Hendersonville, Tennessee; Keith Richards backstage playing guitar, completely lost in his music; and lots of musicians hanging out, happy, in the old days, to have Marshall around. Marshall says, "I do see the music," and by showing us the vulnerability and souls of the musicians, he makes us see the source of the sound.

This photograph of the Beatles was taken the day of their last concert. That evening, in Candlestick Park, San Francisco, to a loud but not sold-out crowd, the Fab Four performed together for the last time. Marshall was the only photographer allowed backstage, and he had excellent "in the field" opportunities for showing the musicians' last stand as a group.

The Beatles, San Francisco Airport
August 29, 1966

RYAN McGINLEY

Ryan McGinley has been to hundreds of Morrissey concerts. Between 2004 and 2006, he first smuggled in and then openly brought in his camera. He has been a fan (short for "fanatic") since he was sixteen. "I couldn't believe how someone so far away could speak so directly to me. How he could speak so simply, addressing so many of the issues I was dealing with . . . These are my songs just like they are everyone else's, but they are still mine."

It was the "everyone else" that McGinley chose to photograph—the people who share a passion, a sensibility, a love, a moment in time. Using the muted colors of Morrissey's stage lights as they throw hues over the audience, McGinley's pictures are a pastel palette of soft lavenders, oranges, blues—often monochromatic. The technique unifies the audience even as he picks out particular faces in moments of rapture. He is after a feeling he knows well—of belonging, not quite to a religion but to a shared transcendental experience.

At twenty-nine years old, New Yorker McGinley was the youngest artist to ever have a one-person show at the Whitney Museum of American Art. Solo shows around the world, fashion and celebrity shoots, and, most of all, a fanatical following not that dissimilar to Morrissey's followed.

"Untitled (Morrissey 7)"
2005–2006

HANNES SCHMID

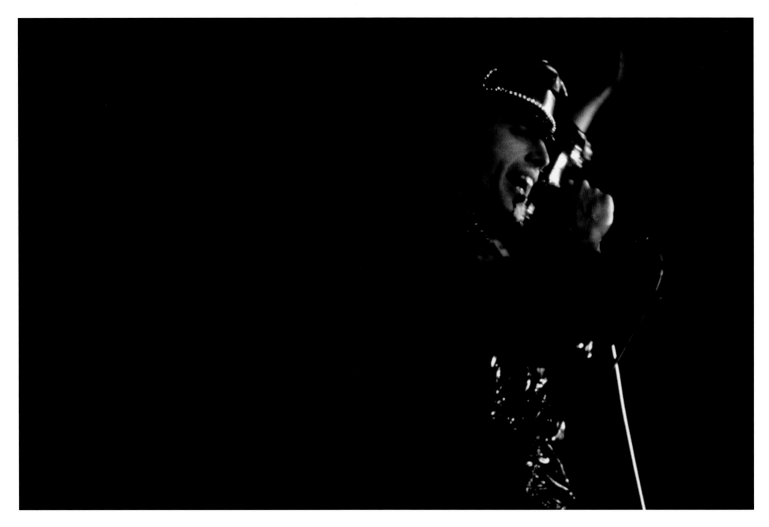

Freddie Mercury
1982

This photograph of Freddie Mercury, a flash on a dark stage, is part of Hannes Schmid's "Blackstage" series. Although all eyes are on the performer, the musician onstage is blinded by the lights illuminating him or her, and cannot see the audience. The star becomes like an electric current onstage, radiant energy pulsating in the dark void. In this series of photographs, ZZ Top is a luminous beard and the tip of a cowboy hat; Tom Scholz is a wave of red hair; Bob Marley is dreadlocks glowing like a set-ting sun; David Lee Roth is a punctuation mark in red and white; Mick Jagger is a flowing Union Jack and tight red pants; Angus Young of AC/DC is a blue-green aquaticlike monster; Ian Dury is a red scarf and sequined jacket; the Bee Gees are a single flame; Frank Zappa is a bodiless profile, arm, and guitar; and Rod Stewart is eliminated in a flash of white light. Schmid's goal in "Blackstage" is to communicate a sense of the musician being *alone* onstage with just his or her music.

BOB GRUEN

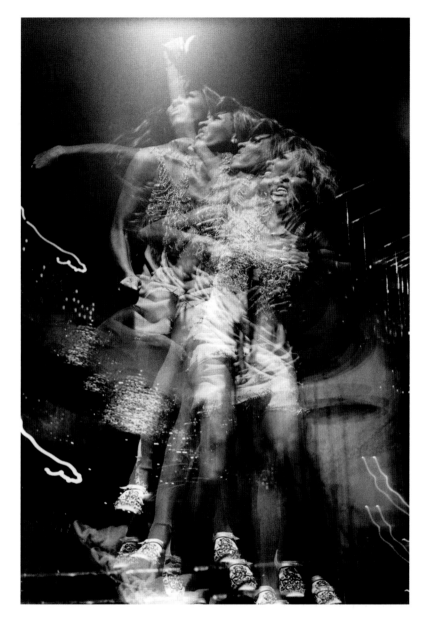

Tina Turner, Honka Monka Room, Queens, New York
1970

ob Gruen's career began in 1970 with Tina Turner. Ike Turner saw the photographs Gruen shot of Tina at the Honka Monka Room, liked them, and asked him to go on tour with them. Ike also graciously introduced the young photographer to many people in the business. The Turners' album *'Nuff Said* was Gruen's first cover.

Gruen tries to capture the "passion and emotion" of the performers onstage. He can't abide by the rule laid down by the industry whereby photographers are allowed in the "pit" for the first three songs at a concert, and then

continued on page 288

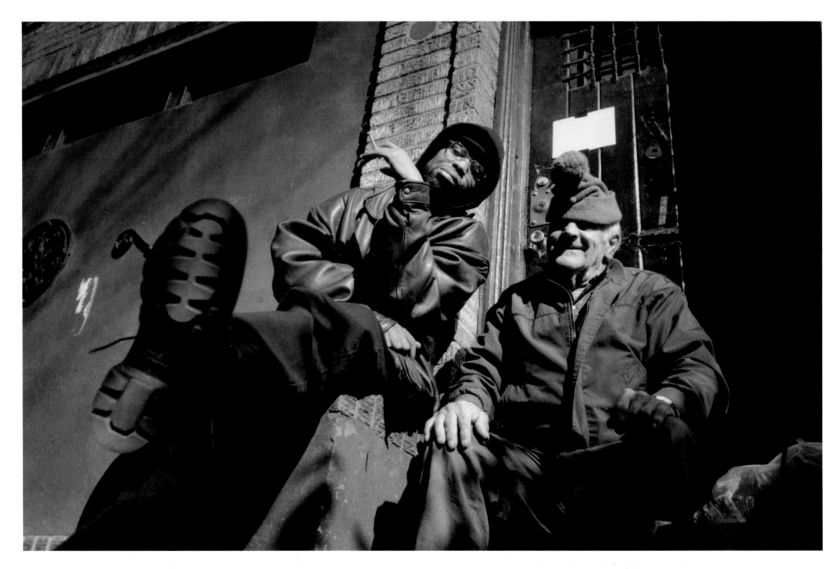

"Wu-Tang Clan's Method Man Kickin' It with Huckleberry Mahoney," West Fourth Street, New York City
1996

RICKY POWELL

I never set out to be a photographer. I started taking pictures in '85, but it was really just a hobby—I was getting my B.S. in Physical Education at Hunter College. . . . I was basically just a playground rat who knew a dope photo when he saw it. . . . I didn't really get serious about my own shots until I saw the Beastie Boys at the Cat Club. . . .

I'm in the front row, and I remember a buzz of anticipation, a loud bass drum beat dropped, and suddenly the boys ran out, slinging beer . . . and cussing. It was dope! They fucked me up, and I loved it. I wound up going backstage to hang out with them, and my days of photography had begun.

—FROM THE PREFACE TO *OH SNAP! THE RAP PHOTOGRAPHY OF RICKY POWELL*, BY RICKY POWELL

The best way to describe Ricky Powell would be with a rap song. Ordinary language just can't hack it. Graffiti over his portrait might conjure an image of the man, but only if it was really clever and funny. Powell can't be described any more than his photographs can be generalized. Each picture is different. Each one has its own rough edges. That is the fun. He is the flip side of slick photography. He hangs out with hip-hop stars and movie stars, dogs, bums, girls, and boys. He is a gate crasher, illustrator, man about town (his part of town), gadfly, fly-on-the-wall photographer who, as the title of one of his books suggests, has "public access" to the wild and woolly New York street, night, and social life.

DANNY CLINCH

Danny Clinch is a believer—in God, in man, in music, in photography. He ends his book *Discovery Inn: The Photographs of Danny Clinch* with a quote from Matthew 6:22: "The light of the body is the eye. If therefore the eye be clear, the whole body shall be full of light."

Clinch is from Tom's River, New Jersey, and is a streetwise kid who never had much ambition until he started sneaking a camera into concerts and realized he was lazy only when there was nothing he wanted to do. Photography courses at the two-year Ocean County College helped him recognize he was good at photography—very good. He started his professional career as an assistant to Annie Leibovitz and Steve Meisel before opening his own studio. He has done album covers and videos for Michael Stipe, David Byrne, Jay-Z, Rage Against the Machine, Radiohead, Metallica, Nas, Pavement, Johnny Cash, Bruce Springsteen, the Smashing Pumpkins, Dave Matthews Band, Phish, Björk, Tom Waits, and Ben Harper, among others. He photographs the biggest names in the business—but connects because he really does remember his roots—and still lives with his wife and children in New Jersey. Also, he is totally into the music. He plays the harmonica, occasionally even for Foo Fighters' recordings.

Clinch was a key figure at the Tibetan Freedom Concerts from 1996 to 1999, taking photographs of the musicians, security guards, Tibetan monks, and human rights activists. They are collected in his book *When the Iron Bird Flies*. The book ends with another favorite quote from an eleventh-century Tibetan saint: "The light filling space is Compassion dispelling the darkness of ignorance."

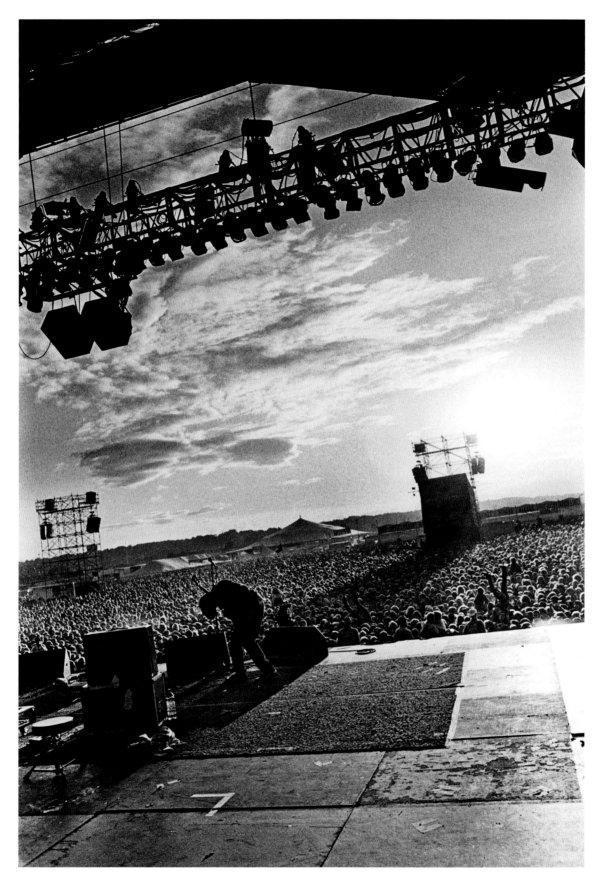

Pavement, Reading Festival, Reading, England
1995

ADRIAN BOOT

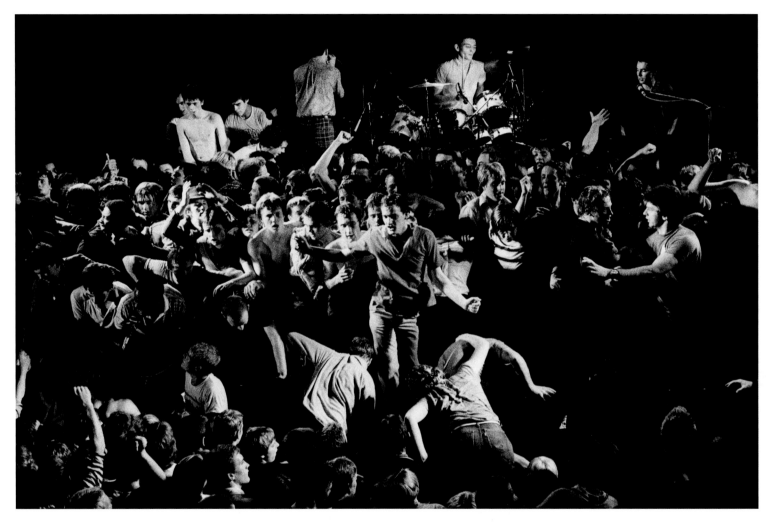

The Specials, Top Rank Theatre, Brighton, England
1981

The promoter of the Specials' gig was buried under the collapsing PA system. He tried, and failed, to stop the stage invasions, usually confined to smaller venues than the Top Rank Theatre in Brighton. But these were the hellfire days of punk, and Adrian Boot's picture has a bit of Hieronymus Bosch about it. As Boot says, these rushes couldn't happen today because the stage is roped off. Hence the tender memories of not wine and roses but bangs and bruises. The Specials kept on playing as long as they could and Boot retreated to the balcony in order to get perspective on the scene.

continued on page 288

MICHAEL ZAGARIS

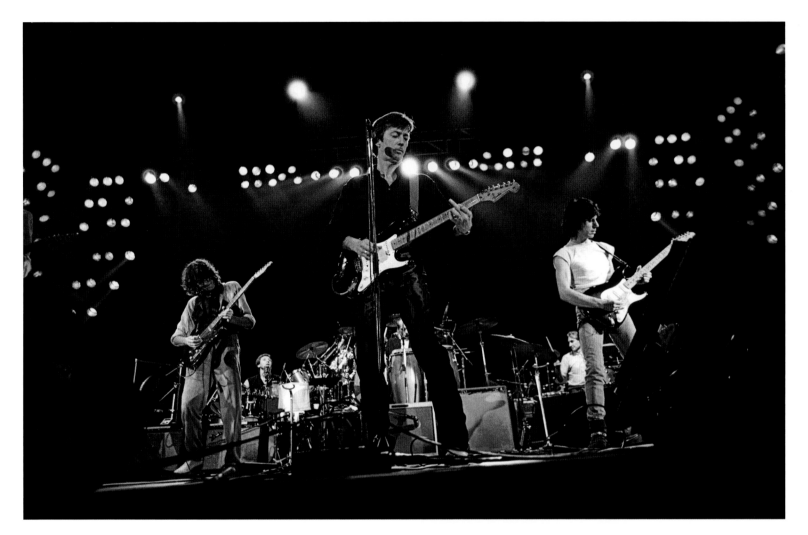

**Jimmy Page, Eric Clapton, and Jeff Beck with Charlie Watts on drums,
ARMS (Action for Research into Multiple Sclerosis) Benefit concert, Cow Palace, San Francisco, California**
December 1, 1983

Michael Zagaris was a brainy kid. He went to college, he went to law school, he worked for the Kennedys. He was standing behind Robert Kennedy when RFK was shot. His world fell apart.

Like many of his generation, after John F. Kennedy, Martin Luther King Jr., and Robert F. Kennedy were assassinated; after cities burned; and while the Vietnam War seemed without end, young men and women dropped out and turned on. Zagaris went to San Francisco in 1973, "dabbling in LSD and mescaline—in search of self, in search for truth," he said.

continued on page 289

DENNIS MORRIS

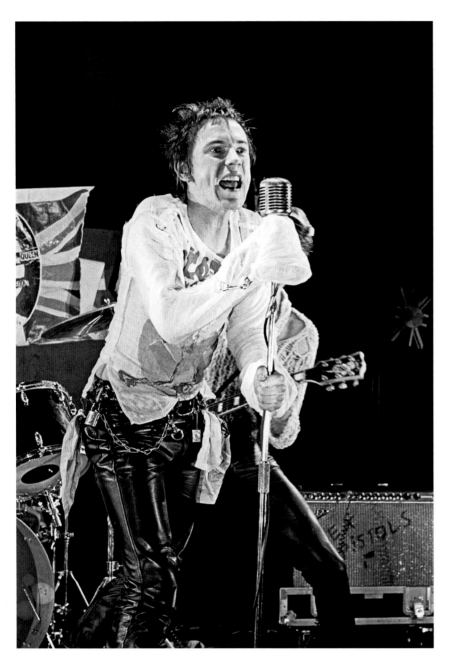

Johnny Rotten, the Marquee Club, Soho, London
1977

en years after the Jimi Hendrix Experience gave a virtuoso performance at the Marquee Club (see page 231), the Sex Pistols insulted and self-mutilated and were obnoxious on the same London stage. "Actually, we're not into music, we're into chaos," opined guitarist Steve Jones. Nevertheless, the sheer force of Johnny Rotten's voice, a "voice that denied all social facts, and in that denial affirmed that everything was possible," as Greil Marcus writes in *Lipstick Traces*, is captured perfectly in Dennis Morris's picture. "Everyone shouted past melody," continues Marcus, "then rhyme, then harmony, then rhythm, then beat, until the shout became the first principle of speech—and sometimes the last."

Morris literally jumped on the bus—the Wailers' bus—when he was a fourteen-year-old schoolboy and Bob Marley had taken a fancy to the black kid with the camera at one of his concerts. (Morris had his first photograph published when he was eleven years old.) Morris's pictures of the Wailers were so alive and unposed they attracted Johnny Rotten's attention four years later. Morris, now eighteen and the same age as the Sex Pistols, was asked to go on tour with them—the 1977 tour to give the Brits something to think about other than the queen's Silver Jubilee. Morris had complete access. He captured the performances, the craziness, and the behind-the-scenes shots. These "punks" actually didn't know how to eat "proper." Bad manners make great copy, and the Sex Pistols, in the photographs by their "official" photographer, Morris, were everywhere. Punk is photogenic. There is something simultaneously compassionate and frenetic in Morris's pictures.

IAN DICKSON

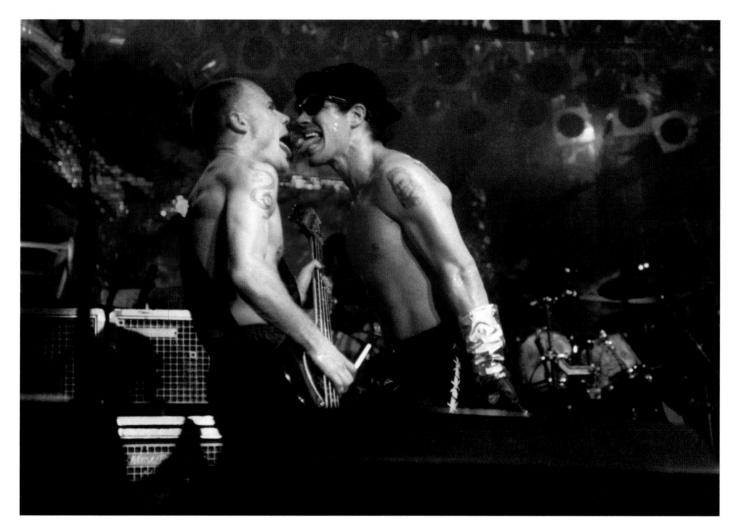

Red Hot Chili Peppers, Hamburg, Germany
1992

an Dickson photographs the lump in Robert Plant's tight pants, the thrust in Paul Weller's guitar stance, the veins in Iggy Pop's chest, the sneer on Steven Tyler's face, the wide-open mouth of Mick Jagger, and the red, the hot, and the insane in the Red Hot Chili Peppers, because it helps with understanding his subject—rock and roll. Unlike other photographers whose vision is interchangeable with, for example, shooting sports or shooting celebrities, Dickson is a music photographer through and through. He sees the music, feels the vibes, loves the audience reaction, and makes one understand that his subject is unique, profoundly visual, and central to comprehending the adolescent (and older) human experience.

GERED MANKOWITZ

Rock blows your mind. Gered Mankowitz created a portrait of Jimi Hendrix that does the same thing. His mammoth (131 × 81-inch) lenticular portrait is made up of nineteen images arranged in six panels, three different images in each panel except for an additional fourth image in the central panel on the bottom row ("the now you see it, now you don't guitar"). The photographs were shot in Mankowitz's London studio in 1967, and the lenticular was assembled in 2006. Hendrix's spirit is resurrected. Hendrix moves nice and slow.

Ninety-nine out of one hundred lenticulars are tacky. You buy them as postcards at holiday resorts, find them as prizes in Cracker Jack boxes, see them as large-size advertisements in airports worldwide. They are all made with a lenticular lens and give an illusion of depth or the ability to change or move as the image is viewed from different angles, but rarely are they a thing of beauty and imagination. Mankowitz's six-panel tour de force is just that.

The 3-D lenticular technology has been known since the 1940s but it was improved upon in the 1960s by Cowles Communications, which published *Look* and *Venture* magazines. Championing innovation, Cowles wanted something thin and pliable to use on the cover of its travel magazine *Venture*. With scientists in Japan,

Cowles came up with a suitable product, now known as the lenticular image.

In 1967, Maurice Tuchman, curator of Modern Art at the Los Angeles County Museum of Art, partnered artists with scientists, engineers, and industrialists in a project called "Art and Technology." An exhibition of the same title followed. Tuchman and his associate Jane Livingston put Andy Warhol and Cowles Communications together and the result were two flower lenticular pictures, similar to the daisies Warhol was doing with silk screen at the time. The lenticular flowers had the power of a 3-D punch and were probably the first time the technology was used effectively for artistic ends.

Mankowitz first saw a lenticular image in 1965 when, as the Rolling Stones' "official" photographer, he was on tour with them in the United States. He writes in an e-mail to the author, "I remember showing Mick [Jagger] and Charlie [Watts] the lenticular postcard I bought in Times Square. . . . It was a risqué image of the Madonna flashing her breast as you moved the card—very racy for '65 and fun too! The guys thought it was amusing as well and a couple of years later they produced a lenticular cover for their *Satanic Majesties* album—I was never sure if there was a connection or not."

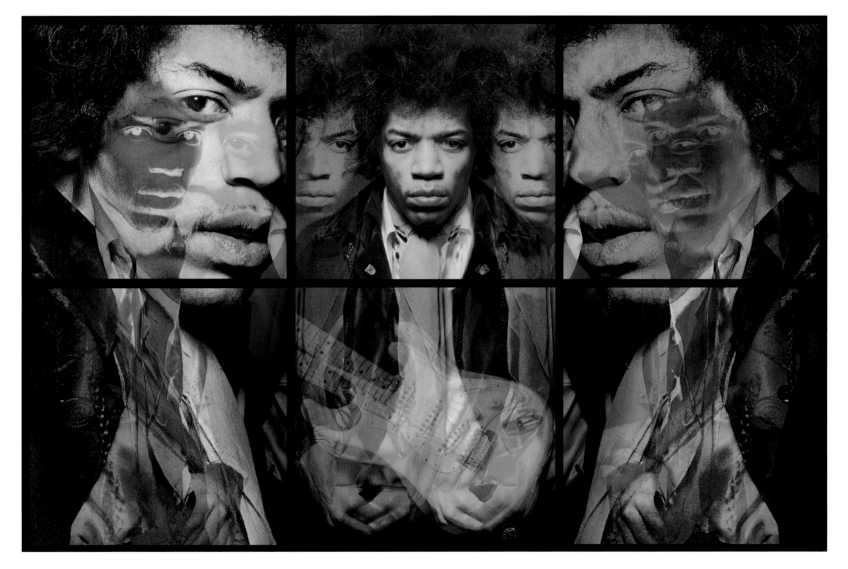

Jimi Hendrix, lenticular image
1967/2006

ANDREAS GURSKY

Andreas Gursky is the perfect photographer for Madonna—not Madonna in detail, Madonna in the marketplace. Gurksy's photography is no more real than Madonna's latest incarnation. Scholars write about Gurksy's exploration of "the hyper-capitalism of today's globalized society" and how we are bound together by "our consumption of globally marketed products" (Nina Zimmer, "Pyongyang: A State of Exception"). Gursky explores what Madonna markets. And like Madonna, Gursky does so with extravagance, skill, careful production, and a lot of manipulation.

"Madonna I" was made by combining fifteen images on a computer. Like an orchestra playing a crescendo, the fifteen exposures combine to make one fantastical, riveting picture. The photographs were taken over a few days from the same vantage point and at the same time near the end of a Madonna concert when the lights flash, confetti falls, and people hang upside down from scaffolding that is mechanically lowered toward the stage. The shots, taken from the upper edges of the belly of the monster, feel almost celestial—Madonna is taking us to heaven.

"Madonna I," Los Angeles, California
2001

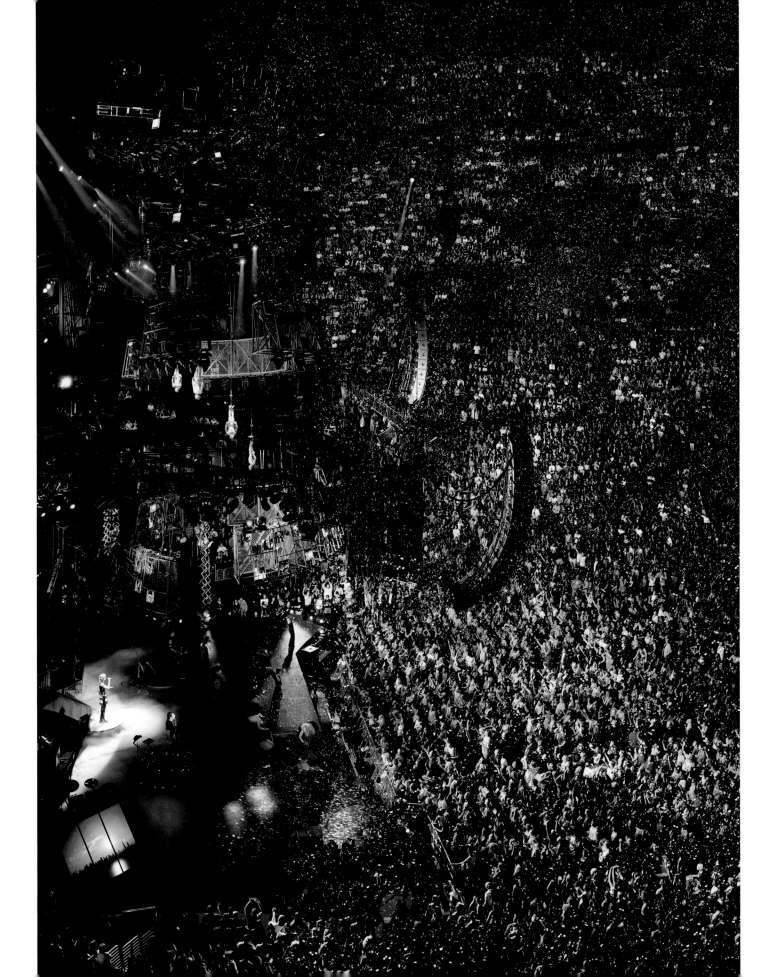

MICK ROCK

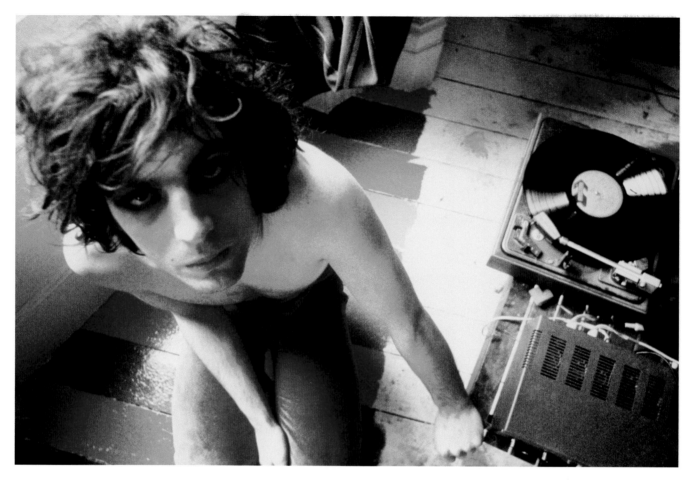

Syd Barrett with record player (Syd's apartment), Earls Court, London
September 1969

n Tom Stoppard's play *Jumpers*, people's surnames are their destinies. Mick's last name really is Rock—Michael David Rock.

Rock, like Stoppard, has Cambridge connections. Rock went to Cambridge University and studied modern languages and literature. Stoppard's play *Rock 'n' Roll* centers on a group of academics and intellectuals in Cambridge, England, and Prague, Czechoslovakia. Rock knew and photographed Syd Barrett, a founding member of Pink Floyd. Stoppard's play concerns the revolutionary power of rock-and-roll music, and Barrett is a constant, though unseen, presence in the play. The best line in the play is spoken by Jan, the protagonist and the author's alter ego, when asked why he returned to Prague in 1968: "I came back to save rock 'n' roll—and my mother, actually."

This photograph of Barrett was taken after he had left Pink Floyd. It is a picture of a brain dwarfing a body, weighing the body down. An Alice in Wonderland–like moment—as if Barrett popped a pill and became small, except the pill made the head very, very large. The record player is his nemesis . . . or savior—hard to say.

Rock met Barrett at the Cambridge Arts College Christmas party in 1966, the first time he heard Pink

continued on page 289

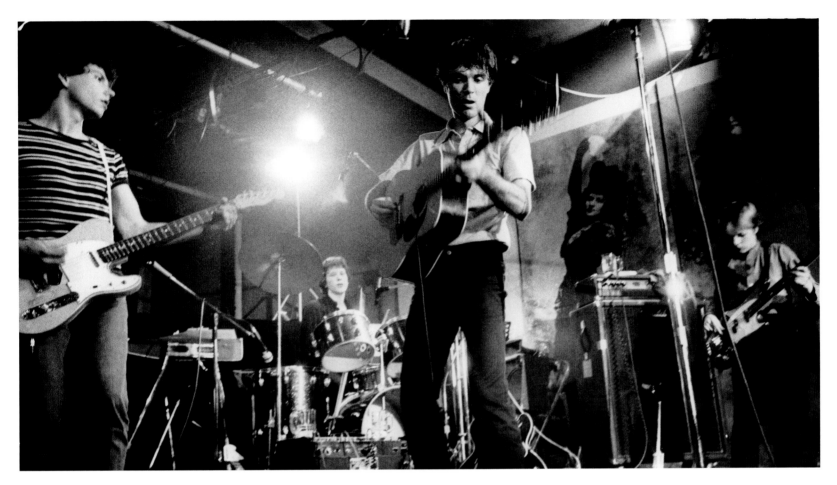

Talking Heads, CBGB, New York City
1977

Jerry Harrison on guitar, Chris Frantz on drums, David Byrne as lead singer–guitarist, and Tina Weymouth on bass play their first gig at CBGB. It is hard to take a good photograph of four people playing on a stage. It is hard to get a good angle. Rarely does the composition make the image compelling; more often it is the performers' sex appeal or clothes that catch the eye. Sometimes it is just the sheer energy of the performance that is photogenic. Godlis's picture of the Talking Heads is an exception. It is precisely composed. The famous CBGB Edwardian dance hall girls seem to be part of the performance. Lines con-

verge on Byrne, lights pop. There is a geometry and form to the picture that makes it resonate.

In *CBGB & OMFUG: Thirty Years from the Home of Underground Rock*, John Holmstrom, the co-founder of *PUNK* magazine, said there wouldn't have been the Talking Heads—or Television or Patti Smith or any punk rock (or its progenies, hardcore and grunge)—without CBGB: "[It] got to be the most important club in rock 'n' roll history." There would have been only "disco, hair metal, Madonna and MTV." Godlis's photograph is also a study of the womblike stage at CBGB that birthed all those bands.

STORM THORGERSON

STORM THORGERSON

The only limitations are your imagination and the photos with which you start.

—STORM THORGERSON IN *THE WORK OF HIPGNOSIS: "WALK AWAY RENÉ,"* P. 25

Who the hell needs to understand everything anyway?" said Robert Plant, in response to an album cover design presented to Led Zeppelin by the incomparable design team Hipgnosis. Storm Thorgerson said, of that now famous curiosity on the cover of the LP *Presence* (see p. 12), "The black object is as powerful as one's imagination cares it to be, and Zeppelin could, rightfully perhaps, feel the same about themselves in the world of rock music." And here you have the power of Hipgnosis and Storm Thorgerson designs—they open up the imagination.

Walter Pater said all the arts aspire to the condition of music. Music can't be explained in words. Hipgnosis and Storm-Studios' album cover art (some of which prefigures fine art photography—Gregory Crewdson's suburban melodramas, for example) reach the "condition of music"—mysterious, seductive, compelling, haunting, beautiful, startling, discomforting, and inexplicable. Thorgerson writes, "Perhaps a design can be a visual mnemonic like a catchy tune and therefore promote the album by

Pink Floyd, *Tree of Half Life*
Design and photography by
Storm Thorgerson and Tony May
1997

being easily remembered. In the end it may just be a matter of personal choice by the artiste—and perhaps it's simply better now to have an evocative picture, whether portrait or abstract, rather than a boring piece of shit. . . . It is the music that matters—anyone who buys a record for its cover has got to be a little crazy, or very rich. . . . I lament only that record companies generally retreat into tastefulness and predictability . . . for if tastefulness and predictability become synonymous with banality and boredom (which they usually do), then we want no part of it" (*The Work of Hipgnosis: "Walk Away René,"* p. 134).

Hipgnosis did so many Pink Floyd album covers they are honorary members of the band. Thorgerson went to Cambridge High School for Boys with Roger Waters and Syd Barrett. The prism Hipgnosis created for Pink Floyd's *Dark Side of the Moon* represents, according to Hipgnosis, "the conceptual power of the lyrics and the clean and seamless sound quality of the music. The prism idea also echoed [Pink Floyd's] famous and much admired light show." The image itself is life-affirming—magical, beautiful, mystical. This may be the most famous single image in all of rock and roll.

Neither Thorgerson nor Aubrey "Po" Powell was trained in photography or graphic design. They serendipitously started setting up shop as album designers

continued on page 289

How Dare You! (inner spread), 10cc
Design and photography by Hipgnosis: Storm Thorgerson and Aubrey Powell
1975

The idea was prescient—how people connect to or dis-connect themselves from one another. Hipgnosis thought there was no better way of suggesting this than filling a room up with people and having them speak into tele-phones (rotary phones with cords) instead of directly to each other. This was decades before cellular phones became ubiquitous. Band members are among the bab-bling guests.

Elegy, the Nice
Design and photography by Hipgnosis: Storm Thorgerson and Aubrey Powell
1971

Storm Thorgerson admits life would be easier if more time was spent dreaming. The cover for the vinyl _Elegy,_ by the Nice, came to him in a dream after listening to the music. A watercolor sketch of Storm's dream was done by Aubrey Powell. The execution was a little tricky. One, fly to Marrakech with sixty red deflated vinyl balls. Two, explain to the Moroccan customs official why it is neces- sary to travel with them. Three, hire a car and drive 250 miles over the Atlas Mountains to the Sahara. Four, inflate sixty balls and try to get them into a Renault. Five, locate a beautiful set of dunes; place balls, with difficulty, in a curved line "without leaving footprints." Six, take the picture during the sunset. Seven, drive over the treacherous mountains at night and get back alive.

continued on page 290

Frances the Mute, the Mars Volta
Design and photography by Storm Thorgerson and Rupert Truman
2004

One of the aspects of the story [of the Mars Volta album *Frances the Mute*] was addiction . . . the idea that the addicted party thinks he's alright and is in control, thinks he knows where he's headed even though still addicted and therefore probably doesn't have a fucking clue . . .

I imagined car drivers navigating their way through town, i.e. through life, thinking they are steering a safe path but in fact having no idea where they are going . . . passing each other as if in normal traffic, blithely unaware it would seem of impending collisions . . . inhabitants in a world of velvet delusion.

—*TAKEN BY STORM: THE ALBUM ART OF STORM THORGERSON*, P. 132

Jimmy Page asked Hipgnosis to come up with some ideas for an album cover. "Good grief," writes Storm Thorgerson in *Taken by Storm: The Album Art of Storm Thorgerson*, "how do you come up with ideas for the biggest band in the known universe?" Presto! Kids from the future in spiritual mass migration leaving the Earth "as a tower of flaming energy" (an idea Storm got from reading Arthur C. Clarke's *Childhood's End*). Powell made the photographs of the two children clambering over the hexagonal rocks of the Giant's Causeway in Northern Ireland in black and white. The weather was "foul," and Hipgnosis had promised Led Zeppelin a "glorious sunrise"—hence the hand-coloring. A bit garish, but that is not why the album was banned in Oklahoma and Spain. Guess.

Houses of the Holy, Led Zeppelin
Design and photography by Hipgnosis:
Storm Thorgerson and Aubrey Powell
1973

MARCIA RESNICK

The royalty of No Wave cinema
(left to right: Scott B and Beth B, Diego Cortez, Lydia Lunch, Johnny O'Kane, Bill Rice, and Adele Bertei), New York City
1980

ow rents in high-risk areas of Manhattan was the reason artists could live in the city in the seventies. Marcia Resnick, a graduate of the Cooper Union and the California Institute of the Arts, got a job teaching one day a week at Queens College. She was paid $200 a month; her rent was $70 a month.

Every night she hung out with the musicians and film-makers who were her age, many of whom had also been to art colleges. Punk, New Wave, No Wave—New York was exciting and the creative energy was phenomenal.

Resnick was everywhere and knew everyone and, more important, brought intellectual and creative ideas to the

continued on page 290

JEAN-MARIE PÉRIER

Chuck Berry, Atlanta, Georgia
October 1964

The French photographer and filmmaker Jean-Marie Périer had two extraordinary teachers—Daniel Filipacchi and Maurice Tabard. At sixteen, Périer was an assistant to Filipacchi, who was then a photographer at *Marie Claire*. Also at *Marie Claire* was the surrealist photog-rapher Tabard (Périer remembers him "sweeping floors"), who is now recognized as one of the great twentieth-century French art photographers. He was the "old man" to whom no one gave much respect, but in 2008, Périer wrote to the author: "Tabard showed me what was photography. He had this little lab he had made in the

continued on page 290

LINDA McCARTNEY

Linda McCartney started photographing in the sixties, like many people of her generation. Young people were learning how to use the camera, not in a technical sense but as a form of visual literacy and self-discovery. The camera was a tool for connecting with people and exploring the world, and an aid to new ways of seeing.

The sixties' generation was not going to portrait studios. They wanted to be pictured running barefoot through fields of wildflowers. McCartney was a photographer of her generation—not because she photographed almost all the rock-and-roll heroes but because she insisted on seeing the world passionately from a multitude of perspectives.

Before Linda Eastman married Paul McCartney, she earned her living as a music photographer. Talking about her early days in New York as a young photojournalist, she said:

> These were the days when Jimi Hendrix would walk up to see me at my apartment, and when Jim Morrison and I would go down to Chinatown to eat. I can remember going out to buy peanut butter with Janis Joplin for a late-night feast and traveling out on the subway with Jackson Browne. People who later became icons were on the brink of their careers wondering whether anybody was ever going to notice them.
>
> That's what made it exciting to be taking photographs. It was before the self-consciousness set in. I wanted to record what was there—every blemish, every bit of beauty, every emotion. I wasn't interested in manufacturing a show business image.

—FROM THE INTRODUCTION TO
LINDA McCARTNEY'S SIXTIES: PORTRAIT OF AN ERA

Her first important shoot was in 1966, when she got herself on a yacht in New York Harbor with the Rolling Stones. Her camera angles made the viewer feel like they were snuggling up to the Stones, and it was hot. Not as hot, though, as a picture years later of a naked Paul with their infant daughter on his tummy as his only covering.

McCartney was never exploitative; tender is her style. Paul McCartney is one of the world's most public figures. In "My Love. London," Linda records the feeling and complexity of sitting next to her husband in the car. There is a familiar world out there, now viewed only at a distance through stardom, but inside the car is intimacy and security.

"My Love. London" (Paul McCartney)

1985

Elvis Costello, Paris
1989

CLAUDE GASSIAN

lvis Costello would be the first to admit that "no one ever bought one of my records because of my looks." He says he could have gotten contact lenses, cultivated a cooler demeanor, but realized "miraculously" he had sex appeal from the get-go. In Claude Gassian's photograph, reminiscent of a Bill Brandt portrait with its expanse of black and white and off-centered composition, he looks mysterious with his two fingers raised against his face. The wide-rimmed glasses add to the geometry of the haunting picture.

Oliver Craske, in the catalogue for the Gassian exhibition at the Govinda Gallery in Washington, D.C. (April 13–May 12, 2007), writes about Gassian's photographs: "His images frequently defy the expectations of the genre. His subjects, pictured in corridors or hotel rooms, on the pavement, or, more often than not, against that great backdrop . . . the architecture of Paris, seem to disappear into the shadows of the corners of the frame, blending into the landscape . . . Boxed in, blending in, enclosed by their surroundings, submerging the ego: not how we usually see rock stars."

Gassian says: "The environment and light are two fundamentals but what interests me is the final photographic result. It must be more than the simple presence of a star before a lens. I am often looking to merge the artists into a setting and make them a little more anonymous." Anonymous? Again, not the usual goal of a celebrity photographer. Gassian's brilliance is that he eliminates the distance between subject and viewer and creates encounters. A Gassian photograph never has the subject on a proverbial pedestal.

Photojournalists are witnesses to social and political movements. Music photography, outside of studio portraiture, is a subdivision of the genre. Gassian, like many of his colleagues, was present during times of great change. He emotionally describes a photograph he took of Keith

continued on page 291

James Brown, a hotel in Paris
1986

STÉPHANE SEDNAOUI

This is a picture of a woman in control. Björk is provocative as she radiates independence, beauty, and sensuality. She is one of the greatest and smartest creators/destroyers of cultural myths performing today.

This photograph of Björk, taken by Stéphane Sednaoui, her former lover, is tender and joyful. In the history of photography, the most deeply sensual images have frequently been made by lovers in the spirit of collaboration. Alfred Stieglitz's extended portrait of Georgia O'Keeffe comes most readily to mind.

Sednaoui, born in France, is perhaps best known for his music videos—Red Hot Chili Peppers, U2, Madonna, the Smashing Pumpkins, Mirwais, R.E.M., Alanis Morissette, and, of course, Björk. He has also photographed the usual suspects of celebrities for all the usual magazines.

Björk
Summer 1995

JIM MARSHALL

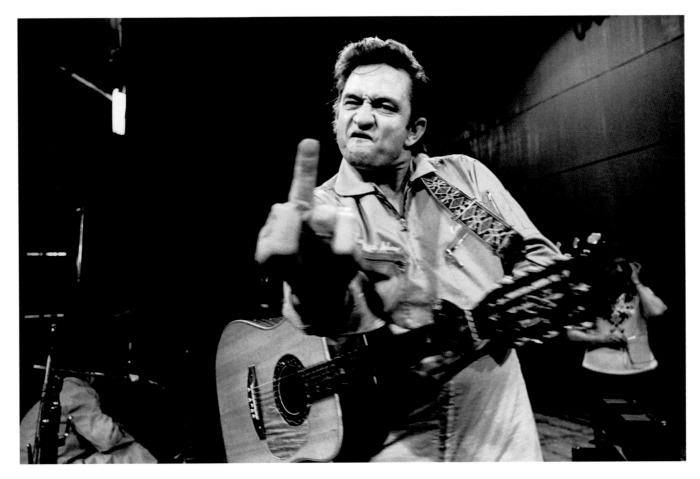

Johnny Cash (flipping the bird), San Quentin Prison, California
1969

Jim Marshall went to San Quentin Prison with Johnny Cash to photograph the concert Cash was giving for the prisoners. During a sound check, Marshall remembers shouting out, "Let's do one for the warden!" Cash's version is that the finger was aimed at the television crew that had been following him around. What matters is that both Marshall and Cash live/lived at their nerve endings—wound up, reactive, burning with their individual creativity. Great portraiture is about relationships. Two greats—Jim Marshall and Johnny Cash—ignite.

ASTRID KIRCHHERR

The art student Klaus Voormann wandered into the Kaiserkeller club in Hamburg one evening in 1960 and was overwhelmed with what he saw and heard. He insisted his classmates, Jürgen Vollmer and Astrid Kirchherr, join him the next evening to see the British group the Silver Beatles. These young German students had never heard rock and roll. They were blown away once they did. Kirchherr said, "It was like a merry-go-round in my head, they looked absolutely astonishing. . . . My whole life changed in a couple of minutes. All I wanted was to be with them and to know them."

Kirchherr was not only a subtly gorgeous, mysterious blonde who, when she sat in the front of the club every evening, caught the eye of John, Paul, George, Pete, and, most especially, the bassist Stu Sutcliffe. She and her friends wore black and made sure to look "moody." As Kirchherr said years later, they were "little kids" reading Sartre and trying hard to look cool by dressing like "French existentialists."

John Lennon and Stu Sutcliffe, former art students in Liverpool, were as intrigued by these three young Germans as the German students were by them. The British musicians and Kirchherr, Vollmer, and Voormann were all experimenting with alternative lifestyles and reinventing themselves in a Europe that was only slowly emerging from the horrors of the Second World War.

Kirchherr, studying photography at college, asked the Silver Beatles if she could photograph them. The Hamburg Fun Fair was chosen as a location by Kirchherr because of the "busted things" and "old rusty steel wagons" (perhaps a metaphor for the past that this new group was about to transform into a new world).

Astrid had never seen a real rock-and-roll photograph, but she was a talented photographer and made the first great series of pictures of the Beatles. Prior to her pictures, they had only snapshots. Kirchherr says of the Beatles in 1960, "They were just discovering who they were and I think that [my] photos helped them make that discovery."

In Kirchherr's touching book *When We Was Fab* she writes: "The Beatles weren't famous at all. They were just young boys with great talent, wonderful humour and intelligence. What amazed me was that, behind all the outfits and rock and roll behaviour, they were very sensible, sensitive young men looking for something new in life, which was exactly what I was doing then in the Sixties. We were so confused straight after the war and we were searching for ways to exist."

And to set the record straight, she insists she did not "create" the Beatles' famous sixties haircuts. Lots of her friends in art school had the look. She just, upon her fiancé, Stu Sutcliffe's, request, cut his hair that way, and the other Silver Beatles followed.

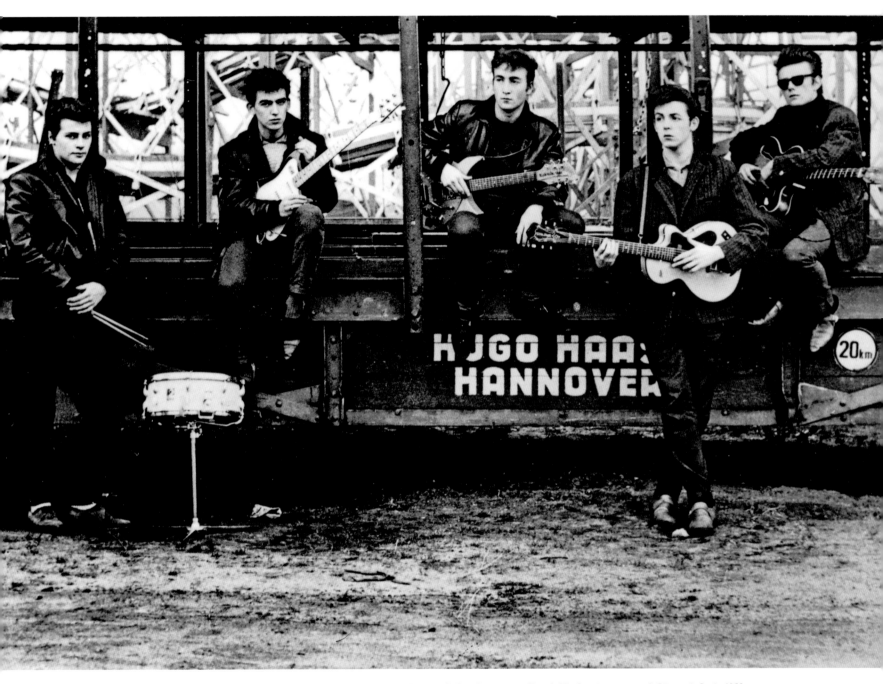

**The Beatles in Hamburg: Pete Best, George Harrison, John Lennon, Paul McCartney, and Stuart Sutcliffe,
Hamburg Fun Fair, Hamburg, Germany**
1960

BARON WOLMAN

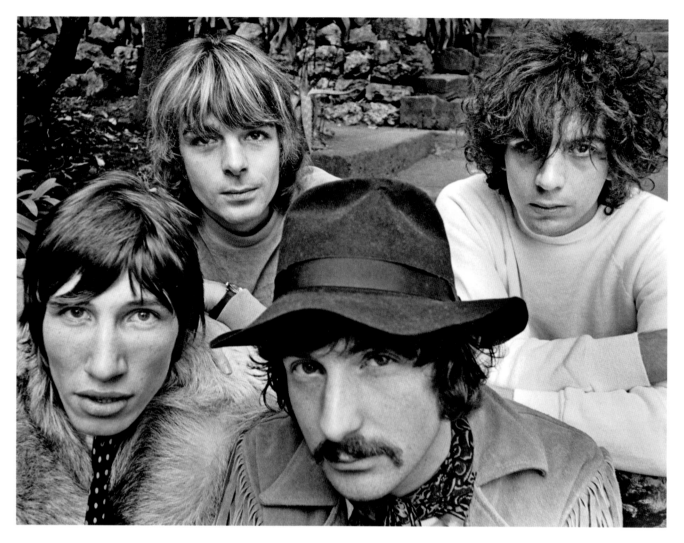

Pink Floyd, Casa Madrona Hotel, Sausalito, California
November 1967

n November 1967, Baron Wolman, chief photographer for the recently launched *Rolling Stone* magazine, made some of his defining images: Janis Joplin in Haight-Ashbury, the Steve Miller Band in Golden Gate Park, the Who at the Cow Palace, and Procul Harum and Pink Floyd in Sausalito.

David Gilmour of Pink Floyd said, "We were always incredibly uncomfortable . . . with photo-sessions. We tended not to use pictures of ourselves on the album cov-

ers, partially because of our discomfort with photo-sessions" (Jill Furmanovsky, *The Moment*, p. 122). The awkwardness is there in Wolman's group portrait, but so is the unwillingness to turn themselves into stereotypes. They are not trying for a look or to even make an impression or to be cool. The photograph is remarkable because of its directness, its honesty, and how it brings out something quite profound in each member of the band.

MARIPOL

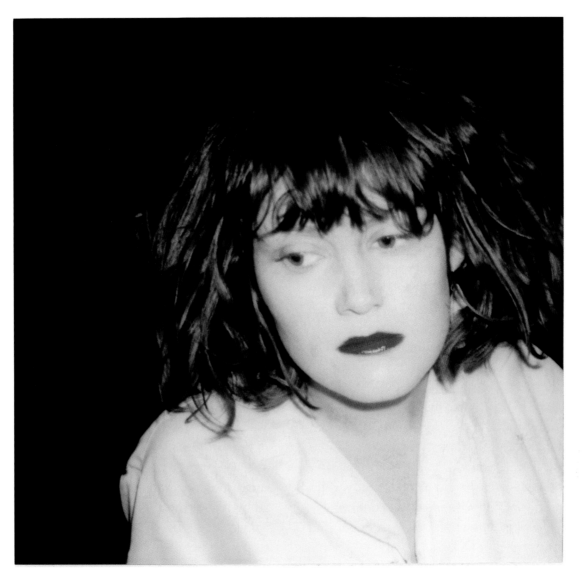

Exene Cervenka, Los Angeles, California
1978

Maripol has magical seeing. In an instant, she sees a person, a place, a time, and a yearning. The time is always "now" in her pictures, but the future looms large. For as she clicks the shutter of her Polaroid, the future has arrived. Her photographs give the moment (for that is all it is) its reality. Maripol is a major chronicler of her times. Her pictures are snapshots of her life and relationships. Her subjects are the beautiful people not because of their multicolor eye shadow and red lips, svelte bodies, and incredible style but because Maripol never lets the dazzling surface hide the burning inside.

HARRY GOODWIN

I started out as a bookmaker," said Harry Goodwin. "It was in my family and in my blood. I used to be a tic-tac man, shouting the odds. You need the same quick reactions for that job that you need to be a photographer." Goodwin is unique in the history of music photography. He is a tradesman who photographed every week the most popular musicians in the United Kingdom for the BBC's *Top of the Pops*. Into their dressing rooms he would come with his big camera and flash, and he wasn't going to take any nonsense from the Beatles, the Beach Boys, the Bee Gees, David Bowie, Cher, Neil Diamond, Freddie and the Dreamers, the Dave Clark Five, Billy Fury, Aretha Franklin, Jimi Hendrix, the Hollies, Michael Jackson, the Rolling Stones, the Kinks, Lulu, Freddie Mercury, Otis Redding, the Searchers, Dusty Springfield, Sandie Shaw, Tom Jones, T.Rex, or Paul Weller. He had a job to do and he was bloody well going to do it and not put up with any prima donnas. He tells the story of almost coming to blows with Bob Dylan in 1966 when, as revenge for Dylan's "grumpiness" during the session, Goodwin doubled his flash on the last shot to temporarily blind Dylan as punishment for a bad attitude.

Most still photographers working for television are forgettable. Goodwin is not. When Cher played in Goodwin's hometown of Manchester, England, many years after his *Top of the Pops* gig, she arranged six front-row seats for Goodwin and his party and dedicated a song to him. He is considered a bit of a British monument because he is the man who made the still pictures that appeared on the TV screen every week in front of 15 million viewers. When the musicians whose music was top of the U.K. charts could not appear live, up on the screen went a Goodwin portrait while the song played. Goodwin, who was at *Top of the Pops* from 1964 until 1973, missed only six transmissions over nine years, even when the program moved from Manchester to London and he had to travel there each week by train.

Goodwin can also be called a baby photographer. Most of the future rock gods he photographed are still quite awkward in front of a camera and struggling with their images. Goodwin doesn't really help them. He just shoots straight. But then, as Goodwin says, "When I have a camera in my hands, something magical happens. I never stop until I have it." That "it" is what photography is all about. A lesser mortal would have been thrown out of those dressing rooms. Goodwin made the stars laugh, and they have ended up in his precious archive of rock—and photographic—history.

Portraits taken for *Top of the Pops* at the Manchester and London, England, television studios between 1964 and 1973

Gladys Knight

Stevie Wonder

Elton John

Sonny and Cher

GERED MANKOWITZ

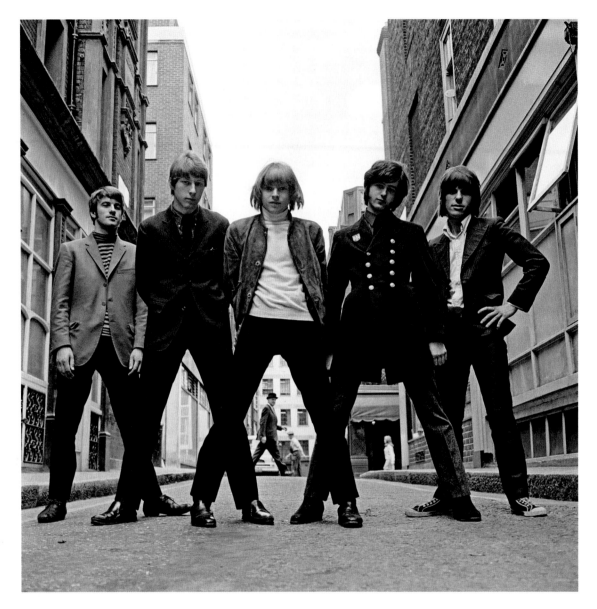

The Yardbirds (left to right: Jim McCarty, Chris Dreja, Keith Relf, Jimmy Page, and Jeff Beck), Ormond Yard, London
1966

ere you have Great Britain, vintage 1966—
the establishment man in his bowler hat
striding confidently, the working man in his
cloth cap staying in the background, the
dolly bird in a miniskirt—all dwarfed by
rock-and-roll heroes.

Gered Mankowitz was only nineteen when he took
this photograph, but he had been running his own
London studio for two years already and was creating
naughty-boy images for the Rolling Stones and tenderly
seductive portraits of Marianne Faithfull. One thing
Mankowitz was sure of: male rock musicians should look

continued on page 291

GLEN E. FRIEDMAN

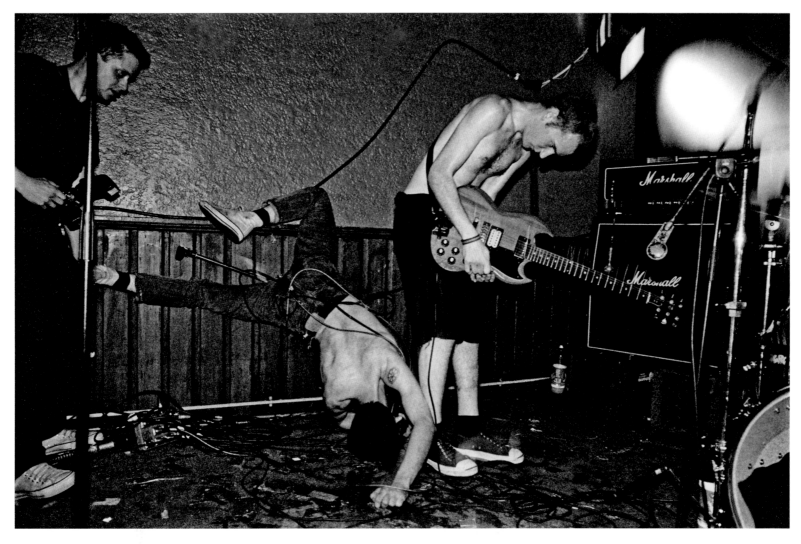

Fugazi (left to right: Guy Picciotto and Ian MacKaye), Maxwell's, Hoboken, New Jersey
May 1988

len E. Friedman gets the photographs he does because, in part, he is a skateboarder. He bends at the knees; eye level for him has an entirely different meaning than for the standing man.

This photograph, from the first time Fried-man shot the band, was taken with flash and used in the inner sleeve of their first release. He writes in his book *Keep Your Eyes Open: The Fugazi Photographs of Glen E. Friedman* that the band Fugazi, which he loves and respects, later became his "laboratory for experiments with light, action, composition and emotion." He

continued on page 291

GEORGE DuBOSE

was lucky throughout my career to wear two hats frequently. I was the photographer and the art director [for album and CD covers]. I got to influence the concept, the image selection, and the design. Didn't leave me too much room to complain," wrote George DuBose.

For many years, DuBose was the go-to man for a concept and photograph for an album or CD cover. He made more than three hundred. He did the first album covers for Melissa Etheridge, Biz Markie, the Go-Go's, Kid Creole, and the B-52s. He helped the Ramones with their last nine covers. He designed or photographed covers for R.E.M., Joan Jett, Run-DMC, Big Daddy Kane, and Marianne Faithfull.

DuBose served as a picture editor for *Interview* and *Spin*, and was a senior art director for Island Records, specializing in black music. He considers this B-52s photograph the beginning of his career.

DuBose was learning the tricks of fashion photography as an apprentice when, in 1978, the B-52s, from Athens, Georgia, played their New York debut concert at Max's Kansas City. He shot them live but the memorable pictures are the frozen frames taken in a borrowed studio. The white background and Mylar carpet were perfect for showing off their angles—hairstyles and kooky fashions. When they were ready to release their first album two years later, they remembered the perfectly stilted picture that just needed outrageous colors to be totally bizarre. The original black-and-white picture was toned sepia to give good flesh tones, and then the art director cut film overlays to give the image its comic-book colors of yellow, red, blue, and white (see page 300).

The B-52s, New York City
1978

BOB GRUEN

I met John and Yoko in 1971, shortly after they moved to New York City. We were friends and neighbors and for nine years I was their personal photographer when they needed pictures for publicity, or for an album cover, or for their family.

John Lennon and Yoko Ono both had a strong sense of history, they knew that the work they were doing was significant. They understood the importance of documenting their lives themselves. They knew the world was watching, and they wanted to have some control of the image they presented.

Through their art they were expressing ideas that were important to them, and they wanted the accompanying photographs to be true to the spirit of their message.

—BOB GRUEN, *ROCKERS*, P. 56

John and Yoko trusted Bob Gruen. This was essential. There was also mutual respect. Gruen has never been the kind of photographer to show someone in a bad light. What is the point, feels Gruen, when you want to be given access again? In an interview he said, "You get better pictures when you know someone better. I like to show a person as they want to be seen." Gruen would release only pictures that Lennon and Ono approved.

The photograph of Lennon in the NEW YORK CITY T-shirt, number 31A on the contact sheet, is one of the most pilfered pictures in the world. Hundreds of street vendors sell it as everything from posters to coasters. Gruen doesn't seem to mind the theft as long as he gets paid when people buy the "real thing"—a print from the actual negative. What bothers Gruen more is that he shot four rolls of Lennon that day and two went missing years ago—lost, stolen, or damaged.

The photograph was taken on the roof of the penthouse apartment where Lennon was staying. Gruen had been asked to take pictures for the *Walls and Bridges* album cover. The background was very "New York." Gruen remembered having given Lennon a cheap NEW YORK CITY T-shirt he bought from a Times Square street vendor. Gruen asked Lennon if he still had it and if he would mind putting it on. People across the globe know the answer was affirmative.

The day Gruen made the Lennon picture, he also shot Siouxsie Sioux and the Banshees, and he remembers making more money on that picture than on the one that would become the iconic John Lennon image. What makes a seemingly straightforward portrait resonate through time?

Lennon is a hero. He was martyred in his adopted beloved city of New York. His music speaks to millions, communicating common ideas that most people can't express themselves. Lennon, in Gruen's famous photograph, has the attitude of a free man who questions authority while searching for his own personal truth. Heroes are people to believe in. Lennon, because of his moral authority and ability to make music that speaks "for us," as Gruen says, is a rock-and-roll hero, and this photograph is a rock-and-roll kind of monument to the man. There is no artifice in this picture, and that is one of the reasons people relate to it so strongly. Maybe it's because Lennon belongs to everyone that Gruen has allowed his democratic "monument" to be shared by so many.

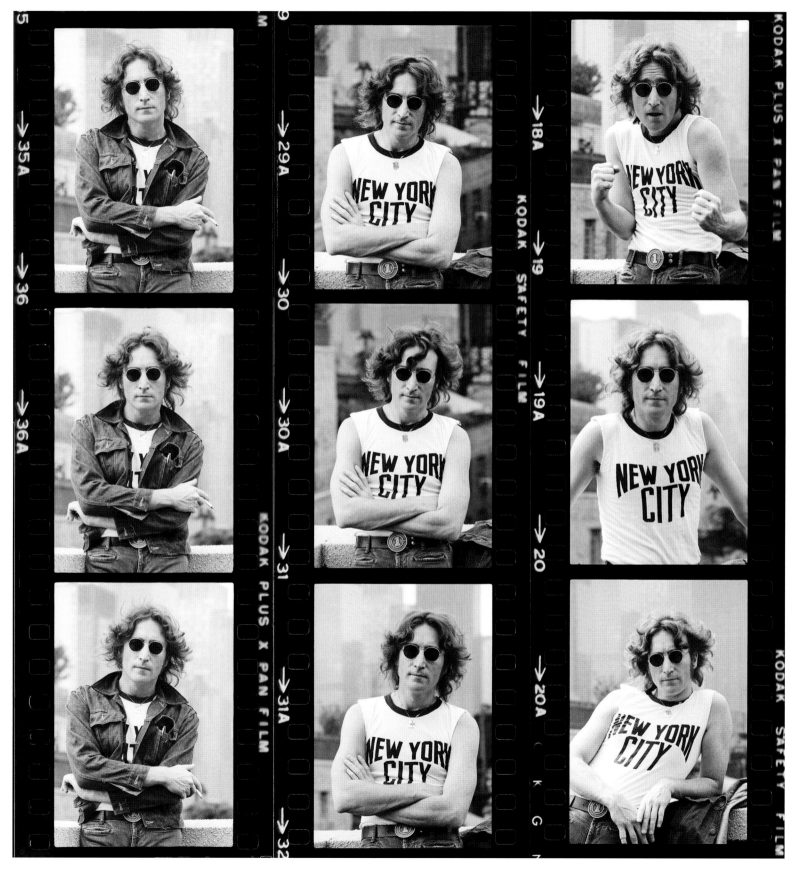

John Lennon, contact sheet from the famous shoot, East Fifty-second Street, New York City
1974

NAT FINKELSTEIN

Documenting Andy Warhol, the Factory, and the Velvet Underground in the sixties was a self-assigned photo essay for photojournalist and rebel Nat Finkelstein. He learned photography from famed art director Alexey Brodovitch ("astound me") and Garry Winogrand, a master of psychologically disturbing street photography. Finkelstein was the Factory's unofficial photographer from 1964 to 1967, or, as he describes it, its "mirror by answering [the] group's insistent desire for publicity." This hard-nosed, left-wing, cynical photojournalist was represented by one of the most respected photo agencies, Black Star. Black Star photographers, including Finkelstein, were particularly distinguished in their coverage of the civil rights movement. Finkelstein was simultaneously attracted and repelled by the goings-on with Warhol and his followers but decided to join the party for as long as he could keep having fun and making his documentary photographs. He tried for objectivity and nuance. He remarked that another reason he enjoyed hanging out was that there was an excess of highly accessible women, as many of the men were gay.

David Dalton, a founding editor of *Rolling Stone*, writes, "As a photographer, Nat has this almost psychic ability to capture the mood and character of a place." Finkelstein always imbues his pictures with attitude and atmosphere, and his portraits generally include a good dose of the drug-infused spaces where the action unfolds. Critic Ian Johnston, reviewing Finkelstein's book *Andy Warhol: The Factory Years, 1964–1967*, writes, "Finkelstein's shots of the Velvet Underground [the name taken from a novel about sadomasochism] must rank among the best ever portraits of a rock band, exuding sleaze, menace and decadent glamour."

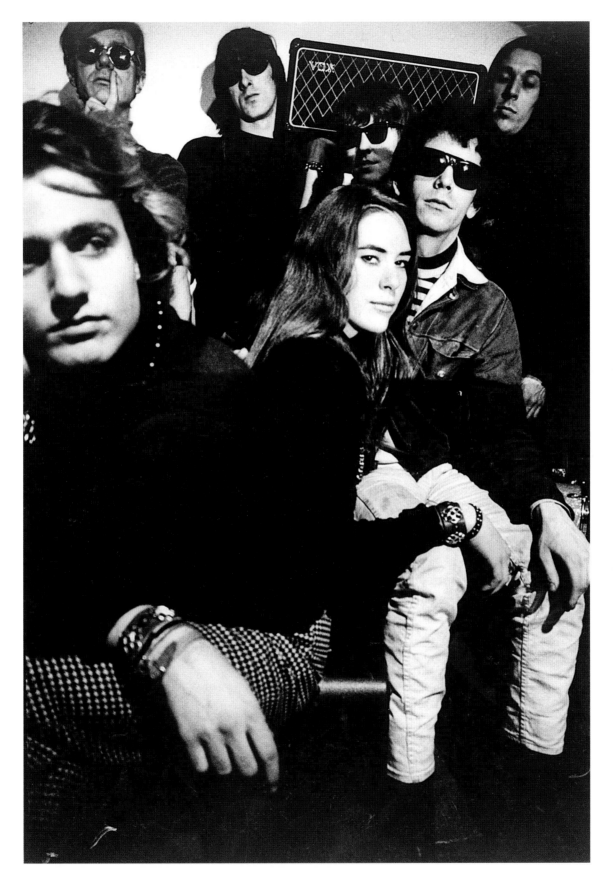

The Velvet Underground and friends (left to right: Gerard Malanga, Andy Warhol, Sterling Morrison, Mary Warnov, Maureen Tucker, Lou Reed, and John Cale), the Factory, New York City
1966

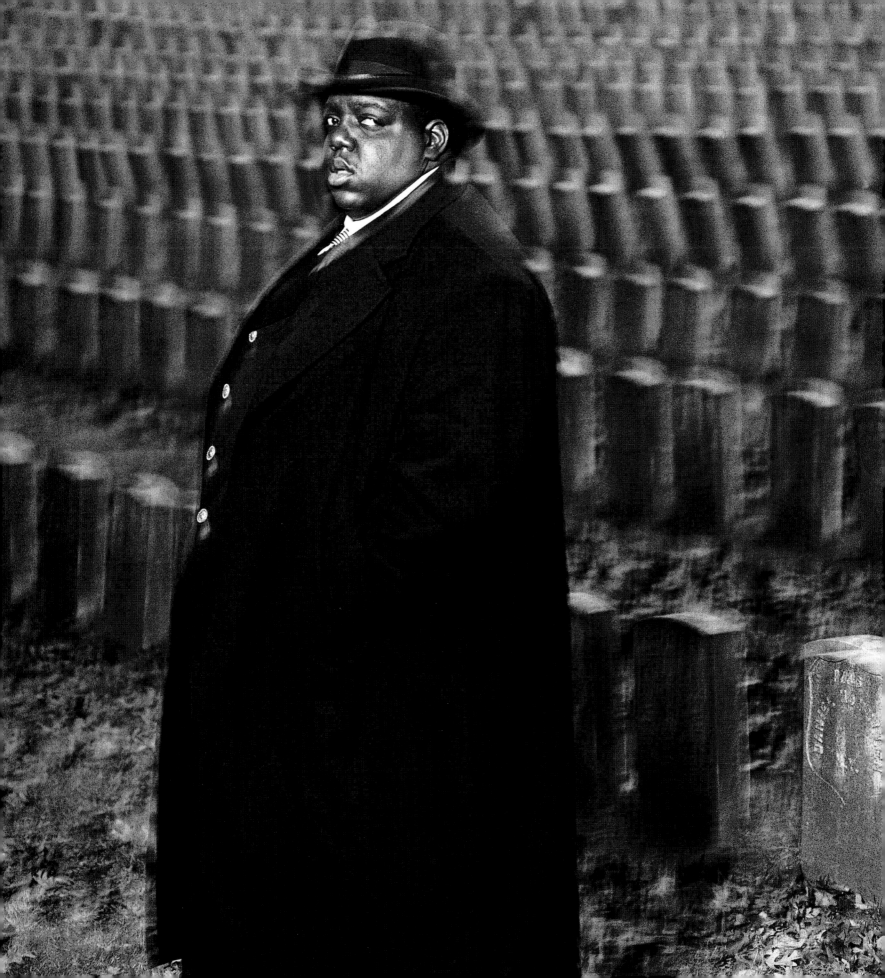

MICHAEL LAVINE

Notorious B.I.G.'s first album is titled *Ready to Die*. His next album, released fifteen days after his death at the age of twenty-four, is *Life After Death*. Michael Lavine, a graduate of Parsons School of Design, with magical and masterful lighting and printing and capturing that look in Biggie's eyes, made a haunting portrait of a man weighing his mortality.

"The problem with rock photography is that you get trapped by the celebrity of it," says Lavine with sincerity. "That is the inherent problem with celebrity portraiture in general. Is it a good picture or is it just the celebrity you are looking at?" Lavine cares about making good photographs even as he knows he has to earn a living supplying the "industry." One can feel the tension when he talks—that divide between probing the depths of the individual to make the most revealing portrait and presenting a picture to satisfy the magazines and record companies.

Henry Rollins, in the introduction to Lavine's book of photographs, *Noise from the Underground: A Secret History of Alternative Rock*, writes:

> The music was treated like a curiosity piece, and the band members were treated like strange brats who . . . had not yet settled down to becoming good Americans. . . . Sometimes when the band would come to town they were considered a hazard by the local police force, which often threatened violence, arrest, or impoundment of equipment. Shows were often picketed by strange herds of sign-carrying women, high on daytime TV paranoia and Dexatrim, angrily protesting the band's music, which they probably hadn't heard anyway but could blame their families' dysfunction and the whole damn country's moral decay upon. . . .
>
> But the way alternative music is seen is different these days [1995] and that's where a fine fellow like Michael Lavine comes in. . . . Just by the respect he gives the artists and the sheer quality of his artistry, he's one of the good eggs who gives much-needed legitimacy to a music scene that so totally deserves it.

Notorious B.I.G. at Cypress Hills Cemetery, Brooklyn, New York
1997

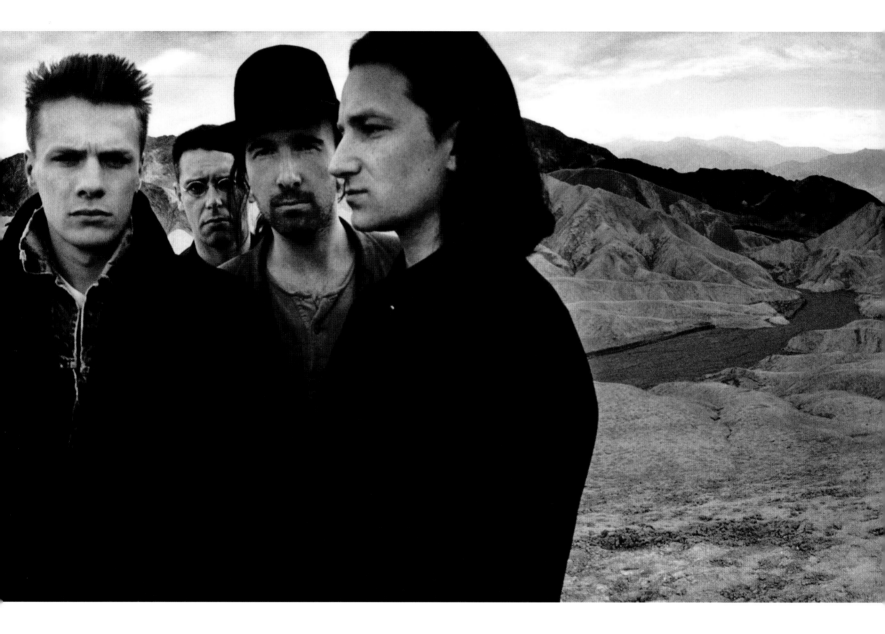

ANTON CORBIJN

They look like saints carved on the side of a gothic cathedral. Of his photographs of U2, Corbijn says, "I never realized the pictures would work out the way they did, where I think they look stronger, really, than any other band in the world." For more than a decade Corbijn has been using the power of photography to give visual strength—and mystery—to U2 and others.

The idea for *The Joshua Tree* album came after U2 performed at Live Aid 1985, a concert to raise awareness and money for the famine victims in Ethiopia. After Bono and his wife worked at an orphanage in Ethiopia to see firsthand the drought conditions and desolation, Bono started to dwell on the meaning of "desert." Bono said in a *Rolling Stone* interview, "I started thinking, 'They may have a physical desert, but we've got other kinds of deserts.' That's what attracted me to the desert as a symbol."

Corbijn attended some of the recording sessions to better understand the essence of the music U2 was making, which at the time had a working title of *The Desert Songs* or *The Two Americas*. Corbijn kept thinking about the physical American desert and the Joshua trees that appear on the horizon as "hardy survivors." He took the band to Joshua Tree National Park and made a portrait of spiritual strength. The band is simultaneously grounded and transcendent.

Bono is recorded as saying he didn't think the title *The Joshua Tree* sounded very rock and roll: "It sounds like it would sell about three copies." It sold 12 million. And many more than 12 million people see and contemplate Corbijn's picture. Ulf Poschardt writes in the introduction to Corbijn's book 33 *Still Lives*: "At a time when authenticity as a revolutionary concept had long been derided, Corbijn unwaveringly and courageously entered

continued on page 291

U2, *The Joshua Tree*, Joshua Tree Desert, California
December 1986

JEAN-PAUL GOUDE

Grace [Jones] has a geometric face, a bit like an African mask. Her outrageously prominent cheekbones form two triangles. Together with her hair that I cut in the shape of a square to dramatize the volumes of her morphology, she did somewhat look like an African-inspired cubist sculpture. . . .

If Grace's androgyny, combined with her natural skin color that I tried to sublimate by painting her blue, appeared to some music business professionals to be less than attractive, it wasn't long before they changed their minds. She was now regarded as a completely modern creature, a slightly threatening alien, whose unique beauty transcended both her sex and her race.

—JEAN-PAUL GOUDE, *SO FAR SO GOUDE*, PP. 138–39

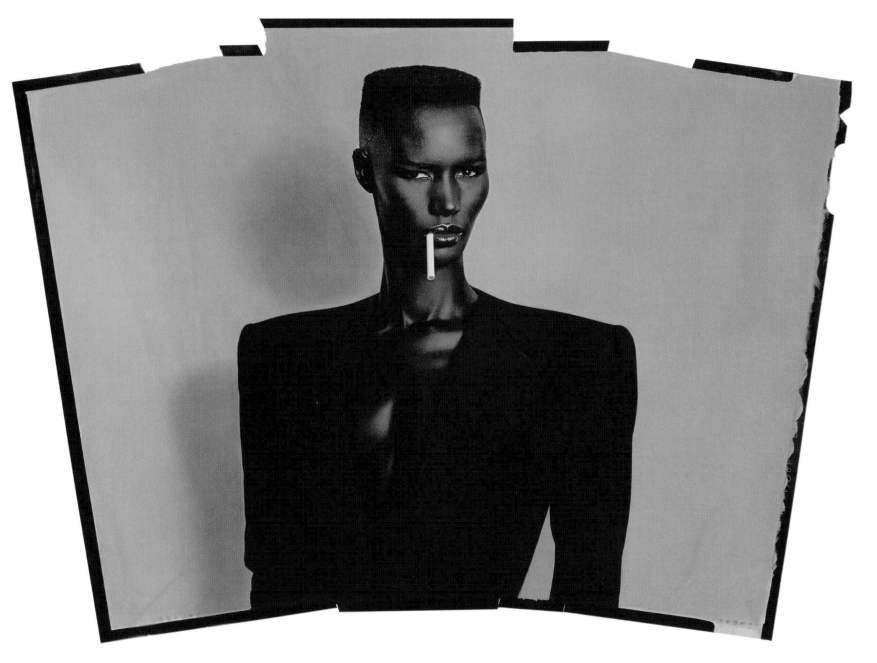

Blue-black in black on brown, oil paint on cut-up photo, New York City, album cover *Nightclubbing*
1981

MAX VADUKAL

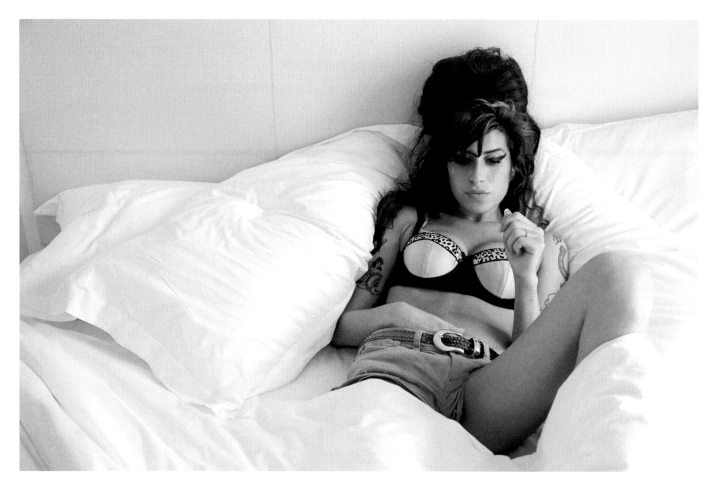

Amy Winehouse, Miami, Florida
May 18, 2007

Cecil Beaton, the celebrated portrait and fashion photographer from the 1920s through the 1970s, remembered the revolutionary feeling in fashion photography when the female models were allowed to spread their feet apart—even a little. Prior etiquette demanded that the two feet touch. Women had to be "ladylike." Times change! Beaton understood that the best photographers didn't follow societal mores but led, and often the world went along.

Max Vadukal takes the viewer into bed with Amy Winehouse—on her wedding day! That she is clothed takes nothing away from the seduction. (Vadukul photographs for the Victoria's Secret catalogue, as well as for *The New Yorker, Vogue, Rolling Stone*, and other publications). Short shorts show off thighs, her hand down her pants makes her "concentration" that much more naughty, and her bra, breasts, and tattoos set off a face that is made-up and inscrutable. *Rolling Stone* ran the picture across two pages in its June 14, 2007, issue under the heading "The Diva and Her Demons." The photograph dramatizes the challenge of all stars of the twenty-first century—what do you reveal and what do you protect?—as stardom engulfs your being.

BARON WOLMAN

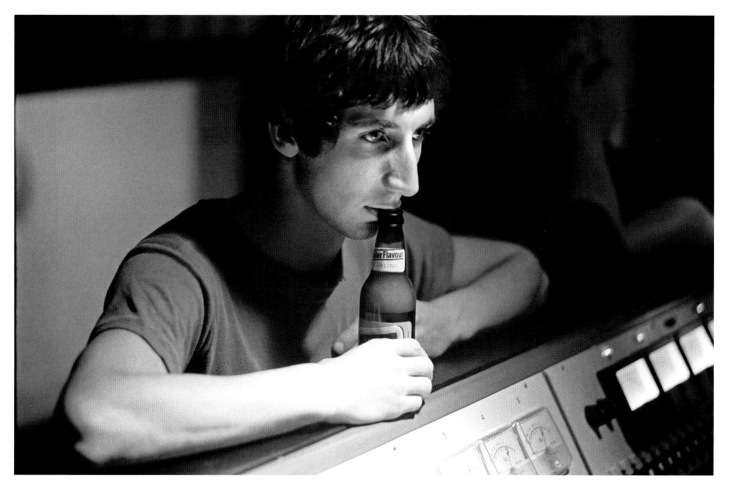

Pete Townshend in the studio during the recording of the rock opera _Tommy,_ London
October 1968

There are thousands of pictures of Townshend's wild gyrations, leaps, and guitar-smashing on-stage. Seeing him quiet, concen-trating on the recording of _Tommy,_ is surprising and commanding.

PENNIE SMITH

Joe Strummer of the Clash on a London rooftop writing music. He wrote lyrics by hand, but decided he needed a prop for the photograph and got a typewriter.

Joe Strummer on roof, London
December 1980

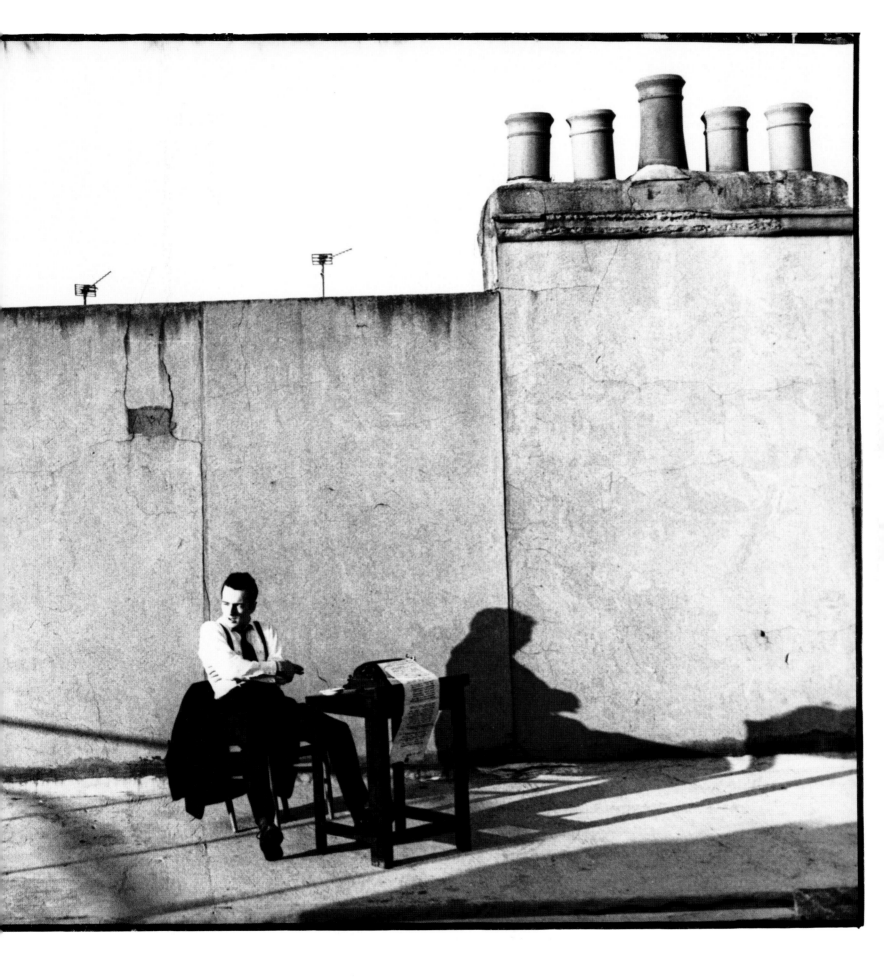

RICHARD AVEDON

They could be young princes. They could be young dockworkers.

We see the Beatles as Richard Avedon saw them on August 11, 1967—a moment in time. Their history, their future, suspended in the studio while "now" is all that matters. Avedon's genius is connected to the transcendental act of "being in the moment," the point in meditation when one is completely present. His portraits engage the mind, body, and soul. They are total experiences for the viewer. Who the person is pales next to the massive mystery of the human condition. More than any photographer in the history of the medium, Avedon focuses the viewer's attention completely.

Viewing an Avedon portrait is a meditative experience.

Light rays are Avedon's metaphorical lump of clay. He shapes his subjects. He is an artist dealing with aesthetics. Constructs of "photographic truth" have little importance to him. In an interview, he said, "Any artist picks and chooses what they want to paint or write about or say." Although some of his pictures will forever be considered the "definitive" visual summation of a life, they are never about "image" but always about art. Pretty faces, false smiles, and artificial body language have no place in Avedon's lexicon. "Photographic truth" for Avedon was ambiguous and troublesome, but leading a creative life with integrity was an absolute.

The Beatles: John Lennon, Paul McCartney, George Harrison, and Ringo Starr, London
August 11, 1967

PHILIP TOWNSEND

The Rolling Stones, Australia pub, London
March 1963

T he only thing Andrew Loog Oldham, the Rolling Stones' nineteen-year-old manager, told Philip Townsend, the sophisticated twenty-three-year-old British photographer, was to make Mick, Brian, Charlie, Keith, and Bill look mean and nasty for their first photo session as a group. Oldham had signed them up only a few days before in early 1963. They didn't even have a record deal, but Oldham already had plans to turn them into the world's greatest rock-and-roll band. It has been said that the Beatles were bad boys made to look wholesome via the vision of their manager, Brian Epstein, and

continued on page 292

Joe Strummer captioned this picture "We asked those creeps to clear off, but they wouldn't. No, really, we double-booked the studio with Devo."

The Clash was political and punk. They had something to say, and what they had to say was more important to millions of young people than anything any politician—president or prime minister—had to say. The revolutionary heroes behind them in the picture form a perfect backdrop. Pennie Smith's portrait of the Clash, like many of her others, shows a cohesive group while giving each member his own personality. There is no superstar; no one is trying to upstage the others. The picture shows what a band of brothers can feel like.

Smith speaks about "how little time you can keep people amused, taking group shots." One of the greatest challenges for a music photographer is making that group shot serve as the "image" of the band. Most fail because they are pretentious and dishonest. Little photographic tricks of manipulation often look pathetic; most are just not good portraiture. Smith will release only pictures that meet her high standards, and her pictures never look like anyone else's.

The Clash (left to right: Topper Headon, Mick Jones, Joe Strummer, and Paul Simonon), London
Late 1976 or 1977

WILLIAM "POPSIE" RANDOLPH

On May 5, 1966, PoPsie Randolph was asked to photograph a record release party for Percy Sledge, a new musician for Atlantic Records. Performing at the Prelude Club in Harlem were Esther Phillips, Wilson Pickett, and the King Curtis Band, which included a very talented original but not well-known guitarist, Jimi Hendrix, who played his guitar "upside down." A year later, he would give up the tuxedo and the back of the stage to emerge as one of the most powerful rock-and-roll performers of all time. When the picture was made, Pickett was the star, having already released "In the Midnight Hour" the year before. It is shocking to see Hendrix playing in a tuxedo, but many of Randolph's pictures are unique in music history; he was often the only photographer present at momentous occasions.

Randolph was a seminal figure in American music photography. Quincy Jones writes: "Quintessential New York photographer 'PoPsie' Randolph chronicled the transition of modern music from swing to jazz. His camera captured segues from rhythmically flavored modern blues to a developed style of choral numbers, pumping shuffles of the electric guitar, and archetypal rock 'n' roll" (from the foreword to "PoPsie" N.Y.: Popular Music Through the Camera Lens of William "PoPsie" Randolph, edited by Michael Randolph).

The son of Greek immigrants, he dropped out of school in eighth grade, then worked in a bordello frequented by musicians. He enjoyed the musicians as much as the music, and he gradually started managing groups, working his way up to being the manager for the Benny Goodman Band. It was Goodman who gave PoPsie his first camera, and Goodman was godfather to PoPsie's son

Michael. It was because of his years managing bands that he knew so many people in the music business. His friends told him when to show up for a gig. He had unusual access to performers.

Almost every major American musician from the 1940s through the early 1970s posed for Randolph. He photographed the guests on Dick Clark's *American Bandstand* and *The Ed Sullivan Show;* he took his camera to nightclubs, airports, recording sessions, private homes, and concert halls. He was a whirlwind of energy and the record companies could rely on him for a publicity shot. He always tried to show the musician in a good light, figuratively and photographically.

Jones stated that John Hammond, legendary talent scout and freelance producer for Columbia Records, along with PoPsie, helped launch the careers of many great talents in folk, jazz, blues, and rock—quite an endorsement for a photographer. Hammond was instrumental in integrating the music business, which had been divided by race. Randolph was there to show musicians as equals. His pictures of Miles Davis and Stan Getz in 1951, Mary Lou Williams in front of an all-white audience in 1948, the multiracial Benny Goodman Band, Kay Starr and Coleman Hawkins, and hundreds more were dramatic challenges to an America that was still struggling with segregation and Jim Crow.

PoPsie, old-timer that he was, liked to get his subjects to smile. When they glowered at the camera, his formula was to ask them to say "shit" and they invariably cracked up. When he tried this with the Rolling Stones on June 2, 1964, standing outside his studio on Broadway and Forty-fifth Street, he didn't get a smile, but he got something better—that "just try to make me" rock-and-roll attitude.

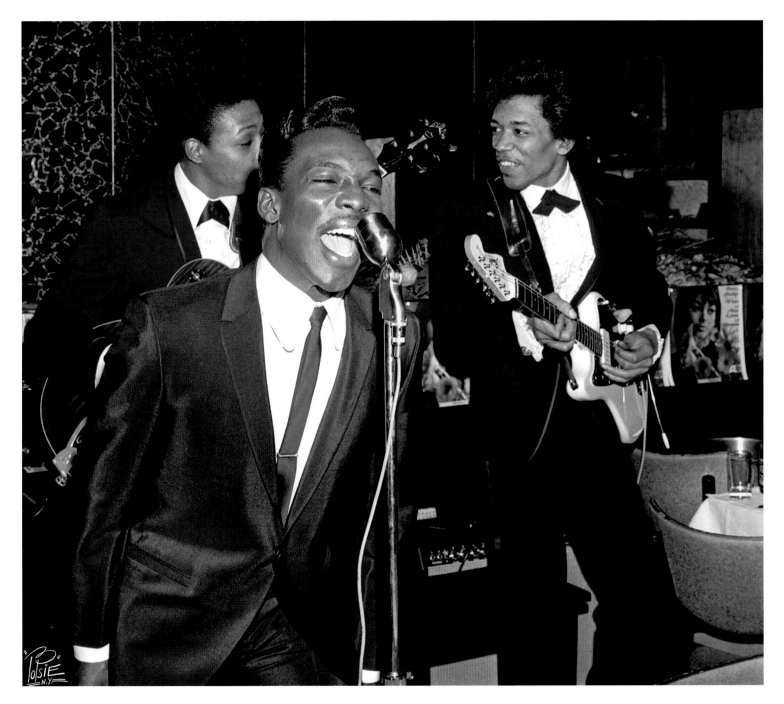

Wilson Pickett and Jimi Hendrix, Prelude Club, Atlantic Records release party, Harlem, New York City
May 5, 1966

Courtney Love, San Fernando Valley, California
December 1993

Doll with severed head, from series "Anna's Garden," East Eleventh Street between Avenues B and C, New York City, August 11, 1992. Love saw the photograph in *Ms.* magazine and used it as the cover for the insert for her CD *Live Through This.*
Photograph by Margaret Morton

Everything about the nomadic Shawn Mortensen was compelling—his energy, his enthusiasm, his knowledge, his friends, his adventures. Mortensen took it all in and gave it back with clarity. His untimely death in 2009 is a shock and a sorrow.

He had fun doing what he did because it was always part of his larger-than-life life. He photographed rappers, movie stars, artists, Zappatistas. And for the most part, they feel real. The common thread is reaching some level of intimacy.

Color was his forte. Clothes, hair, and attitude are important parts of the formula—for both the red-carpet elite and the revolutionaries. Glenn O'Brien, editor of *Interview*, called Mortensen "a first responder in the emergencies of culture."

Courtney Love has captioned her own photo. She is having a break from a shoot for Hole's album *Live Through This*, released on April 12, 1994, seven days after the suicide of her husband, Kurt Cobain.

ERNEST C. WITHERS

Ernest C. Withers was one of the great photographers of the twentieth century. He photographed the civil rights movement, the Negro Baseball League, the daily life of African Americans in the South, and almost every black musician who passed through Memphis, Tennessee, from the late 1940s to the end of the twentieth century. Some of the most iconic images of African Americans' struggle for equality—the integration of Little Rock Central High School, the Montgomery Bus Boycott, Medgar Evers's funeral, Memphis Sanitation Workers' Strike, and Dr. Martin Luther King Jr.'s funeral—were taken by Withers but often reproduced anonymously.

One such picture is of the first time a black man, Mose Wright, stood up in a Southern courtroom, pointed his finger at a white man, and accused him of murder. The case was the murder trial of Emmett Till. Wright was Till's uncle and a witness to the savage crime. What makes the picture bone-chilling is not just the documentary aspect but that Withers could within one frame photograph the power in Wright's outstretched hand and his isolation in the courtroom.

Withers's picture of Ike and Tina Turner is more than a "music" photograph. Ike plays backup for his wife as he studies her from a distance. Withers captures the stage atmosphere of Club Paradise along with Ike's silk suit and skinny tie and Tina's tight beaded dress.

Before Withers became a full-time photographer with a studio on Beale Street, he was one of nine African Americans hired by the Memphis Police Department. He may have been given a badge, a uniform, and a gun, but his hands were figuratively shackled. He was not allowed to arrest whites; his beat was keeping the peace in all-black areas, including the popular music spots—Ebony,

Paradise, Handy, Currie's Club Tropicana, and others. He decided he could accomplish more with his camera than his nightstick. He began photographing the magnificent music scene and selling his pictures to the performers and owners of the clubs. When the *Tri-State Defender* newspaper, as well as *Ebony* and *Jet* magazines, realized they needed a photojournalist in the Memphis area to cover the nascent civil rights movement and the dynamic music scene, Withers was enlisted.

In the 1940s, after returning from fighting in the Pacific during World War II, Withers photographed a very young B. B. King, and then he photographed him in every succeeding decade. In the 1950s, Withers made the kinds of pictures no one else was making—for example, Elvis Presley hanging around backstage with black musicians after performances, without Colonel Parker supervising him. He photographed Evelyn Young, B. B. King, and Bill Harvey together; Rufus Thomas; a young Isaac Hayes; Louis Armstrong; Dewey Phillips; Count Basie, Ruth Brown, and Billy Eckstine; Lionel Hampton; Louis Jordan; Calvin Newborn; Big Mama Thornton; Ray Charles; Junior Parker; Roscoe Gordon with Sam Phillips; Marian Anderson; Howlin' Wolf; and many others. That was just the fifties. Throughout his life, Withers continued photographing these giants and added James Brown, Aretha Franklin holding hands with Sam Cooke, Otis Redding, Jerry Butler, Diana Ross, Al Green, Dizzy Gillespie, Dionne Warwick, Ma Rainey, Big Ella, and many more musicians.

Rock and roll has roots. Withers didn't just make portraits or take performance pictures. He captured the wellspring of the music—the world that nurtured and challenged and produced the musicians.

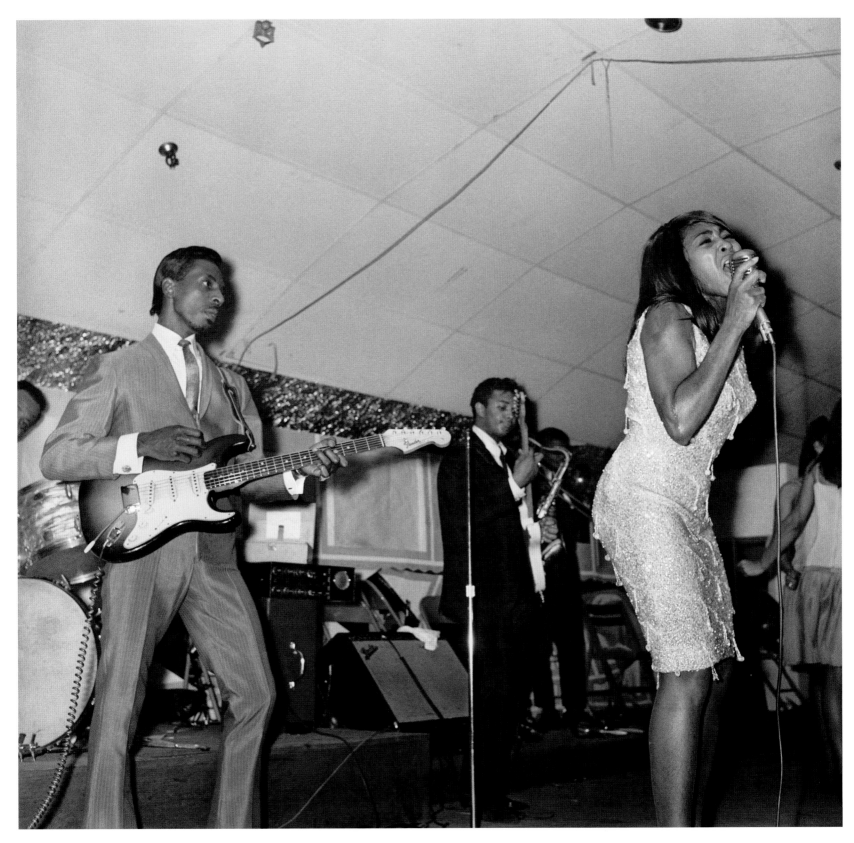

Ike and Tina Turner, Club Paradise, Memphis, Tennessee
1962

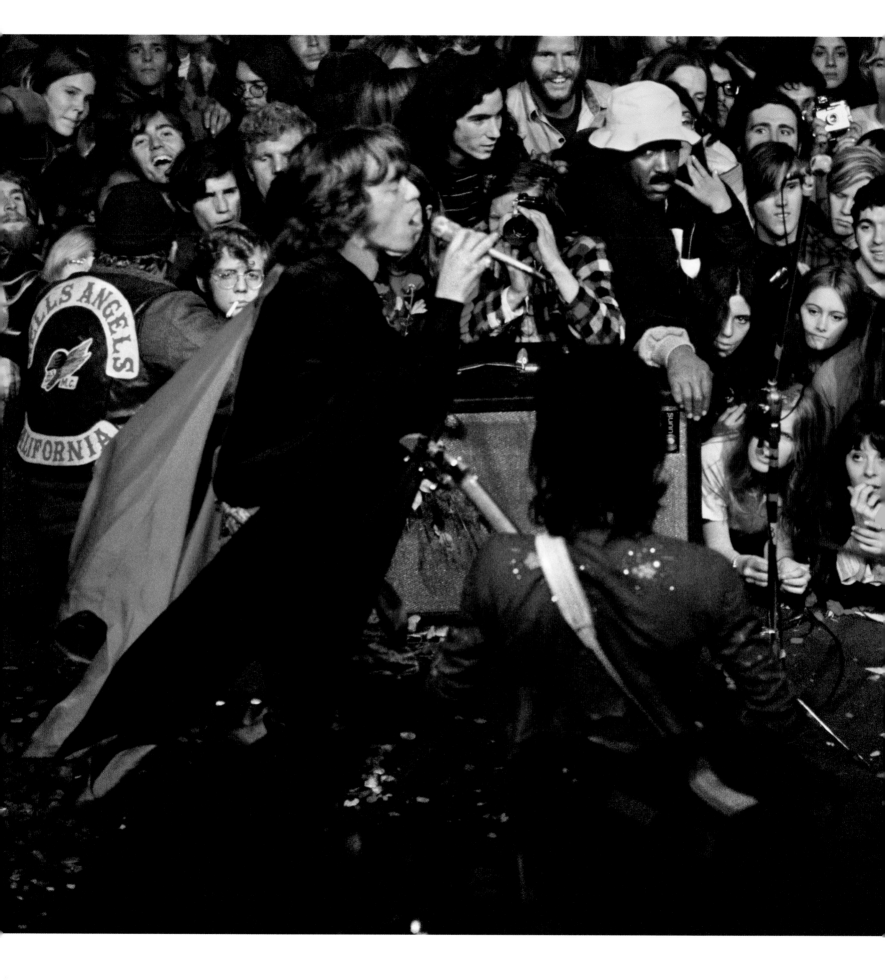

Nothing is free, as the old adage goes, and the Rolling Stones' "free" concert at Altamont in 1969 was paid for in blood. The concert, the Hells Angels, the stabbing death of one attendee, and the accidental deaths of three others are part of rock-and-roll history. So, too, is Ethan Russell's iconic shot of Mick Jagger, the crowd, and one Hells Angel on that fateful day. Every face matters. Everyone is charged. It is as close to a perfect picture as a photojournalist can get. It is reminiscent of an Antoine-Jean Gros historical painting. Even the faded colors of this 1969 photograph appear canvaslike, muted, accented by Jagger's red cape and the flowers strewn on the stage. In 1969 there was still hope that rock and roll could "save the world." Altamont was more "the eve of destruction."

The Rolling Stones at the Altamont Speedway Free Festival, California
December 6, 1969

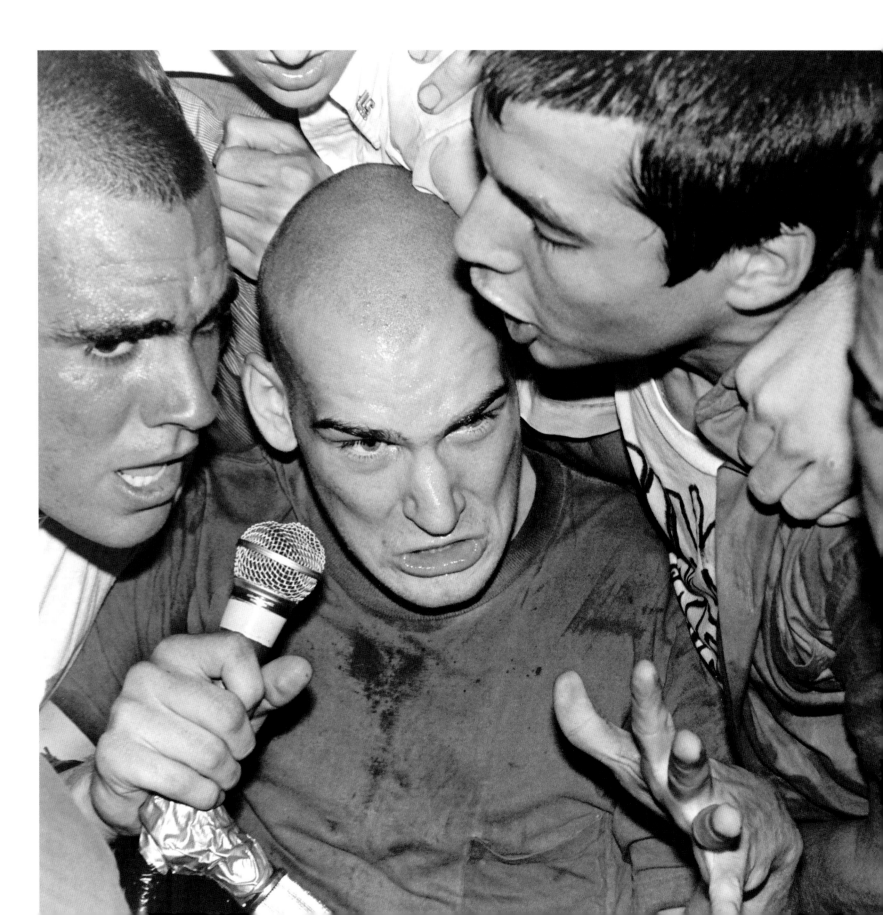

EDWARD COLVER

dward Colver was named after an ancestor who arrived in the New World from Cornwall, England, in 1635. Flash forward: the current Ed Colver is the unparalleled chronicler of L.A. punk. Basically self-taught by looking at a lot of Dada and Surrealism, Colver did take night classes at UCLA with the art photographer Eileen Cowin. California native artist Edward Kienholz is the strongest influence on him, and in the 1960s his "perspective on life and art was changed by his exposure to composers such as Edgar Varèse, Karlheinz Stockhausen, Krzysztof Penderecki, and John Cage," Colver writes in his monograph *Blight at the End of the Funnel*.

What got this tall, lanky cerebral guy (who hasn't watched television since 1979) into the trenches of punk and hardcore? "It was the seventies and there wasn't much going on," sighs Colver. He had broken up with his girlfriend. He started going to downtown L.A. punk clubs—seven nights a week. "Right away," he explains, "I made a distinction between punk rock and New Wave. I *hated* New Wave, but just loved the antisocial attitude of L.A. hardcore." That was it. He "borrowed" a busted camera with a 50mm lens. Because of the focal length of the lens, he was forced to get into his subjects' faces. He became hooked on the adrenaline rush. But he was hooked as an artist who had discovered a subject that resonated with his being. He wasn't just snapping.

Hardcore punk, Colver observes, "didn't really translate well to vinyl. The best evidence of the scene was through photography." What Charles Peterson did for Seattle grunge, Colver did for L.A. hardcore punk—

continued on page 292

Minor Threat, Ian MacKaye, Los Angeles, California
1980

Sonic Youth, four stills from the video for "Death Valley '69"
1984

RICHARD KERN

hat scares me is people who don't have a sense of history," Kim Gordon (one of the founders of Sonic Youth) says. The Charles Manson massacre—like it or not—is history, and Sonic Youth and Richard Kern address the pathology and conjure up images.

Kern is a leading filmmaker in the Cinema of Transgression, which shocks as it turns the viewer on and off. A sense of humor is part of its manifesto: "Nobody's guts are really that big," Kern says, stating the obvious about one of his photographs in the series. "They are sausages with shaving cream on them."

The series of "crime scene" pictures are from Sonic Youth's "Death Valley '69" music video, directed by Sonic Youth, Judith Barry, and Kern. When the Beatles wanted to use Robert Whitaker's photograph of them as butchers in white coats holding sausages and dismembered dolls for an album cover (see page 284), it was way too hot for the music industry to handle. John Lennon famously reminded people that the Vietnam War was far more shocking than a made-up photograph.

Ignoring the actuality and significance of the Manson murders was far more disturbing for Sonic Youth and Kern than pretending the world was sweet or comprehensible. "There was one period, at least in my scene," says Kern, "everyone was fascinated with Manson. A lot of it had to do with that he was like a punk rock guy, the death of hippies—but there was also in the eighties a time when Tom Snyder or someone interviewed him in prison and it is just amazing because he is a psycho but everything he says makes sense. . . . Part of the video, the camera comes into the apartment and the whole band is dead, like Sharon Tate and all those guys . . . I made all this fake junk . . . shot in an old apartment, [used] my bathtub . . . Manson was seen as the more lunatic version of [the Symbionese Liberation Army] like rock and roll gone [berserk] . . . [Manson] was a folk singer who hung out with the Beach Boys."

All crime scene photographs attract and repel simultaneously. We want to look—and look away. It is part of the human condition.

JILL FURMANOVSKY

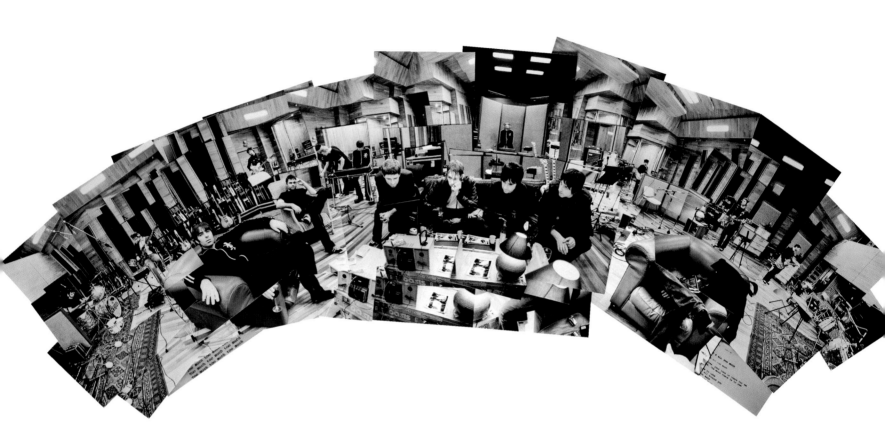

Oasis with Johnny Marr at Olympic Studios, Barnes, London
"Joiner" or composite photograph
December 2002

go-ridden, disrespectful, uncouth, volatile, dangerous, riveting, and brilliant" is how Jill Furmanovsky, the official unofficial photographer for Oasis, characterized the group. Noel Gallagher, half of the brothers Gallagher, understood, in the words of journalist Andrew Perry, "the power of not so much image, as imagery, in the shaping of rock dreams" (in the official Oasis exhibition program *Was There Then*).

Oasis is a story, as well as a band. The story is part picture story, and the best pictures are by Furmanovsky. She has photographed the band since 1994 and toured extensively with them. Noel, for the longest time during the U.S. tour, thought Furmanovsky was the tea lady, so unobtrusive was she with her camera.

Oasis, because they lived hard, felt their success might be short and wanted a photographer to thoroughly record who they were—the biggest British band in the 1990s. Oasis has a reputation of not wanting to work with photographers, having little patience for studio shots, and not lik-

continued on page 292

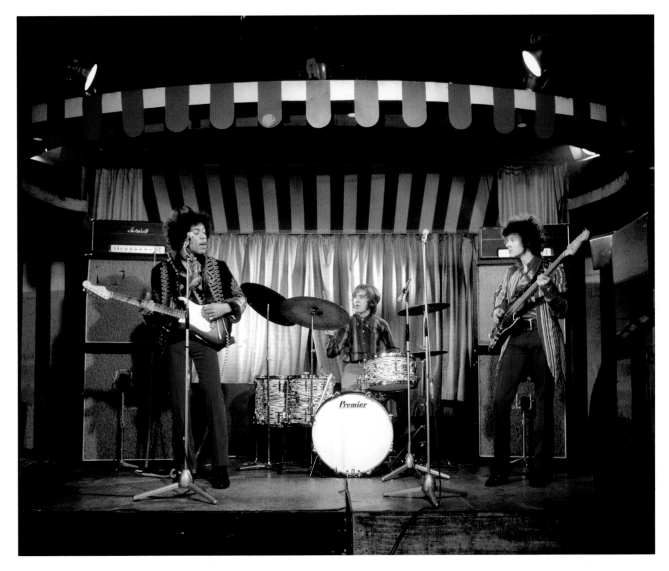

The Jimi Hendrix Experience (Jimi Hendrix, Mitch Mitchell, and Noel Redding), the Marquee Club, London
March 1967

The Jimi Hendrix Experience, the Moody Blues, the Who, Yes, David Bowie, Jethro Tull, and Pink Floyd had "residencies" at the Marquee Club, a famous London musical venue. The stage has a puppet-theater quality; it allowed for intimacy and good listening. No light shows or special effects; this was about the music, and Stevenson's photograph shows it how it was.

"Another Hotel Room," Eric Clapton
1974

Marriage to two rock gods—George Harrison and Eric Clapton—drove Pattie Boyd to photography.

The photograph taken in "another hotel room" conveys a deep sense of isolation. The "ideal" in the picture on the wall—a couple sitting together on the beach, looking toward the horizon—is rendered flat and one-dimensional. Peace is belied in the room of sharp angles and voids. Clapton's companions are his guitar, his addictions, and his thoughts. Boyd's powerful image is a portrait of her husband and her struggle to connect. Only art can achieve perfection; life has too many flaws.

Patti Smith in a sofa bed, Twenty-third Street, New York City
Early 1970s

This is the loft Patti Smith shared with Robert Mapplethorpe on Twenty-third Street, near the Chelsea Hotel. In the bed in the back is the homeless drifter who robbed them after they picked him up off the street. Here is the mess of two artists living and creating in one small space. Here are humble and fertile beginnings.

Judy Linn went to Pratt Institute with Mapplethorpe. Through him, she met and became close friends with Smith. Occasionally, in the history of photography, two female artists have collaborated on creating an extended portrait. Imogen Cunningham took many photographs of the young dancer Martha Graham, clothed and naked. Each brought their enormous creativity to the sessions. Some of the most sensuous and complex photographs of Smith, naked and clothed, were taken by Linn in the early 1970s. Sometimes she is alone, sometimes with her then boyfriend Sam Shepard. The photographs have an intimacy arrived at only through trust. Smith used one of Linn's black-and-white images for her second album, *Radio Ethiopia*.

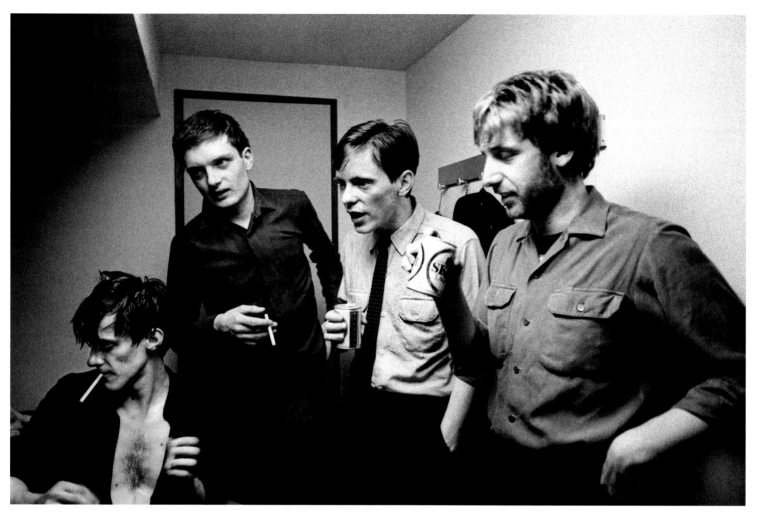

Joy Division (left to right: Stephen Morris, Ian Curtis, Bernard Sumner, and Peter Hook),
YMCA, Tottenham Court Road, London
August 1979

ill Furmanovsky is a musicians' photographer, specifically rock-and-roll musicians. She will fight the guys in the pit for space to photograph a live concert. She wears baggy black clothes and comfortable shoes so she can move easily, be discreet, and make certain she isn't confused with the groupies in their tight jeans, short skirts, and low-cut T-shirts. She might fight in the pit, but backstage she is quiet and unobtrusive with the musicians. Before a con-

cert, Furmanovsky says, musicians are generally pretty tense; after a concert, they unwind. This photograph of Joy Division was taken in the dressing room about fifteen minutes after their London concert at the YMCA. It was the first time Furmanovsky saw them perform and observed Ian Curtis's twitching, jerky movements, brilliantly reenacted by Sam Riley in Anton Corbijn's film *Control.*

Furmanovsky probably didn't spend more than ten minutes after the concert with Joy Division. In those

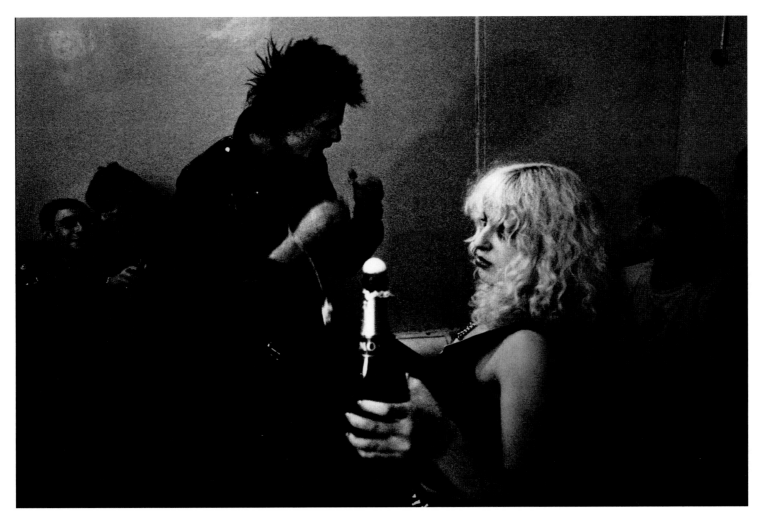

Sid Vicious and Nancy Spungen at the Rainbow, London
1977

days, a photographer for the music "mags"—*New Musical Express* or *Sounds,* both of which frequently gave her assignments—could get backstage without a pass, work somewhat unnoticed, and get out. For the photojournalist, the challenge was to capture the musicians in natural poses, compose well, and, most important, convey something vital about the subject—whether it be through the facial expressions, body language, or interactions. Here, the young members of the band are focused, energized, and very much a unit.

In another of Furmanovsky's iconic behind-the-scenes photographs, the Sex Pistols are partying with the Ramones and a bottle of Moët, but it is the shapes and spaces formed between the people—Sid Vicious, Nancy Spungen, Dee Dee Ramone, and a couple cozy in the corner—that create the drama. In both pictures, Furmanovsky's camera is noninvasive. Musicians trust Furmanovsky to not be exploitative. Without that trust, there is no access.

KEVIN CUMMINS

ike Paul Strand, one of America's greatest photographers, Kevin Cummins gets to know his subjects before photographing them. "My best pictures are when I am given the time to work with people," says Cummins. "I tend to photograph people I like. I like to photograph people whose music I like. I have to respect their work in order to photograph them."

Joy Division took its name from a prostitution wing of a Nazi concentration camp. They were seen as an enigmatic group in the Manchester, England, music scene of the late 1970s. Cummins understood very well the importance of myth-making in rock and roll and released pictures of their lead singer, Ian Curtis, only pensive or mournful. It propagated the "Manchester miserablists" myth. But as Cummins says, "Nothing was further from the truth. Sorry to disappoint you but Ian Curtis liked a

pint [of beer]. He didn't just sit on the bus reading Sartre."

This photograph was taken in the band's rehearsal room. Cummins hung a gray overcoat on the hook behind Curtis to add a heaviness and somberness. The composition—coat, electric outlet, an illegible piece of paper taped on the wall, and an elegant elongated hand—frames a reflective and beautifully lit Curtis.

Curtis committed suicide in 1980 at the age of twenty-three. He left behind a one-year-old daughter, Natalie. Many years later, Cummins was speaking in Manchester about his photography and mentioned that he had never published photographs of Curtis smiling, but he has some in his files. A young woman came up to him afterward and asked if it would be possible to see the smiling pictures. "Why?" Cummins asked. She replied that she was Curtis's daughter and she had never seen a photograph of her father with a smile.

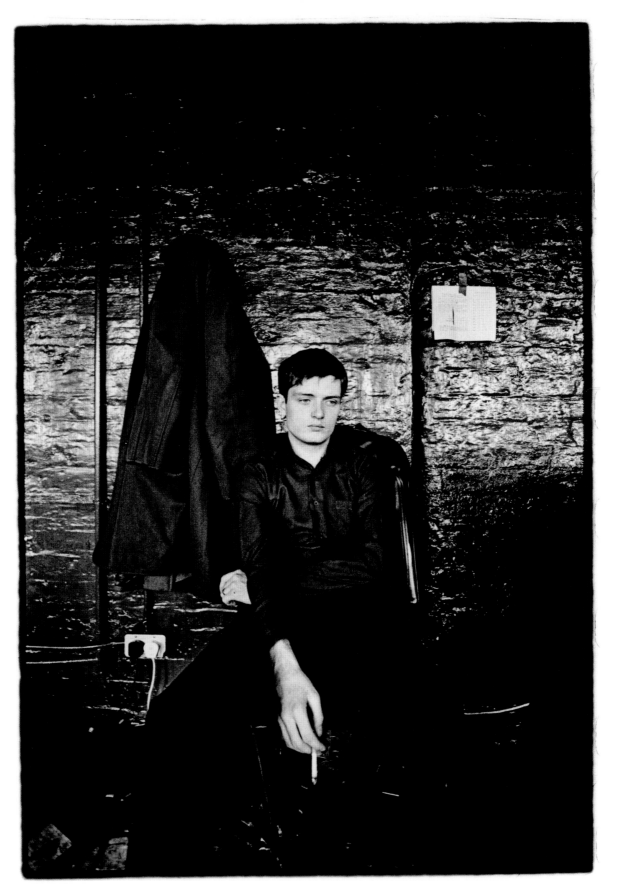

Ian Curtis, TJ Davidson's rehearsal room, Manchester, England
August 19, 1979

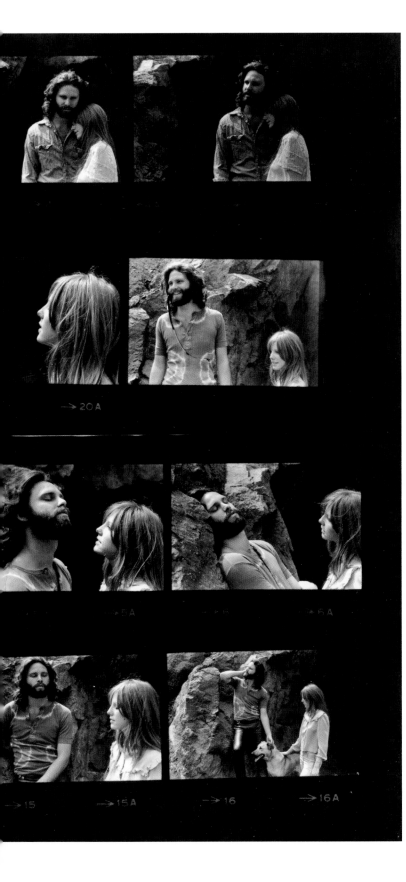

The artist Edmund Teske certainly wasn't "into" rock and roll in 1969, when he was introduced by a mutual friend to Jim Morrison. Teske, born in 1911, listened to Chopin, Mozart, and Beethoven. Teske, a sagelike figure who was an artist and student of Hinduism's Vedanta philosophy, and Morrison, lead singer of the Doors, immediately connected. Teske commented on the young man's beauty, "the quality of being" and "the poetic spirit of his nature." At once Teske wanted to photograph Morrison, and the first of three or four sessions was arranged.

The first session was on March 31, 1969, with Morrison and Pamela Courson. Teske took some interior photos at home and then went up to the Bronson Caves in Hollywood near where they lived. There he made ethereal pictures of the couple, sometimes with their dog Sage, sometimes alone. When Teske showed Morrison the pictures, not as they were taken but after he had performed his magic in the darkroom with double exposures and overlays giving texture and a surreal look to the prints, "Jim Morrison . . . went out of his mind" (from an interview with Edmund Teske, "Images from Within," by Jan E. Morris, *The Doors Collectors Magazine*). The cover image of *An American Prayer* was taken at that time; it was used as a straight photograph. Morrison looks Christlike.

The next photo session was on July 8 at the Doors' studio, where Teske photographed the entire band for the first time. The third photography session was at Teske's studio on North Harvard Boulevard. Outside Teske's studio was a garbage-filled alley, where he made some pictures before going into his garage. The picture of the Doors sitting around a table was taken then and later

continued on page 293

Jim Morrison and Pamela Courson, Bronson Caves, Hollywood Hills, California

March 31, 1969

He was so intense, he could kill you with one glance," Kate Simon says of Bunny Wailer. "I waited [in Jamaica] for a week for this session. I waited for him to come down from the hills and it was like the meeting at the O.K. Corral—I was ready and he was ready. It was a real meeting of the minds. How intense can you get? I enjoyed it. This man is serious business."

Bunny represents roots reggae—when reggae was new to white audiences—and Simon was determined to get the deep, heartfelt, soul-drenching essence of the music in her portrait. She did. It looks like his eyes—as well as his spliff—are going to burn right through you.

Simon, who thinks deeply about her pictures, speaks of a "circle of energy" between photographer and subject. "You can't make a picture happen," she says. "[The person has to] give it to you and you have to be ready for it." Her photographs of Bob Marley and the Wailers are the most alive, most emotional, most poetic of any that have been made of them. Sometimes her photographs feel so real they send shivers down one's back. "So what you see with someone like Bob [Marley] and me, Barry [Feinstein] and Dylan—we have the trust of the artist and you can see it in the pictures, and you can get some depth," she explains. Her smiling, graceful portrait of Marley on the *Kaya* cover (see page 300) is one of the most famous photographs in music history and was selected by the award-winning French journalist, producer, and editor Marie-Monique Robin as one of the hundred defining images of the twentieth century for her television program and book, *Les 100 photos du siècle*.

Chris Blackwell, the founder of Island Records, had been observing Simon since she started photographing the Wailers with great passion in London in 1975. (She knew Marley because they lived in the same neighborhood both in New York City and in London.) Blackwell frequently invited her down to Jamaica to photograph reggae artists. The Bunny Wailer picture was made to help promote Bunny's *Blackheart Man* LP. Even though Simon was very young, Blackwell wanted her as the tour photographer when Bob Marley and the Wailers went on their multicity *Exodus* tour in Europe in 1977. "It was a huge undertaking for a young girl . . . and I remember thinking . . . this is intense . . . [the] shows lasted three and a half hours."

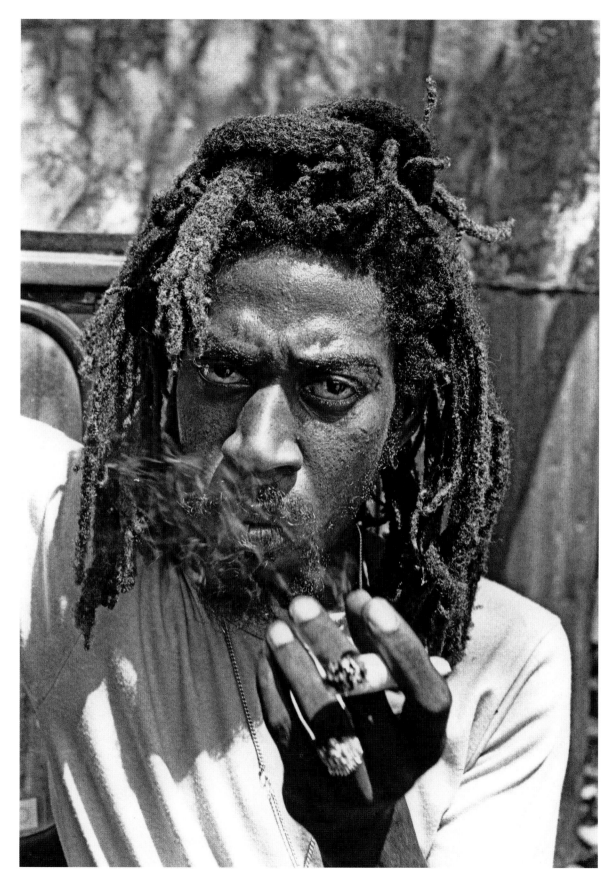

Bunny Wailer, Kingston, Jamaica
1976

TIMOTHY WHITE

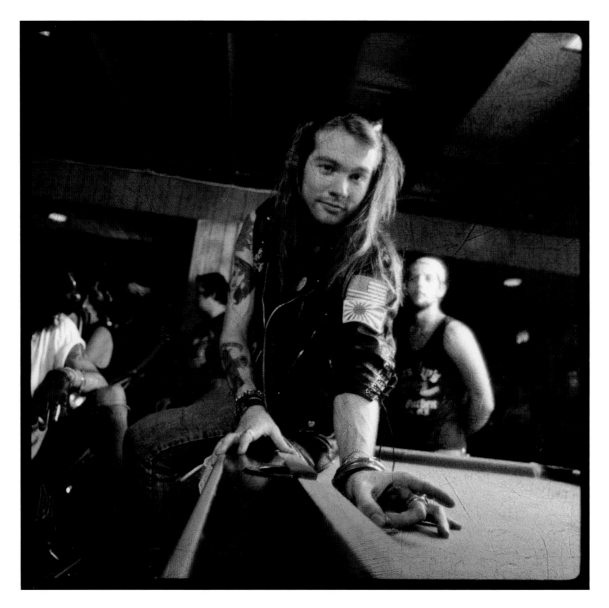

Axl Rose, Asbury Park, New Jersey
October 14, 1988

Timothy White wanted something a little wild for Guns N' Roses' first *Rolling Stone* cover. He arranged for the group to be driven by limo to Mrs. J's, a bar in Asbury Park, New Jersey. "Sometime after 2 a.m. on the morning of October fourteenth, they arrived . . . [and] everybody was, like, 'What the fuck is this?' " said publicist Bryn Bridenthal.

"I was a nervous wreck," recalls White. ". . . We had bikes burning rubber, everyone was drunk—it was an insane scene. It was like baby-sitting a bunch of spoiled brats. Finally I had Axl where I wanted him, and he gave

continued on page 293

EDWARD COLVER

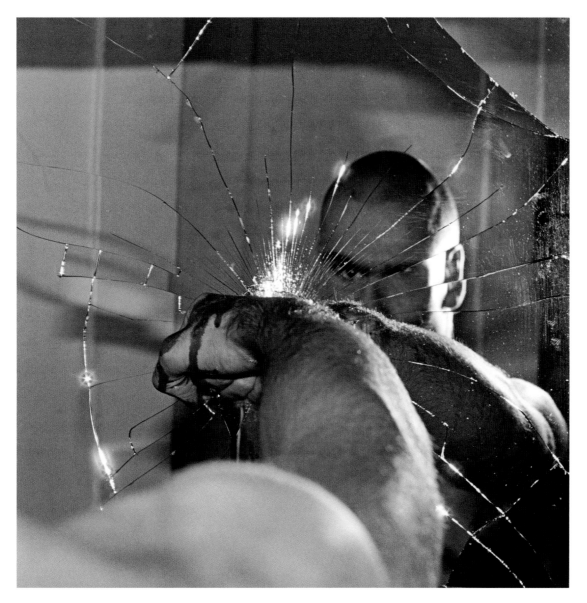

Henry Rollins, outtake for Black Flag's *Damaged* album, Los Angeles, California
1981

n the late seventies and early eighties, Edward Colver nailed the visual and visceral identity of Black Flag, the Dead Kennedys, the Circle Jerks, the Germs, the Minutemen, T.S.O.L., and the Gun Club. His pictures of 45 Grave, Insane Clown Posse, Devo, Human Drama, Motorcycle Boy, R.E.M., Nuclear Assault, L.A.P.D., and the Red Hot Chili Peppers could be stills from a Fellini film. One of the chapters of his book *Blight at the End of the Funnel* is titled "The Daze of Our Lies."

Between 1979 and 1983, he did eighty record jackets and sleeves. His most famous jacket is Black Flag's 1981 album, *Damaged*. Henry Rollins had just become Black

continued on page 293

AMY ARBUS

t was a thrilling guessing game, walking around the East Village in the 1980s. The parade of fabulous fashion "freaks" did not reveal who was the artist and who was the homeless person or who would succeed and who would end up back in New Jersey. Fashion was driven by street kids looking great at bargain prices. They also saw clothes as street art and political statements. What they wore reflected their disgust for Reagan's sunshiney, cleaner-than-clean, hypocritical white middle America. And they were definitely not hippie wannabes either.

Amy Arbus's photographs appeared in *The Village Voice* over the course of ten years and were collected in a book titled *On the Street, 1980–1990.* She photographed men and women and boys and girls wearing "something that turned my head." Her photograph of Madonna was taken the week her first single, "Everybody," hit the charts, but that wasn't the reason Arbus photographed the not-yet-famous singer. She photographed Madonna because she recognized her from the gym, and she looked fabulous walking down the street. She also looked great naked at the gym, Arbus noted.

Arbus is the daughter of portrait photographer Diane Arbus. Invariably, she is compared to her mother. Both have taken poignant and powerful pictures of people on the street and in parks but, as Amy says, "My work is less confrontational. It was clear to my subjects that I adored how they looked. I tried to make them feel like they were getting an award for their creativity." Madonna was one of the few subjects who didn't need such affirmation; she was about to make it very, very big.

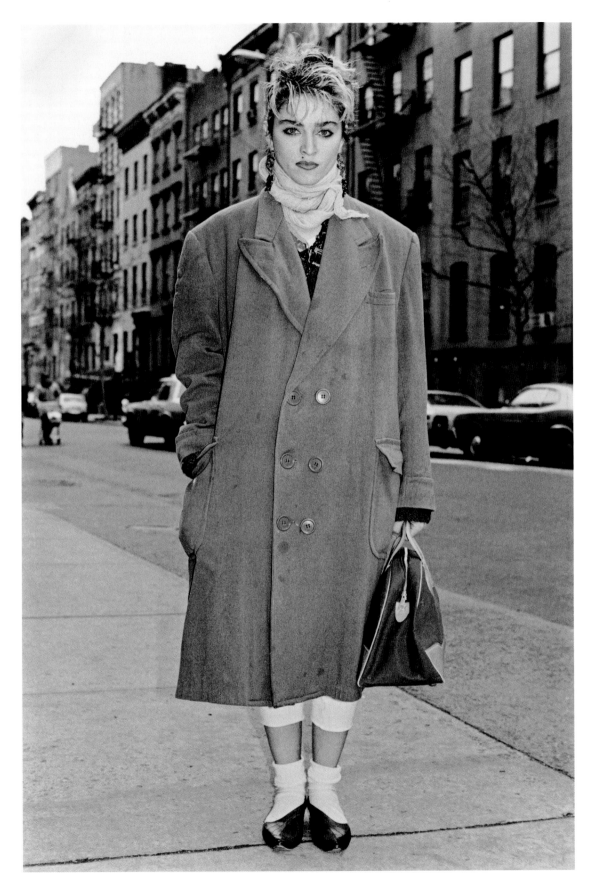

Madonna, New York City
1983

JEAN-PIERRE LELOIR

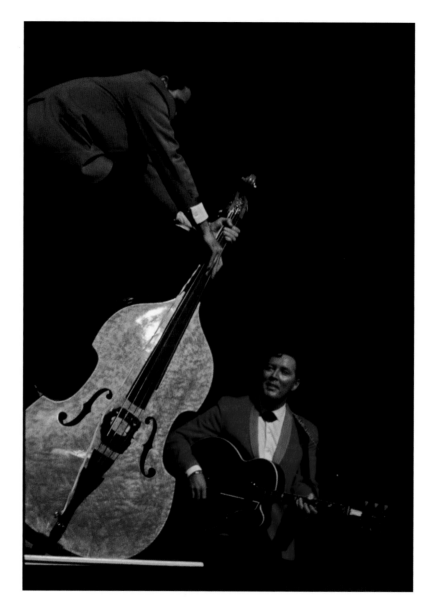

Bill Haley, Théâtre de l'Alhambra, Paris
1965

Jean-Pierre Leloir, a founder of *Rock & Folk* magazine, started shooting color in 1958 for album covers. Staunchly independent, always working for himself, sometimes making enemies as he defended himself and his profession from exploitation, he nevertheless has done more than 1,500 covers in color. His eye is equally good in color and black and white. The source of his vision, he says, is the "sound," not any "theory of photography."

DAVID GAHR

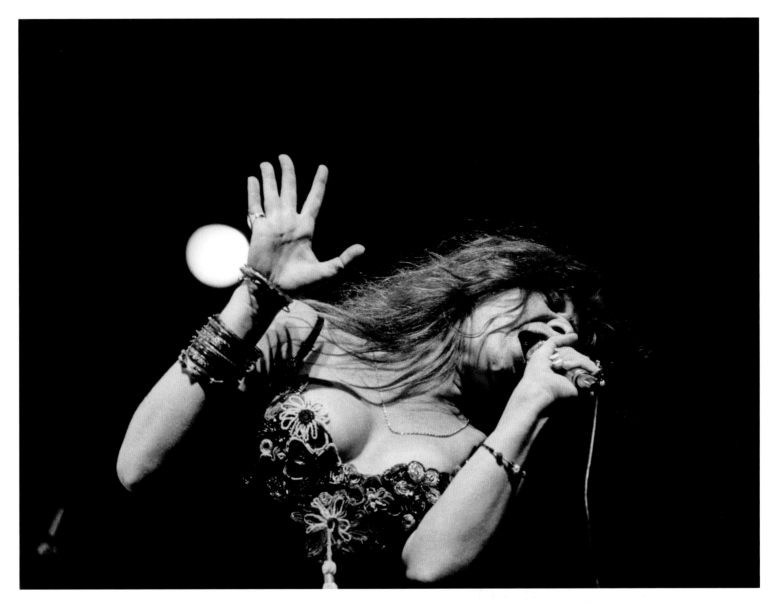

Janis Joplin
1968

The two American music photographers spoken of with maximum reverence are David Gahr and Jim Marshall. Others, such as Barry Feinstein, are greatly respected but have more diverse careers. Marshall is still shooting; Gahr died in 2008. Both saw the music. They were there for the musicians, to take their fluid art and give it a form that resonated with the sound.

EBET ROBERTS

bet Roberts was a painter first, then a regular at CBGB. She began taking photographs with a painterly eye. The light on the faces of the Cramps (Slim Chance, Lux Interior, and Poison Ivy Rorschach) have a Caravaggesque glow, even if Poison Ivy's hair is more Pre-Raphaelite. Not everyone could paint with light at CBGB or balance colors in that crazy graffiti-infested black box.

Roberts has written, "Walking into CBGB's for the first time in 1977, I immediately knew I had to photo-graph what was happening there . . . the energy . . . the music . . . the people . . . I had been incorporating photo-graphic imagery into my work on canvas, in drawings, prints, and collages. CB's was a turning point. . . . Sud-denly, I wanted to do photography as an end in itself. What started as a desire to photograph the excitement of CBGB's expanded into the New York music scene and evolved into a career photographing bands and musi-cians" (Tamar Brazis, ed., *CBGB & OMFUG: Thirty Years from the Home of Underground Rock*).

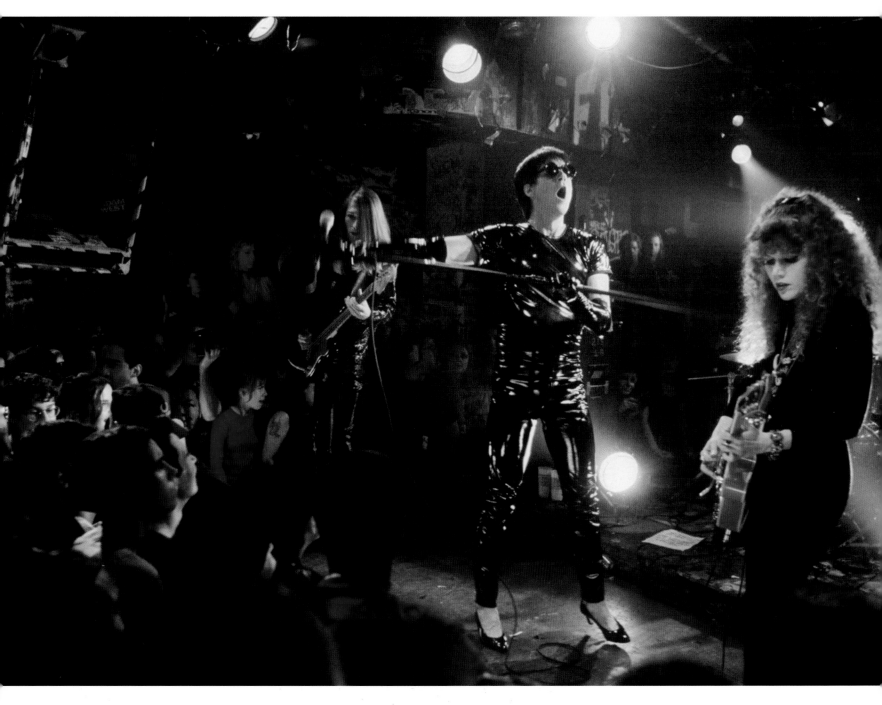

The Cramps, CBGB, New York City
December 10, 1993

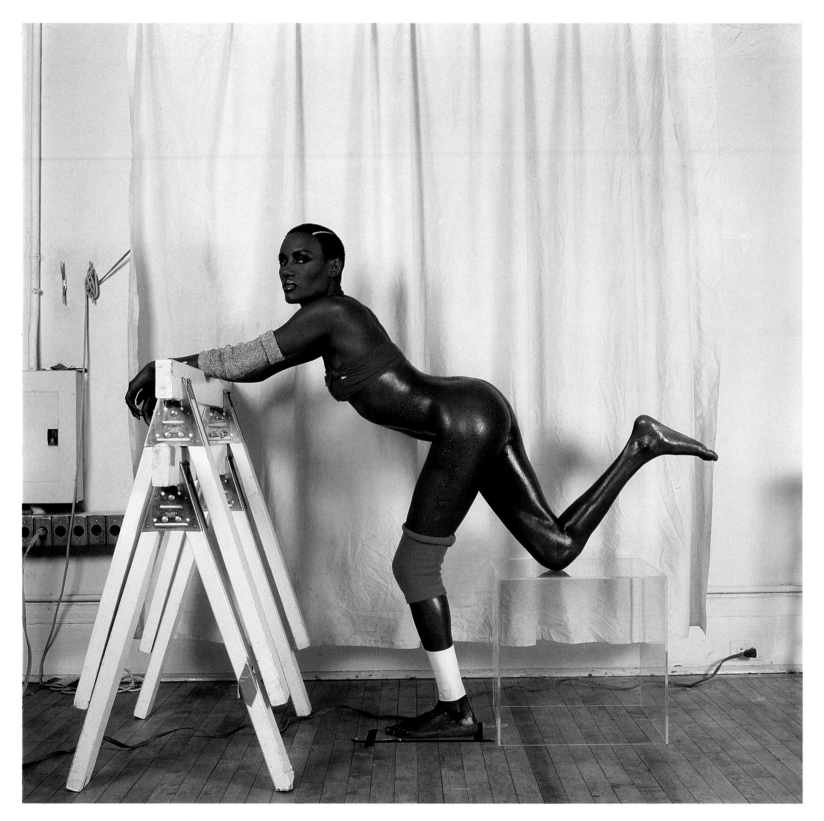

Grace, revised and updated photograph (with red knee band and saw horses), New York City
1978

JEAN-PAUL GOUDE

s Jean-Paul Goude the most creative person on the planet? Some, with good cause, would argue yes. His imagination, and his ability to realize it—whether as an album cover or a mammoth parade through Paris for France's bicentennial celebration—is electrifying and astonishing. Each image he creates—in two or three dimensions—is a jewel.

The first time Goude—graphic designer, illustrator, photographer, film director—saw Grace Jones perform was at a gay disco in Paris called Les Mouches. He was struck by her "ambiguities" and her "classical African beauty." He would possess her and remake her. She was his muse; he was her Pygmalion. Chris Blackwell, the founder and president of Island Records, Jones's record company, described Goude and Jones as a "match made in heaven." Even when Jones was more carnal than angelic, her performances under Goude's art direction were always celestial. Throughout their tenure as a team—professionally and personally (they have a son together)—Jones looked like no other person on earth, either in live performance or in Goude's fantastical and wondrous photographs and videos.

Grace, revised and updated
cut-up Ektachrome, New York City
1978

Grace, revised and updated cover for
***Island Life*, New York City**
1978

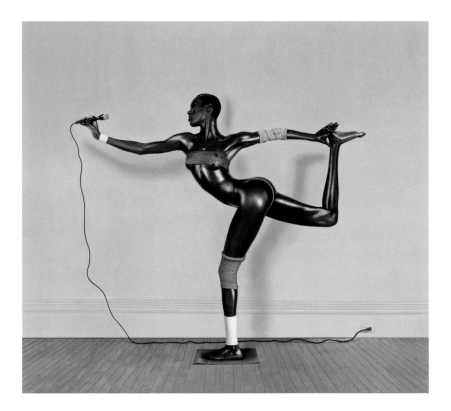

Albert Watson, an expat from Scotland, now living in New York and Marrakech, is one of the world's most sought-after photographers. He has done hundreds of covers for leading fashion, music, and general-interest magazines; campaigns for the Gap, Levi's, Revlon, Chanel, and others; more than five hundred television commercials; scores of album covers; and much more. The trade journal *Photo District News* named him one of the twenty most influential photographers of all time. All this he achieved though he was born with only one functioning eye—a lesson in taking one's disability and kicking it out the door. He titled his first book, appropriately, *Cyclops*.

This photograph of Michael Jackson was taken for the artwork for Jackson's *Invincible* album, but this print was not the one used. Watson writes in an e-mail to the author: "We chose the multiple mirrors to capture Michael's energy and the variety of his dance moves. As soon as I saw the contact sheet, I knew that the way to present this print was with the multiples atop one another, because it captured his energy even more. The full print is really just a representation of the original contact sheet. There are only eight mirrors, but they create hundreds of images of Michael Jackson, or at least parts of him, when assembled like this."

Michael Jackson, New York City
1999

JULIA GORTON

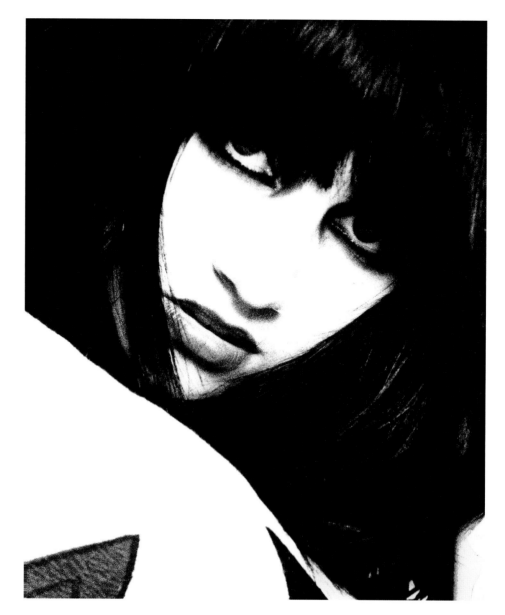

Lydia Lunch, New York City
March 1980

This portrait of Lydia Lunch, with its homage to Bill Brandt, wasn't just a lucky shot in the chaotic world of No Wave music. Julia Gorton, like Marcia Resnick and Godlis, is a trained artist. Godlis mastered street photography—the street often being the Bowery. Resnick sought enough distance between herself and her subject to see the whole person in her viewfinder while she explored the psychological space between them. Gorton, a graduate in graphic design from Parsons School of Design in New York City, was the best photographer on the scene for close-up portraits. One of her teachers was

continued on page 294

KEVIN WESTENBERG

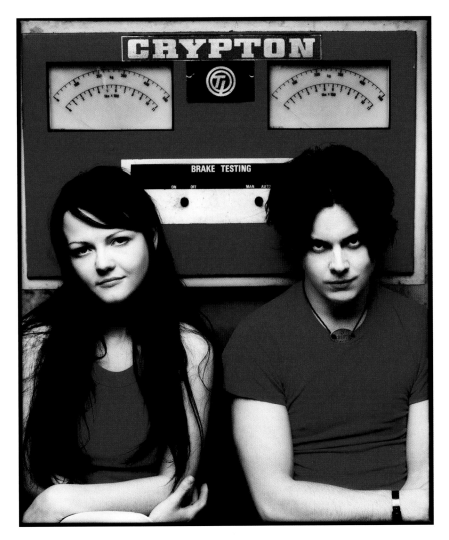

The White Stripes, London
May 8, 2002

evin Westenberg has a master's degree in architecture. It shows in the precise structural elements in his photographs.

Although he started out, as most of the photographers in this book did, shooting live performances, he is known for his studio portraiture, carefully conceived and executed. He still occasionally goes on the road with a band, most notably traveling with Coldplay and capturing (almost) everything they do.

Westenberg speaks about helping bands create a public image for their music. The operative word is "create," because it is Westenberg's creativity that attracts the musicians. Yet Westenberg doesn't want to give himself too much credit as a photographer for originality: "You're not a painter. It's original, but it's not that original. You're pushing a button on a machine, capturing moments in history. I think you're more of a historian than anything else. Which is the part I like" (Oliver Craske, *Rock Faces*, p. 108).

continued on page 294

LLOYD SHEARER

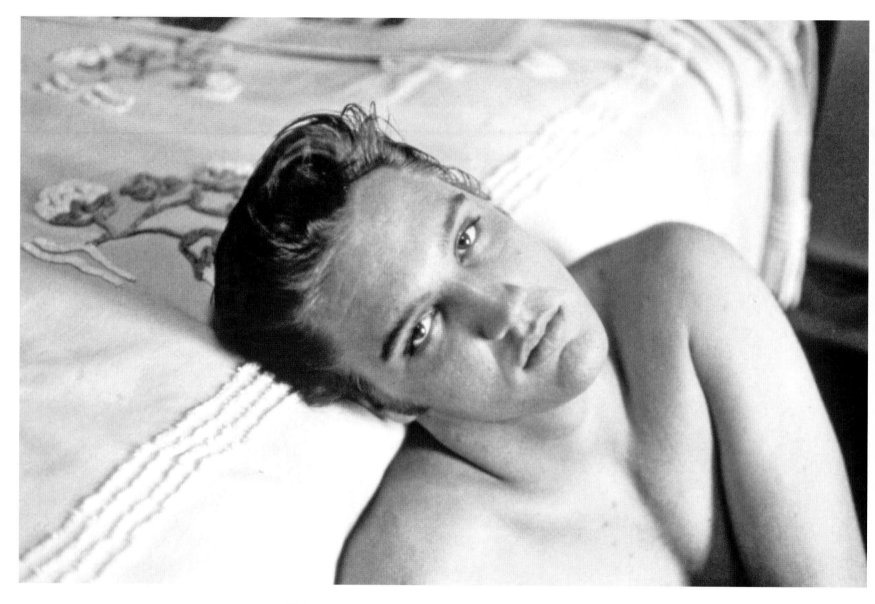

Elvis Presley, Peabody Hotel, Memphis, Tennessee
ca. July 20–29, 1956

This is a face, a look, and a body that breaks hearts. But it is also a face, a look, and a body that can teach people they have hearts. Rock and roll is sex; hence the danger and the allure. This photograph was taken by journalist Lloyd Shearer on assignment for *Parade* magazine dur-

ing an interview in Shearer's room at the poshest, most expensive hotel in Memphis, the Peabody. Rock and roll allowed this poor boy to cross the tracks.

The photograph captures the essence of Elvis; it is potent. Millions of teens would want it by *their* beds. And the King of Rock and Roll would seem right at

continued on page 294

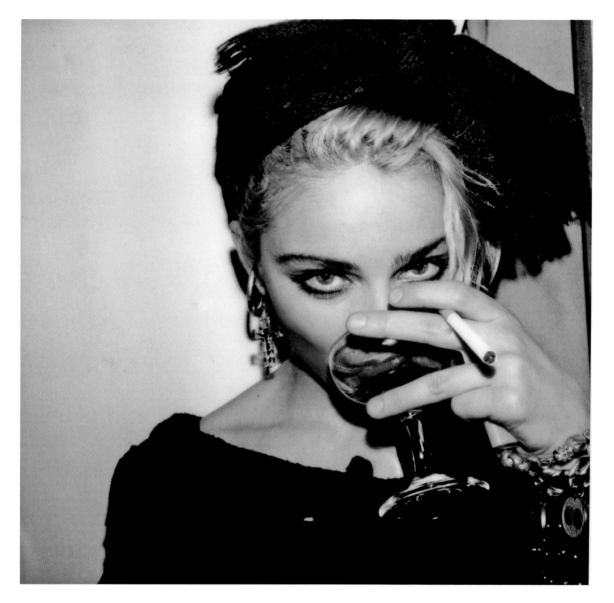

Madonna, Danceteria, New York City
1983

They both are known by single names starting with M.

Maripol helped develop Madonna's "look" during her "Boy Toy" and "Like a Virgin" phases—the crucifixes, jewelry, black rubber bracelets, skimpy skirts, and bodice-revealing blouses. They were friends, part of the same "downtown" scene in New York in the 1980s.

Maripol, multitalented, multiconnected, came to the New World in 1976 after studying film, drawing, and painting at the Ecole des Beaux-Arts in Paris. She is much more than the sum of her parts—artist, photographer,

continued on page 294

DENNIS HOPPER

ennis Hopper is one of the most talented, coolest, and formerly wildest people to have been nurtured in America's womb. He is amazed to be alive because he lived on the edge for so long. This Peter Pan time-traveled on a Harley-Davidson and supplied his own pixie dust. *Easy Rider* was the collective consciousness of a generation. The music held the film (and Hopper's generation) together: Steppenwolf's "Pusher" and "Born to Be Wild," the Band's "The Weight," the Byrds' "Wasn't Born to Follow" and "Ballad of Easy Rider" (written by Bob Dylan and Roger McGuinn), the Jimi Hendrix Experience's "If 6 Was 9," and McGuinn singing Dylan's "It's Alright Ma (I'm Only Bleeding)."

Hopper paints, sculpts, does installations, acts, directs, and photographs. In the early sixties, according to Hopper, the camera was his only creative way of making money and, although he had to buy the film and get the black-and-white prints made, selling his pictures was what "kept him alive." He did the photo for the cover of Tina and Ike Turner's *River Deep—Mountain High* album. Bob Krasnow, then the president of the Blue Thumb label, for whom Ike and Tina recorded in the late 1960s, was interviewed in *Rolling Stone* magazine in 1971 (issue 93) and recalled that Hopper was broke on his ass in Hollywood and trying photography.

In the catalogue of the 2001 Hopper retrospective at MAK Vienna, *Dennis Hopper: A System of Moments*, the art historian and curator Walter Hobbs wrote that at the same time Hopper was making photographs, "he was also making paintings and assemblages. The assemblages combined found objects and large photo blowups which were extraordinary and ahead of their time. . . . In a curi-

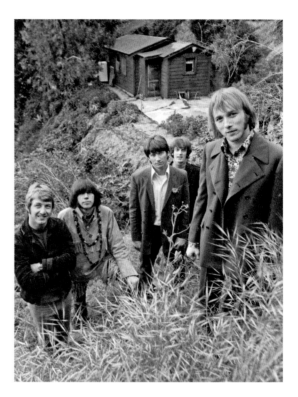

Buffalo Springfield
1969

ous way what seems special about Hopper's photographs now is that they seem to resemble still shots from movies. Not so much frames from films but still photographs made on the set and locations of imagined films in progress" (p. 44).

Among the musicians Hopper photographed in the sixties are the Byrds, Neil Diamond, Jefferson Airplane, the Grateful Dead, Brian Jones, Buffalo Springfield, Phil Spector, Ike and Tina Turner, and, most memorably, James Brown surrounded by ladies.

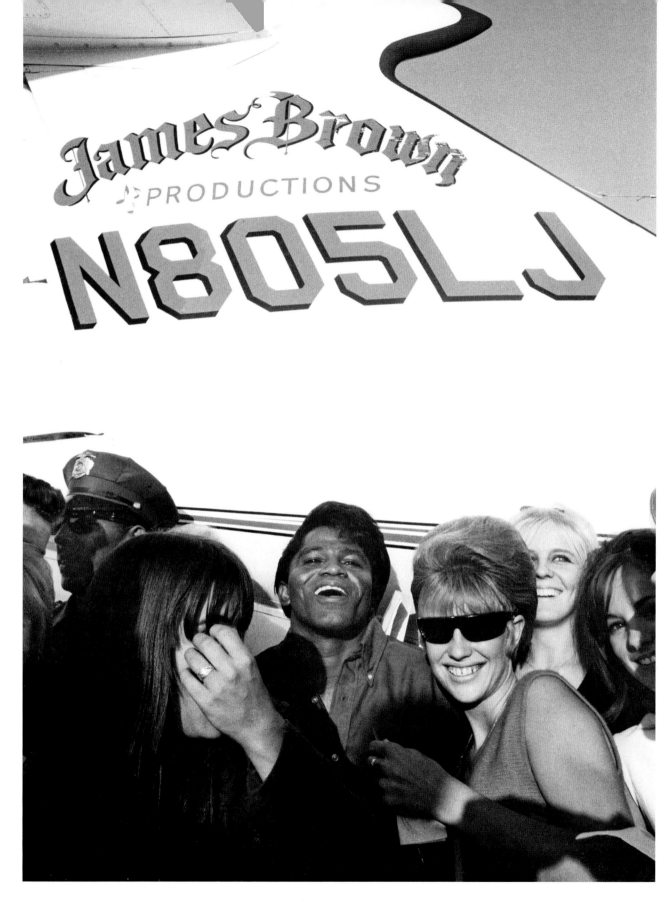

James Brown
1964

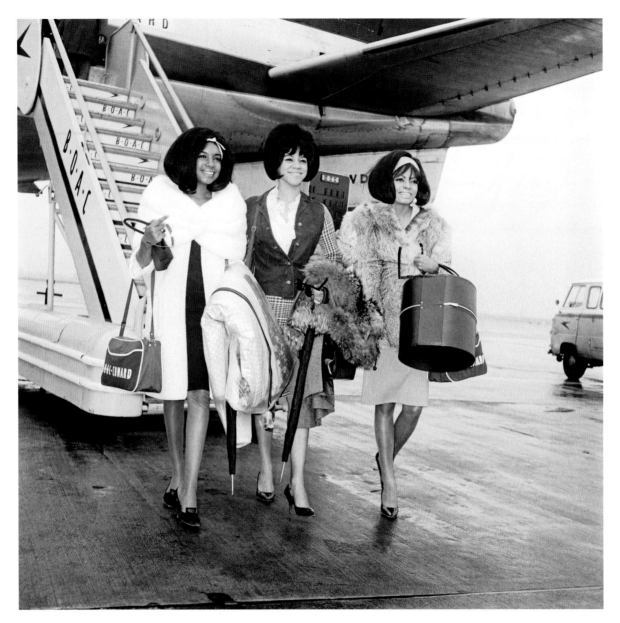

The Supremes arriving at the airport, London
January 1965

The EMI photographer, most likely staff photographer John Dove, knew exactly what he had to do. He had to make a picture of the Supremes smiling, stepping smartly, hair combed, elegantly coming off the airplane. It is not real—no one looks like that after a transatlantic flight—but it is charming and it certainly would make music buyers interested in these three quite amazing-looking women.

The Supremes had been to England the year before and were wonderful in front of the camera. In November 1964, they posed around a Christmas tree, looking like

continued on page 294

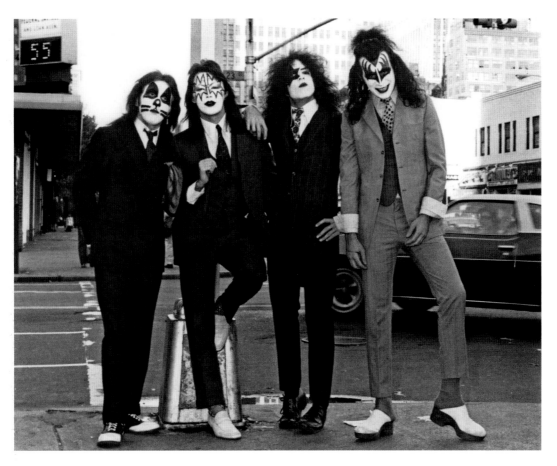

KISS, *Dressed to Kill,* Twenty-third Street and Eighth Avenue, New York City
1974

Humor in photography is good. *CREEM* magazine had the idea for Bob Gruen to shoot a photo comic strip featuring KISS in 1974. *PUNK* magazine followed suit most impressively in 1976 with "The Legend of Nick Detroit" and in the summer (of course it had to be the summer) of 1978 with "Mutant Monster Beach Party."

The story line of the "KISS Komix Presents Clean Machine Grip Gotham—but Their Lives Were Saved by Rock & Roll" is that an Amish boy from Intercourse, Pennsylvania, comes to New York City and becomes a disc jockey with the sole intention of eliminating the destructive forces of rock and roll. Kiss, our heroes, are first seen on a subway platform, faces covered by the newspapers, as they read the headlines: "Rock Music Sales Record Low," "Bob Dylan Bankrupt!" "Dope Crop Goes Unharvested!"

The photograph above was published with bubble captions that read: "This calls for action!" "This calls for a Plan!" "This calls for Speed!" "But first we have to find a phone booth." In Gruen's picture story, our champions emerge from the phone booth fully attired as KISS, ready to save Gotham City and rock and roll. Of course, they wipe out the forces of "good clean fun," and once again, rock and roll saves the day.

Gruen's photograph is so good in itself, it was used on KISS's album *Dressed to Kill*.

DON HUNSTEIN

Wherever that couple was going, I wanted to go. *The Freewheelin' Bob Dylan* was propped up on the chest in my teenage bedroom, next to the record player. They were walking right out of the frame. I wanted to walk right out of my American suburban lifestyle. They were going somewhere, and that somewhere is where I wanted to be.

Don Hunstein made one of the most iconic LP covers in rock-and-roll history (the original transparency is lost; this is a close outtake from the famous shoot). Making album covers was part of his job at Columbia Records. The sensitivity Hunstein brought to his work was all Don Hunstein. He is a deep, reflective, and sensitive man. He worked for Columbia Records from January 1956 to August 1982, but he never sold his soul. His heart was always with the musicians. Photography for Hunstein was a way to help people connect with individual artists. Looking at Hunstein's body of work, one marvels at the constant originality of it. By the time he retired from Columbia, he had made the pictures for at least two hundred album and CD covers in every musical genre— from Philip Glass to Moondog, Glenn Gould to Sarah Vaughan, Leonard Bernstein to Sly and the Family Stone. He shot the picture of Miles Davis on *Kind of Blue*. He worked in the studio, he worked on location. He did whatever he was asked but he did it with such finesse that it is shocking that the name Don Hunstein is not well known. His pictures were in millions of living rooms as well as teenage bedrooms. In the large 12 × 12-inch LP format, his photographs were real pictures that people looked at, cared about, and often put on their walls.

Hunstein, born in St. Louis, Missouri, a graduate of Washington University, knew he would be drafted during the Korean War, so he enlisted in the air force. To this day he can't believe his luck. He landed a desk job in Gloucestershire, England, on an RAF base. He got himself transferred to South Ruislip, near London. The camera his mother had given him was stolen; he bought a Leica cheap in the R.X. He went to Paris on a three-day pass and on Boulevard Saint-Germain discovered a book that would change his life—Henri Cartier-Bresson's *The Decisive Moment*. He started taking photographs on the street à la Cartier-Bresson. He printed them at the London Camera Club.

Upon leaving the military, Hunstein realized that New York City was where he wanted to be. Crashing at friends' homes, he got a job loading film holders and moving lights in a photographer's studio. Through a St. Louis journalist, he was put in contact with Gene Cook, the entertainment editor at *Life*. Cook introduced him to the legendary publicity director at Columbia Records, Deborah Ishlon. He was hired by Columbia full-time in 1956 when, as Hunstein says, "rock and roll was becoming big and [Ishlon] needed help filing negatives and contact sheets and color." Within the year, "Debbie" gave him a try at photographing and, as they say, the rest is history—but not quite. History implies a record of the facts. For the most part, Hunstein's name should have, but did not, become a big part of music and photographic history.

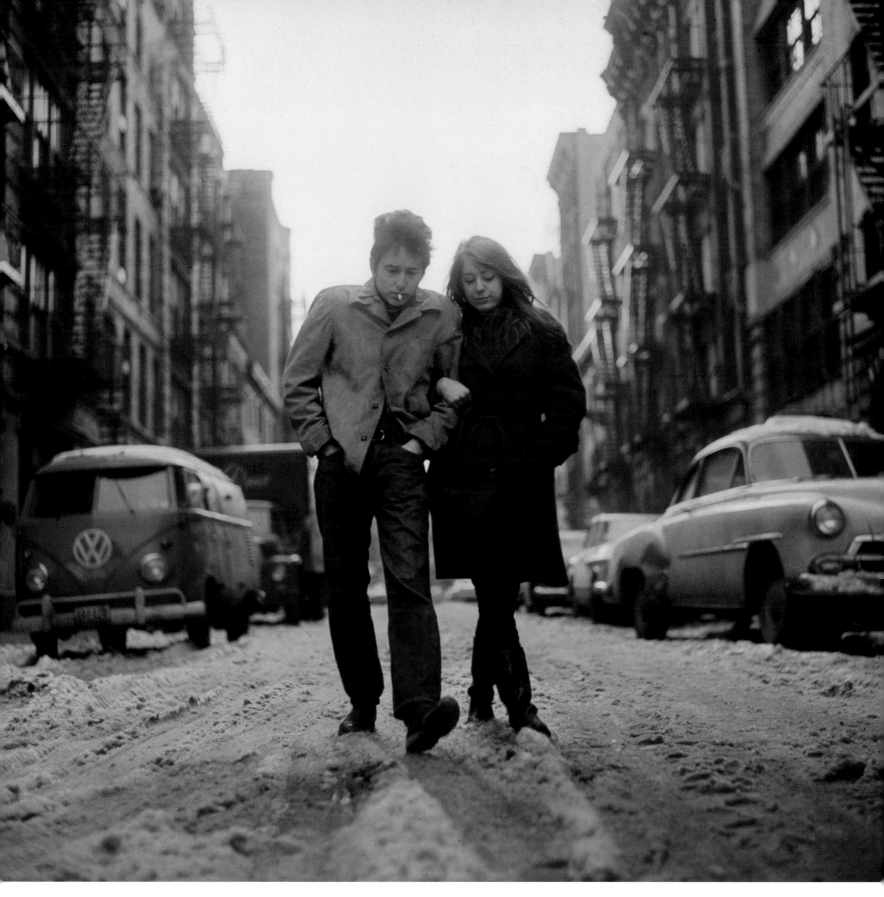

The Freewheelin' Bob Dylan (outtake), Jones Street, New York City
1963

ALLAN TANNENBAUM

You know what I like about your pictures?" John Lennon said to Allan Tannenbaum, photographer for the *SoHo Weekly News* in New York in November 1980. "You really capture Yoko's beauty."

John and Yoko in bed, taken in the studio during the filming of the video for "(Just Like) Starting Over" from the *Double Fantasy* album, is the most beautiful photograph of them together. They intertwine and become one. The beauty resides not just in Yoko but in Tannenbaum's portrayal of love and lovemaking. Two weeks later, Lennon would be dead.

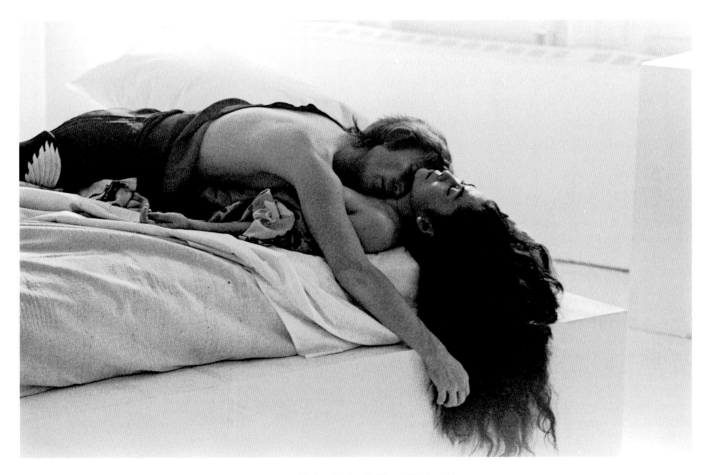

John and Yoko in bed, New York City
November 21, 1980

HENRY DILTZ

I had a wonderful time taking all these pictures.

—HENRY DILTZ

Henry Diltz is a joyful man, kind and considerate. He is one of America's most important rock-and-roll photographers, but yet there is humility about him. If someone had to list the perfect attributes for a rock-and-roll photographer, summarizing Diltz's traits would constitute the list: a laid-back, observant, caring, good ear, good eye, passionate about the music, loving the visual highs, friendly, risk-taking, ponytail-wearing, antiestablishment, keeps it simple, 35mm type of guy.

During an interview in his Los Angeles studio in 2007, Diltz reminisced:

I was a musician and started shooting my friends who were all musicians; that is how I got access to all these people and could do candids and documentary stuff without them thinking it was a photo session. That is what distinguished my stuff, it was behind the scenes. I shot slides because I loved to project them—really huge—and my friends would watch them, great entertainment. It is what made me become a photographer, trying to get more stuff for slide shows. I really cared about color. . . .

I have most of my negatives. I have lost a few. Being the official photographer of Woodstock and official photographer of Monterey Pop, in both cases I lost more than half of what I shot because the producers wanted stuff right away, they wanted slides, they wanted negatives, I would try to give them prints and hold on to the originals but I couldn't always. They would say, Quick, send us forty slides. I never had the money or the time to get dupes made or prints made. That is why the digital age is wonderful in that respect. They can have all the pictures and I can keep all the pictures.

The album cover part of it, I joined up with a graphic artist named Gary Burden. We did about one hundred album covers. He is a terrific artist with great taste and style and . . . this is the important part, we worked for the groups, we never worked for the record companies. The record companies hated us because at some point in the late sixties the groups gained more control and that was because Elliot Roberts and David Geffen starting Asylum Records—the Eagles; Joni Mitchell; Crosby, Stills, Nash and Young; America; Neil Young; Jackson Browne; Joe Walsh; Dan Fogelberg—they gave the record company the finished product—the record companies had nothing to do with the album covers. Absolute freedom. We would talk to the guys and say, "What do you want to do?" and then we would take a trip somewhere and have fun. . . . Musicians hate photo sessions, it is like going to the dentist. Especially if it is in a studio, the lights and all, and you have to stand there. We wouldn't do that. We would say, "Let's go up to Big Sur, let's go out to Joshua Tree, the desert, spend the night." That way you got the group away from all the girlfriends and the managers and you could let things unfold and have a good time. . . . We would have this adventure and photograph what happened and somewhere in there would be the image that was really these guys and it always worked out.

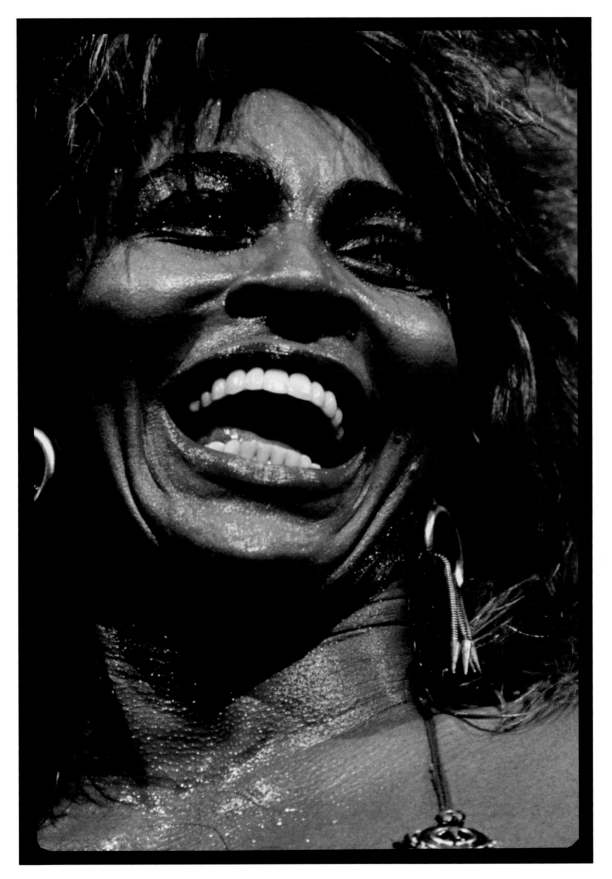

Tina Turner, Universal Amphitheater, Los Angeles, California
October 1985

HANNES SCHMID

Hannes Schmid's music archive numbers more than seventy thousand images. He was one of the most prolific rock photographers working in Europe from 1977 to 1982. Much of the time, "working" was just hanging out, traveling, visiting at home, and going on vacation with the musicians he called friends. Schmid is an ebullient world traveler, skier, adventurer, mountain climber, and storyteller. His pictures of the Who, the Police, ABBA, Barclay James Harvest, Genesis, Paul and Linda McCartney, Queen, Angus and Malcolm Young, Nina Hagen, Debbie Harry, Bob Geldof, Nazareth, and Black Sabbath are as friendly as sharing a pint of beer. They are intentionally low-key. Schmid said, "Nobody took notice when I pointed my camera. I wanted to make pictures that were very intimate, like family pictures, not made up."

Schmid used his access to the rock stars to make portraits of them either before or just after they went onstage. These were sometimes inserted in rock-and-roll magazines in fragments—one would have to buy five or six consecutive issues of the publications in order to piece together the A4-size pages to form a life-size poster of the rock-and-roll star. These piecemeal posters were called Star Cuts. This picture of David Lee Roth is one of these.

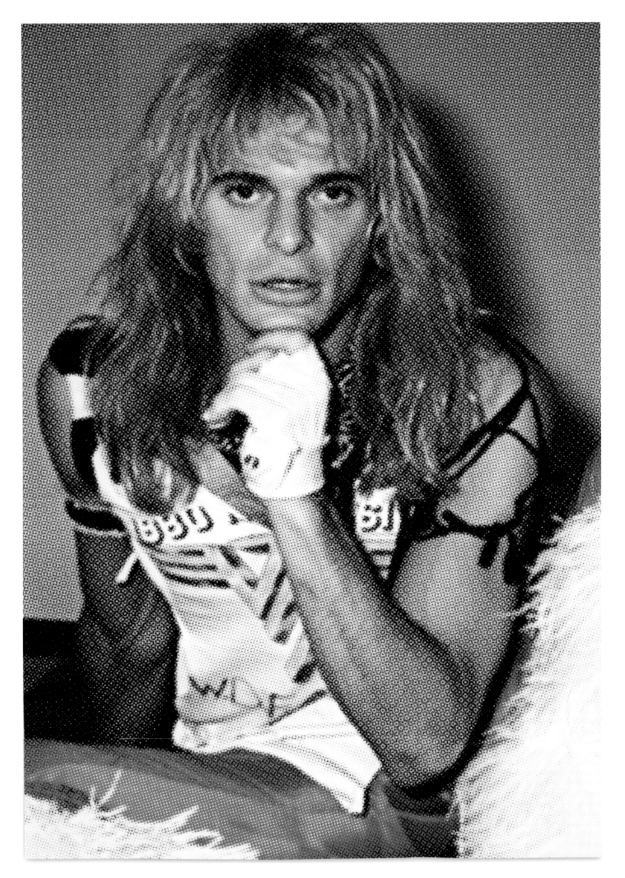

David Lee Roth, Van Halen
1980

ALBERT WATSON

ook at me. Look me in the eye. Look at me. Rarely in the history of photography is an image so demanding, so unequivocal, as Albert Watson's portrait of LL Cool J. Look at me as I look at you.

This is the power of photography. This is the poignancy of great portraiture—the absolute recognition of another's humanity, and a connection so immediate that something happens inside of the viewer—a tightening, a shudder, and an awakening to the beauty, the strength, and the uniqueness of each and every individual.

One of Watson's most famous images is the composite of Mick Jagger and a leopard (see page 80), brilliantly done so that they are one. The picture is much more than a gimmick; it is meditation on the shared traits of man and animal. In this LL Cool J image, there is no need for montage; the singer, the star, is everything in one.

In the introduction to Watson's book *Cyclops*, James Truman describes Watson as a "compulsive perfectionist and a romantic dreamer who still believes in the luxurious power of photography to seduce, shake, rattle, and roll."

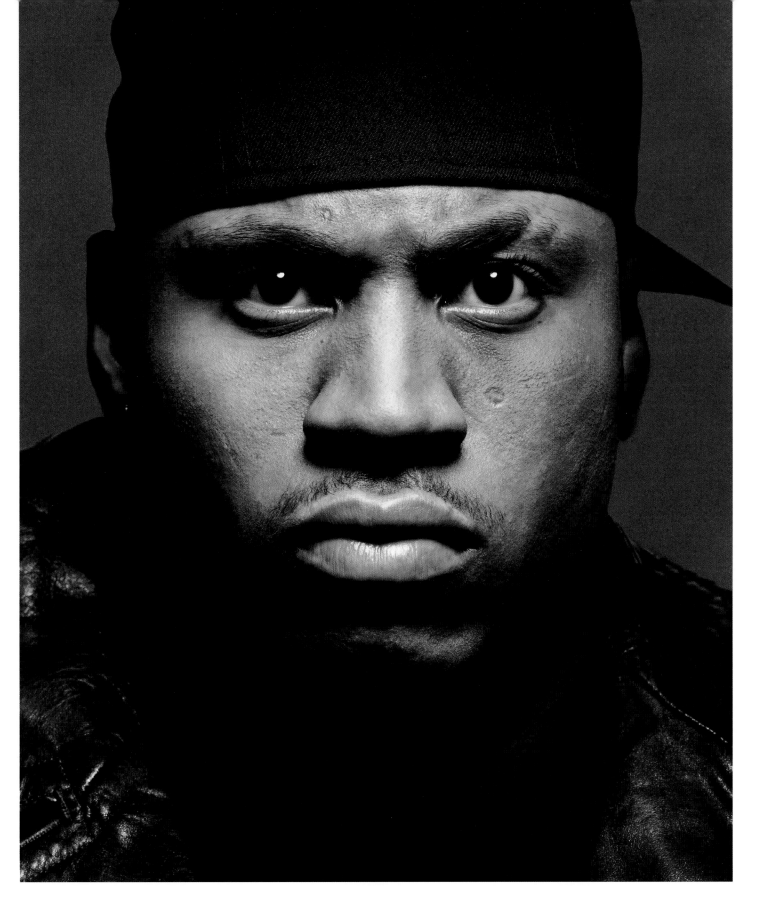

LL Cool J
1992

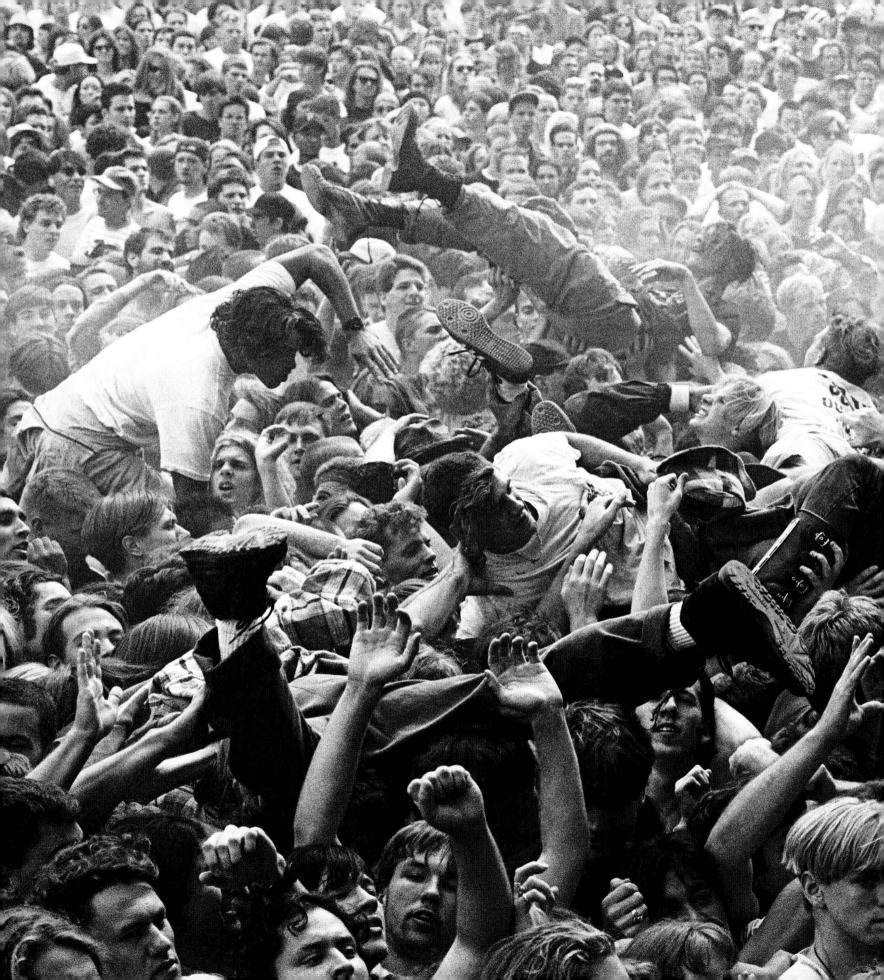

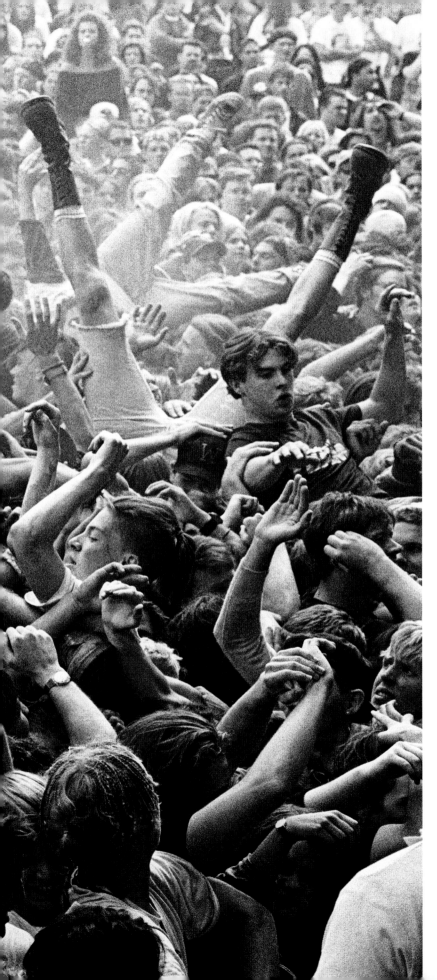

CHARLES PETERSON

Jennie Boddy, music critic and publicist, has written that Charles Peterson is "the visual part of what happened in Seattle." And, she adds, "he's fucking responsible for the look of the Seattle scene. . . . When you think of a Charles Peterson photo, you think of emotion and stinky bodies and energy." His kinetic imagery includes Nirvana, Pearl Jam, Soundgarden, Alice in Chains, Sleater-Kinney, Mudhoney, Sonic Youth, L7, Hole, Tad, Girl Trouble, and Black Flag.

How does Peterson jump into a mosh pit and come out relatively unscathed and with brilliant photographs? He says, "Part of it is spending a lot of my youth diving off stages and slam dancing. . . . I know how to fall; I know how to stiff-arm somebody if need be. I just know how to react. I know how to keep one eye looking through my camera, one eye looking out behind my head. Part of it is suiting my gear to what I do. I use a motor drive; I use a heavy-duty flash. . . . Simple things like that can make the work easier."

Peterson, a music photographer who identifies with war photographers, speaks about going to the front lines and not returning until he has the pictorial evidence that provides the emotional impact of what he has witnessed. No one would believe in the revolution—military or musical—if there weren't photographs to serve as witness. In Peterson's photos, one imagines young men going off to war or to rock concerts. (Up with rock concerts, down with war!)

Peterson had to master the technical aspects of photography in order to get "the thrill of the moment." In his book *Touch Me I'm Sick*, one of the best books of rock-and-roll photography, he writes, "I always had a higher agenda with photography—fine art aspirations. For me,

continued on page 295

Mosh pit at Endfest, Kitsap County, Washington
1991

MARK SELIGER

The pose is supposed to signify the rock star. Chris Martin, lead vocalist of Coldplay and classicist, looks more like Aristotle contemplating the bust of Homer than a headliner. The body language, the innate sex appeal, is mute. Mark Seliger's Chris Martin is an anti-rock image, more about brains than bravado.

The photograph of Martin appears in Seliger's book *In My Stairwell*. The book opens with a close-up of old battered bricks and then a negative image of Mick Jagger, eerie with its lights and shadows reversed. Pictures of Jagger and Keith Richards follow, each monumental and hewn. The rough brick background brings out the topography of their features. Placing them and nearly one hundred other celebrities in a stairwell imposes a confining context for the portraits, all taken with natural light. From Luciano Pavarotti to a nude Lenny Kravitz, this who's who of contemporary culture appears imprisoned with their fantasies and thoughts. Indeed, the space was once a women's correctional facility. The series is an homage to Irving Penn's portraits from the 1950s taken in a corner of a studio—but a smooth, clean corner. Both series use one physical space as a constant to investigate the nuances and essences inherent in each individual.

Seliger was twenty-six years old when he succeeded Annie Leibovitz as chief photographer for *Rolling Stone* magazine, a dream job he held for ten years. Much of his portraiture is studio-based with a veneer of glamour, but his goal is to initiate and maintain an intimacy with his subject, no matter where the photograph is taken. For Seliger, the mastery of his craft, the lighting, the tools—with the apotheosis his printing his 8×10 negatives in his platinum darkroom—are what keep his finger on the shutter and his photographic journey profound.

Chris Martin, New York City
August 27, 2003

ALFRED WERTHEIMER

W hether it was the "laying of hands" or the singing of a song, Elvis's touch was transformative. Every child in this picture was changed by Elvis and grew up in a world that was "all shook up." This photograph is one of the rare exceptions of Alfred Wertheimer's not using natural light. It was so dark, he had to use a flash.

Elvis leaving his home at 1034 Audubon Drive, Memphis, Tennessee, on his way to perform at Russwood Stadium, with the local sheriff waiting to drive him and Colonel Tom Parker to the event
July 4, 1956

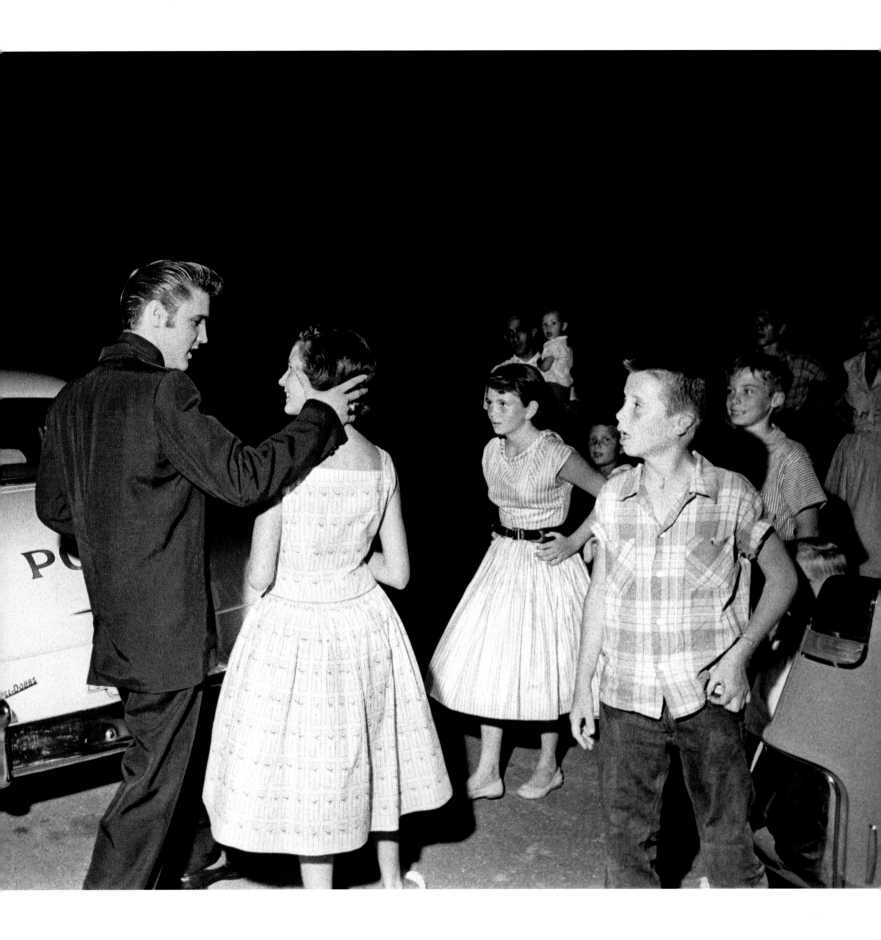

ALAIN DISTER

The New York Dolls stop traffic. They have nothing to worry about.

Alain Dister's picture shows the lads' swagger and inimical style. It is a wonderful, fun picture suggesting their triumphal entry into the city.

The French photographer and writer Dister never studied photography; as a teen he studied his grandmother's fashion magazines every Sunday rather than be bored by the adult conversation. It was, he admitted, his first education in training his eye.

Dister lived in the United States from 1966 to 1969, some of the time on the same street as the Grateful Dead in Haight-Ashbury, and became close with many of the musicians of the sixties and seventies. While photographing and writing about the musicians, he developed a keen interest for the audience, with the ever-changing styles and attitudes. "I soon realized they were a better subject than the guy up there in the spotlight," he observes. "[I became] interested in how people react to musicians, not making 'rock' photographs."

The New York Dolls, Arc de Triomphe, Paris
1973

BOB GRUEN

The kids got the lifestyle from the photographs," says Bob Gruen, former chief photographer for *Rock Scene* magazine. "They put the photos on the wall to make the experience more real while they were listening to the music. A lot of the lifestyle they got not from the music but from the photographs—how people dressed, how they interacted, where they went. A lot of people don't recognize the role of photography," Gruen emphasizes. The magazines Gruen worked for were handbooks for teenage reinvention. Gruen specialized in the candid, you-are-there photo features. He got the behind-the-scenes snaps by hanging out with the musicians and touring with them. He covered the punk and New Wave scenes more extensively than anyone else, doing great pictures of not only the Clash but also the New York Dolls, the Sex Pistols, the Ramones, Blondie, and the Patti Smith Group. His success lies in his stated aim: "Try to show feelings, not facts. Make sure the feelings are clear even if the focus isn't."

Gruen feels passionately that both his photography and the music were about "how you can live in a free way." Rock and roll, he says, is about personal freedom. Elvis's "kiss" by Alfred Wertheimer (see pages 40, 41, and 43) is a fifties form of conquest, taking place in a hidden stairwell away from public view. Strummer and his girlfriend, leaning against Gruen's '54 Buick, the horizon behind them, don't care who sees their embrace.

Joe Strummer of the Clash and Gaby Salter, Battery Park, New York City
1981

PENNIE SMITH *continued from page 44*

had a sixth sense about when things were going to happen. The night the photograph, voted by the readers of *Q* magazine "The Greatest Rock and Roll Photograph" of all time, was taken, Smith was close enough with her camera to Simonon to see and feel his rage. She took the shot and then ran away "cos I thought he was coming at me." She was not prepared to be the next thing Simonon wanted to smash.

Smith originally thought that because the picture is not sharp, it perhaps should not have been used for the cover of *London Calling*. But the band was adamant that they wanted it.

"Sharp" can mean "cutting-edge," "involving a sudden or abrupt change in direction," "felt acutely, intense," "fierce or violent," and, in colloquial expression, "very cool." The picture is definitely sharp.

RICHARD CREAMER *continued from page 45*

author, she recalls Creamer, who died at about age fifty in 1998 or 1999:

> Richard was not art inspired, he was rock 'n' roll group besotted. . . . His passion was being able to capture the whimsy and party time vibe of the bands he shot. . . . Richard inspired goofy rock 'n' roll mayhem. He had been the geeky high school guy, and he transformed into the photog

that bands liked to josh with and sometimes pose for, and often toss into pools. . . . He shot and printed the same night as his shows. He'd hurtle himself back to Grace Avenue [his home and studio], develop, print and deliver to the record companies, mags, the next morning. Later in his career, he opened a small studio on Vine Street in Hollywood for himself and other photogs. This motley crew was certainly not art inspired, but music motivated, like Richard. They also, like Richard, enjoyed the huge excesses, which marked music in the 70s, of lavish record company bashes: Beach Boys free beach towels, lobster buffets, caviar mountains. . . . Many of us photogs and journalists lived for these spreads, and often dined on the spoils for the coming weeks.

PETER VERNON *continued from page 50*

Vernon's picture was taken while he worked for EMI and is owned by them. In the spirit of the times, it was used uncredited on the Sex Pistol's bootleg album *The Filth and the Fury*, circulated before the release of *Never Mind the Bollocks, Here's the Sex Pistols*.

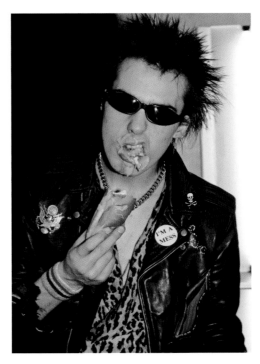

Sid Vicious "I'm a Mess," Sex Pistols
1978
Photograph by Bob Gruen

MICK ROCK *continued from page 56*

Mick Rock never studied photography—he is a student of faces and attitude. He was Ziggy Stardust's official photographer and he caught the glam, wore the lip gloss, and also made sense of the nonsense. Mick Rock is a very intelligent man inside a very cool façade. He gets it—the sex, the drugs, the music, the fuck-you attitude, the kids, and the beauty of it all—even if he no longer lives it. Through his camera, he helps musicians figure out who they are. Rock photographers are part image-maker, part

analyst, part sage, part friend. Mick Rock is one photographer who has no desire to peel off the mask as long as he is able to reveal the intellect and the talent beneath it.

My ambition was not to be a great photographer (though that certainly would have been a worthy stance). It was a lust to embrace anything that startled or energized me. This was the road down which my instinct for the colourful and decadent led me. And in the process I captured moments in time that still resonate today. I certainly wasn't trying to consciously document or define. I just needed to prime my nervous system on the sharpest edges of my time. . . .

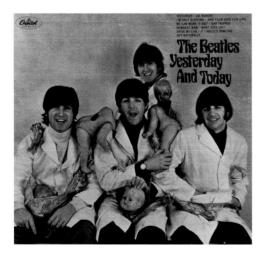

The famous Beatles "butcher" album cover
by Robert Whitaker
1966

A camera is a wonderful ally. It requires minimal maintenance and provides entry to a world of endless imagery. Follow the frame, say I. . . . Throw out all the rules and caress the tiniest twitch, the loneliest thrill, the blessed image.

—MICK ROCK, INTRODUCTION, *GLAM! AN EYEWITNESS ACCOUNT*

PENNIE SMITH *continued from page 66*

tant book take the viewer on a wild but also tender, insightful, fun-filled ride with the Clash. Her book, again unlike most band books, which are schlock, has a structure and great captions written by Smith and the band members. It is divided into sections such as "It's More a Feeling," "In Search of the Perfect Costume," "Hanging Around," and "3 Minute Warning." With its great photography, savvy layout, and often humorous but always honest captions, *The Clash: Before & After* is a classic.

NORMAN SEEFF *continued from page 67*

doing his first commercial assignment, he didn't like the result and refrained from presenting his pictures to this giant of the New York publishing and music worlds. The irony is that when Seeff finally mustered the courage to show the photographs to Cato and the Band, they liked them so much that Cato's own photograph was bumped and Seeff's was put on the cover of *Stage Fright*, which Seeff cer-

tainly had. The poster that was made from Seeff's image and included as part of the design package of the album was soon seen on walls everywhere. Although Seeff does not mention this in interviews, perhaps his lifelong exploration of the creative process is an exploration in overcoming the "stage fright" and self-doubt facing every artist.

ROBERT WHITAKER *continued from page 71*

so I thought that by putting the light meter in the picture it might convey an idea of the speed of light running so fast that it shot straight back up your arse. It was just to see what could become a record cover."

The "butcher" picture—not a very good photograph in itself, as Whitaker maintains—was only one part of the original concept, which was never fully executed. He had envisioned gold halos over these gods' heads, a semiprecious stone inlaid, and additional conceptual photographs to form a gatefold. As the musicians were getting more radical, the industry was getting more nervous. But it wasn't only the record companies that were conservative. Certain music stores, too, were frightened of album covers that showed toilets, raw meat, or too much sex. The Vietnam War was raging, as both Lennon and McCartney vehemently observed, but no raw meat or dismembered dolls!

BOB GRUEN *continued from page 75*

what America is about. I was always told this is a free coun-

try. One of my earliest memories is saying "it is a free country" and not getting out of bed at summer camp.

—INTERVIEW WITH BOB GRUEN, 2008

Gruen shot about five or six bands a night—very few of which are still remembered. He would develop the negatives before going to sleep in the wee hours and make the prints in the morning before his daily hustle to make a buck from photography. It wasn't lucrative, but it was fun.

And he always kept his copyright.

CHRIS STEIN *continued from page 87*

Bayley was the principal photographer. For issue number 10 (1977), Stein took readers on tour with Blondie, writing satirical captions for his photographic travelogue. The style is perfect deadpan, and when a picture gets artsy, he gives it a caption such as "Storm in Chicago—Tornado Warnings 9 p.m. This is the most artistic photo."

"The Legend of Nick Detroit," a photo-cartoon ahead of its time, has characters that include "ruthless murderers," a former government agent who "killed 966 people in the line of duty," "Nazi dykes," and a cast of actors directly out of CBGB. With photographs by Bayley, William Winans, and Dan Asher as well as Stein, it is a romp and roll. In one picture, Debbie Harry, "a Nazi dyke," gets *Fwok* by Nick Detroit (Richard Hell). In a second picture, Anya Phillips gets splattered while Harry fruitlessly tries to wipe out the hero, Nick Detroit. What might the

couple seated quietly on the Staten Island ferry be thinking?

GERED MANKOWITZ *continued from page 89*

"leering" at a teenage girl. Decca nixed the picture.

Rock and roll has always been front and center in the cultural wars; it speaks truth to the hypocrisy and lies of the elders. Photography, not just the music, was part of this cultural shift. Photographers tried to see clearly the world around them, not pretend it was something other than what it was.

GUY WEBSTER *continued from page 94*

of well known. A billboard on Sunset. A friend of mine invited me to his home and he was showing me around and we went into the kid's room and there was my poster of the Byrds over this kid's bed. I had no idea there were posters in bedrooms all over the country. . . .

I was a romantic and studied Renaissance painting and got my master's in Renaissance fine art. . . . I tried to show the beauty of the people of the sixties, not as freaks but as soulful, beautiful, even Christlike (Jim Morrison's picture is very Christlike). Then I realized we were changing the world and we were educating

If You Can Believe Your Eyes and Ears
Photograph by Guy Webster
The Mamas and the Papas
1966

people from Kansas as to what was going on on the West Coast and the East Coast and that it was very important. I am a political idealist and I thought we were going to change the world politically but then Nixon came into power and then I bought a farm in Europe and lived there.

BOB SEIDEMANN *continued from page 102*

Dorset landscape. In pre-Photoshop days, getting the scale correct for the album cover and combining the two best transparencies was a challenge.

Seidemann, a graduate of Manhattan High School of Aviation Trades, learned to love airplanes by watching them over-

head on their flight path to LaGuardia near his childhood home in Queens. He learned photography—shooting with an 8 × 10 camera, developing Ektachrome—at a big-time New York studio that produced stock pictures for calendars and catalogs.

Seidemann had been living in San Francisco in the late sixties, making psychedelic posters and photographing musicians (he made the famous nude photograph of Janis Joplin in nothing but her beads). When he made a picture titled "Piete 1968" of a young nude woman as the dead Christ, it scared him sufficiently that he left the country and crashed at Clapton's London flat before moving into his own digs. He needed renewal as much as America did. That is when he made "Blind Faith."

Outtakes for *Blind Faith*
London and Dorset, England
1969

GLORIA STAVERS *continued from page 108*

GLORIA STAVERS *continued from page 108*

pictures, what she lacked in technical know-how she made up in good instincts. The girls who read her magazine wanted to see "the real" rock star, and this picture of David Bowie perfectly communicates "Here I am, take a good look, I am gorgeous and I am cool." The hotel room, rather than a studio, emphasizes that in Stavers's world, the picture didn't need to be slick, it just had to seem honest and intimate.

BARRIE WENTZELL *continued from page 112*

BARRIE WENTZELL *continued from page 112*

Working mainly for *Melody Maker*, Wentzell took pictures that were seen by

people all over the world in those pre-MTV days. He wanted to bring readers close to the people who made the music. He also was astutely aware that the photographers and the musicians were part of a group creating youth culture—"we invented it as we went along. There was nothing for us kids until rock and roll set us free."

DANNY CLINCH *continued from page 117*

DANNY CLINCH *continued from page 117*

a clear look at themselves. Sometimes he shoots in the studio; more often he goes to a location that resonates with who the musician is—ghetto kid, dreamy rebel, solitary wanderer.

JEAN-PIERRE LELOIR *continued from page 131*

JEAN-PIERRE LELOIR *continued from page 131*

days." The story has an important point. Leloir has always seen photography as a dignified profession. In turn, he has always fought to be treated with dignity.

When Leloir began photographing, film speeds were 12 ASA, then 24 ASA. To get sharp photographs, he had to work in the studio with lights; flash was "obligatory" on location. He affectionately recalls going to the Photokina festival in Cologne in 1962 and coming back with a 400mm lens. Voilà! As the musicians and/or their agents made it harder and harder to get near the stage, Leloir could still create a sense of closeness to the performance. His picture of Chuck Berry is a perfect example.

Like almost every music photographer, he is disgusted by the three-song rule that, he says, the Rolling Stones introduced in 1973. "They ask you to leave after three songs. Complete lack of respect," says Leloir, a most dignified man. He always treated musicians with respect; he feels he deserves the same.

KEN REGAN *continued from page 135*

The Last Waltz and George Harrison's benefit for Bangladesh. He was also a principal photographer for Live Aid and other rock festivals supporting human rights. How did a kid from the Bronx do all of this? With a good education at Columbia and NYU and a sensitive eye and generosity of spirit.

ANNIE LEIBOVITZ *continued from page 143*

snaps. Leibovitz had the chutzpah (has the chutzpah and will always have the chutzpah) to present him with something different. Within the month, Jann Wenner, founder of *Rolling Stone*, took her to New York to photograph John Lennon, resulting in her first cover for the magazine she would be closely identified with from 1970 to 1983.

For someone as famous and successful as Leibovitz, the adjective "earnest" may appear disingenuous. Throughout her career, though, she has believed in and loved what she does. Her exhibition at the Brooklyn Museum, *A Photographer's Life, 1990–2005*, presented her argument, not convincingly but passionately, that the camera, used spontaneously or in elaborate studios, is an extension of her being and thus aligned. Viewers of the exhibition experienced not one sensibility but two strains of her being—one professional and focused on celebrities, the other deeply emotional and committed to family and friends.

Leibovitz started as a photojournalist and, as the early issues of *Rolling Stone* prove, she was wonderful as a fly on the wall. She did not have to "direct" much; rock-and-roll musicians put on quite a show, offstage as well as on. She was then, and still is, a keen observer.

Rolling Stone needed a cover every month, and making a photograph with pizzazz to fit the format meant Leibovitz had to learn to use color and lights and come up with *ideas*. "Annie" was not always the technical wizard of the American Express ads, *The Sopranos* publicity stills, *Vanity Fair* portraiture. In her best-selling book *Annie Leibovitz at Work* she writes: "I had rudimentary technical skills when I started work. I had never shot in color when *Rolling Stone* began printing four-color covers in 1973 although Jann Wenner had given me the title 'chief photographer.'" Her first color cover was botched. It was supposedly of Marvin Gaye but is all sunset, little Gaye.

In her photo biography, one phrase becomes the "open sesame" to an understanding of Leibovitz's work from the 1980s to the present. Describing the photograph of author Tess Gallagher in mask, sequined dress, and bareback on a horse, she says it "is the beginning of placing my subject in the middle of an idea." Lauren Hutton mostly naked in the mud, Bette Midler on a bed of roses, Patti Smith surrounded by flames, all five members of Fleetwood Mac on a mattress, Whoopi Goldberg in a milk bath, and John Lennon naked in the fetal position next to a clothed Yoko are some of the ideas as images she is best known for.

Leibovitz is "perplexed when people say that a photograph has captured someone. A photograph is just a tiny slice of a subject. A piece of them in a moment. It seems presumptuous to think you can get more than that" (Leibovitz, *Annie Leibovitz at Work*, p. 125). But getting the "more" is exactly what has made Leibovitz one of the most famous photographers in the world. The "more than" is a recognition that most famous people—actors, musicians—understand that to be photographed for a publication is to be marketed. They want to become a memorable image. They might as well join in the act (Leibovitz calls it "performance art"). The public wants escapism, and celebrities cling to their fame and invest in posterity. Leibovitz brings together the original ideas, the appropriate props, the famous people, and, unlike her first color cover of Marvin Gaye when she fended for herself, the technical team to blow viewers away.

In the history of photography, it is not Leibovitz's personal pictures vis-à-vis her professional work that is the interesting story. It is that she has helped us understand the nature of photography itself through the arc of her work. From 35mm black-and-white snaps to the most sophisticated studio and computer graphics, Leibovitz has done it all.

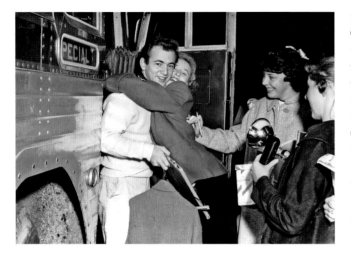

Bobby Darin surrounded by fans as he leaves the bus at the Rochester Community War Memorial, Rochester, New York. Photograph by Lew Allen
October 15, 1958

LEW ALLEN *continued from page 147*

and taught generations of art photographers.

Lew Allen had both of them as teachers at the Rochester Institute of Technology. It is not surprising that Allen would have caught Buddy Holly in deep thought during a quiet moment. It is as if Holly is looking inward and Allen is honoring that journey into himself. And he makes his picture on the bus, the way most musicians in the fifties traveled the country—but not always. Don McLean's "American Pie" is a touching reminder of the plane crash that killed Holly, "The Big Bopper" Richardson, and Ritchie Valens in 1959.

Allen, born in Cleveland, Ohio, in 1939, started photographing in high school, apprenticing himself to a local yearbook photographer when he was fif-

teen. When Elvis came to Cleveland in 1956 and the three local newspapers were on strike, he had his first break in the world of music photography. He was the only "photographer" in Cleveland to photograph Elvis onstage and behind the scenes, even though he was still in high school. Between 1956 and 1958, Allen photographed, as he titled his book, *Elvis & the Birth of Rock*—Buddy Holly, the Everly Brothers, Elvis Presley, Frankie Avalon, Bobby Darin, and other heartthrobs of the period.

DANIEL KRAMER *continued from page 152*

Revisited (see page 298), considered Dylan's finest, ranks fourth in *Rolling Stone's* top five hundred greatest albums. Kramer's photograph of the young singer—head cocked; eyes quizzical; wearing a shiny, arty abstractly printed, puffy-sleeved shirt over a T-shirt with a motorcycle logo; legs spread apart so his crotch is prominent but not sexual (Dylan, clean shaven, sensual lips slightly colored, bouffant hair, wearing a "pretty" shirt, appears uncharacteristically androgynous)—seated next to a headless man dangling Kramer's 35mm camera, is a strange and haunting image. In its cropping it has the feel of a snapshot, but as millions who have seen it on album cov-

ers and CDs know, Dylan's eyes *connect* powerfully with their own.

BOB GRUEN *continued from page 161*

have to leave before the makeup and the sweat starts running down faces. It is only when the performers get going for real that Gruen—and all the other photographers in this book—are interested in making live shots.

Because Tina Turner is such an amazing performer with moves onstage like no one else, Gruen tried to capture some of that energy by leaving the camera open to a second exposure while the strobe lights were going off. He caught her dancing feet and her celestial face.

ADRIAN BOOT *continued from page 166*

Boot studied physics at Surrey University and went to Jamaica to teach in 1970. He roamed the island with his 35mm camera, capturing the street life the travel agents censored from the brochures. He was friends with Perry Henzell, who directed the Jimmy Cliff film *The Harder They Come*, but didn't get involved in photographing the unique music scene until later. After three years on the island, he returned to England, did a book about Jamaica titled *Jamaica: Babylon on a Thin Wire* with the music writer Michael Thomas, and drifted into music photography. He shot black and white both because he liked it and because the music magazines, such as *New Musical Express* and *Melody Maker,* did not run color. After freelancing at many publications,

including *The Face,* he replaced Barrie Wentzell at *Melody Maker.* He was a chief photographer for Live Aid and still works throughout the world, especially in Africa, on humanitarian and goodwill projects.

Boot never put aside his science and technological leanings. As new gadgets appear, he figures out if he can make them work for him professionally. He is not a purist. Whereas many of the photographers in this book have an adversarial relationship with "the industry," Boot loves propagating rock and roll through new technologies and bringing ideas to "the industry." He makes movies; DVDs; traveling exhibitions with large-scale prints, glossy panels, and music; books; videos; and Internet sites. He also still goes into the darkroom—reluctantly.

MICHAEL ZAGARIS *continued from page 167*

Zagaris started going to the Fillmore West, and says the music was "fabulous." In an interview with the author, he recalls:

> [I got into] shooting rock and roll. It was exciting, it was change, it was politics, it was sex, it was youth. All self-taught . . . For me, the camera was merely an entrée to this world, the way an actor puts on a costume, puts on the paint, and then, as in the Stanislavski method [of acting], you become what you are shooting. . . . What I was try-

ing to do, beyond live it, was to bring to people something they weren't going to see all the time. I shot things live . . . but I wanted to, as much as possible, get behind the scenes as well, so you get a feeling of what it was like tuning up, in the hotel room, what it is like being on the road as a rock and roll [band]. . . .

> The English bands . . . impacted on us as a culture and resonated with us much more than the American bands. . . . They were playing American blues roots. . . . They put on incredible shows combined with the drugs and . . . Dionysian thing, it totally changed our culture.

Zagaris, who loves the rock-and-roll lifestyle, also adds, "The great thing about it, from Elvis onward, is that it epitomized *cool.*" Not many people are paid to pursue their passions, but Zagaris, a renowned music photographer, is also the team photographer for the San Francisco 49ers and the Oakland A's.

MICK ROCK *continued from page 174*

Floyd play. Rock and Barrett hung out over the next couple of years while Rock was developing his photography and Pink Floyd was jettisoning to the heights. When Barrett needed a cover for his first solo album, he called Rock. This is not the photograph used for *The Madcap*

Laughs, which was made by Hipgnosis, but it was taken in the same flat in Earls Court with the strange striped floorboards painted by Barrett. All Rock's photographs from this series are haunting, partly because of the strangeness in Barrett but also because Rock found a means of photographing his friend on the edge, disorienting the viewer with angles, perspectives, and even color relationships that create an unease and a sense of dislocation.

STORM THORGERSON *continued from page 176*

around 1970 (they did their first Pink Floyd album in 1968). An illiterate "dope freak" scribbled on the door of Storm and Po's flat the word "Hipgnosis." It sounded like hypnosis, which they liked. Wouldn't it be nice to design "hypnotic visuals"? Unlike the "dope freak," Thorgerson, a product of the progressive Summerhill School, Cambridge schools, Leicester University (B.A. with honors in English and philosophy), and the Royal College of Art, and Powell, educated at the King's School, Ely, Cambridgeshire and the London School of Film Technique, are very literate. They liked the made-up word "Hipgnosis" because it "possessed a nice sense of contradiction, of an impossible co-existence, from hip=new and groovy, and Gnostic relating to ancient learning."

How do they come up with a concept? They listen to the music. "Eventually, an idea that appeals comes to light and it can appeal just because it's odd, cute, romantic, bizarre, appropriate, or striking, and

so on," recounts Thorgerson. They pass it by the musicians and with their okay, they go out and take the photograph—even if it means carrying sixty red balls to the Moroccan desert; hanging people upside down; building and erecting monolithic sculptures; arranging seven hundred wrought-iron hospital beds, each individually made up with different sheets and blankets, along the Devon coast; erecting twenty real telegraph poles so twenty people can sit upon them contemplating the Earth and (really) sending out good wishes for its survival. Represent the music—which, actually, cannot be represented. In a world of Photoshop, it is important to remember the lengths Storm and Po went to to "keep it real."

PINK FLOYD, *TREE OF HALF LIFE*
page 176

Thorgerson's lips are sealed. Normally forthcoming in revealing his painstaking machinations, he won't tell how this tree profile came into being. Helicopter topiary just doesn't hack it. The picture was taken in Richmond, Surrey, and was made into a Pink Floyd T-shirt. It is so beautiful, one just has to believe in magic.

THE NICE, *ELEGY* continued from page 178

Storm considers the "private confidence that this whole adventure gave us . . . equaled only by the public confidence we derived from [making the album cover for Pink Floyd's] *Dark Side of the Moon*." Reflecting on Hipgnosis's contribution to the history of rock and roll, how can we not celebrate the image as well as the sound?

MARCIA RESNICK continued from page 182

ferment. In the seventies she produced brilliant, small books exploring gender, sexuality, and acts of seeing and remembrance. She sequenced her photographs thematically and used her pictures as parts of narratives with subtext. She often posed her rock-and-roll and "downtown" subjects in ways that explored perspective and the idea of vantage point. Even with her most straightforward portraits, Resnick was always developing a concept within the frame.

Her work was part of the larger art scene, and she photographed her friends—musicians, filmmakers, writers, artists—in ways that explore relationships. Resnick says: "A photo session is a kind of conversation. Photographic portraiture reveals how humans relate to each other, whether it is with deliberate staged artifice or with an abandonment of contrivance, revealing hints of genuine honesty. The viewer, in turn, enters into the exchange while forming his own relationship with the subject. The resulting image can range from the predictable to the outrageous."

JEAN-MARIE PÉRIER continued from page 183

back of the *Marie Claire* studio. He showed me how to develop his pictures—they were everywhere on the wall. . . . Tabard was a very sweet man, very patient, he helped me a lot . . . just by pure generosity. He was from another century."

When Filipacchi began his magazine empire (which included *Paris Match*) by buying *Jazz Magazine*, he brought Périer, still a teenager, along as an assistant and a photographer. Five people produced the magazine read by 1.5 million people.

Filipacchi then brought out the teen magazine *Salut Les Copains* (*Hi Friends*) based on Filipacchi's successful television show modeled after Dick Clark's *American Bandstand*. Between 1962 and 1974, Périer had the freedom to photograph whom he wanted and how he wanted. Experimentation was part of the fun. He tries not to be nostalgic about the sixties or the large budget he had for photography. He remembers it as a "time of joy and freedom." Périer spent fifteen days in 1964 with Chuck Berry, just the two of them in a Cadillac driving around America to concerts. He photographed him performing for all-white Southern audiences, sitting on park benches, driving through Mobile, Alabama. He recalls how Berry would go to town and look for musicians to back him up (as well as for women).

This head shot of Berry is unusual. Rarely does one have a chance to study the nuances in his face. It is as if we are seeing Berry's cheekbones, seductive lips, Adam's apple, and five-o'clock shadow for the first time. He is almost always pictured in motion, a rock-and-roll star, onstage or going somewhere.

CLAUDE GASSIAN *continued from page 187*

Richards in 1990 sitting quietly by himself having a cigarette (see page 304). There is a large screen nearby, cordoning off 100,000 young people in Prague waiting for their dream—synonymous with freedom—to come true. They are about to experience a live Rolling Stones concert a year after the fall of the Berlin Wall.

Gassian is a wonderful photographer, and among his masterpieces are James Brown sitting in a Paris hotel lobby with maids peeking at him through a doorway; Boy George sitting in the corner of a grocery store reading a magazine, the entire scene in true Technicolor; David Bowie performing and looking more like Marcel Marceau than a rock star; a close-up of Aretha Franklin's face, slightly blurred with smoke rising from her cigarette; David Byrne and Tina Weymouth in a hotel corridor, looking like they are lost in a Buñuel film; Patti Smith forlorn and cold at Père Lachaise Cemetery; a portrait of Johnny Thunders, out of focus and timeless; and Iggy Pop doing the most amazing backbend, eyes popping, body sinuous.

GERED MANKOWITZ *continued from page 196*

"rude, edgy, dangerous." His cover for the Rolling Stones' 1965 album *Out of Our Heads* (in the United States titled *December's Children [and Everybody's]*) is gritty, dark, and brilliantly composed—the Stones form a vortex with their bodies, pulling the viewer into their (nether) world. It is a classic.

The photograph of the looming Yardbirds, their legs spread apart, woven like a willow fence, each his own person but intertwined, shows defiant expressions. They, too, had the "look" of a rock-and-roll band, as well as being blessed with two of the most brilliant guitarists in rock history—Jimmy Page and Jeff Beck, on the right in the picture. Part of the developing image of a rock band was to take them out of the studio and put them "onto the streets as if to physically connect them with their audiences; to show that they were not artificial products of Brylcreem and tungsten lighting, but real people whom their fans could emulate" (Philip Hoare, *Icons of Pop*, p. 21).

Mankowitz feels he was able to make strong pictures, in part, because he was of the same generation as the musicians. Equally important, he was independent of the recording studios, and his photography had to please only himself and the musicians. EMI, for example, had their PR department work with staff photographers to come up with vapid ideas for each new group, making sure they looked squeaky-clean and wholesome. Most of the pictures of early rock groups from the labels followed the Beatles' model: four or five young men, dressed almost identically, following the directions of the studio photographer. The results would be ludicrous: rock-and-roll musicians winding their watches, fixing their ties, putting their hands in their pockets or over their hearts, throwing their jackets up in the air or jumping for joy. Even the supercool David Bowie, while still Davy Jones performing with the Lower Third, threw his floral tie over his shoulder on command.

GLEN E. FRIEDMAN *continued from page 197*

wanted to shoot them without a flash, in natural light, because he concluded that flash creates "inorganic and flat images." He wanted to find a means of "composing images that technically mirrored the organic, democratic, charged and generous ethos of Fugazi in an aesthetically sensible and symmetric style."

There is a photographer on the left of the frame, incredulous at the performance style onstage. So are we. Upon first viewing, the upside-down musician is so shocking, one thinks there is nothing more to see. But gradually, one discovers the beauty of the form, the curve that extends from the fingers to the knee, the negative space between the two musicians, the graceful electrical wire. It is a radical picture of a radical band.

ANTON CORBIJN *continued from page 207*

a battle he could only lose—a battle against the predominance of soullessly and mechanically manufactured images of man. He was looking for the beauty and the truth of man, well aware that they could not exist but in the realm of *emotional perception* [emphasis added]."

Julia Margaret Cameron, the nineteenth-century British portrait photographer and one of the greatest artists in the history of photography, understood the challenge of using a machine to convey essence. In 1864 she wrote to Sir John Herschel, "I could not help wishing you had been writing on the subject and that you had spoken of my photography in that spirit which will elevate it and

induce an ignorant public to believe in other than mere conventional topographic photography. . . . My aspirations are to ennoble photography and to secure for it the character and uses of High Art by combining the real and ideal and sacrificing nothing of Truth by all possible devotion to Poetry and beauty."

Corbijn is Cameron's photographic heir. Born in the Netherlands, resident of the United Kingdom, Corbijn is one of the most significant photographers and filmmakers working today. He makes strange and haunting pictures. His photography is the opposite of common celebrity pictures where "perfection" and gloss are the norm. His photographs don't purport to tell the truth or give an easily comprehended image of the people who stand before his camera. Instead, Corbijn's camera is a means of transport into the essence of being. Mystery, not packaging, is the result.

PHILIP TOWNSEND *continued from page 216*

photography, and the Rolling Stones were sweet but made to seem streetwise and tough by Oldham and the photographers he hired. When it comes to creating "image," it's not sound, it's sight.

Townsend's pictures are wonderful for many reasons, and not only because they are the first in-depth look at the group. They reveal how "image" is manufactured. In the days before "packaging" musicians and putting millions of dollars into perfecting a "product," Townsend went out with his camera and the Stones and had some fun. They all were innocent and trying to figure out how photog-

raphy could be used to project an image, even if they didn't exactly know what that image should be.

Example: the five Rolling Stones stand before a graffiti-covered derelict building with boarded-up windows. Bill Wyman is sitting with his feet in a hole in the sidewalk. All of them hold cigarettes. Brian Jones, Keith Richards, and Mick Jagger have mastered a tough, know-it-all stare. Watts has a half-grin and Wyman is forcing back the smile he had been conditioned to give to the camera. Townsend nailed it—and this isn't even one of his famous photographs.

Townsend remembers going around Chelsea, Earls Court, and Marble Arch finding locations. He took the Stones to the waterfront and to alleyways with laundry drying to evoke a working-class milieu and to pubs with remnants of "old England." He succeeds better than many early music photographers in tackling what is a huge problem even today— making a strong composition out of four or five guys who don't know how to pose and who simultaneously want to project individuality yet show the cohesiveness of a group. The Stones' hair is long and scruffy (for the early 1960s), the clothes range from matched checkered jackets to turtlenecks, and the only time the Stones seem truly comfortable in Townsend's photographs is when they are making music on a bare wooden stage with a few simple amplifiers and their instruments.

Oldham, the Rolling Stones' first manager, came up with the provocative question, "Would you let your daughter go out with a Rolling Stone?" and the press ran with it. Oldham succeeded in marketing his band as dangerous and wild, even

when, in some early snapshots, they look warm and cuddly and very nervous.

EDWARD COLVER *continued from page 227*

made it real, made it palatable, made it as dangerous and exciting as the actual concert experience.

Jello Biafra of the Dead Kennedys says it best:

> Anyone even slightly interested in L.A.'s punk underground has seen it through an Edward Colver photo. Edward shined a light on the underlying darkness in a way that would make Weegee proud. The menace, the alienated kids, [their] on again off again camaraderie, and the fright behind the macho eyes.
>
> —QUOTED IN *BLIGHT AT THE END OF THE FUNNEL*, BY EDWARD COLVER, P. 30.

JILL FURMANOVSKY *continued from page 230*

ing being told what to do. Furmanovsky isn't that kind of photographer. She is a photojournalist trying to honestly portray, not exploit or idealize, her subject. The band admired how the Beatles' photographers humanized them for their fans. They wanted to do a similar thing for their followers, and they let Furmanovsky get close and personal. Among her best pictures are Oasis in the pub and snooker hall and at the recording studio.

Furmanovsky describes the scene in her "joiner" picture, an homage to David Hockney's composite pictures of the late 1970s and early 1980s:

Oasis was recording their third album, *Standing on the Shoulder of Giants*, at Olympic Studios, which has a very beautiful wooden floor and interesting wood paneling on the ceiling. I was invited to drop in at various times over a period of about a month with a view to documenting the process, possibly for a record sleeve or publicity. I appeared at random times and never knew what I would find. One night I arrived to find the band and Johnny Marr (guitarist of the Smiths) listening to a playback of the George Harrison song "It's All Too Much." He had died a few days before and this was a sort of tribute. The settee and listening back speakers were in the middle of the room surrounded by the band's equipment and it occurred to me that it might be interesting to leave the camera "running" on a tripod over the next few hours while they recorded overdubs. I think I shot about four rolls of film over three hours. These I had made into 5 × 7-inch glossy b&w prints. Over Christmas of that year I spread the prints out on the kitchen table and played with them

like a giant puzzle that joined up, à la David Hockney circa 1982. The resulting image is like a short film that both highlights the feeling of that famous studio and also gives some insight into the recording process.

—E-MAIL TO THE AUTHOR, JULY 22, 2008

EDMUND TESKE *continued from page 239*

printed in the darkroom in combination with a negative of a parched and cracked vinyl seat cushion, impressions of ferns, and a stone statue of Beethoven. The picture is very strange, giving visual form to the "doors of perception." The four musicians take on the quality of a fossil, their bodies and faces become one with the crackled, textured pattern. The image was used for the back of their album *13*.

In Teske, with his complex, spiritual, brilliant layered photography, Morrison found an artist whose experimentation with his medium and ability to shift from states of consciousness and tap spiritual realms while looking both inward and outward matched his own quest. Morrison asked Teske to shoot the photographs for the cover of his book *The Lords and the New Creatures: Revealing, Early Poems from the Voice of a Generation*. Morrison wrote this poem about photography:

Camera, as all-seeing god, satisfies our longing for omniscience. To spy on others from this height and angle: pedestrians pass in

and out of our lens like rare aquatic insects.

TIMOTHY WHITE *continued from page 242*

me that sly smirk, so I took the shot. . . . Then he flicked the cockroach at me!" ("Every Picture Tells a Story," *Rolling Stone* 828/829, December 16–23, 1999, p. 159)

This was not the type of photography White thought he would be doing when he was at Rhode Island School of Design. His teachers—the Abstract Expressionist Aaron Siskind and the New Bauhaus–influenced Harry Callahan—were the two best photography teachers in the country, if not the world, at the time. Today, White has a very successful and lucrative professional photographic career. Although his commercial photography is somewhat in contradiction to his "lofty ideals" in art school, his pictures are still based on the "art of seeing" that he learned during his student days. The photographers who inspired him then—Walker Evans, Eugene Atget, Helmut Newton—still guide him and, to paraphrase the Broadway musical *Rent*, you can take the boy out of art school, but you can't take art school out of the boy.

EDWARD COLVER *continued from page 243*

Flag's front man, but the group decided to put him on the cover. Colver doesn't claim credit for coming up with the idea of the fist smashing the mirror, but the execution is all his. He put masking tape over the back of the mirror and smashed

it with a hammer. The blood was made out of red india ink, dishwashing soap, and instant coffee. "I like the way the lighting looks—his arm is so close that it doesn't catch a lot of the flash," Colver says. Considering the shoot cost next to nothing—his beat-up 35mm camera was held together with tape—he finds it ironic that "I heard the mirror was for sale in a record-collector magazine called *Goldmine* for four thousand bucks. It's easily identifiable—you can't break a mirror the same way twice."

JULIA GORTON *continued from page 254*

Lisette Model, who also taught Diane Arbus, Larry Fink, Peter Hujar, Rosalind Solomon, and Bruce Weber. Model abhorred imitation; her students were inspired not only by her vision but also by her forays into jazz clubs and local bars. Gorton directed her close-up lens on torn fishnet stockings, lace bras, zebra jackets, leather skirts, and fabulous faces. She did this for fun as well as for classroom assignments. She created a calendar using a photograph of Lydia Lunch for each month. Her photographs convey the texture and feel of her times in a way similar to Model's studies of Europeans in the 1930s and New Yorkers in the 1940s and 1950s.

Between 1976 and 1981, Gorton, while still a student, started going to Max's Kansas City and CBGB. She was from Delaware, a shy kid wanting adventure. The camera was her crutch; it supported her emotionally and gave her courage to go places alone where she would have feared to tread on her own.

Her initial $180 rent was too much, so she moved into an apartment in Alphabet City with a roommate for $110 a month. Her home was her studio; her darkroom was still at college. Rarely has student work passed the test of time as well as Gorton's has.

KEVIN WESTENBERG *continued from page 255*

This picture of the White Stripes was taken in an old garage in London. The brake-testing machine has echoes of Superman born on Krypton. The word "cryptography" is derived from the Greek meaning "the practice and study of hiding information."

LLOYD SHEARER *continued from page 256*

home. Unlike most pictures of Elvis, this photograph shows him not as an unattainable rock god but as a boyfriend who snuck into a girl's bedroom when her parents were away.

One of the finest books on the revolution that is rock and roll is *Rock 'n' Roll Times: The Style and Spirit of the Early Beatles and Their First Fans*, by Jürgen Vollmer. Captions are taken from song titles of the early 1960s: "Whole Lotta Shakin' Goin' On," "The Kind of Boy You Can't Forget," "Be My Baby," and "Are You Lonesome Tonight?" The photographs are of European teens. Behind them on the walls in many of the photographs, while they are making out and "going all the way," is Elvis (see page 23).

MARIPOL *continued from page 257*

jewelry designer, stylist, director of documentaries, producer. She connects people in a unique and caring way. She energizes the design, art, music, and fashion worlds. She understands that creativity is the wellspring of life and that what you do matters only if you care what others do. Her photographs are an extension of her determination to make a connection, to celebrate her friends, and to capture precious moments. She is the most interesting and attractive "mother hen" nesting in New York.

EMI STUDIO *continued from page 260*

American princesses (only black) and happy to see that all the presents underneath the tree were EMI records, the most prominent being *The Chipmunks Sing the Beatles Hits*. Another time, Diana, Florence, and Mary were given umbrellas to dance with. (One of the photographs from this shoot ended up on the cover of *A Bit of Liverpool*—hence the umbrellas). Writing about this era, the journalist Liz Jobey describes the photographs from the early years of pop as the "good-humoured compliance with which so many acts greeted the corniest suggestions for a picture" (*The End of Innocence*, page 11.) Even Pink Floyd, after having their mandatory "signing of contract" photograph taken, were asked to "jump for joy" for the photographer—and *even* Pink Floyd followed direction.

The recording artists were "owned" by their labels, and the labels felt they owned the stars' images, as well. It is fasci-

nating to view photographic archives of the big record companies. There are pictures used for album covers. There are PR shots. When the Supremes agreed to pose with the umbrellas and neat hairstyles and suits, EMI, their label, invited a dozen press photographers to the roof of their building, so all the newspapers could have basically the same picture the next morning.

In the EMI archives there are negatives of musical groups in envelopes that have written on them DO NOT USE: NEW IMAGE. Once the group's PR "image" had changed, there was no way an old photo could be utilized. Even independent photographers often benefited by being called back a week or two later after an initial shoot because the musicians' hairstyles or style of clothing had changed.

By the second half of the 1960s, many groups realized their power and insisted on using freelance photographers of their choice. They were sick of smiling. Sick of wearing stupid clothes. Their record sales had earned them the right to shape their own images.

CHARLES PETERSON *continued from* *page 273*

it's important that the photographs stand on their own as purely great photographs."

Peterson's mosh pit has all the power, monumentality, and elegance of a great historical painting. In the history of photography only war and sports photography have, in the words of the brilliant Hugh Edwards, former curator of photography at the Art Institute of Chicago, "the nobility of the completed gesture, not merely a split fraction of movement, stopped dead. This was something we believed possible only in the hands of geniuses of draughtsmanship like Géricault and Degas" (back jacket of *The Sports Photography of Robert Riger*). Now we can add to the pantheon the best music photographs of Charles Peterson.

AN ALBUM COVER CHRONOLOGY
1954–2009

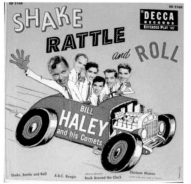
Photographer unknown, 1954

Buddy Holly,
photographer unknown, 1957

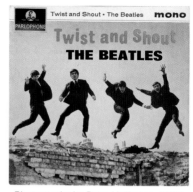
Photographer unknown, 1957

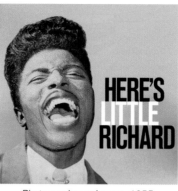
Photography by Dezo Hoffmann, 1964

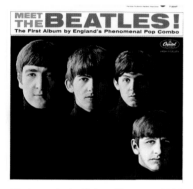
Photography by Robert Freeman, 1964

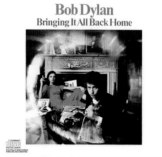
Photography by Daniel Kramer, 1965

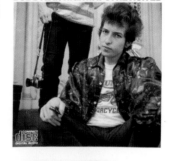
Photography by Daniel Kramer, 1965

Photography by David Montgomery,
1967

Jefferson Airplane,
photography by Herb Greene, 1967

The Doors, *Strange Days,*
photography by Joel Brodsky, 1967

Two Virgins (back), photography by
John Lennon and Yoko Ono, 1968

Two Virgins (front), photography by
John Lennon and Yoko Ono, 1968

Photography by Ed Caraeff, 1969

The Beatles, *Abbey Road,*
photography by Iain Macmillan, 1969

Photography by Joel Bernstein, 1970

Photography by Henry Diltz, 1970

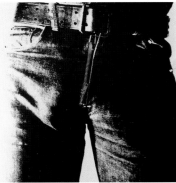

Rolling Stones, *Sticky Fingers,*
photography by Andy Warhol, 1971

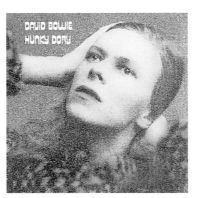

Photography by Brian Wood, 1971

The Who, *Who's Next,*
photography by Ethan Russell, 1971

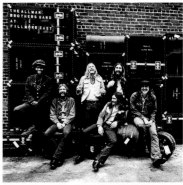

The Allman Brothers Band, *At Fillmore
East,* photography by Jim Marshall, 1971

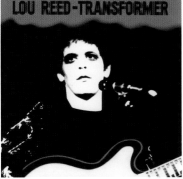

Photography by Mick Rock, 1972

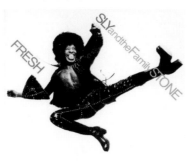

Photography by Richard Avedon, 1973

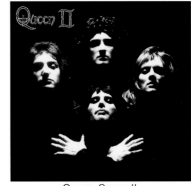

Caribou,
photography by Ed Caraeff, 1974

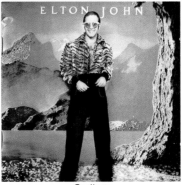

Queen, *Queen II,*
photography by Mick Rock, 1974

Photography by Norman Seeff, 1975

Photography by Robert Mapplethorpe,
1975

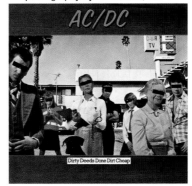

Photography by Hipgnosis, 1976

Joni Mitchell, *Hejira,* portrait by
Norman Seeff/Joel Bernstein, 1976

Photography by Shig Ikeda, 1976

Photography by Andy Kent, 1977

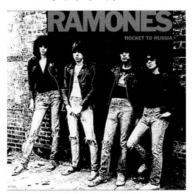

Photography by Danny Fields, 1977

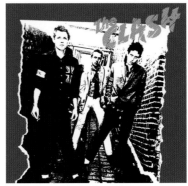

Photography by Kate Simon, 1977

Photography by Kate Simon, 1978

Photography by George DuBose, 1979

Photography by Janette Beckman, 1979

Photography by Steve Harvey, 1979

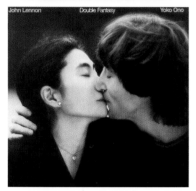

Photography by Kishin Shinoyama, 1980

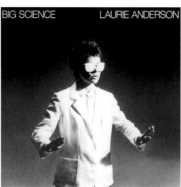

Photography by Greg Shifrin, 1982

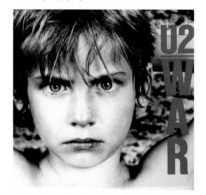

Photography by Anton Corbijn, 1983

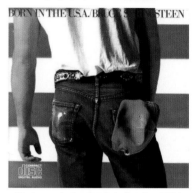

Photography by Annie Leibovitz, 1984

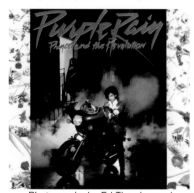

Photography by Ed Thrasher and Associates, 1984

Photography by Brian Griffin, 1985

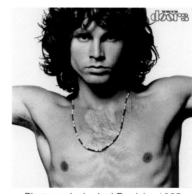

Photography by Joel Brodsky, 1985

Photography by Richard Kern, 1986

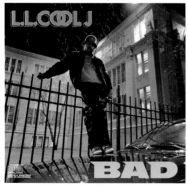

Photography by Glen E. Friedman, 1987

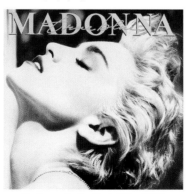

Photography by Herb Ritts, 1987

Photography by Glen E. Friedman, 1988

Prince, *Lovesexy*, photography by Jean-Baptiste Mondino, 1988

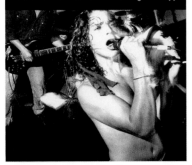

Photography by Charles Peterson, 1990

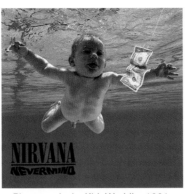

Photography by Kirk Weddle, 1991

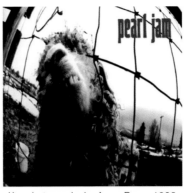

Vs., photography by Ames Bros., 1993

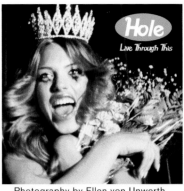

Photography by Ellen von Unwerth, 1994

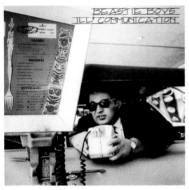

Photography by Bruce Davidson, 1994

Youthanasia,
photography by Hugh Syme, 1994

Photography by Pat Graham, 1994

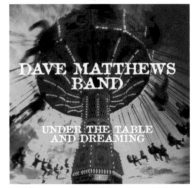

Photography by Stuart Dee, 1994

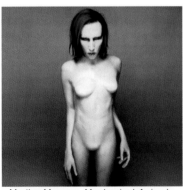

Marilyn Manson, *Mechanical Animals,*
photography by Joseph Cultice, 1998

Photography by Danny Clinch, 1999

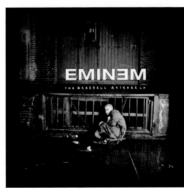

Photography by
Joe Mama-Nitzberg, 2000

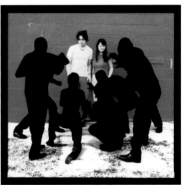

The White Stripes, *White Blood Cells,*
photography by Patrick Pantano, 2001

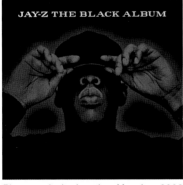

Photography by Jonathan Mannion, 2003

Björk, *Debut,* photography by
Jean-Baptiste Mondino, 2006

Nine Inch Nails, *The Slip,*
photography by Rob Sheridan, 2008

U2, *No Line on the Horizon,*
photography by Hiroshi Sugimoto, 2009

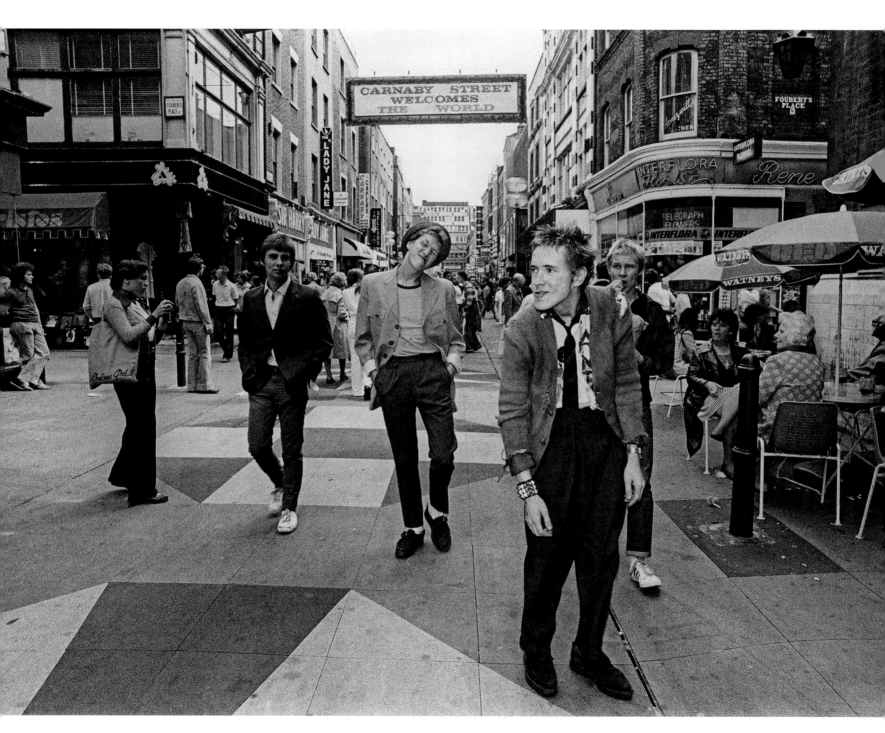

The Sex Pistols on Carnaby Street (left to right: Glen Matlock, Steve Jones, Johnny Rotten, Paul Cook), London, spring 1976. Rotten described his body language and clothes as being modeled on Richard III and the British television characters Steptoe and son, who were rag and bone men.

Photograph by Ray Stevenson

ACKNOWLEDGMENTS

My three children—Kevin Buckland and Alaina and Stephen Taylor—were my guides and inspiration for this book. Knowing they were there gave me the confidence to tackle a new subject. They help me stay "forever young."

This book could not have materialized without the vision and hard work of my editor, Victoria Wilson, and her editorial assistant, Carmen Johnson. The entire team at Knopf—Iris Weinstein, book designer; Carol Devine Carson, jacket designer; Maria Massey, production editor; and Roméo Enriquez, production manager, prove, once again, there is no better publisher than Knopf.

I am indebted to my literary agent, Luke Janklow, who has been unfailing in his support and guidance, and to his assistant, Claire Dippel. Jonathan Marder, Jonathan Marder + Company, had the original idea for a book of rock-and-roll photography and I deeply value his encouragement and friendship.

I want to thank Universal Music Group and especially Doug Morris and Nick Henny, who saw the uniqueness of this project and agreed to give it financial support. Sarah Frank, friend and colleague, was the facilitator of this collaboration, and I am sincerely appreciative of her professionalism and generosity.

At the beginning of my research, I was fortunate to hold the Olympus Chair in the History of Photography at the Cooper Union. Mark Gumz, CEO of Olympus, U.S.A., and Dave Willard, former director of marketing and communication services, are strong supporters of photographic education and the history of photography.

Dr. Arnold Lehman, director of the Brooklyn Museum, upon hearing that I was working on a book about rock-and-roll photography, was immediately excited about its potential as a museum exhibition. His enthusiasm is infectious, and no one got the "bug" more joyously than Matthew Yokobosky, chief designer at the Brooklyn Museum and my collaborator in every detail of the exhibition. This book serves as a catalogue to the exhibition. A very special thank-you goes to Matthew and to my talented assistant, Corey Towers. The museum staff—most especially Megan Carmody Doyle, Deana Setzke, Jennifer Bantz, Sallie Stutz, and Traslin Ong—know how to get the job done and still make it fun.

Michael Zilkha kindly allowed me to view his unparalleled collection of music photographs. His vision, manifested in his choice of pictures, inspired me and helped me understand the cultural as well as aesthetic significance of this unexplored genre.

Dave Brolan, although still young, is a legend in his own time. He knows and is admired by almost every rock-and-roll photographer, and he is also one of the sweetest, most helpful of men. He has been an adviser to me since the beginning, generously sharing names and addresses as well as facilitating my access to many of the artists. Jill Furmanovsky, head of Rockarchive and one of the photographers in the book, directed me to wonderful photographers I might have missed. Terence Pepper, curator of photography at the National Portrait Gallery, London, has turned rock-and-roll exhibitions into a sideline and shared his images and knowledge.

The staff at Getty Images have a particular affection for and knowledge of my subject. I would like to thank Jonathan Hyams of the Michael Ochs Collection/Getty Images, Los Angeles; Matthew Butson, Sarah McDonald, and Alex Timms of Getty Images, London; and Ari Levine, Getty Images, New York. I am appreciative of the late Roger Eldridge of Camera Press and of David Redfern and his knowledgeable staff, especially Jon Wilton.

Many people have helped me along the way. I would particularly like to thank: Cey Adams; Bill Adler, Eyejammie; Bonnie Benrubi; Peter Blachley and Aaron Zych, Morrison Hotel Gallery; Jesse Blatt, Annie Leibovitz Studio; Todd Brandow; Barbara Baker Burrows; Kate Calloway, EMI; Luke Charde; Charles Cowles; Karon Crosby; Bill Dautremont-Smith; Shelley Dowell and the entire staff at the Richard Avedon Foundation; Gerry and Joanne Dryansky; Larisa Dryansky; David Fahey and Ken Devlin, Fahey Klein Gallery; Judith Jamison; Francesca Kazan and Martin Monk, my hosts in London; Judith Fisher Freed; Jessica Friedman; Julie Grahame; Debbie Harry and Chris Stein; Bill Hunt, HASTED HUNT; Theron Kabrich, San Francisco Art Exchange; Steven Kasher; Laurie Kratochvil; Kevin Kushel; Sharon Lawrence; Gillian McCain; Sir Paul McCartney and his staff at MPL; David Montgomery; Robert Montgomery; Christian Olguin; John Pelosi; Philip Perkis; Sara Rosen; Shelly Rice; Jeffrey Rosenheim, Metropolitan Museum of Art; David and Nadine Samuels; Joel Selvin; Shelter Serra, Mark Seliger Studio; Temmie and David Siegal; Jeffrey D. Smith, Contact Press Images; Helena Srakocic-Kovac; Etheleen Staley and Takouhy Wise, Staley+Wise Gallery; David Strettell, Dashwood Books; Pat Kerr Tigrett; Anne Tucker, Museum of Fine Arts, Houston; Nils Vidstrand; Aaron Watson; Stephen and Mus White; and Schuyler Van Horn. I would also like to thank the many family members who are conscientious custodians of significant archives in the history of rock-and-roll photography.

Most important, I would like to thank all the photographers, some of whom are not even represented in the book, who invited me into their homes and studios, opened up their files and their boxes, and spoke to me for hours about their photographs, sometimes taken during a short, intense period, sometimes the result of a lifetime commitment to picturing rock and roll.

Keith Richards, Prague, 1990
Photograph by Claude Gassian

BIBLIOGRAPHY

Allen, Lew. *Elvis & the Birth of Rock: The Photographs of Lew Allen*. Guildford, U.K.: Genesis Publications, 2007.

Andreas, Robert, ed. Life *Remembering John Lennon 25 Years Later*. Des Moines: *Life* Books, 2005.

Andrews, Nancy Lee. *A Dose of Rock 'n' Roll*. Deerfield, Ill.: Dalton Watson Fine Books, 2008.

Arbus, Diane. *Diane Arbus Revelations*. New York: Random House, 2003.

Avedon, Richard. *The Sixties*. New York: Random House, 1999.

Bailey, David. *David Bailey's Rock and Roll Heroes*. New York: Bulfinch Press, 1997.

Bailey, David, and Martin Harrison. *Birth of the Cool*. New York: Viking, 1999.

Bailey, David, and Peter Evans. *Goodbye Baby & Amen: A Saraband for the Sixties*. London: Corgi Books, 1969.

Bayley, Roberta, Stephanie Chernikowski, George DuBose, Godlis, Bob Gruen, and Ebet Roberts. *Blank Generation Revisited: The Early Days of Punk Rock*. New York: Schirmer Books, 1997.

Beckman, Janette. *The Breaks: Stylin' and Profilin' 1982–1990*. New York: Powerhouse Books, 2007.

———. *Made in the UK: The Music of Attitude, 1977–1983*. New York: Powerhouse Books, 2008.

Belsito, Peter, and Bob Davis. *Hardcore California: A History of Punk and New Wave*. Berkeley: Last Gasp, 1983.

Benson, Harry. *The Beatles: In the Beginning*. New York: Universe Publishing, 1993.

———. *Harry Benson: Fifty Years in Pictures*. New York: Abrams Books, 2001.

Beste, Peter. *True Norwegian Black Metal*. New York: Vice Books, 2008.

Björk. *Björk: A Project by Björk*. New York: Bloomsbury, 2001.

Black, Johnny. *Rock and Pop Timeline: How Music Changed the World Through Four Decades*. San Diego: Thunder Bay Press, 2003.

Blakesburg, Jay. *Between the Dark and Light: The Grateful Dead Photography of Jay Blakesburg*. San Francisco: Backbeat Books, 2004.

Borucki, Justin. *Being There*. New York: Justin Borucki, 2007.

Boyd, Joe. *White Bicycles: Making Music in the 1960s*. London: Serpent's Tail, 2005.

Brazis, Tamar, ed. *CBGB & OMFUG: Thirty Years from the Home of Underground Rock*. New York: Abrams Books, 2005.

Brooks, David. *Visual Music*. London: David Brooks Publishing, 2006.

Brown, Max, ed. *Rock X-Posed: Five Decades of Attitude in Pictures*. Toronto: Rock Shutter Productions, 2002.

Burrows, Terry. *John Lennon: A Story in Photographs*. San Diego: Thunder Bay Press, 2000.

Chedid, Matthieu, and Claude Gassian. *M: Qui De Nous Deux*. Paris: Editions Flammarion, 2004.

Chernikowski, Stephanie. *Dream Baby Dream: Images from the Blank Generation*. Los Angeles: 2.13.61 Publications, 1996.

Cheuse, Josh. *Rockers Galore*. Irvine: Stussy Books, 2007.

Clinch, Danny. *When the Iron Bird Flies*. New York: Razorfish Studios, 2000.

Clinch, Danny, and Craig Kanarick, eds. *Discovery Inn: The Photographs of Danny Clinch*. New York: Razorfish Studios, 1998.

Cohen, John. *There Is No Eye: John Cohen Photographs*. New York: Powerhouse Books, 2003.

Colver, Edward. *Blight at the End of the Funnel*. San Francisco: Last Gasp, 2006.

Conzo, Joe. *Born in the Bronx: A Visual Record of the Early Days of Hip Hop*. New York: Universe Publishing, 2007.

Cooper, Martha. *Hip Hop Files: Photographs 1979–1984*. New York: Powerhouse Books, 2005.

Cooper, Michael. *Blinds and Shutters*. Guildford, U.K.: Genesis Publications, 1990.

Corbijn, Anton. "Innocence." *Spezial Fotografie*. Portfolio No. 37, 2005.

———. *Star Trak*. Munich: Schirmer/Mosel, 1996.

———. *33 Still Lives*. New York: teNeues, 1999.

———. *U2 & I: The Photographs 1982–2004*. Munich: Schirmer/Mosel, 2008.

Corio, David. *The Black Chord: Visions of the Groove: Connections Between Afrobeats, Rhythm & Blues, Hip Hop and More*. New York: Universe Publishing, 1999.

Court, Paula. *New York Noise: Art and Music from the New York Underground 1978–88*. London: Soul Jazz Publishing, 2007.

Cox, Julian. *Spirit into Matter: The Photographs of Edmund Teske*. Los Angeles: Getty Publications, 2004.

Craske, Oliver, ed. *Rock Faces: The World's Top Rock 'n' Roll Photographers and Their Greatest Images*. Mies, Switzerland: RotoVision SA, 2004.

Crump, James. *Albert Watson*. London: Phaidon Press Limited, 2007.

Cyr, Merri. *A Wished-for Song: A Portrait of Jeff Buckley*. Milwaukee: Hal Leonard, 2002.

Davies, Chalkie. *Pointed Portraits*. London: Eel Pie Publications, 1981.

DeCurtis, Anthony, James Henke, and Holly George-Warren, eds. *The Rolling Stone Illustrated History of Rock & Roll*. New York: Rolling Stone Press, 1992.

Denenberg, Thomas, ed. *Backstage Pass: Rock and Roll Photography*. New Haven and London: Yale University Press in association with the Portland Museum of Art, Maine, 2009.

Dickson, Ian. *Flash, Bang, Wallop!* London: Abstract Sounds Publishing, 2000.

Diltz, Henry. *California Dreaming: Memories and Visions of LA 1966–1975.* Guildford, U.K.: Genesis Publications, 2007.

Dister, Alain. *It's Only Rock and Roll.* Paris: Marval, 1990.

———. *Punk Rockers!* Paris: Editions de Collectionneur, 2006.

———. *60s Colors.* Paris: Editions de Collectionneur, 2006.

Earl, Andy. *Vista.* London: Sanctuary Publishing Limited, 2000.

Evans, Mike. *Elvis: A Celebration.* East Sussex, U.K.: The Ivy Press, 2002.

Fasolini, Fabio, and Christoph Radl, eds. *Frozen: A Retrospective by Albert Watson.* Milan: Rotonda di Via Besana, 2004.

Feinstein, Barry. *Real Moments: Bob Dylan by Barry Feinstein.* London: Vision On Publishing, 2008.

Feinstein, Barry, Daniel Kramer, and Jim Marshall. *Early Dylan.* New York: Bulfinch Press, 1999.

Finkelstein, Nat. *Andy Warhol: The Factory Years, 1964–1967.* New York: Powerhouse Books, 2000.

Foreman, Kamilah, and Amy Teschner, eds. *Sympathy for the Devil: Art and Rock and Roll Since 1967.* Chicago: Museum of Contemporary Art, 2007.

Friedlander, Lee. *American Musicians.* New York: Distributed Art Publishers, 1998.

Friedman, Glen E. *Fuck You Heroes.* New York: Burning Flag Press, 1994.

———. *Fuck You All.* Rome: Museo Laboratorio Di Arte Contemporanea, 1998.

———. *The Idealist.* New York: Burning Flag Press, 2003.

———. *Keep Your Eyes Open: The Fugazi Photographs of Glen E. Friedman.* New York: Burning Flag Press, 2007.

Furmanovsky, Jill. *The Moment: 25 Years of Rock Photography.* Surrey, U.K.: Paper Tiger, 1995.

Gassian, Claude. *Anonymous.* Washington, D.C.: Govinda Gallery, 2007.

———. *Intersections.* Lyon: Musée d'art contemporain de Lyon, 2003.

George-Warren, Holly, ed. *Punk 365.* New York: Abrams, 2007.

———. *Rolling Stone Images of Rock & Roll.* New York: Rolling Stone Press, 1995.

———, ed. Rolling Stone: *The Complete Covers.* New York: Abradale Press, 2001.

Goldsmith, Lynn. *Photodiary.* New York: Rizzoli, 1995.

———. *Rock and Roll.* New York: Abrams Books, 2007.

Goude, Jean-Paul. *So Far So Goude.* New York: Assouline Publishing, 2005.

Graham, Pat. *Silent Pictures.* New York: Akashic Books, 2007.

Gruen, Bob. *New York Dolls.* New York: Abrams Image, 2008.

———. *Sometime in New York City.* Guildford, U.K.: Genesis Publications, 1995.

———. *Rockers.* São Paulo: Cosac Naify, 2007.

Grunenberg, Christoph, ed. *Summer of Love: Art of the Psychedelic Era.* London: Tate, 2005.

Guernsey's Auction Catalogue. The Dick Clark Auction. New York: Guernsey's, 2006.

Gullick, Steve. *Pop Book Number One: Photographs: 1988–1995.* London: Independent Music Press, 1995.

———. *Showtime.* London: Vision On Publishing, 2001.

Gullick, Steve, and Stephen Sweet. *Nirvana.* London: Omnibus, 2005.

Halfin, Ross. *Fragile: Human Organs.* Los Angeles: 2.13.61 Publications, 1996.

———, ed. *The WHO Live.* Guildford, U.K.: Genesis Publications, 2000.

Harrison, Martin. *Young Meteors: British Photojournalism, 1957–1965.* London: Jonathan Cape, 1988.

Harry, Debbie, Chris Stein, and Victor Bockris. *Making Tracks: The Rise of Blondie.* London: Da Capo Press, 1998.

Hendler, Herb. *Year by Year in the Rock Era.* New York: Praeger Publishers, 1987.

Hipgnosis and George Hardie, eds. *The Work of Hipgnosis: "Walk Away René."* Garden City, N.Y.: A & W Visual Library, 1978.

Hirsch, Abby, ed. *The Photography of Rock.* New York: The Bobbs-Merrill Company, 1972.

Hoare, Philip, ed. *Icons of Pop.* London: Booth-Clibborn Editions, 1999.

Hoffmann, Dezo. *With the Beatles: The Historic Photographs of Dezo Hoffman.* New York: Omnibus Press, 1982.

Holmstrom, John, ed. *Punk: The Original.* New York: Trans-High Publishing, 1996.

Hopper, Dennis. *Out of the Sixties.* Pasadena: Twelvetree Press, 1988.

———. *A System of Moments.* Vienna: MAK, 2001.

Israel, Marvin, and Martin Harrison. *Elvis Presley 1956.* New York: Abrams Books, 1998.

Jobey, Liz, ed. *The End of Innocence: Photographs from the Decades That Defined Pop.* Zurich: Scalo, 1997.

Jocoy, Jim. *We're Desperate: The Punk Photography of Jim Jocoy.* New York: Powerhouse Books, 2002.

Kasher, Steven, Michael Chaiken, and Sara Maysles, eds. *A Maysles Scrapbook: Photographs/Cinemagraphs/Documents.* New York: Steidl/Steven Kasher Gallery, 2007.

King, Dennis. *Art of Modern Rock.* San Francisco: Chronicle Books, 2007.

Kirchherr, Astrid. *When We Was Fab.* Guildford, U.K.: Genesis Publications, 2008.

Kirchherr, Astrid, and Max Scheler. *Golden Dreams.* Guildford, U.K.: Genesis Publications, 1998.

Kirchherr, Astrid, and Klaus Voormann. *Hamburg Days.* Guildford, U.K.: Genesis Publications, 1999.

Kirchherr, Astrid, Gunter Zint, and Peter Bruchmann. *BIG: Beatles in Germany*. Guildford, U.K.: Genesis Publications, 1997.

Kisseloff, Jeff. *Generation on Fire: Voices of Protest from the 1960s, An Oral History*. Lexington: The University Press of Kentucky, 2007.

Kramer, Daniel. *Bob Dylan: A Portrait of the Artist's Early Years*. London: Plexus, 2001.

Kratochvil, Laurie, ed. Rolling Stone: *The Photographs*. New York: Simon & Schuster, 1989.

LaChapelle, David. *Heaven to Hell*. Cologne: Taschen, 2006.

———. *Hotel LaChapelle*. New York: Bulfinch Press, 1999.

———. *LaChapelle Land: Photographs by David LaChapelle*. New York: Simon & Schuster, 1996.

Landy, Elliott. *Dylan in Woodstock*. Guildford, U.K.: Genesis Publications, 2000.

———. *Woodstock Dream*. Kempen, Germany: teNeues, 2000.

———. *Woodstock Vision: The Spirit of a Generation*. Woodstock: Landyvision, 1996.

Lavine, Michael, and Pat Blashill. *Noise from the Underground: A Secret History of Alternative Rock*. New York: Fireside, 1996.

Law, Lisa. *Flashing on the Sixties*. Santa Rosa, Calif.: Squarebooks, 2000.

Leibovitz, Annie. *American Music*. New York: Random House, 2003.

———. *Annie Leibovitz at Work*. New York: Random House, 2008.

———. *A Photographer's Life, 1990–2005*. New York: Random House, 2006.

———. *Photographs*. New York: Rolling Stone Press, 1983.

———. *Photographs—Annie Leibovitz, 1970–1990*. New York: HarperCollins Publishers, 1991.

Lemke, Gayle. *The Art of the Fillmore: The Poster Series 1966–1971*. New York: Thunder's Mouth Press, 1997.

Lens, Jenny. *Punk Pioneers*. New York: Universe Publishing, 2008.

Levy, Joe, ed. Rolling Stone: *The 500 Greatest Albums of All Time*. New York: Wenner Media, 2005.

Life magazine. Life *Rock and Roll at 50: A History in Pictures*. New York: *Life* Books, 2002.

Malarkey, Sarah, ed. *Unplugged*. New York: MTV Books, 1995.

Mankowitz, Gered. *Jimi Hendrix: The Complete Masons Yard Photo Sessions*. Berlin: Schwarzkopf & Schwarzkopf, 2004.

———. *The Rolling Stones: Out of Their Heads, Photos 1965–67/1982*. Berlin: Schwarzkopf & Schwarzkopf, 2005.

Marchbank, Pearce. *With the Beatles: The Historic Photographs of Dezo Hoffmann*. New York: Omnibus Press, 1982.

Marcopoulos, Ari. *Out & About*. Milan: Alleged Press, 2005.

Marcus, Greil. *Lipstick Traces: A Secret History of the Twentieth Century*. Cambridge, Mass.: Harvard University Press, 1989.

———. *Mystery Train: Images of America in Rock 'n' Roll Music*. New York: Plume, 1997.

———, ed. *Stranded: Rock and Roll for a Desert Island*. New York: Da Capo Press, 2007.

Maripol. *Maripolorama*. New York: Powerhouse Books, 2005.

Marshall, Jim. *Not Fade Away: The Rock & Roll Photography of Jim Marshall*. New York: Bulfinch Press, 1997.

———. *Proof*. San Francisco: Chronicle Books, 2004.

Matsushita, Hiroko. *Hardcore*. Tokyo: Little More, 1999.

Mayes, Elaine. *It Happened in Monterey*. Culver City, Calif.: Britannia Press, 2002.

McCartney, Linda. *Linda McCartney's Sixties: Portrait of an Era*. New York: Bulfinch Press, 1992.

———. *Roadworks*. New York: Bulfinch Press, 1996.

McNeil, Legs, and Gillian McCain. *Please Kill Me: The Uncensored Oral History of Punk*. New York: Penguin Books, 1997.

Miessgang, Thomas. *Punk: No One Is Innocent*. Vienna: Kunsthalle, 2008.

Miles, Barry, Grant Scott, and Johnny Morgan. *The Greatest Album Covers of All Time*. London: Collins & Brown, 2005.

Moore, Thurston, and Byron Coley. *No Wave: Post-Punk, Underground, New York, 1976–1980*. New York: Abrams Books, 2008.

Mortensen, Shawn. *Out of Mind*. New York: Abrams Books, 2007.

———. *Shawn Mortensen: "It's My Life . . . or It Seemed Like a Good Idea at the Time."* Tokyo: Nowhere Code, 2002.

Murray, Chris, ed. *Rolling Stones 40 × 20*. New York: Billboard Books, 2002.

Nite, Norm N. *Rock On: The Illustrated Encyclopedia of Rock and Roll*. New York: Crowell, 1978.

O'Brien, Glenn. *Bande à Part: New York Underground 60's 70's 80's*. Corte Madera, Calif.: Gingko Press, 2009.

Ochs, Michael. *Rock Archives: A Photographic Journey Through the First Two Decades of Rock & Roll*. Garden City, N.Y.: Doubleday & Company, 1984.

Padilha, Roger, and Mauricio Padilha. *The Stephen Sprouse Book*. New York: Rizzoli, 2009.

Pang, May. *Instamatic Karma: Photos of John Lennon by May Pang*. New York: St. Martin's Press, 2008.

Paniccioli, Ernie, and Kevin Powell, ed. *Who Shot Ya? Three Decades of Hiphop Photography*. New York: Amistad, 2002.

Paytress, Mark. *I Was There: Gigs That Changed the World*. London: Cassell Illustrated, 2005.

Perich, Anton, Billy Name, Bob Gruen, Oliviero Toscani, and George DuBose. *Max's Kansas City: Art Imitating Life, Imitating Art.* Copenhagen, Denmark: Nikolaj Copenhagen Contemporary Art Center, 2004.

Périer, Jean-Marie. *Mes Années 60.* Paris: Editions Filipacchi, 2002.

Perrin, Alain Dominique. *Rock 'n' Roll 39–59.* Paris: Fondation Cartier pour l'art contemporain, 2007.

Peterson, Charles. *Screaming Life: A Chronicle of the Seattle Music Scene.* New York: HarperCollins Publishers, 1995.

———. *Touch Me I'm Sick.* New York: Powerhouse Books, 2003.

Peterson, Christian. *San Francisco Psychedelic.* Minneapolis: Minneapolis Institute of Art, 2007.

Powell, Ricky. *Frozade Moments. Classic NYC Street Photography.* New York: Eyejammie Books, 2004.

———. *Oh Snap! The Rap Photography of Ricky Powell.* New York: St. Martin's Griffin, 1988.

———. *Public Access: Ricky Powell Photographs 1985–2005.* New York: Powerhouse Books, 2005.

———. *The Rickford Files: Classic New York Photographs.* New York: St. Martin's Griffin, 2000.

Proud, Alexander E., ed. *Rock 'n' Roll Years, 1960–2000: The Photographers' Cut.* London: Vision On Publishing, 2000.

Putland, Michael. *Pleased to Meet You.* Guildford, U.K.: Genesis Publications, 1999.

Randolph, Michael, ed. *"PoPsie" N.Y.: Popular Music Through the Camera Lens of William "PoPsie" Randolph.* Milwaukee: Hal Leonard, 2007.

Redfern, David. *The Unclosed Eye: The Music Photography of David Redfern.* London: Sanctuary Publishing, 2005.

Riger, Robert. *The Sports Photography of Robert Riger.* New York: Random House, 1995.

Rijff, Ger J., and Jay B. Leviton. *Elvis Close-Up: Rare, Intimate, Unpublished Photographs of Elvis Presley in 1956.* New York: Fireside, 1987.

Robin, Marie-Monique. *The Photos of the Century: 100 Historic Moments.* Cologne: Evergreen, 1999.

Rock, Mick. *Glam! An Eyewitness Account.* London: Vision On Publishing, 2005.

———. *Picture This: Debbie Harry and Blondie.* London: Sanctuary Publishing, 2004.

———. *Psychedelic Renegades: Photos of Syd Barrett.* Guildford, U.K.: Genesis Publications, 2002.

Rock, Mick, and David Bowie. *Moonage Daydream: The Life and Times of Ziggy Stardust.* New York: Universe Publishing, 2002.

Rolling Stone, "Behind the Scenes, 1967–1999: An Intimate Photo History of the Music That Changed the World," December 16–23, 1999.

Rollins, Henry. *Get in the Van: On the Road with Black Flag.* Los Angeles: 2.13.61 Publications, 2004.

Rosenkranz, Patrick. *Rebel Visions: The Underground Comix Revolution: 1963–1975.* Seattle: Fantagraphics Books, 2002.

Rothschild, Amalie R. *Amalie R. Rothschild.* Florence: Angelo Pontecorboli Editore, 2006.

———. *Live at the Fillmore East: A Photographic Memoir.* New York: Thunder's Mouth Press, 1999.

Russell, Ethan A. *Dear Mr. Fantasy: Diary of a Decade: Our Time and Rock and Roll.* Boston: Houghton Mifflin Company, 1985.

———. *Let It Bleed: The Rolling Stones 1969 U.S. Tour.* Burbank: Rhino Entertainment, 2008.

Rynski, Sue. *Hysteric Fifteen.* Tokyo: Hysteric Glamour, 2006.

Salewicz, Chris, and Adrian Boot. *Reggae Explosion: The Story of Jamaican Music.* New York: Abrams Books, 2001.

Santelli, Robert. *The Bob Dylan Scrapbook: 1956–1966.* New York: Simon & Schuster, 2005.

Schatzberg, Jerry. *Thin Wild Mercury: Touching Dylan's Edge.* Guildford, U.K.: Genesis Publications, 2006.

Seeff, Norman. *Hot Shots.* New York: Flash Books, 1974.

———. *Sessions!* Bellevue, Wash.: The WhaleSong Collection, 1994.

Sednaoui, Stéphane. *The Work of Stéphane Sednaoui.* New York: Palm Pictures, 2005.

Seliger, Mark. *In My Stairwell.* New York: Rizzoli International Publications, 2005.

———. *The Music Book.* Kempen, Germany: teNeues, 2008.

Selvin, Joel. *Photopass: The Rock and Roll Photography of Randy Bachman.* Berkeley: SLG, 1994.

Shabazz, Jamel. *Back in the Days.* New York: Powerhouse Books, 2001.

Shafrazi, Tony, ed. *Andy Warhol Portraits.* New York: Phaidon Press, 2007.

Shore, Stephen. *The Velvet Years: Warhol's Factory, 1965–67.* New York: Thunder's Mouth Press, 1995.

Simon, Kate. *Rebel Music: Bob Marley & Roots Reggae.* Guildford, U.K.: Genesis Publications, 2006.

Slimane, Hedi. *Rock Diary.* León, Spain: Museo De Arte Contemporaneo de Castilla y Leon, 2008.

Smith, Pennie. *The Clash: Before & After.* Boston: Little, Brown and Company, 1980.

Stefanko, Frank. *Days of Hope and Dreams: An Intimate Portrait of Bruce Springsteen.* New York: Billboard Books, 2003.

Summers, Andy. *I'll Be Watching You: Inside the Police, 1980–83.* Cologne: Taschen, 2007.

Tannenbaum, Allan. *John & Yoko: A New York Love Story.* San Rafael, Calif.: Insight Editions, 2007.

———. *New York in the 70s.* Berlin: Feierabend, 2003.

Tanner, Lee. *The Jazz Image: Masters of Jazz Photography.* New York: Abrams, 2006.

Tarlé, Dominique. *Exile.* Guildford, U.K.: Genesis Publications, 2001.

Thorgerson, Storm, and Aubrey Powell. *For the Love of Vinyl: The Album Art of Hipgnosis.* New York: PictureBox, 2008.

———. *100 Best Album Covers.* New York: DK Publishing, 1999.

Thorgerson, Storm, and Peter Curzon. *Taken by Storm: The Album Art of Storm Thorgerson.* London: Omnibus Press, 2007.

Tolinksi, Brad. *Classic Hendrix: The Ultimate Hendrix Experience.* Guildford, U.K.: Genesis Publications, 2005.

Versace, Gianni, ed. *Rock and Royalty.* New York: Abbeville Press, 1996.

Vollmer, Jürgen. *From Hamburg to Hollywood.* Guildford, U.K.: Genesis Publications, 1997.

———. *Rock 'n' Roll Times: The Style and Spirit of the Early Beatles and Their First Fans.* Woodstock, N.Y.: The Overlook Press, 1983.

Ward, Ed, Geoffrey Stokes, and Ken Tucker. *Rock of Ages: The* Rolling Stone *History of Rock & Roll.* New York: Rolling Stone Press, 1986.

Ward, Michael. *A Day in the Life: Photographs of the Beatles.* Guildford, U.K.: Genesis Publications, 2008.

Watson, Albert. *Cyclops.* New York: Bulfinch Press, 1994.

Weller, Paul. *A Thousand Things.* Guildford, U.K.: Genesis Publications, 2008.

Weller, Sheila. *Girls Like Us: Carole King, Joni Mitchell, Carly Simon—and the Journey of a Generation.* New York: Atria, 2008.

Wenner, Jann S. Rolling Stone *Cover to Cover: The First Forty Years.* New York: Bondi Digital Publishing, 2007.

Wertheimer, Alfred. *Elvis at 21: New York to Memphis.* San Rafael, Calif.: Insight Editions, 2006.

———. *Elvis '56: In the Beginning.* New York: Pimilco, 1979.

Whitaker, Robert. *Beatles (U.S.A.) Ltd.* New York: Raydell Publishing, 1966.

———. *Cream: The Lost Scottish Tour.* London: Repertoire Books, 2006.

Whitaker, Robert, and Marcus Hearn. *8 Days a Week: The Beatles' Last World Tour.* London: Endeavour, Ltd., 2008.

Whitaker, Robert, and Martin Harrison. *The Unseen Beatles.* San Francisco: Collins, 1991.

White, Timothy. *Rock Stars.* New York: Stewart, Tabori and Chang, 1984.

Withers, Ernest C. *The Memphis Blues Again: Six Decades of Memphis Music Photographs.* New York: Viking Studio, 2001.

———. *Pictures Tell the Story.* Norfolk: Chrysler Museum of Art, 2000.

Wolman, Baron. *Classic Rock & Other Rollers: A Photo Portfolio.* Santa Rosa, Calif.: Squarebooks, 1992.

Woodward, Fred, ed. Rolling Stone *Images of Rock & Roll.* Boston: Little, Brown and Company, 1995.

Wright, Tom, and Susan VanHecke. *Roadwork: Rock and Roll Turned Inside Out.* New York: Hal Leonard, 2007.

Yellen, David. *Too Fast for Love: Heavy Metal Portraits.* New York: Powerhouse Books, 2004.

Many Web sites and magazines were used in the research for the book, too many to list separately.

Amy Winehouse, 2007
Photograph by Hedi Slimane

INDEX

Page numbers in **bold italics** refer to illustrations.

ABBA, 268
AC/DC, 160, **299**
Adam and the Ants, 126
Adams, Ansel, 118
Adams, Carolyn Elizabeth (Mountain Girl),
 134, **134**
Adamson, Robert, 47
Adler, Lou, 94
Aguilera, Christina, 37
Albers, Josef, 150
Albin, Peter, **100**
Ali, Muhammad, 135
Alice in Chains, 273
Allen, Lew (born 1939, Cleveland, Ohio),
 147, **147**, 288, **288**
Allison, Jerry, **147**
Allman Brothers Band, 8, **299**
Alt, Bobby, 88, **88**
America, 266
Ames Bros., **301**
Anderson, Laurie, 132, **300**
Anderson, Marian, 222
Andretti, Mario, 135
Andrew, Sam, **100**
Ansaldo, Michael, 3
Arbus, Allan, 152
Arbus, Amy (born 1954, New York, N.Y.),
 244, **245**
Arbus, Diane, 64, 150, 152, 244, 294
Armstrong, Louis, 222
Armstrong, Tim, 76, **76**
Asher, Dan, 285
Atget, Eugène, 64, 137, 293
Avalon, Frankie, 29, 288
Avedon, Richard (1923–2004, born New
 York, N.Y.), 148, **149**, 150, 214, **215**,
 299
Avery, Ray (1920–2002, born Winnepeg,
 Canada; American), 72, **73**

B-52's, 132, 144, 198, **199, 300**
Baez, Joan, 8, 152
Bailey, David (born 1938, London), 64, **vi**
Baker, Ginger, 102

Ballard, Florence, 294
Band, the, 67, 74, **74**, 135, 258, 284
Barrett, Syd, 174, **174**, 176, 289
Barry, Judith, 229
Basie, Count, 222
Basquiat, Jean-Michel, 47, 87
Bators, Stiv, **75**
Bayley, Roberta (born 1950, Pasadena,
 Calif.), 78, 87, 154–5, **154, 155**, 285
Beach Boys, 94, 194, 229, 283
Beastie Boys, 126, 163, **301**
Beatles, ix, 20–4, 71, **90–1**, 91, 108, 111,
 156, **157**, 190, **191**, 194, 214, **215**, 216,
 229, 284, **284**, 291, 292, **298**
Beaton, Cecil, 81, 210
Beck, Jeff, 134, **167, 196**, 291
Beckman, Janette (born London;
 American), 78, **300**
Bee Gees, 98, 160, 194
Benjamin, Walter, 15
Bennett, Estelle, **73**
Benny Goodman Band, 218
Benson, Harry (born 1929, Glasgow,
 Scotland; American), 22
Bernstein, Joel, **298, 299**
Bernstein, Leonard, 3, 262
Berry, Bill, 144
Berry, Chuck, **15, 131, 142–3**, 143, **183**,
 286, 290
Bertei, Adele, **182**
Best, Pete, 20, 24, 190, **191**
Beste, Peter (born 1978, Washington,
 D.C.), 36, **36**
Beth B., **182**
Bhajan, Yogi, 125
Biafra, Jello, 292
Big Bopper (J.P. Richardson), 288
Big Brother and the Holding Company,
 100, 101
Bikini Kill, **301**
Björk, 92, **92**, 164, 188, **188, 301**
Black Crowes, 126
Black Flag, 243, **243**, 273, 293–4
Black Sabbath, 268
Blackwell, Chris, 240, 251
Blank Generation, 65

Blind Faith, 12, 102, **103**, 286, **286**
Blitz, Johnny, 65
Blondie, 65, **77**, 86, 280, 285, **299**
Bloomfield, Michael, 156
Blue Cheer, 134
Blue Thumb, 258
Blumenfeld, Erwin, 81
Bob Marley and the Wailers, 146, **146**,
 300
Boddy, Jennie, 273
Bolder, Trevor, **56**
Bono, 207
Bono, Sonny, **73, 195**
Boot, Adrian, 166, **166**, 288–9
Borucki, Justin (born 1975, Bronx, N.Y.),
 76, **76**, 88, **88**
Bosch, Hieronymus, 166
Bowie, David, **2**, 25, **26**, 56, **56**, 57, **57**, 98,
 106, **108**, 194, 231, 286, 291, **299**
Bow Wow Wow, 96, **97**
Boyd, Pattie, 232, **232**
Boy George, 291
Brando, Marlon, 24
Brandt, Bill, 64, 187, 254
Brassaï, 78
Brazis, Tamar, 154, 248
Bridenthal, Bryn, 242
Brodovitch, Alexey, 60, 150, 202
Brodsky, Joel (born Brooklyn, N.Y.), **298**,
 300
Brown, James, 49, **187**, 222, 258, **259**, 291
Brown, Jeffrey, 148
Brown, Max, 56
Brown, Ruth, 222
Browne, Jackson, 184, 266
Bubbles, Barney, 58
Buck, Peter, 144
Buckland, Kevin, ix
Buffalo Springfield, 258, **258**
Burden, Gary, 266
Burlington, Lord, 71
Burn, Gordon, 20
Bush, George W., 65
Butler, Jerry, 222
Byrds, the, 94, 258
Byrne, David, 87, 164, 175, 291

Cage, John, 227
Cale, John, **203**
Callahan, Harry, 293
Cameron, Julia Margaret, 54, 291–2
Capa, Robert, 20
Capote, Truman, 68
Captain Beefheart, 63, 87, 94, **298**
Caraeff, Ed (born 1950, Los Angeles, Calif.), 62–3, **62**, **63**, **298**, **299**
Cartier-Bresson, Henri, 64, 112, 137, 262
Cash, Johnny, 8, 156, 164, 189, **189**
Cato, Bob (1923–1999, born New Orleans, La.), 60, 67, 284
Cave, Nick, 19, **32**
Central Press Ltd., **90–1**, 91
Cervenka, Exene, **193**
Chamberlain, Wilt, 135
Charlatans, 134
Charles, Ray, 222
Cher, 194, **195**
Chernikowski, Stephanie (born Houston, Tex.), 65, **65**, 78
Cheuse, Josh (born 1965, New York, N.Y.), **5**, 126, **126**
Christiane J., 88, **88**
Christopherson, Peter (born 1955, Leeds, England), 12
Circle Jerks, 243
Clapton, Eric, 102, **167**, 232, **232**, 286
Clark, Dick, 29, 218, 290
Clarke, Arthur C., 181
Clash, the, 4–5, **4**, 24, 44, **44**, 66, 126, 212, 217, **217**, 280, **281**, 284, **299**
Cliff, Jimmy, 289
Clinch, Danny (born 1964, Neptune, N.J.), 117, **117**, 164, **165**, 286, **301**
Clurman, Dick, 3
Cobain, Kurt, **6**, **18**, 52, **53**, 121, **122**, 221
Coldplay, 255, 274
Coltrane, John, 8
Colver, Edward (born 1949, Pomona, Calif.), **226–7**, 227, 243, **243**, 292, 293–4

Cook, Gene, 262
Cook, Paul, **302**
Cooke, Sam, 222
Cooper, Tom, 96
Corbijn, Anton, 12, 27, **206–7**, 207, 234, 291–2, **300**
Corio, David (born 1960, London), 116, **116**, 118, **119**, 127, **127**
Cortez, Diego, **182**
Costello, Elvis, 50, 154, **186**, 187
Cougar, John, 154
Courbet, Gustave, 86
Courson, Pamela, **238–9**, 239
Cowin, Eileen, 227
Cramps, 248, **249**
Craske, Oliver, 187, 255
Creamer, Richard (born Hollywood, Calif.), 45, **45**, 283
Creole, Kid, 198
Crewdson, Gregory, 176
Crickets, the, **147**
Crosby, David, 19, 101
Crosby, Stills, Nash and Young, 266, **298**
Cultice, Joseph, **301**
Cummins, Kevin (born 1953, Manchester, England), 64, **64**, 236, **237**
Cunningham, Imogen, 233
Curtis, Ian, 234, **234**, 236, **237**
Curtis, Natalie, 236

Daily, Jasper (died late 1990s), 130, **130**
Dalí, Salvador, 71
Dalton, David, 202
Daltrey, Roger, 132
Danko, Rick, 74, **74**
Danny and the Juniors, **147**
Darin, Bobby, 288, **288**
Darling Buds, 92
Dave Clark Five, 194
Dave Matthews Band, 164, **301**
Davidson, Bruce, **301**
Davis, Miles, 78, 218, 262
Dead Boys, 65, **75**

Dead Kennedys, 243, 292
Dean, James, 24, 150
DeCarava, Roy, 8
Dee, Stuart, **301**
Degas, Edgar, 295
Densmore, John, **130**
Depeche Mode, **300**
Destroy All Monsters, 87
Devo, 217, 243
D Generation, 126
Diamond, Darcy, 45, 283
Diamond, Neil, 194, 258
Dickson, Ian (born 1945, Darlington, Durham, England), **110–11**, 111, 146, **146**, 169, **169**
diCorcia, Philip-Lorca, 96
Diddley, Bo, **142–3**, 143
Diltz, Henry (born 1938, Kansas City, Mo.), **viii**, **13**, 19, 266, **267**, **298**
Dister, Alain (1941–2008, born Lyon, France), 278, **279**
Doherty, Denny, 94, **95**
Doisneau, Robert, 64
Doors, the, 94, **130**, 239, 293, **298**, **300**
Dreja, Chris, **196**
DuBose, George, 78, 198, **199**, **300**
Dunaway, Faye, 60
Duncan, David Douglas, 41
Duran Duran, 98
Dury, Ian, 160
Dylan, Bob, 7, **15**, 25, 38, 54, **54**, 74, 101, 135, **136–7**, 137–40, **138**, **139**, **140–1**, 145, 152, **153**, 156, 194, 240, 258, 262, **263**, 288, **298**

Eagles, **13**, 19, 266
Earl, Andy, 14, **14**, 96, **97**
Eckstine, Billy, 222
Edwards, Hugh, 295
Eggleston, William, 96
Elliot, "Mama" Cass, 94, **95**, 156
Eminem, 37, **37**, **301**
EMI studio, 50, 260, **260**, 283, 294–5

Eno, Brian, 27, 87
Epstein, Brian, 20, 22, 71, 216
Ess, Barbara, 87
Etheridge, Melissa, 198
Eurythmics, 14
Evans, Walker, 38, 293
Everly, Don, **149**
Everly, Phil, **149**
Everly Brothers, 148, **149**, 288
Evers, Medgar, 222

Factory, 202
Faithfull, Marianne, 89, **89**, 106, 132, 196, 198
Feinstein, Barry, 25, **136–7**, 137–40, **138**, **139**, **140–1**, 240, 247
Fields, Danny (born 1939, New York), **4**, 78, **299**
50 Cent, **6**
Filipacchi, Daniel, 183, 290
Fink, Larry, 294
Finkelstein, Nat (born 1933, Brooklyn, N.Y.), 202, **203**
Fitzgerald, Ella, 131, 222
Flea, 121
Fleetwood Mac, 287
Flint, Keith, **33**
Fogelberg, Dan, 266
Foo Fighters, 164
45 Grave, 243
Frank, Robert, 22, 66
Franklin, Aretha, **35**, **83**, 194, 222, 291
Frantz, Chris, 87, 175
Freddie and the Dreamers, 194
Freed, Alan, **28**, 29, **29**
Freeman, Robert (born 1936, London; resident Spain), 22, **298**
Friedlander, Lee, 78
Friedman, Glen E. (born 1962, Pinehurst, N.C.), 197, **197**, 291, **300**
Frusciante, John, 121
Fugazi, 197, **197**, 291
Fuller, Thomas, 96

Furmanovsky, Jill (born 1953, Bulawayo, Rhodesia, now Zimbabwe; British), 106, 127, 192, 230, **230**, 234–5, **234**, **235**, 292–3
Fury, Billy, 194

Gahr, David (1923–2008, born Milwaukee, Wis.), 38, **39**, 247, **247**
Gallagher, Noel, 230
Gallagher, Tess, 287
Garcia, Jerry, 134, **134**
Gassian, Claude (born 1949, Paris, France), **186**, 187, **187**, 291, **304**
Gaye, Marvin, 287
Geffen, David, 266
Geldof, Bob, 268
Genesis, 268
Géricault, Théodore, 295
Germs, 243
Getz, David, **100**
Getz, Stan, 218
Gibson, Ralph, 96
Gilbert, Douglas, 25
Gillespie, Dizzy, 222
Gilmour, David, 192
Ginsberg, Allen, 101
Girl Trouble, 273
Glass, Philip, 87, 262
Godlis, David (born 1951, New York, N.Y), 77, **77**, 78, **79**, 175, **175**, 254
Go-Go's, 198
Goldberg, Whoopi, 287
Goldin, Nan, 78
Goldman, Vivien, 116
Goldsmith, Lynn (born 1948, Detroit, Mich.), 49, **124**, 125, 132, **132**, 145, **145**
Goodman, Benny, 218
Goodwin, Harry (born 1924, Manchester, England), 194, **195**
Gordon, Kim, 87, 229
Gordon, Roscoe, 222
Gorton, Julia, 254, **254**, 294

Goude, Jean-Paul (born 1940, Saint-Mandé, Paris), 208, **209**, **250**, 251, **251**
Gould, Glenn, 262
Graham, Martha, 233
Graham, Pat (born 1970, Milwaukee, Wis.), **301**
Grateful Dead, 134, 258, 278
Gray, 87
Gray, Macy, 37
Gray, Robert, 3
Grech, Ric, 102
Green, Al, 222
Greene, Herb (born 1942, Indio, Calif.), 134, **134**, **298**
Greene, Stanley, 78
Greenwood, Colin, 55
Greenwood, Jonny, 55
Griffin, Brian (born 1948, Birmingham, England), **300**
Gros, Antoine-Jean, 225
Gruen, Bob (born 1945, New York, N.Y.), 5, 50, 75, **75**, 78, 161, **161**, 200, **201**, 261, **261**, 280, **281**, **283**, 284–5, 288
Grundy, Bill, 50
Gullick, Steve (born 1967, Coventry, England), 32, **32**, **33**
Gun Club, 243
Guns N' Roses, 242, 293
Gurley, James, **100**
Gursky, Andreas (born 1955, Leipzig, Germany), 172, **173**

Hagen, Nina, 268
Halberstam, David, 3
Haley, Bill, 20, **246**, **298**
Halfin, Ross, **114–15**, 115
Halley, Peter, 47
Halsman, Philippe, 152
Hammond, John, Jr., **153**, 218
Hampton, Lionel, 222
Handel, George Frideric, 71
Hansen, Patti, 132, **135**
Hardie, George, **12**

Hardin, Tim, 101
Hardy, Bert, 64
Haring, Keith, 47
Harper, Ben, 164
Harrison, George, 20, **21**, 22, 24, **70**, 71, 190, **191**, **215**, 232, 287, 293
Harrison, Jerry, 175
Harry, Deborah "Debbie," 48, 65, **65**, **77**, **86**, **87**, 132, 268, 285
Harvest, Barclay James, 268
Harvey, Bill, 222
Harvey, Steve, **300**
Hattersley, Ralph, 147
Hawkins, Coleman, 218
Hayes, Isaac, 116, 222
Headon, Topper, 66
Heartbreakers, 154, **154**
Hell, Richard, **86**, 88, 285
Helm, Levon, 74, **74**
Hemingway, Ernest, 20
Hendrix, Jimi, 7, **7**, **10**, 11, 62–3, **62**, 170, **171**, 184, 194, 218, **219**, **231**
Henzell, Perry, 288
Herschel, John, 54, 291
Hetfield, James, 115
Hill, David Octavius, 47
Hill, Paul, 96
Hipgnosis, 12, **12**, 176–81, **176**, **177**, **178**, **180–1**, 289, 290, **299**
Hirst, Damien, 126
Hoare, Philip, 50, 291
Hobbs, Walter, 258
Hockney, David, 293
Hoffman, Abbie, 78
Hoffman, Michael, 150
Hoffmann, Dezo (1912–1986, born Czechoslovakia, active England), 20–2, **298**
Holbein, Hans, 121
Hole, 221, 273, **301**
Holiday, Billie, 29
Hollies, 94, 194
Holly, Buddy, **147**, 288, **298**

Holmstrom, John, **86**, **87**, 155, 175
Hook, Peter, **234**
Hopper, Dennis, 258, **258**, **259**
Horenstein, Henry, 78
Hosoe, Eikoh, 121
Houston, Bob, 112
Houston, Whitney, 37
Howlin' Wolf, 222
Hudson, Garth, 74
Hujar, Peter, 294
Human Drama, 243
Hunstein, Don (born 1928, St. Louis, Mo.), 7, 262, **263**
Hurrell, George, 121
Hutton, Lauren, 287
Hynde, Chrissie, 127, **127**

Ikeda, Shig, **299**
Incredible String Band, 94
Insane Clown Posse, 243
Ishlon, Deborah, 262
Israel, Marvin (1924–1984, born Syracuse, N.Y.), 150, **151**

Jackson, Michael, 49, **49**, 194, **252**, 253, **300**
Jackson, Roger, **90–1**
Jagger, Mick, 13, 27, **80**, **81**, 89, 98, **99**, 112, **124**, 143, 160, 169, 216, 225, 270, 274, 292
Jarmusch, Jim, 126
Jay-Z, 104, **105**, 164, **301**
Jefferson Airplane, 134, 258, **298**
Jethro Tull, 231
Jett, Joan, 198
Jimi Hendrix Experience, 168, 231, **231**, 258
Jobey, Liz, 294
Jodoin Keaton, Valérie (born 1947, Montreal; Canadian/American), *v*
Joel, Billy, 98
John, Elton, **9**, 37, 96, 106, 112, **113**, 195, **299**

Johnston, Ian, 202
Jones, Brian, 82, **85**, 216, 258, 292
Jones, Grace, 118, **119**, 208, **250**, 251, **251**
Jones, Mick, 66
Jones, Quincy, 218
Jones, Steve, 168, **302**
Jones, Tom, 106, 194
Joo, Michael, 126
Joplin, Janis, **100**, 101, 112, 134, 184, 192, **247**, 286
Jordan, Louis, 222
Joy Division, 64, 234–5, **234**, 236, **237**

Kane, Art (1925–1995, born Bronx, N.Y.), 82, **83**, **84**, 85
Kane, Big Daddy, 198
Kashi, Ed (born 1957, New York, N.Y.), **6**
Kelley, Mike, 87
Kennedy, John F., 167
Kennedy, Robert F., 167
Kent, Andy, **299**
Kent, Nick, 58
Kern, Richard (born 1954, Roanoke Rapids, N.C.), 87, 109, **109**, **228**, 229, **300**
Kerouac, Jack, 94
Kertész, André, 38
Kiedis, Anthony, 121
Kienholz, Edward, 227
King, B. B., 222
King, Carole, 13, **13**, 94
King, Martin Luther, Jr., 167, 222
King Curtis Band, 218
Kingsbury, Robert, 143
Kinks, 194
Kirchherr, Astrid (born 1938, Hamburg, Germany), 20, **21**, 22–4, **22**, 190, **191**
KISS, 261, **261**
Knight, Gladys, **195**
Kramer, Daniel (born 1932, Brooklyn, N.Y.), **15**, 152, **153**, 288, **298**
Krasnow, Bob, 258
Kravitz, Lenny, 274
Krieger, Robby, **130**

Kristal, Hilly, 154
Kvitrafn, **36**

L7, 273
LaChapelle, David (born 1969, Fairfield, Conn.), 37, **37**, 68, **68–9**, 283
Landy, Elliott, 25, 74, **74**
Lange, Dorothea, 41
L.A.P.D., 243
Lauper, Cyndi, **48**
Lavigne, Avril, 37
Lavine, Michael, **204–5**, 205
Law, John Phillip, 101
Law, Lisa (born 1943, Hollywood, Calif.), **100**, 101
Law, Tom, 101
Led Zeppelin, *viii*, **12**, 45, 58, **59**, 134, 176, **180–1**, 181, 289–90
Leibovitz, Annie (born 1949, Waterbury, Conn.), 12, 64, **142–3**, 143, 164, 274, 287, **300**
Leloir, Jean-Pierre, 131, **131**, 246, **246**, 286–7
Lennon, John, 5, 20, **21**, 22, **22**, 24, 71, 190, **191**, 200, **201**, **215**, 229, 264, **265**, 284, 287, **298**, **300**
Lennox, Annie, 96
Lens, Jenny, 78
Levine, Laura, 19, 92, **92**, 144, **144**
Liebling, Jerome, 64
Lil Kim, 37, **68**
Linn, Judy (born 1947, Detroit, Mich.), 233, **233**
Little Richard, **30**, **298**
Livingston, Jane, 170
LL Cool J, 126, 270, **271**, **300**
Longo, Robert, 87
Lopez, Jennifer, 37
Loren, Cary, 87
Love, Courtney, 37, **220**, 221
Lovin' Spoonful, 19
Lower Third, 291
Lulu, 194

Lunch, Lydia, **182**, 254, **254**
Lux Interior, 248
Lwin, Annabella, 96

MacKaye, Ian, **197**, **226–7**
Macmillan, Iain (1938–2006, born Carnoustie, Scotland), **298**
Madonna, **5**, 14, 37, 96, 126, 172, **172**, 175, 188, 244, **245**, 257, **257**, **300**
Maffei, Frank, **147**
Mahoney, Huckleberry, **162**
Malanga, Gerard, **203**
Mama-Nitzberg, Joe, **301**
Mamas and the Papas, the 19, 94, **95**, 101, **285**
Manet, Édouard, 96
Mankowitz, Gered (born 1946, London, England), 7, **7**, 89, **89**, 170, **171**, 196, **196**, 285, 291
Mannion, Jonathan, **301**
Manson, Charles, 229
Manson, Marilyn, **17**, 37, 109, **109**, **301**
Manuel, Richard, 74
Manzarek, Ray, **130**
Mapplethorpe, Robert (1946–1989, born Floral Park, Queens, N.Y.), 233, **299**
Marcopoulos, Ari, **46**, 47
Marcus, Greil, 50, 168
Marcuson, Alan, 58
Maripol (born 1956, Rabat, Morocco; French, now American), 193, **193**, 257, **257**, 294
Markie, Biz, 198
Marley, Bob, 146, **146**, 160, 168, 240, **300**
Marr, Johnny, 293
Marshall, Jim (born 1936, Chicago, Ill.), 3, 8, 62, 63, 156, **157**, 189, **189**, 247, **299**
Mars Volta, 179, **179**
Martin, Chris, 274, **275**
Martin, George, 22
Matlock, Glen, **302**
May, Tony, **176**

Mayes, Elaine (born 1938, Berkeley, Calif.), 48–9, **48**, 49
McCartney, Linda Eastman (1941–1998, born New York, N.Y.), 184, **185**, 268
McCartney, Paul, 20, 22, 24, 111, 184, **185**, 190, **191**, **215**, 268, 284
McCarty, Jim, **196**
McCrary, Jim (born 1939, Long Beach, Calif.), 13, **13**
McGinley, Ryan (born 1977, Ramsey, N.J.), 11, **158–9**, 159
McGuinn, Roger, 258
McGuire, Barry, 94, 101
McLaren, Malcolm, 96
McLean, Don, 288
McNeil, Legs, 155
Megadeth, **301**
Meisel, Steve, 164
Melcher, Terry, 94
Mellencamp, John, 154
Memling, Hans, 121
Menthol Wars, 87
Method Man, **162**
Mercury, Freddie, 160, **160**, 194
Metallica, **114–15**, 115, 164
M.I.A., *v*
Michael, George, 98
Midler, Bette, 287
Miles, Barry, 54
Miller, Lee, 64
Milligan, Mick, 102
Mills, Mike, 144
Minor Threat, **226–7**
Minutemen, 243
Mirwais, 188
Mitchell, Joni, *ix*, 19, 266, **299**
Mitchell, Mitch, **231**
Moby, 37
Model, Lisette, 294
Mollison, James (born 1973, Nairobi, Kenya; British, resident Italy), **17**
Molon, Dominic, 88

Mondino, Jean-Baptiste (born 1949, Aubervilliers, France), **300**, **301**
Monkees, 108
Montgomery, David (born 1937, Brooklyn, N.Y.; resident London), **298**
Moody Blues, 231
Moon, Keith, **8**, 112
Moondog, 262
Moore, Thurston, 87
Morgan, Johnny, 54
Morissette, Alanis, 188
Morris, Dennis (born Jamaica; British), 168, **168**
Morris, Jan E., 239
Morris, Stephen, **234**
Morrison, Jim, 130, **130**, 184, **238–9**, 239, 285, 293, **300**
Morrison, Sterling, **203**
Morrissey, **11**, 64, **64**, **128–9**, 129, **158–9**, 159
Mortensen, Shawn (1965–2009, born Long Beach, Calif.), **220**, 221
Morton, Margaret (born Akron, Ohio), **221**
Mothers of Invention, 82
Motorcycle Boy, 243
Mountain Girl (Carolyn Elizabeth Adams), 134, **134**
Mudhoney, 18, 273

Nas, 164
Nash, Graham, 19
Nazareth, 268
Newborn, Calvin, 222
Newcombe, Maurice, 112
New Kids on the Block, **132**
Newton, Helmut, 293
Newton, Huey P., **15**
New York Dolls, 278, **279**, 280
Niagara, 87
Nice, the, 178, **178**, 290
Nine Inch Nails, **301**
Nirvana, **6**, 7, 18, 52, 273, **301**
Nixon, Richard, 285

No Doubt, 37
Notorious B.I.G., **204–5**, 205
Novoselic, Krist Anthony, II, 52
No Wave, 19, 65, 182, **182**, 254
Nuclear Assault, 243

Oasis, 126, 230, **230**, 292–3
Obama, Barack and Michelle, 7
O'Brien, Ed, 55
O'Brien, Glenn, 19–20, 25, 221
O'Kane, Johnny, **182**
O'Keeffe, Georgia, 188
Oldham, Andrew Loog, 89, 216, 292
O'Neill, Terry (born 1953, London), **9**, 106, **107**
Ono, Yoko, 87, 200, 264, **265**, 287, **298**
Oppenheim, Meret, 71
Orkin, Ruth, 64
Oursler, Tony, 87

Pacino, Al, 60
Page, Jimmy, **58**, **59**, **167**, 181, **196**, 291
Pantano, Patrick, **301**
Parker, Colonel Tom, 3, 222, **276**
Parker, Junior, 222
Parkinson, Norman, 22
Pater, Walter, 176
Patti Smith Group, 280
Paul Revere & the Raiders, 94
Pavarotti, Luciano, 274
Pavement, 164, **165**
P. Diddy (aka Puff Daddy), **17**, 104, **105**
Pearl Jam, 18, 273, **301**
Penderecki, Krysztof, 227
Penn, Irving, 64, 274
Perich, Anton, 78
Périer, Jean-Marie (born 1940, Neuilly, France), 14, **15**, 131, 183, **183**, 290
Perrin, Dominique, 3
Perry, Andrew, 230
Peterson, Charles (born 1964, Longview, Wash.), 18–19, **18**, 227, **272–3**, 273, 295, **301**

Peterson, Christian, 134
Pettibon, Raymond, 87
Phillips, Anya, **87**, 285
Phillips, Dewey, 222
Phillips, Esther, 218
Phillips, John, 94, **95**
Phillips, Michelle, 94, **95**, 156
Phillips, Sam, 222
Phish, 164
Picciotto, Guy, **197**
Pickett, Wilson, 218, **219**
Pink Floyd, 96, 112, 174, 176, **176**, 192, **192**, 231, 289, 290, 294
Plant, Robert, **viii**, 45, **59**, 169, 176
Poetics, 87
Pointer Sisters, 134
Poison Ivy, 248
Police, the, **107**, 268, **300**
Pop, Iggy, 45, **45**, 132, 169, 291, **299**
Poschardt, Ulf, 207
Powell, Aubrey "Po" (born 1946, Sussex, England), 12, 176–81, **176**, **177**, **178**, **180–1**, 289–90
Powell, Ricky (born 1961, Brooklyn, N.Y.), **162**, 163
Presley, Elvis, **ii**, ix, 3–4, **4**, 20, 24–5, **24**, 40–2, **40**, **41**, **43**, 44, 65, 133, 150, **151**, 222, 256, **256**, 276, **276–7**, 280, 288, 289, 294, **320**
Pretenders, **127**
Prince, **x**, 14, 96, **300**
Prince, Richard, 87
Procol Harum, 94, 192
Prodigy, 32, **33**
Public Enemy, **300**
Puff Daddy (aka P. Diddy), **17**, 104, **105**
Putland, Michael (born 1947, Harrow-on-the-Hill, London), 98, **99**, 112

Queen, 98, 268, **299**

Radcliffe, Charles, 58
Radiohead, 55, **55**, 164

Rae, Corinne Bailey, 14, **14**
Rage Against the Machine, 164, **301**
Rainey, Ma, 222
Ramone, Dee Dee, **155**, 235
Ramone, Joey, **155**
Ramone, Johnny, **155**
Ramone, Tommy, **155**
Ramones, **4**, 5, 24, **110–11**, 111, 154, 155,
 155, 198, 235, 280, **299**
Ranaldo, Lee, 87
Rancid, 76, **76**
Randolph, Michael, 218
Randolph, William "PoPsie" (1920–1978,
 born New York City), 29, **29**, 218, **219**
Rank, J. Arthur, 129
Rawlings, John, 60
Ray, Man, 71
Ray-Jones, Tony, 64
Redding, Noel, **231**
Redding, Otis, 156, 194, 222
Red Hot Chili Peppers, **120**, 121, 169, **169**,
 188, 243
Reed, Lou, 29, **203**, **299**
Regan, Ken (born 1950, New York, N.Y.),
 135, **135**, 287
Relf, Keith, **196**
R.E.M., 144, **144**, 188, 198, 243
Resnick, Marcia (born 1950, Brooklyn,
 N.Y.), 78, 182, **182**, 254, 290
Rice, Bill, **182**
Richards, Keith, 82, 89, 132, **135**, 143, 156,
 187, 216, 274, 291, **304**
Richards, Theodora Dupree, **135**
Richardson, J. P. ("The Big Bopper"),
 288
Richter, Gerhard, 87
Riley, Sam, 234
Ritts, Herb (1952–2002, born Santa
 Monica, Calif.), **300**
Roberts, Ebet (born Washington, D.C.), 78,
 248, **249**
Roberts, Elliot, 266
Robertson, Robbie, 74

Robertson, William V. "Red," **ii**, **4**, 44
Robin, Marie-Monique, 240
Rock, Mick (born 1949, London,
 England; resident United States),
 25, **26**, 56, **56**, 174, **174**, 283–4, 289,
 299
Rolling Stones, ix, 14, 60, 94, 96, 98,
 112, 135, 143, 170, 184, 194, 196,
 216, **216**, 218, **224–5**, 225, 286, 291,
 292, **299**
Rollins, Henry, 205, 243, **243**, 293
Ronettes, 72, **73**
Ronson, Mick, **56**
Rose, Axl, 242, **242**, 293
Ross, Diana, 112, 222, 295
Roth, David Lee, 160, 268, **269**
Rotolo, Suze, 7, **263**
Rotten, Johnny, 168, **168**, **302**
Run-DMC, **126**, 198
Russell, Ethan (born 1945, Mt. Kisco,
 N.Y.), **224–5**, 225, **299**

Salomon, Erich, 41
Salter, Gaby, **281**
Salt-n-Pepa, 116, **116**
Santana, Carlos, 8, 134
Schatzberg, Jerry (born 1927, New York,
 N.Y.), 54, **54**, 60, **61**
Schmid, Hannes (born 1946, Zurich,
 Switzerland), 160, **160**, 268, **269**
Scholtz, Tom, 160
Scott, Grant, 54
Scott B., **182**
Searchers, 194
Sednaoui, Stéphane (born 1963, Paris;
 French/American), 188, **188**
Seeff, Norman (born 1939, Johannesburg,
 South Africa; American), 12, 60, 67,
 67, 284, **299**
Seeger, Pete, 8
Seidemann, Bob (born 1941, New York,
 N.Y.), 12–13, 102, **103**, 285–6,
 286

Seliger, Mark (born 1959, Amarillo, Tex.),
 12, 104, **105**, **120**, 121, **122**, **123**, 274,
 275
Selway, Phil, 55
Sex Pistols, 50, **51**, 96, 111, 168, 235, 280,
 283, **283**, **302**
Shakur, Tupac, 117, **117**
Shames, Stephen (born 1947,
 Massachusetts), **15**
Shaw, Jim, 87
Shaw, Sandie, 194
Shearer, Lloyd (1916–2001, born New
 York, N.Y.), 256, **256**, 294
Shepard, Sam, 233
Shepherd, Judy, **147**
Sheridan, Rob, **301**
Shifrin, Greg, **300**
Shinoyama, Kishin (born 1940, Tokyo),
 300
Silver Beatles, 20, 111, 190; *see also*
 Beatles
Simon, Carly, **299**
Simon, Kate (born 1953, Poughkeepsie,
 N.Y.), 240, **241**, **299**, **300**
Simon and Garfunkel, 94
Simonon, Paul, 5, 44, **44**, 66, 283
Siouxsie and the Banshees, 126, 200
Siskind, Aaron, 293
Sleater-Kinney, 273
Sledge, Percy, 218
Slim Chance, 248
Slimane, Hedi (born 1968, Paris),
 310
Sly and the Family Stone, 262, **299**
Smashing Pumpkins, 164, 188
Smith, Chad, 121
Smith, Junior, **133**
Smith, Patti, **79**, 175, 233, **233**, 287, 291,
 299
Smith, Pennie (born Isleworth, Middlesex,
 England), 4–5, **4**, 44, **44**, 58, **58**,
 59, 66, **66**, 212, **212–13**, 217, **217**, 283,
 284

Smith, W. Eugene, 41, 112, 152
Smiths, 64, **128–9**, 129, 293
Snyder, Tom, 229
Solomon, Rosalind, 294
Sonic Youth, 87, **228**, 229, 273, **300**
Sonny and Cher, **195**
Soundgarden, 18, 273, **301**
Spandau Ballet, 96
Spears, Britney, 37, 98
Specials, 166, **166**
Spector, Phil, 72, **73**, 258
Spector, Ronnie, **73**
Spender, Humphrey, 64
Springfield, Dusty, 194
Springsteen, Bruce, 38, **39**, 145, **145**, 164,
 300
Spungen, Nancy, 235, **235**
Starr, Kay, 218
Starr, Ringo, 22, **215**
Stavers, Gloria (1926–1983, born
 Wilmington, N.C.), 108, **108**, 286
Stein, Chris (born 1950, Brooklyn, N.Y.),
 77, 78, 86–7, **86**, **87**, 132, 285
Steppenwolf, 258
Stern, Bert, 64
Steve Miller Band, 192
Stevenson, Ray (born Rochester, Essex,
 England), 231, **231**, **302**
Stewart, Rod, **17**, 134, 160
Sticca, Michael, **77**
Stieglitz, Alfred, 121, 188
Stigwood, Robert, 102
Stills, Stephen, 19
Sting, 96, 106
Stipe, Michael, 144, 164
Stockhausen, Karlheinz, 227
Stone, Sly, 67, **67**, 134, **299**
Stoppard, Tom, 174
StormStudios, 176, 289–90
Strand, Paul, 121, 236
Strummer, Joe, 66, **66**, 126, 212, **212–13**,
 217, 280, **281**
S.T.U.N., 88, **88**

Sugarcubes, 92
Sugimoto, Hiroshi, **301**
Sukita, Masayoshi (born 1938, Fukuoka,
 Japan), 57, **57**
Sumner, Bernard, 234
Supremes, 260, **260**, 294–5
Sutcliffe, Stuart, 20, **21**, **22**, 24, 190, **191**
Syme, Hugh, **301**

Tabard, Maurice, 183, 290
Tad, 273
Taj Mahal, 94
Talking Heads, 87, 175, **175**
Talley, Nedra, **73**
Tannenbaum, Allan (born 1945, Passaic,
 N.J.), 264, **265**
Tate, Sharon, 229
Television, 88, 132, 175
Temple, Alice, **46**, 47
10cc, **177**
Tenebrous Liar, 32
Teske, Edmund (1911–1996, born Chicago,
 Ill.), **238–9**, 239, 293
Thomas, Michael, 288
Thomas, Rufus, 222
Thorgerson, Storm (born 1944, Potters Bar,
 England), 12, 176–81, **176**, **177**, **178**,
 179, **180–1**, 289–90
Thornton, Big Mama, 222
Thrasher, Edward Lee, Jr. (1932–2006, born
 Glendale, Calif.), **300**
Thunders, Johnny, 291
Thurman, Judith, 7
Till, Emmett, 222
Tilton, Ian (born 1964, Blackpool,
 England), 52, **53**, 129, **128–9**
Tiny Tim, 101
Townsend, Philip, 216, **216**, 292
Townshend, Pete, 82, 112, 211, **211**
T.Rex, 194
Truman, James, 270
Truman, Rupert, **179**
T.S.O.L., 243

Tuchman, Maurice, 170
Tucker, Maureen, **203**
Turner, Ike, 161, 222, **223**, 258
Turner, Tina, 161, **161**, 222, **223**, 258, **267**,
 288
Tyler, Steven, 169
Tyson, Mike, 135

U2, 118, 188, **206–7**, 207, **300**, **301**

Vadukul, Max (born 1961, Nairobi, Kenya;
 British), 12, 210, **210**
Vadukul, Nitin (born 1965, Nairobi, Kenya;
 British), 55, **55**
Valens, Ritchie, 288
Van Halen, **269**
Varèse, Edgar, 227
Varvatos, John, 88
Vaughan, Sarah, 262
Vedder, Eddie, 18–19
Vek, Tom, 14
Velvet Underground, 101, 202, **203**
Vernon, Peter, 50, **51**, 283
Vicious, Sid, 50, 235, **235**, **283**
Vollmer, Jürgen (born 1941, Hamburg,
 Germany), 20, **23**, 24, 190, 294
von Unwerth, Ellen (born 1954, Germany),
 301
Voormann, Klaus (born 1938, Berlin,
 Germany), 20, 24, 71, 190

Wailer, Bunny, 240, **241**
Wailers, 146, **146**, 168, 240
Waits, Tom, 164
Walsh, Joe, 266
Wardruna, **36**
Warhol, Andy, 47, 101, 170, 202, **203**,
 299
Warlocks, 134
Warnov, Mary, **203**
Warwick, Dionne, 222
Waters, Roger, 176
Watson, Albert (born 1942, Edinburgh,

Scotland; resident United States and Morocco), 12, **80**, 81, **252**, 253, 270, **271**

Watts, Charlie, **167**, 170, 216, 292

Wavy Gravy, 101

Weber, Bruce (born 1946, Greensburg, Penn.), 294

Weber, Marnie, 87

Webster, Guy (born 1939, Los Angeles, Calif.), 94, **95**, 285, **285**

Weddle, Kirk (born 1959, Columbia, Mo.), 7, **301**

Weegee, 64, 292

Weller, Paul, 169, 194

Welling, James, 87

Wenner, Jann, 11, 287

Wentzell, Barrie (born 1942, Durham, England; resident Toronto, Canada), 34, **35**, 112, **113**, 286, 289

Wertheimer, Alfred (born 1929, Coburg, Germany; American), **24**, 24–5, 40–2, **40**, **41**, **43**, 133, **133**, 150, 276, **276–7**, 280, **320**

West, Ted, **90–1**

Westenberg, Kevin (born Seattle, Wash.), 255, **255**, 294

Westwood, Vivienne, 96

Weyland, Jocko, 19

Weymouth, Tina, 87, 175, 291

Wheeler, Alice (born 1961, Kansas City, Mo.), **6**

Whitaker, Robert (born 1939, Harpenden, England), **70**, 71, 229, 284, **284**

White, Minor, 147

White, Timothy (born 1956, Fort Lee, N.J.), 12, 242, **242**, 293

White Stripes, **255**, 294, **301**

Who, the, 82, **84**, 192, 231, 268, **298**, **299**

Wilde, Oscar, 25

Williams, Mary Lou, 218

Wilson, Mary, 294

Winans, William, 285

Winehouse, Amy, 72, 210, **210**, 310

Winogrand, Garry, 78, 202

Winwood, Steve, 102, 132

Withers, Ernest C. (1922–2007; born Memphis, Tenn.), 222, **223**

Wolfe, Tom, 60

Wolman, Baron (born 1937, Columbus, Ohio), **10**, 11, **30**, 31, 192, **192**, 211, **211**

Wonder, Stevie, **195**

Wood, Brian, **299**

Wray, Cheryl, 116

Wright, Mose, 222

Wyman, Bill, 216, 292

Yardbirds, **196**, 291

Yarrow, Peter, **153**

Yes, 231

Yorke, Thom, 55

Young, Angus, 160, 268

Young, Evelyn, 222

Young, Malcolm, 268

Young, Neil, 19, 121, **123**, 266, **298**

Young and the Useless, 126

Zagaris, Michael (born 1945, Chicago, Ill.), 167, **167**, 289

Zappa, Frank, 60, **61**, 160

Zimmer, Nina, 172

ZZ Top, 160

On the train from New York City to Chattanooga, Tennessee, Elvis Presley listens to the acetate (gramophone record made from the master tape) of "Hound Dog," "Don't Be Cruel," and "Any Way You Want Me," and hears his music as his fans will hear it on a cheap record player, 1956

Photograph by Alfred Wertheimer

A NOTE ON THE TYPE

The text of this book has been set in Goudy Old Style, one of the more than one hundred typefaces designed by Frederic William Goudy (1865–1947). Although Goudy began his career as a bookkeeper, he was so inspired by the appearance of several newly published books from the Kelmscott Press that he devoted the remainder of his life to typography in an attempt to bring a better understanding of the movement led by William Morris to the printers of the United States.

Produced in 1914, Goudy Old Style reflects the absorption of a generation of designers with things "ancient." Its smooth, even color combined with its generous curves and ample cut marks it as one of Goudy's finest achievements.

COMPOSED BY
North Market Street Graphics,
Lancaster, Pennsylvania

PRINTED AND BOUND BY
Tien Wah Press, Singapore

DESIGNED BY
Iris Weinstein